Dancing *to the* Flute

MUSIC AND DANCE IN INDIAN ART

THE ART GALLERY *of* NEW SOUTH WALES

Principal sponsors

PRESIDENT'S COUNCIL, THE ART GALLERY OF NEW SOUTH WALES
AUSTRALIA–INDIA COUNCIL
NEWS LIMITED

The President's Council of the Art Gallery of New South Wales is proud to sponsor **Dancing to the Flute**. This outstanding exhibition, developed and presented at the Art Gallery of New South Wales, celebrates one of the world's great civilisations. India has a continuous cultural tradition dating back to 2500BCE, yet the rich and complex heritage of this splendid civilization with its unrivalled cultural legacy is unfamiliar to most Australians.

This is the second major exhibition sponsored by the President's Council at the Art Gallery of New South Wales. The first was the impressive **Masterpieces of the Twentieth Century: the Beyeler Collection**. It is our objective to further the tradition of partnership between the corporate community and the Gallery. By assisting the Gallery through consultative advice and the facilitation of funding support and sponsorship, the Council plays an invaluable role in the Gallery's future.

This is an important exhibition for the Art Gallery of New South Wales. It is a demonstration of our Gallery's commitment to displaying a wide range of art of enduring artistic significance. This is the largest exhibition of Indian art to be presented in Australia and a fitting tribute to India in its year of celebration of fifty years of independence.

David Gonski
President Board of Trustees
Chairman President's Council

Dancing to the Flute

MUSIC AND DANCE IN INDIAN ART

JIM MASSELOS
JACKIE MENZIES
PRATAPADITYA PAL

WITH CONTRIBUTIONS BY
REIS FLORA
JOHN GUY
ROBYN MAXWELL
KAPILA VATSYAYAN

EDITED BY PRATAPADITYA PAL

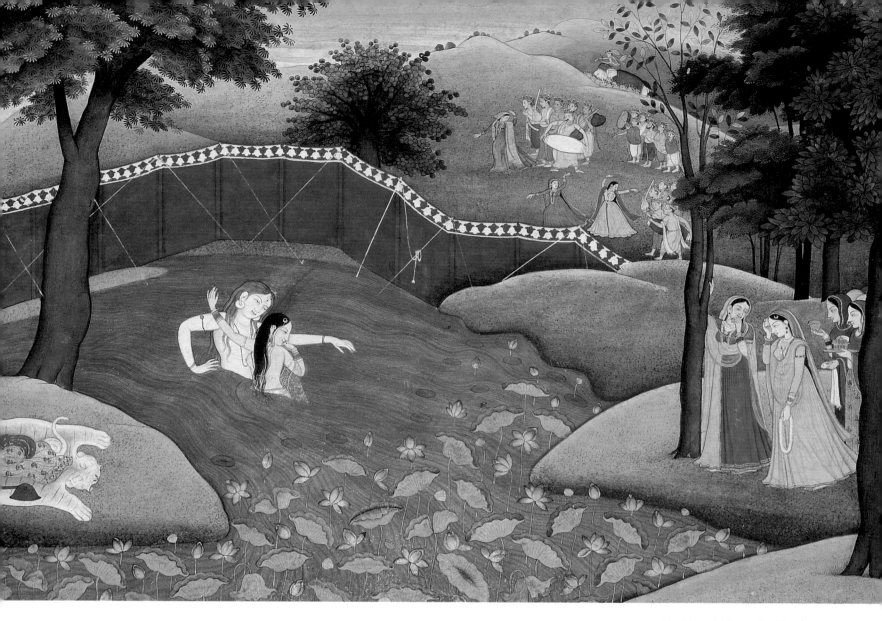

14 Shiva and Parvati bathing

Published by
The Art Gallery of New South Wales
© The Art Gallery of New South Wales,
Sydney Australia 1997

National Library of Australia
Cataloguing-in-publication data:
Dancing to the flute:
music and dance in Indian art.

Bibliography
ISBN 0 7313 0003 3 (pbk)

1. Art, Indic – Exhibitions. 2. Dance in art –
Exhibitions. 3. Music in art – Exhibitions.
I. Masselos, J.C. (James Cosmas). II. Menzies,
Jackie. III. Pal, Pratapaditya, 1935- . IV. Flora, Reis
Wenger. V. Art Gallery of New South Wales.

709.540749441

Film by
Response Colour Graphics Pty Ltd, Sydney

Printing organised by
Mandarin Offset, Hong Kong

Exhibition dates
12 June –24 August 1997
The Art Gallery of New South Wales, Sydney

Cover image
184 Vasant ragini
Rajasthan, Kota; c1770
detail

Back page image
36b Krishna fluting (Venugopala)
Orissa; 15th century; bronze
back view

Design
Tracy Paine, Lamb Design, Karen McKenzie

Production
Karen McKenzie

Illustrations
Danielle Cairis

Editorial assistance
Haema Sivanesan, Ann MacArthur,
Colin Paine

CONTENTS

ACKNOWLEDGEMENTS

THE ART GALLERY OF
NEW SOUTH WALES
Edmund Capon
Jenni Carter
Danielle Cairis
Ross Clendinning
Liz Gibson
Sarah Keogh
Victoria Lynn
Ann MacArthur
Angela Martin
Karen McKenzie
Tracey Mills
Tracy Paine
Susan Schmocker
Anupam Sharma
Haema Sivanesan
Alex Smythe
Christopher Snee
Ray Woodbury

SYDNEY
Joan Bowers
Shankar Dhar
Robyn Fugaccia
Nan Goodsell
Joan Grounds
Trevor and Ester Hayter
Sue Hunt
Marjorie Jacobs
John Kirkman
Geeta Kirpalani
Vijay Kumar
Stephen Menzies
Margaret Olley
Pradeep Singh
Ronita Singh
Rami Sivan

ADELAIDE
Michael Abbott
Dick Richards

CANBERRA
Ian Black
Michael Brand
Betty Churcher
G Shanker Dhar
Robyn Maxwell
Michelle McMartin
G Parthasarathy
David Sequiera

MELBOURNE
Reis Flora
Derek Gillman
Jim Kennan
Gordon Morrison
Timothy Potts

CANADA
Barbara Stephen

ENGLAND
Nicholas Barnard
Martin Durrant
Rachael Dwyer
John Guy
Howard Hodgkin
Ann Marchini
Deborah Swallow

INDIA
Sanchin Biswas
Shymalkanti Chakravarti
Basudev (Robi) Chatterjee
Saryu Doshi
Darren Gribble
Geeta Kapoor
Ashok Kulkarni
Ravinder Kumar
Chhanda Mukherjee
Lalita Nehru
Samaraditya Pal
Taj Group of Hotels
Rajeev Varma
Kapila Vatsyayan

UNITED STATES
CALIFORNIA
Sara Campbell
Andrea Clark
Julia Emerson
Robert Henning Jnr
Stephen Markel
Virginia Mann
Tom Nixon
Steve Oliver
Susan Oshima
Emily Sano
Sharon Steckline
Cherrie Summers
Susan Tai
Terese Tse Bartholomew

ILLINOIS
Stephen Little
Betty Seid
James Wood

MASSACHUSETTS
Darielle Mason
Malcolm Rogers
Alan Shestack
Wu Tung

MISSOURI
Cindy Cart
Walter Smith
Marc F Wilson

NEW JERSEY
Robert and Aida Mates

NEW YORK
Vishakha Desai
Denise Leidy
Martin Lerner
Laurence Libin
Amy McEwen
Phillipe de Montebello

OHIO
Robert P Bergman
Stan Czuma
Mary Suzor

WASHINGTON
Mary Gardner-Neill
Lauren Tucker

SUPPORTERS
Consulate-General of India,
Sydney
Indian Council for
Cultural Relations
India Tourist Office
Response Colour Graphics
SBS Corporation
TIME Australia

PERFORMERS
Australian Institute of
Eastern Music
Bricolage
Krishna Chakravarty
Lingalayam Dance Company
Odissi Dance Company
Beena Sharma
Devinder Singh Dharia

INDIAN CLASSICAL
MUSIC
produced by Celestial Harmonies:
David Parsons, Eckart Rahn.
Recorded digitally 1996 in
Benares especially for
Dancing to the Flute.

LENDERS TO THE EXHIBITION

The Alsdorf Collection, Chicago

The Art Gallery of
South Australia, Adelaide

The Art Institute of Chicago

Art of the Past Inc, New York

Asian Art Museum of
San Francisco

The Asia Society Galleries,
New York

Australian Museum, Sydney

Dr Siddharth Bhansali, New
Orleans, Louisiana

Joan Bowers, Sydney

Catherine and Lewis J. Burger,
Atlantis, Florida

The Christensen Fund, California

The Cleveland Museum of Art,
Ohio

Robert Hatfield Ellsworth,
New York

Dr Leo S. Figiel, Atlantis, Florida

Reis Flora, Melbourne

Mr and Mrs John Gilmore Ford,
Baltimore, Maryland

Chester and Davida Herwitz,
Worcester, Massachusetts

Sir Howard Hodgkin, London

Maximilian Hughes, Sydney

Kapoor Galleries Inc, New York

The Freeman-Khendry Collection,
Toronto

The Kronos Collections,
New York

Los Angeles County
Museum of Art

The Metropolitan Museum of Art,
New York

Monash University, Melbourne

Museum of Fine Arts, Boston,
Massachusetts

Dr David Nalin, Pennsylvania

Natesans' Galleries Ltd, London

National Gallery of Australia,
Canberra

National Gallery of Victoria,
Melbourne

Navin Kumar Gallery, New York

The Nelson-Atkins Museum
of Art, Missouri

Norton Simon Museum,
California

Dr and Mrs Narendra Parson,
California

Philadelphia Museum of Art

Mr and Mrs Lawrence R. Phillips,
New York

Portvale Collection

Mr and Mrs Michael Pucker,
Chicago, Illinois

Dr and Mrs Harsha and
Srilatha Reddy, New York

Royal Ontario Museum, Toronto

Santa Barbara Museum of Art,
California

Seattle Art Museum,
Washington

Dorothy R. Sherwood, California

Dr and Mrs Gursharan Singh
Sidhu, California

Spink and Son Limited, London

R. Suthanthiraraj, Sydney

The Victoria and Albert Museum,
London

Gerry and Pamela Virtue,
Sydney

Paul F. Walter, New York

Doris Wiener, New York

Zimmerman Family Collection,
New York

Private collections

FOREWORD

Edmund Capon AM
Director

8

How is it possible to convey the magnificence of thousands of years of Indian civilisation – a cultural continuum where past and present, foreign and indigeneous, secular and sacred, co-exist and co-mingle across a spectrum of different times, places and perceptual frameworks? How else but through those themes common to all whatever their ethnic, religious or cultural background; those themes that communicate the inexpressible and the transcendent; those themes intrinsic to the Indian understanding of the universe: namely, music and dance. Music and dance permeate every aspect of Indian life in a spontaneous and completely natural way that exposes a desideratum in our more ordered and compartmentalised life, with its designated religious and 'leisure' activities, its assumptions about the role and time for professional entertainers, recitals and performances.

The first Indian treatise on the arts, the *Natyasastra*, was about dance. It is this interactive and performative nature of artistic expression that this exhibition seeks to capture by demonstrating the centrality of music and dance to religious worship, to love, to the expression of every spiritual and emotional nuance possible to a human being. Although the theme is so fundamental to the arts of India, it is surprising that there has never been an exhibition devoted to its demonstration.

The initial concept was the inspiration of Dr Jim Masselos, Reader in History at the University of Sydney, and the Gallery's Head Curator of Asian Art, Jackie Menzies who has executed her duties in organising this enormous exhibition with her usual skill and enthusiasm. Dr Masselos has been exceptionally generous in his knowledge, time and considered opinions in realising the imaginative concept of this show. His commitment to India is unparalleled, and his love of Indian art infectious. To both go our deepest thanks.

It is also a matter of great satisfaction that the highly respected scholar, Dr Pratapaditya Pal, a man of formidable knowledge and perspicacity, agreed to co-curate the exhibition and edit the catalogue. Dr Pal brought with him the respect and esteem in which he is held around the world, and it was through his efforts, as well as those of so many of his museum colleagues and collector friends, that such an outstanding array of works can be presented in this show. John Guy, Deputy Keeper of Indian and Southeast Asian Art at the Victoria and Albert Museum in London and a long time devotee of Indian art, has been unfailingly generous in his advice and help from the very beginning of this project, making available rare treasures of the Museum, and contributing to the catalogue. It is also a pleasure to thank the other contributors to the catalogue, the distinguished Indian scholar Dr Kapila Vatsyayan; Dr Reis Flora, a respected authority on Indian music from Monash University, Melbourne; and Robyn Maxwell from the Australian National University in Canberra.

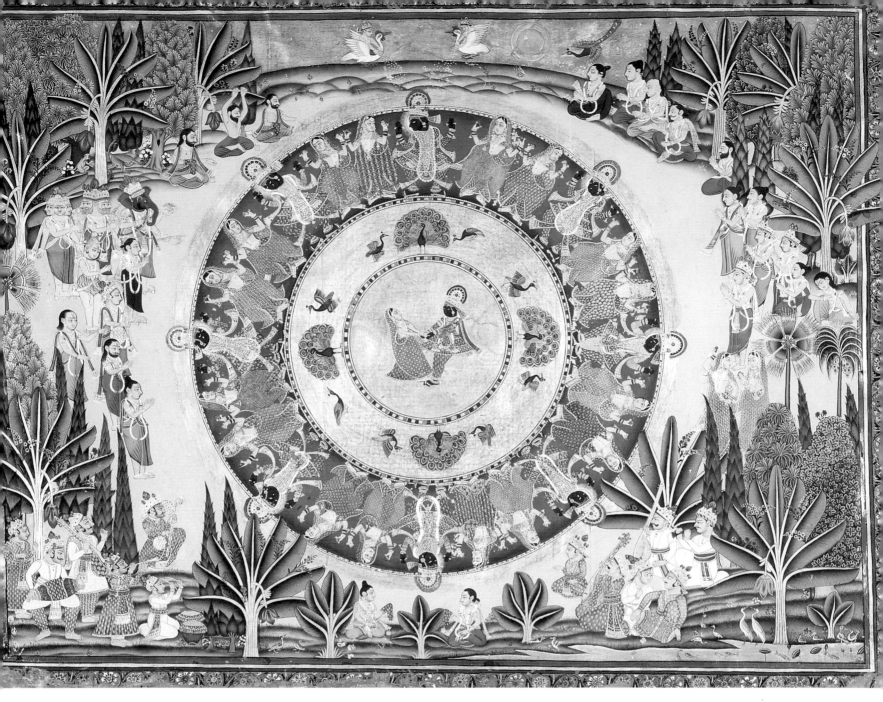

44c Circular dance of Krishna and the milkmaids

Obviously it is impossible to thank the many people involved in a project of this scale, but my gratitude goes particularly to the many lenders to the show as well as to our main sponsors – the President's Council of the Gallery, the Australia-India Council, and News Limited – all of whom recognise the significance of India and its unique cultural heritage. This exhibition has been timed to coincide with India's celebrations of fifty years of independence, officially celebrated on 15 August, and what better way to celebrate than with a huge festival of music and dance. To complement the exhibition itself, there is a special CD, produced by Celestial Harmonies, and the various local Indian dance and music groups who have participated in this programme have been extraordinarily supportive and enthusiastic. To everyone our thanks, and my hope that the exhibition, and its related activities, capture just a bit of the overwhelming experience that is India.

CURATORS' PREFACE

Jim Masselos, Jackie Menzies, Pratapaditya Pal

What strikes everyone on their first encounter with India and its art is the pervasiveness of music and dance everywhere at all times: India itself is a total experience in which music and dance are embedded as a dominant element within the overwhelming racial, linguistic and cultural variety. It was with the aim of demonstrating this unique integration of music and dance within Indian society in general and the plastic arts in particular that we embarked on this show. The exhibition is divided into the sacral – 'Realm of the Gods' – and the secular – 'Realm of the Mortals'. From the very beginning when Shiva performs his dance of creation, the intimate relationship between music and dance is established. It is subsequently developed through sections on Krishna, Celestials, Buddhism and Jainism, preceding more secular scenes of music and dance. It was difficult to organise the catalogue into discrete sections since there are so many overlaps with music and dance integrated into every facet of the sacred and secular. Although music and dance are so fundamental to the plastic arts in India, the theme was not something that had been attempted before specifically as an exhibition and no-one had attempted the synthesising overview that we have.

It is never an easy task to put together an exhibition of this magnitude and one rarely gets one's wish fulfilled. In our original planning India was to play a major role but unfortunately the negotiations produced no result when the government decided to freeze all loans for 1997. This meant a fast re-organisation of the exhibition with requests for additional loans from several of our institutional lenders. We are most grateful that our colleagues in these institutions, especially John Guy in England, and Martin Lerner, Stephen Little and Stephen Markel in America acceded to our requests with exemplary professionalism.

We have tried to create an exhibition that is joyous and jubilant, a proper celebration of the fiftieth year of independence on the subcontinent from foreign rule. But in doing so we hope we have also shown the richness of the ideas that distinguish the civilisation of India, and given some insight into the greatness of its art and the creative genius of its mostly anonymous artists. It is an art which should resonate in the mind long after the exhibition has closed just as the sound of the music and the movements of the dance caught in all these objects still resonate in the mind of viewers today, many years after their creation.

Many people have been especially helpful in realising this project, and were, like us, enthused by the topic. To our lenders, those listed in the acknowledgements, and those 'at the coalface' – Ann MacArthur, Haema Sivanesan, Ross Clendinning, and Karen McKenzie – we would like to extend our warmest gratitude.

CONTRIBUTORS

Reis Flora [RF]

Senior Lecturer, Department of Music,
Monash University, Melbourne.

John Guy

Deputy Curator,
Indian and Southeast Asian Collection,
Victoria and Albert Museum, London.

Jim Masselos [JCM]

Reader, Department of History,
The University of Sydney.

Robyn Maxwell [RM]

Senior Lecturer,
Department of Art History,
The Australian National University,
Canberra.

Jackie Menzies [JM]

Head Curator, Asian Art,
The Art Gallery of New South Wales.

Pratapaditya Pal [PP]

Visiting Curator Indian and Southeast
Asian Art, Art Institute of Chicago;
Fellow for Research, Norton-Simon
Museum of Art, Pasadena.

Kapila Vatsyayan

Academic Director, Indira Ghandi
National Centre for the Arts,
New Delhi.

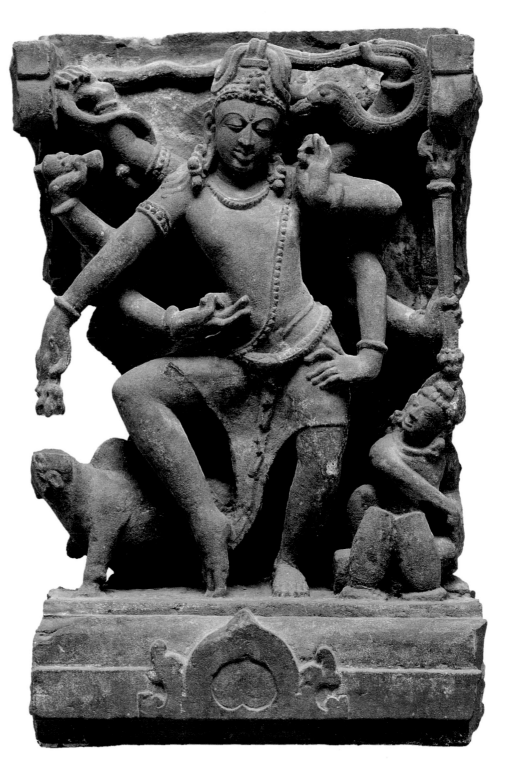

1b Shiva as the Lord of Dance (Natesa)

SELECTED CHRONOLOGY

BCE = Before Common Era
CE = Common Era

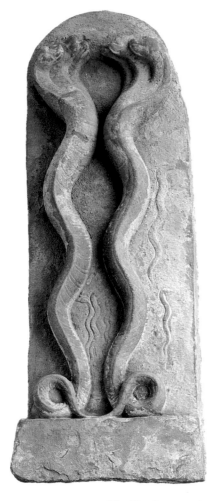

26 Dancing serpents

c2500 - 1700BCE	INDUS VALLEY CIVILISATION: Harappa, Mohenjo-daro
c1500 - 500BCE	VEDIC PERIOD: Vedas, Brahmanas, Upanisads
c563 - c480BCE	BUDDHISM: the life span of the Buddha
c500BCE - 500CE	HINDU EPICS: compiled Mahabharata (and Bhagavad-Gita), Ramayana,
c477BCE	JAINISM: death of Mahavir, the founder of the Jain religion
c322 - 185BCE	MAURYA DYNASTY: Ashoka pillars and early stupas
c200 - 50BCE	SHUNGA DYNASTY: development of the stupa; Barhut reliefs
c25BCE - 111CE	SATAVAHANA DYNASTY: Deccan, Pratishthana, Amaravati
50CE - c600	KUSHAN DYNASTY: Gandharan kingdoms and Mathura
320 - 540	GUPTA DYNASTY: Sarnath, Udyagiri and Ajanta
c574 - 600	PALLAVA DYNASTY: Mahabalipuram, Kanchipuram
c609 - 642	CHALUKYA DYNASTY: Badami, Aihole
c750 - 975	RASHTRAKUTA DYNASTY: Ellora, Elephanta
c730 - 1250	PALA AND SENA DYNASTIES: Nalanda – stone and bronze sculptures
c850 - 1150	CHOLA DYNASTY: Thanjavur – stone and bronze sculpture
c900 - 1100	CHANDELLA DYNASTY: Khajuraho – Hindu and Jain temples
c1100 - 1310	HOYSALA DYNASTY: Halebid, Belur, Somnathpur
c1100 - 1350	PANDYA DYNASTY: Thiruvanamallai
1206 - 1555	SULTANATE KINGDOMS: Lodi (1451-1526)
c1336 - 1565	VIJAYANAGARA KINGDOM
1489 - 1687	DECCANI KINGDOMS: Ahmadnagar (1490-1638), Bijapur (1489 - 1686), Golconda (1512-1687)

39 Krishna serenades Radha

c1500 - 1947	RAJPUT DYNASTIES
	RAJASTHAN: Twenty states including: MEWAR established by Sisodia Rajputs, Udaipur their capital from 1568; BUNDI and KOTA – two separate princely states which arose out of the division of the Haraoti state (1625) established by the Hara Rajputs; painting flourished in KOTA under Ram Singh II (r 1828 - 1866); BUNDI school flourished 18th-19th century; KISHANGARH – founded by Kishan Singh; the distinctive Kishangarh style of painting flourished under Rajah Savant Singh (r 1748-1757).
	CENTRAL: GWALIOR – Mughal annexure 1523-18th century; BUNDELKHAND; MALWA: capital Mandu Muslim-controlled 16th-18th century.
	NORTH-WEST HIMALAYAS: three groups of 34 states; JAMMU – BASOHLI; CHAMBA, KANGRA, GULER; KULU, BILASPUR; painting flourished from second half 17th century.

1526 - 1857	THE MUGHAL EMPIRE
1526	BABUR: the first Mughal conqueror
1530	HUMAYUN'S ACCESSION
1556 - 1605	EMPEROR AKBAR: the Akbarnama series; Fatehpur Sikri
1605 - 1627	EMPEROR JAHANGIR
1627 - 1658	EMPEROR SHAH JAHAN: Taj Mahal, Agra Fort, Jama Masjid
1658 - 1707	EMPEROR AURANGZEB
1719 - 1748	DECLINE OF EMPIRE: Muhammad Shah; sack of Delhi by Nadir Shah (1739); British establish Oudh dynasty (1724); establishment of non-Mughal kingdoms; the spread of British power; Mughal emperors including Emperor Shah Alam (1759-1806), ruled Delhi until 1857

c1565	NAYAK DYNASTY: Madurai
1675 - 1818	MARATHA DYNASTY: led by Shivaji (1627-1680); capital in Pune
1724 - 1950	ASAFIYA DYNASTY: Hyderabad (Deccan)

| c1790 - 1849 | SIKHISM AND SIKH DYNASTIES: Guru Nanak (1469-1539) established the Sikh religion; Govind Singh, the last Sikh guru (d1708); Sikh rebellion against Mughal power (1710); Ranjit Singh established Sikh kingdom (1790); Punjab kingdom overthrown by the British (1849). |

| 1858 - 1947 | BRITISH RAJ |
| 1947 | INDEPENDENCE (celebrated 15 August) |

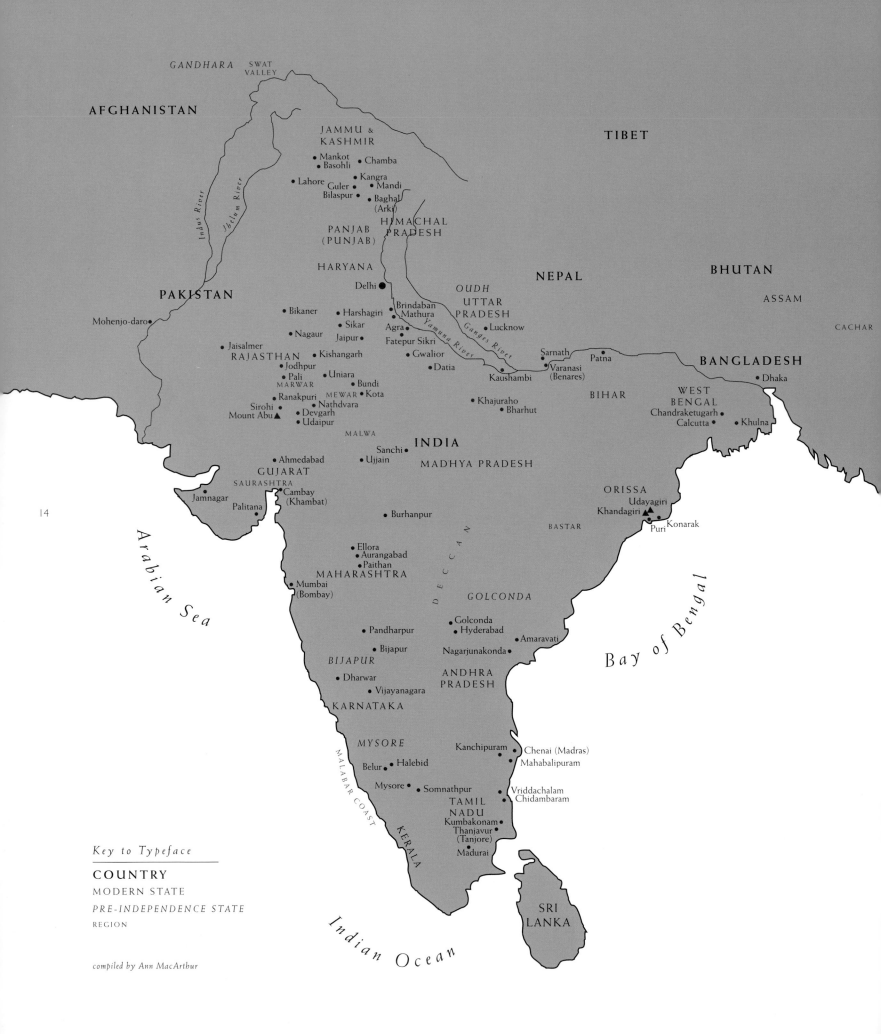

GANDHARA SWAT
VALLEY

AFGHANISTAN

TIBET

JAMMU &
KASHMIR

• Mankot • Chamba
• Basohli
• Kangra
Lahore • Guler • Mandi
Bilaspur • • Baghal
(Arki)

PANJAB
(PUNJAB)

HIMACHAL
PRADESH

NEPAL

BHUTAN

HARYANA

ASSAM

PAKISTAN

Delhi •

OUDH
UTTAR
PRADESH

CACHAR

Mohenjo-daro •

• Bikaner

• Harshagiri
• Sikar
• Nagaur
Jaisalmer •

Jaipur

Brindaban
Mathura

Agra •
Fatepur Sikri

• Lucknow

Ganges River

BANGLADESH

Yamuna River

RAJASTHAN

• Kishangarh
• Jodhpur
• Pali • Uniara

• Gwalior
• Datia

Kaushambi

Sarnath
• • Patna
Varanasi
(Benares)

• Dhaka

MARWAR
Ranakpuri •
Sirohi •
Mount Abu ▲

MEWAR • Kota
• Nathdvara
• Devgarh
• Udaipur

Bundi

• Khajuraho
• Bharhut

BIHAR

WEST
BENGAL
Chandraketugarh
Calcutta •

• Khulna

MALWA

INDIA

Sanchi •
• Ahmedabad • Ujjain

MADHYA PRADESH

GUJARAT
SAURASHTRA

ORISSA
Udayagiri

Jamnagar •
Palitana •

• Cambay
(Khambat)

Khandagiri
Puri • ▲ Konarak

• Burhanpur

BASTAR

Arabian Sea

14

D
E
C
C
A
N

• Ellora
• Aurangabad
• Paithan

GOLCONDA

MAHARASHTRA
• Mumbai
(Bombay)

Bay of Bengal

• Golconda
• Pandharpur • Hyderabad
• Amaravati
• Bijapur Nagarjunakonda •

BIJAPUR

ANDHRA
PRADESH

• Dharwar

• Vijayanagara

KARNATAKA

MALABAR COAST

MYSORE

Belur •

Kanchipuram
• Chenai (Madras)
• Halebid Mahabalipuram

Mysore • • Somnathpur

TAMIL
NADU

Vriddachalam
Chidambaram

KERALA

Kumbakonam
Thanjavur •
(Tanjore)

Madurai

SRI
LANKA

Key to Typeface

COUNTRY
MODERN STATE
PRE-INDEPENDENCE STATE
REGION

compiled by Ann MacArthur

Indian Ocean

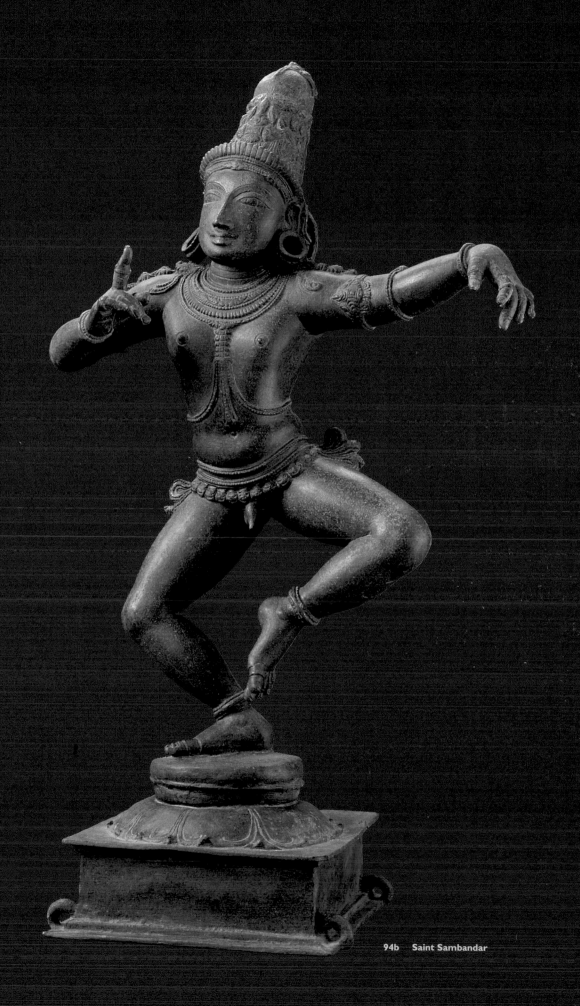

94b Saint Sambandar

INTRODUCTION

Pratapaditya Pal

Strength much to be desired is in thee Indra
the Immortal dances forth his hero exploits.
(Griffith, 1963, 496)

Make of my body the beam of a lute
 Of my head the sounding gourd
 Of my nerves the strings
 Of my fingers the plucking rods
Clutch me close
 And play your thirty-two songs
 O Lord of the meeting rivers!
(Basavanna (1106-1167) in Alphonso-Karkala, 1971, 493)

16

Even though I grew up in so urbane an environment as Calcutta during the forties, music was a constant part of our daily life. Every morning around six I would be woken by the chimes of the handbell that my mother rang with regularity as she worshipped her household deities. Again, every evening as dusk descended over the city, and the air was heavy with thick sweet fragrance of incense, the maid would blow the conch shell trumpet. The incense was to keep mosquitoes at bay, and the sound to ward off evil spirits that roam the night. In fact, the entire neighbourhood would reverberate for a few minutes with the sound of numerous conch shells, blown in almost every house.

I do not know whether this daily ritual still prevails in Hindu homes, but certainly in one form or another music is still an integral part of Hindu rituals and ceremonies from birth to death. Indeed, anybody who is 'fortunate' enough to be in India during a religious festival such as Dassera, Diwali or Ganesh Chaturthi cannot possibly escape the relentless blaring of film music over the public speaker system at all times of day and night. Few Western scientific discoveries have had so pernicious an effect on the Indian mind as the microphone.

Anyone who is familiar with the Indian cinema will also realise the enormous importance of song and dance in films. Whatever else they may or may not be, most Indian films can be characterised as musical extravaganza. No Indian film, no matter how serious and socially conscious the story, could expect to be a commercial success if it did not have the obligatory scenes of song and dance. The enormous increase in the popularity of dance today among educated Hindu society is to say the least phenomenal. Even a generation or two ago,

it was considered *infra dig* for boys or girls from respectable families to dance on public or private occasions. It was the Bengali poet Rabindranath Tagore and his family who made dancing an accepted art-form.

Yet, according to Indian mythology dancing is a divine activity which the gods love to watch or participate in. Not only do they appear to spend all their time in paradise watching the celestial courtesans (*apsara*) dance to music provided by the celestial musicians (*gandharva*), but they also engage in dancing themselves. In one way or another, they are all involved with music and dance, as is clear from the array of artworks included in this exhibition.

In Indian religions, whether Hindu, Buddhist, Jain or Sikh, either music or dance or both play a fundamental role in expressing devotion. The founder of Sikhism, Guru Nanak, spread his message of love through simple songs. One of the holiest books of the Hindus, the *Bhagavadgita*, literally means The Lord's Song, and most Hindu saints have praised their chosen deities through songs. Among the Buddhists too, beginning with the nuns' songs (*theri-gatha*) down to the great Adepts (Mahasiddha), songs have played a great part in disseminating the Buddha's teachings. Indeed, the gospel of what is known as Sahajiya or spontaneous Buddhism, favored by the Mahasiddhas, consists mostly of songs couched in mystical language akin to Solomon's *Song of Songs* in the Old Testament.

In Jainism as well, even if there is greater emphasis on asceticism, the lay community, especially of the image-worshipping (*murtipujak*) Svetambara order, chant their mantras as they pay their respect to the images of the Jina in a temple. Reciting or singing hymns of reverence to the twenty-four Jinas is an obligatory part of the Jain's devotional practice. During the annual Paryushana festival that lasts for eight days singing is an essential part of the various rituals.

Dancing also has been a part of the devotional practice of all three religions. Several of the Buddhist reliefs included in this exhibition [50, 51, 88] clearly demonstrate how dancing formed an essential part of Buddhist worship. The most well-known example of dancing in the Buddhist context occurs in the seventh century cave temple of Aurangabad in Maharashtra (fig 1). While dancing does not play a direct role in Jain ritual or devotion, certainly dancing figures are a strong presence on Jain temples. A number of the sculptures of celestial dancers and musicians in this exhibition are from Jain temples [57, 61, 62, 63].

However, the most familiar image of the dancing deity is undoubtedly that of the Hindu god Shiva [1-5]. Conceived by an unknown genius in Tamil Nadu more than a thousand years ago, this portrayal of the dancing god has become the Sydney Opera House of modern India. Pregnant with metaphysical significance and metaphorical meaning, and encapsulating as it does Hindu cosmological and cosmic concepts, aesthetically as well it is a tour de force of dynamic rhythm and equipoise.

Entertaining the gods with dance and music was an integral part of temple ritual and worship. Most important temples in India (as well as in Indonesia, Thailand, Cambodia

Figure 1
Maharashtra, Aurangabad, Cave 7;
Chalukya dynasty, early 7th century

17

and Vietnam where both Hinduism and Buddhism prevailed once) had a large number of dancers attached to the shrine to entertain the deities daily. Known as *devadasi* (servants of the god), these girls were literally slaves to the temple authorities who also enjoyed their favours. It was considered an act of piety for monarchs to donate scores of such dancing girls to a temple, along with other material offerings such as land, cloth, food stuffs, etc. Live dancing having been banned in the 1940s (see the following essay by John Guy), today only the frozen dancers and musicians attached to the temple walls entertain the deities in mute splendour. A large and diverse selection of such celestial performers has been included in the section, 'Other deities and celestials'.

Many years ago I had the opportunity to watch the evening benediction of Shiva Nataraja in the famous Chidambaram temple. Even without the dancers, the service was magical and memorable for the music and songs performed by a group of male musicians was exhilarating in that smoke filled and dimly lit inner sanctum. How much more exciting and exalting the scene must have been in the days when dancers added the sound of their anklets to the divine music. Witnessing an accomplished Odissi dancer perform on the stage today to the sublime songs of Jayadeva's *Gitagovinda*, one wonders how inspired the performances must have been in the temple of Jagannatha in Puri.

Even though today dancing does not form part of a temple ritual, all classical dance is still dedicated to a deity, usually Shiva, but also Vishnu. Everyone who has witnessed a Bharata Natyam dance on a stage will have noticed that the performance begins only after the dancer first offers prayers to and seeks the blessing of Shiva, whose garlanded image sits on a small table at one corner of the stage. Similarly, the Odissi dancer places images of the Puri triad – Jagannatha, Subhadra and Balabhadra – on the stage and they are the real witnesses to the performance. Thus, strictly speaking, there is no gulf between the sacred and the secular in classical dance or music, or for that matter in the visual arts. For instance, a piece of embroidered cloth called *rumal* [149] intended for the bridal trousseau of a terrestrial wedding is adorned with a scene of the celestial marriage of Krishna and Rukmini. Even when the music is not of the devotional *bhajan* or *kirthan* variety, but ostensibly performed at a secular gathering, the words, especially in *dhrupad, thumri* and *tappa*, have often to do with the divine and mystical love of Krishna and the milkmaids of Braja. His audience at a court may have been drunk and disorderly, but the songs the musician sang often had to do with divine rather than human love.

These musical forms involving Hindu devotional lyrics, composed by poets such as Surdas [98], Mirabai [99] and other saints, are sung with equal passion by the Muslim singers of the subcontinent. Islam, which arrived in India as early as the seventh century from West Asia, is the second most important religion on the Indian subcontinent, which is now divided into three sovereign states called India or Bharat, Pakistan and Bangladesh. Even though orthodox Islam may regard music and dance as inappropriate means of expressing devotion to God, it is not a universally held belief in Islamic societies. Although the Muslims believe that

cantilation of the Koran is really 'reading' rather than 'chanting', in point of fact it includes both melody and musical ornamentation. Anyone living near a mosque can hardly be unfamiliar with the distinctive intonation of the daily call for prayer (adhan or ajaan) which can scarcely be characterised as a simple 'reading'. Indeed, powerful Muslim rulers have always ignored the injunctions against music imposed by the orthodox Islamic clergy.

Music and dance have always been essential features of the sufi tradition, which exerted an enormous influence on Guru Nanak, the founder of the Sikh religion. No-one who has visited the extraordinary palaces built by the Mughal emperor Akbar (r1558-1605) at Fatehpur Sikri and has been fortunate enough to listen to the qawwali sung at the Chishti shrine can forget the memorable experience. Originating from the root qual, the mystical saying of sufi saints, the qawwali form of devotional music became popular in India in the thirteenth century. The form became especially associated with Khwaja Moinuddin Chishti Garib Nawaj (1143-1235) in Ajmer in Rajasthan and his followers known as Qawwal Bachchhe. The great Persian poet Amir Khusrau of Delhi (1243-1325) not only inherited this tradition but has remained a legendary figure in Indian musical history.

Some of the greatest patrons of music and dance in India have been Muslim monarchs. Among them the best known is of course Akbar, whose court musician Tansen [138] is certainly as well known a name in the North Indian tradition as Tyagaraja (1767-1847) is in the South. Another ardent and eccentric admirer of music was the Deccani ruler Ibrahim Adil Shah II of Bijapur (r1580-1626). Not only was he a great patron of musicians, but was himself an accomplished musician and a learned musicologist. The third and one of the last great patrons and connoisseurs of both music and dance on the subcontinent was Wajid Ali Shah (r1847-56). It was under his patronage that both the musical form thumri and the dance form Kathak gained popularity. Himself an accomplished dancer, he often played the role of Krishna in dance dramas. It should be noted that the British, who also enjoyed the kind of court entertainment that became known as 'nautch' in English (from the word naach meaning dance), not only encouraged Wajid Ali to indulge himself but ultimately deposed him for leading a life of decadence and debauchery and deported him to Calcutta where he died in 1887. It is not insignificant that at about the same time, while most indigenous landlords were patronising nautch girls and classical musicians, the young, rising Bengali poet Rabindranath Tagore was busy creating his own dance dramas in which, like Wajid Ali Shah, he was the lyricist, composer, director and the lead actor. He was also involved in designing the sets, which were painted by other members of his extraordinarily talented family.

The earliest material evidence of both music and dance on the Indian subcontinent can be traced back to the Indus Valley civilisation (third-second millennium BCE). A small stone sculpture shows a figure striking a pose somewhat similar to that of the much later dancing Shiva, and a bronze figurine of a nude young girl is generally identified as a dancer. Some of the seals have figures who are probably involved in masked dances, which remain

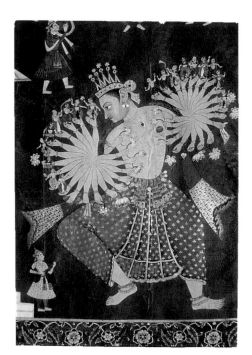

Figure 2
Dancing Indra, *Panchakalyana Pata*;
Rajasthani-Deccani style, probably
Aurangabad school; c1680; cloth
Sena Gana Mandir Collection
Photograph: Dr Saryu Doshi

important in tribal performances and rituals, as well as the classical Kathakali dance of Kerala.

The earliest literary references are found in Vedic literature of the second millennium BCE. Indeed, the principal Vedas, especially the *Rigveda* and *Samaveda*, consist entirely of hymns that were sung by the priests. It is clear that singing the correct hymns to appease the divinity was as important to the followers of Vedic religion as was sacrifice and any kind of material offering, such as the hallucinogenic *soma* extract. The *Rigveda* is replete with allusions to the song-offerings through which the sacrificer expected to increase his material wealth. Typically, a hymn to Indra, the most important Vedic deity, ends as follows (Griffith, 1963, 20):

> *Fulfil, O Satakratu, all our wish with horse and with kine:*
> *With holy thoughts we sing thy praise.*

Or again, (ibid, 24-25)

> *Indra and Agni I invoke; fain are we for their song of praise*
> *Chief Soma-drinkers are they both.*
> *Praise ye, O men, and glorify Indra-Agni in the holy rites.*
> *Sing praise to them in sacred songs.*

It is this tradition of singing the glories of the divine that has remained an integral part of the expression of devotion throughout India's history. The principal difference is that while the Vedic people expected something in return for their songs most later poet-saints (see 'Worship and devotion') praised his or her deity with songs without expecting any material benefit. The goal was spiritual bliss or liberation of the soul (*moksha*) rather than material wealth (*artha*).

While allusions to singing, songs and singers are frequent in the *Rigveda*, dancing is mentioned on relatively few occasions. Once Dawn, personified as a goddess, is compared to a well-dressed dancer. 'She, like a dancer, puts her broidered garments on.' More significant however are the characterisation of Indra and the Asvins, the celestial twins, as dancers. Indeed, in Hymn 130 of Book I, Indra is addressed both as singer and dancer. Elsewhere he is lauded as follows (Griffith, 1963, 286):

> *This, Indra, was thy hero deed, Dancer, thy first and*
> *ancient work, worthy to be told both in heaven.*

In a solitary reference the dancing Asvins are described as (ibid, 634):

> *Famed for your magic arts are ye, magicians! amid the race of gods, ye dancing heroes.*

In later art Indra is rarely shown dancing but is frequently portrayed as a connoisseur of dance [70]. The best celestial dancers perform at his divine court in Amaravati. One unknown artist, however, has given us a rivetting depiction of a cosmic Indra dancing in a Jain context (fig 2). Not only is this one of the most spirited representations of a dancing deity but it shows the multi-armed god holding a bevy of celestial dancers and musicians in his hands as attributes. There can be little doubt, however, that the idea of dancing deities,

which became so common in later Indian religions and art can be traced back to the dancing Indra and Asvins of the *Rigveda*. Indeed, in no religion other than the three indigenous Indian faiths – Hinduism, Jainism and Buddhism – are the gods so closely associated with both music and dance, as is clear from this exhibition.

Nor would it be an exaggeration to state that in no other artistic tradition has the art of dancing been so influential as in the Indic. Most of the hand gestures and a great many of the postures that one encounters, especially in sculpture, are borrowed from the dancer's repertoire. No wonder the first instruction given in Sanskrit theoretical texts to the budding artist is to go and study the art of dance (see John Guy's essay). In fact, it is not possible for a student to understand Indian sculpture without a thorough familiarity with the art of dancing.

Indian artists understood very early that figural sculpture is all about expressing movement through form. Nowhere is that movement more restrained and yet so energetic, graceful and full of life as in dance. Indian sculptors would have agreed with Kenneth Clark that 'energy is eternal delight' and while dance harnesses and expresses energy through the human body, sculpture and painting try to imprison it in durable images. Although dance had a profound influence on Greek art, the Greek artist conveyed energy principally through the athlete and the warrior, in Indian art primacy was given to the dancer.

While music and dance have proved to be a fecund source for the artists in many other cultures, in two important ways their contribution to Indian art differ from all other ways. Nowhere else have the gods been depicted as so fond of dancing and in no other society has music inspired an entire genre of painting as it did in India (see 'Ragamala' section).

The primary purpose of this exhibition is to demonstrate the interface among the various arts, in particular music, dance, literature and the visual arts. While every attempt has been made to be as comprehensive as possible, some regions and periods have unavoidably received more attention than others. The emphasis has been placed on the role of music and dance in both the divine and the mortal realms and to show how profoundly influential both forms have been as far as the visual arts are concerned.

The exhibition should also be of interest to scholars interested in various other disciplines, such as historians of religious experience and anthropologists, but especially to musicologists. Not only does the exhibition include a number of musical instruments, some of which are significant works of art in their own right, but many of the sculptures and paintings include representations of a wide variety of instruments. They should be a convenient source for tracing the history and evolution of musical instruments on the subcontinent.

In some ways the exhibition does unfold the history of Indian art over the last two millennia, albeit through the themes of music and dance. More important, however, is the fact that it brings together expressions of both classical (*marga*) and folk (*desi*), or to put it in another way, cultivated (*sanskut*) and spontaneous (*prakut*), cultures, thereby giving the viewer (and the reader) a more diverse and balanced view of the subcontinent's aesthetic achievements than is usually the case in an exhibition.

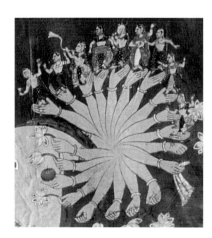

Figure 2
detail

THE ARRESTED MOVEMENT OF THE DANCE

Kapila Vatsyayan

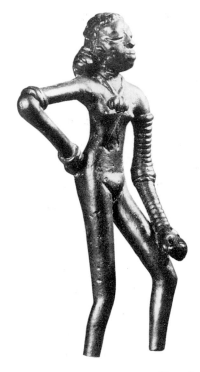

Figure 3
Dancing girl from Mohenjo-daro, Sind;
Indus culture c2000BCE
copper; 10.8
National Museum of India, New Delhi

The pre-historic art of Australia, as also of India, captures Man's first awareness of his corporeal frame in a moment of dynamic movement. The surfaces of rock caves are covered with men and women, running, jumping, skipping, dancing with interlocked hands in rows. Occasionally there is a single dancer accompanied by musicians. This pre-occupation with dance is discernible not only in what is called the Aboriginal art of Australia but also in several types of tribal and rural art in India. Wall paintings of the Warlis and the Saoras are outstanding examples of these incredible continuities with the distant past. Dance continues to be integral to all annual festivals and life-cycle ceremonies in India even at urban levels. The forms of music and dance are innumerable and the levels of sophistication many.

The artistic evidence on the sub-continent unambiguously demonstrates the antiquity as well as continuity of interest in dance as shown in the two following examples. Predating literary evidence, there is the petite beautiful bronze figurine from Mohenjo-daro which heralds a long history of capturing the dancer in a beautiful kinetic moment in stone, wood, bronze and on the surface of walls, palm-leaves and paper. An equally significant figure is the broken torso from Harappa, perhaps a remote first prototype of Shiva as Nataraja.

Millenia elapse before the first friezes of full-fledged dance scenes appear in Indian sculpture. The first amongst these are the panels of dancers in the Udyagiri and Khandagiri caves (second century BCE) of Orissa. Here, a dancer is surrounded by a full orchestra. Her stance is clear proof of a fully evolved characteristic dance style which can be termed as Indian. Stupas at Bharhut, Sanchi and Amaravati are replete with panels of dancers who worship the Buddha. Alongside are the tree-nymphs (the *shalabhanjika*) who intertwine the tree in a movement of dance. The flying figures which adorn the stupa, particularly at Amaravati and Nagarjunakonda, are also all in a movement of dance. The early and late medieval temples of northern, central, western, eastern and southern India reverberate with the silent sound of music in the outer and inner walls – the lute, flute and drums. Panels of dancers envelope the walls of Khajuraho, Mount Abu's Dilware, and Ranakpuri, Thanjavur, Chidambaram and Konarak alike. There is a staggering variety of context, mood and stance. There are *gana* and the *kinnara* of the lower panel who dance in glee, the beautiful women, the *surasundari*, who hold stances of great elegance as if they will burst forth into dance, and there are groups of dancers who appear to accompany processions or herald army marches. Finally there are the *nrittamurti*, the dancing forms of the great deities – Shiva, Krishna and Devi.

By the Gupta period, this mythical world of India appears in a sophisticated yet highly restrained artistic form, as epitomised by the magnificent sculptures of Shiva and

Krishna in their aspects of dance. Female energy is personified as Devi, who, as an independent divinity and in her role as a consort, also dances. Altogether, there is the beautiful and joyous moment of dance, symbolising the perennial movement of the cosmos – as stasis and dynamism, in creation and destruction. In dance, the Self manifests itself in dynamism and stasis. Silence and sound, stillness and movement are all embodied in one. The caves of Ellora echo with the thunderous stamping of the dance of Shiva in his ten modes of the Tandava. The Rasalila of Krishna adorns the temples of the Hoysalas and is recreated in countless murals, wall hangings and miniatures.

The metaphor of the dance is equally pervasive in the *Rigveda* where the rhythms of nature are described as in dance. For example, Ushas, the dawn personified as a goddess, is described in a beautiful hymn as a dancer who appears on a stage:

She wakes to action all who repose in slumber.
Some rise to labor for wealth, others to worship.
Those who saw little before now see more clearly.
Dawn raises to consciousness all living creatures.

One she leads on to power, another to glory;
another she leads on the pursuit of gain;
yet others she directs to varied callings,
raising to consciousness all living creatures.

The Daughter of Heaven now appears before us,
a fair young woman clothed in shining garments as a dancer on the stage.
Auspicious Dawn, mistress of earthly treasure,
shine upon us today in queenly splendour.
(*Rigveda I: 113*, translation: R. Panikkar, 1994, 166)

Indra is the most powerful deity of the pantheon. His dwelling is in the sky and the clouds are his chariots. He is the leader of dancers. It is the hymns of the Veda which gradually crystallise into the Puranic myths of Shiva, Vishnu – especially Krishna, and Devi.

Underlying this celebration of the dance is a distinct Indian attitude to the body and the senses. Neither is a temptation nor snare. The relationship of the body, senses, mind, intellect and soul is articulated in the Upanisads and is seminal to the world-view where the body is regarded as the abode of the divine and the divine descends in the body. Logically, the body beautiful is the temple of God and dance is a medium of invoking the divine. Each form of dance – the stance, the movement and the context – is imbued with deep spiritual and symbolic significance. Dance reflects a state of being at the highest order of spiritual discipline (*sadhana*) and is considered a yoga. Its performance is a ritual act or *yajna*, a sacrifice of the personal self to a higher transcendental order. It is the medium which evokes the supreme state of bliss (*ananda*) and the vehicle of release (*moksha*).

Saints and poets have supplicated to the dancing gods in many ways. In a famous hymn, Appar, the Tamil saint sings:

The hide of the black buck as garment worn,

The little bells on the feet resonating with the tinkling sound,

The consuming fire in the hand, held by

Long and sturdy arms swaying in rhythm

The charming Uma beholds the Lord tenderly

And the adoring celestials standing witness.

The graceful and blissful dance, the Lord performs

At Perumbarrappuliyur, the sacred place renowned,

To sing his glories, or not to be born.

(translation: R. Nagaswamy, 1985, song 6-3)

Sculpture and painting with the motif of dance in Indian art has to be comprehended at many levels as dance is not merely representational of human movement. At its highest level, dance is a discipline or *sadhana*, a spiritual experience. At an aesthetic level, the sculpted or painted figure follows assiduously the theory of *rasa* first enunciated by Bharata in the *Natyasastra* (2nd century BCE-2nd century CE) and equally applicable to all the arts. At the level of formal elements and technique, the movement patterns described by Bharata in the *Natyasastra* and by other treatises, especially the *Vishnudharamottarapurana*, are recreated in a plastic medium in the visual arts. The former text describes many types of movements and classifies cadences of movement into 108 categories. Indian sculpture of all schools – Hindu, Buddhist, Jain – can be identified with one or other of the 108 cadences of movement commonly called *karana*. Thus, the famous Nataraja figure [3] is in the *bhujangatrasita* mode and the figure of Krishna dancing on the serpent Kaliya [33] is in *urdhvajanu*. The flying figures (*apsara*) are all in movement patterns called the *vrischika karana* (literally scorpion-legged).

Significantly, there is a close affinity and similarity between the particular schools of sculpture and those of the diverse styles of Indian dance. The Chola figures of South India are depicted in Bharata Natyam modes which appear frozen in these sculptural forms. Similarly, in Bharata Natyam, the dancer's pose appears as sculptural as a Chola bronze. The wooden panels of Kerala with their fierce demonic expressions are but 'still pictures' from the dance-drama forms of Kathakali [135]. In turn, the Kathakali dance form aims to create pictorial images through 'kinetics'; through slow powerful micromovements of the facial muscles, the dancer becomes a character of the murals and wood-sculpture of Kerala.

In the miniature schools of Mughal, Rajasthani and Pahari painting may be seen the closest representation of the Northern Indian dance form of Kathak. There are no *demi-pliés* of the Chola bronzes, instead, we see erect torsos with *porte-bras* arm gestures and phases of the

pirouette suggested. Multiple skirts are common to the famous scenes of Akbar's court as also in Rajasthani painting. The Kathak dancer's costume is a direct descendant of these. The diverse schools of miniature painting, as also of Kathak, bear testimony to this eclectic amalgamation of Central Asian, Persian and Indian stylistic characteristics in both the arts. The late eighteenth and nineteenth century Mughal, Company school and Bazaar paintings, further reflect the changing milieu and variety of techniques that were introduced during that period.

Time and again on the sub-continent saints, poets and sculptors have responded in unique ways to the movement of the cosmic dancer Shiva. One of the most moving responses is the Bengali poet Rabindranath Tagore's tribute, which reads like a prayer in supplication:

> At each rhythm of your dance, O Nataraja, tear off my bonds one by one; wake me up and ring in
> my consciousness the note of freedom through aeons of time by the rhythm of your tuneful steps.
> Make waves in the lake of Sarasvati's consciousness: bring the lotuses thereon to bloom, and waft
> their fragrance around. I bow down to thee, thee I salute. Measurelessly rich is your dance; let thy
> dance fill my consciousness.
>
> In your dance is the image of freedom, in your dance is charm; in every atom of the body of this
> universe throbs the shadow of your dance. In the swing of your cosmic dance fetters are forged and
> fetters are forced upon; through aeons of time it goes on in the rhythm of your tuneful steps I wonder
> who knows where it draws to a close if it ever does. I bow down to thee, thee I salute. Immeasureably
> rich is your dance, let thy dance fill my consciousness.
> (Tagore, 1945, 543-44)

No less eloquent is the response, not by an Indian saint or poet but by the French sculptor Auguste Rodin (1840-1917) who was a great admirer of the Chola artists:

> The fulfilment of life, the flow of life, the heavens, the sun, the very belief in being and existence is
> expressed as an overflowing burst of feelings. It is, thus, that the art of the Far East appears to us.
> Viewed from a certain profile, the Shiva appears as if reaching towards an infinite end.
> What a genius is expressed in the rendering of the form of the body.
> In the unchanging beauty of the bronze and the imperceptible movement of the light, today one feels
> the immobility of the muscles, all clustered, ready to rise as the light moves.
> As the shadow approaches closer and closer, it plays on the masterpiece and reveals its charms: the
> profound morbidity coming forth from the darkness and obscurity where it has stayed for so long.
> Contours merely hinted at! The hazy form! As in a thing divinely controlled, there is no indication of
> revolt in that form; one feels that everything is in its place.
> (cited in Rodin, 1982)

The exhibition is a small window to the vast expanse of the world of music and dance of the Indian sub-continent.

INDIAN DANCE IN THE TEMPLE CONTEXT

John Guy

At 4.30 or 5am [the puja begins]...the dancing girl officiating for the day, with rudraksha beads in place of jewels, dressed up as a Brahmani and her hair uncombed...open[s] up all the doors up to the mahamandapa. Later the god is taken in procession preceded by musicians and attendant dancing girl...the dancing girl at the door repeats a tevara ujal or a verse in honour of Siva.[1]

So began the daily cycle of ritual worship at the Ramesvaram temple in Tamil Nadu in 1920. Access to the image, especially at those most intimate moments of the day, such as waking, bathing and dressing the deity, was highly restricted. The officiating brahmins devoted their lives to the service of the deity. Yet they did not have a monopoly on this privilege. Temples of any significance had attached to them a group of dancers whose role was the service and veneration of the deity. These women are known most widely as *devadasi*, 'servants of God' who, like the priests, had dedicated their lives to the service of their Lord (fig 4). Dance was the principal act of worship undertaken by the *devadasi* before an image of the deity. Like the rituals performed by the priest, performance before the deity by a *devadasi* bestowed, according to the *Natyasastra*, the same spiritual benefits as the priests, 'sacrifices' (*yajna*). According to the *Agama* (traditional doctrines), the *devadasi* have up to sixteen prescribed duties or rites (*upacara*) to perform, each at prescribed times of the day. These range from dancing and singing hymns to ringing bells and the holding and waving of oil lamps during *puja*. These duties were as much a part of the ritual of daily worship (*nittiya puja*) in the temple as those performed by the priests.

In this essay I wish to examine the *devadasi* as a medium for devotional worship and to review what light this tradition might throw on the prevalence of the dance theme in Indian temple sculpture. Both the traditions of dance and sculpture have their respective texts which serve as sources of authority and legitimacy. There is a considerable concordance between these sources, an overlap which enables us to understand something of the common origins and historical relationship of Indian dance and sculpture in the temple context.

WORSHIP AND THE DEVADASI

Dance as a form of worship is depicted in temple pictorial arts from the Shunga period (2nd century BCE) onwards. It is unclear whether the dance being performed as part of ritual worship (*puja*) was being enacted by lay devotees or by professional worshippers – those who came to be known as *devadasi*. The role of the *devadasi* in the Indian temple is of considerable antiquity and certainly as old as most surviving temples. The origins of the practice, however,

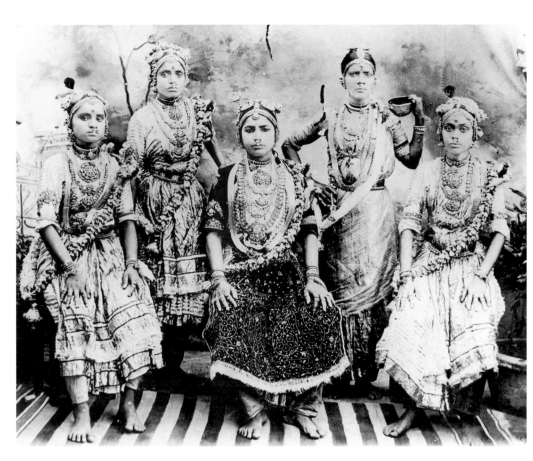

Figure 4
A troupe of *devadasi* who performed the
Kuravanji dance-drama at the Brihadesvara temple
during the Brahmotsava festival,
Thanjavur, c1940s. (see footnote 30)
Photograph courtesy of VK Rajamani.

may not necessarily lie in the religious realm. There is a tendency in the studies of ancient
India, dominated as it is by Vedic literature and Sanskritised Brahmanism, to attribute all
cultural innovations to the stimulus of the great religions. This may not necessarily be the
case. Other sources also need to be considered.

Early Indian secular writings identify dance as one of the refined arts of the
courtesan. The *Arthasastra*, India's most ancient treatise on statecraft attributed to Kautilya and
generally dated to around 300 CE, closely associates dance and music with courtesanship.
Courtesans were assigned a position of considerable status as highly educated and
sophisticated court entertainers, entrusted with such privileged roles as holders of the royal
umbrella and fly-whisk. We should therefore not assume that devotional temple dance
necessarily represents the older tradition, for just as much of the regalia employed in
veneration of the sacred realm had its origins in the celebration of kingship, so the institution
of the *devadasi*, complete with its dimension of sacred prostitution,[2] may have been adapted
from court culture.

Another early classic of Indian literature, the Tamil *Shilappadikaram* (*The Ankle Bracelet*)
attributed to the third century CE, makes frequent reference to the art of dance in a secular
context. The description of the courtesan Madhavi's dance reveals the sophistication and level
of codification of the performing arts in this early period:

> *Madahavi, that beauty of Puhar*
> *displaying upon the stage her dance,*
> *her precise diction, subtle sense of time,*

her knowledge of all rhythmic patterns,
of the five sorts of temple songs,
of the four systems of music,
of the eleven kinds of dance.
Her fame spread to the ends of the world. [3]

The author describes the beauty of the dancers at court, likening them to those who perform in Indra's heaven. In the most famous of celestial courts, the heavenly court of Indra is described (and depicted in art) as a palace peopled with semi-divine dancers (*apsara*) [60] and musicians (*gandharva*) [59] whose function is to celebrate Indra's glory. One of the earliest and most sublimely beautiful paintings of a celestial dancer is preserved in the Jain rock-cut temple at Sittannavasal, dated to the seventh century. In a tenth century relief from Sikar, Rajasthan [12], Shiva and Parvati are depicted seated on the bull Nandi in their celestial abode, celebrated by such *apsara* and *gandharva*. The animation and movement of the heavenly entertainers is ecstatic. How appropriate then to have temple dancers dedicated exclusively to the service of the god when he visited his temporary earthly abode, the temple. This provides an important clue to the origins of dance in India.

The institution of the temple has been and remains at the centre of community life in India. It is clear from the prologues of classical Sanskrit dramas that temples, along with palaces, served as suitable venues for performance. The Chola temple of Darsasuram at Kumbahakonam in Tamil Nadu, has around its inner courtyard encircling the main temple a series of cresset stones in the form of shallow basins carved into the paving, intended to serve as receptacles for oil to be lit during evening performances. Hindu temples in Tamil Nadu have a pillared hall (*arangam* or *aranga-mandalam*) dedicated to dance and drama performance. In Kerala this hall (Malayalam: *kuttambalam*) was dedicated to performances of Kodiattam, the temple version of the dance-drama Kathakali. The dancers, in their extraordinary layered skirt costume, constructed coiffure and elaborate make-up, are a direct continuation of those celestial attendants and guardians represented in Keralan painted wooden sculptures of the seventeenth and eighteenth centuries [64, 126]. Spectacular oil lamps, up to five feet in height, were placed in the dance halls to provide a magical illumination for night performances of the Hindu epics, most notably episodes from the *Ramayana* and *Mahabharata*.

All major temples employed dancing girls, engaged under a great variety of terms.[4] All however, shared the singular honour of being ritually 'married' to the presiding god of their temple. The universality of this practice is clear from a number of sources, including a royal inscription by Rajaraja Chola (985-1014) at the Brihadisvara temple, Thanjavur, dated 1004. It records the recruitment of 400 *devadasi* from temples throughout the kingdom to the royal temple on the orders of the king. The inscription lists each *devadasi* by name, together

with the name of the temple from which she came. It gives a clear indication that in the Chola period every temple of any importance had temple dancers in their service.[5] Other Chola rulers gave similiar encouragement to the promotion of the art: Koluttunga II (1133-1150) appointed dancing masters (*nattuvan*) at his temples to instruct the *devadasi*. Royal patronage in this form ensured that the standards of temple dance in the Chola period reached new heights. The bringing together of the premier dancers from throughout the kingdom was a unique opportunity to standardise the technique and choreography of the temple dance genre. It is to this period that the origins of the South Indian classical dance form of Bharata Natyam is attributed.

The success of Rajaraja's achievement in this field is witnessed in the contemporary mural paintings which survive in the Brihadesvara temple. The temple was dedicated to Shiva, the family deity of the Cholas, and on the first floor of the central shrine of this eleventh-century temple at Thanjavur are a series of paintings depicting dancers celebrating their devotion to Shiva (fig 5). The dancers depicted illustrate 84 of the 108 dance movements (*karana*) of lord Shiva. The figures wear only a diaphanous skirt and are garlanded with strings of pearls, jewels and flowers. The skill of the painter is such that he has captured superbly the complex and enlivening movements of the *devadasi*. We witness here the celebration of one's god through the act of dance.

There is every indication that in South India the institution of the *devadasi* continued without interruption until early this century, following the standardisation of dance styles instituted in the eleventh century. There is evidence however from the medieval period that in certain theological circles the appropriateness of *devadasi* in temples was challenged. The eleventh century Jain reformer Jinavallabha expressed concern in his *Sanghapattaka* at the morally corrupting presence of numerous dancing girls at the Jain temples of Rajasthan. A miniature painting from an edition of the *Uttaradhyayanasutra*, dated to the mid-fifteenth century, gives vivid expression to this same concern (fig 6). It illustrates the Jain maxim that those monks seeking perfect chasity should avoid the attractions of women: the monk, clad in the white robes of the Svetambara sect, stands passively whilst the temple dancers so disapproved of by Jinavallabha, seek to arouse him with dance and music.

The earliest European observers confirm the continuing practice of temple dance. The Italian traveller Pietro della Valle observed at Ikkeri in the southern Deccan during his visit in 1623 a troupe of dancing girls (with musical sticks which they struck together) who, after parading through the streets, performed circle dances in the courtyard of the city temple in honour of the Goddess (Devi).[6]

The French missionary Abbe J.A. Dubois, who worked in Madras Presidency and Mysore in the 1790s, had a unique opportunity to observe temple dance in its traditional form: 'Every temple of any importance has in its service a band of eight, twelve or more

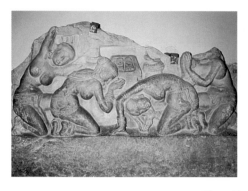

devadasi. Their official duties consist in dancing and singing within the temple twice a day, morning and evening, and also at public ceremonies'.[7]

It was only in the course of the nineteenth century that colonial administrators sought to suppress the institution of the *devadasi* because of the element of prostitution, finally banning it. In the Muslim north these measures were largely effective, but in southern India they were defiantly resisted, as numerous government reports testify.

The dances which the *devadasi* traditionally performed in the temple, and their other duties attending the deity, represent an early form of institutionalised *bhakti* or devotional worship. The concept of *bhakti* has associated with it a strong sense of ardent love for one's god and a desire to attain a state of mystical union. Cults involving ecstatic worship were widespread in the ancient world and the depictions of worshippers in early Indian art point to such practices being well established in the subcontinent as well. Among the earliest pictorial reliefs depicting acts of public worship in ancient India are those at the Buddhist stupas of Bharhut (2nd century BCE), Sanchi (1st century CE), and Amaravati (1st-3rd century CE). Female devotees performing celebratory dances are a recurring feature of these scenes. Devotees are depicted in poses of ecstatic rapture, raising their hands and bending their bodies in highly expressive gestures (fig 7). In addition to the numerous sculptural depictions of such scenes of devotion, there are Buddhist and Jain inscriptions and commentaries which record the presence of dancers during worship.

It is very probable that *bhakti* evolved from such early forms of worship and over time became institutionalised in the post of *devadasi*. In later centuries *bhakti* underwent periods of intense popular revival in which emotive devotion by lay worshippers was encouraged. The most devout of these worshippers were canonised as the saints or spiritual leaders (Nayanmar) who have left such a rich legacy of devotional literature, principally in the form of hymns.[8]

Temple dance is best explained in this context as a mystical level of devotion – it is the uncompromising act of a devotee (*bhakta*) celebrating her love of god. For the dancer it can lead to the state of spiritual intoxication associated with *bhakti*. Dance is potentially both sensual and hypnotic. Its passioned performance would have helped to evoke the atmosphere of the temple as a place removed from the mundane world, the temple as celestial abode of the deity. Dance in this context can be seen as a form of ritual worship in which the emotive and passionate aspects of the devotee's personality are activated. The fact that the *devadasi* are supported by the temple in no way diminishes the conviction or authority of their worship.

The metaphor of dance

The metaphor of dance lies at the heart of Brahmanical creation myths. The centrality of dance as a part of ritual worship stems in part from its importance to Hindu cosmology, where dance is used to express complex metaphysical ideas. The life force expressed in the act of movement became a symbol for creation. This took many forms in Hindu sculpture,

Figure 5
Temple dancers performing before Lord Shiva.
Mural painting, Brihadesvara temple, Thanjavur,
Chola dynasty, 11th century.
Photograph courtesy Archaeological Survey
of India and VK Rajamani.

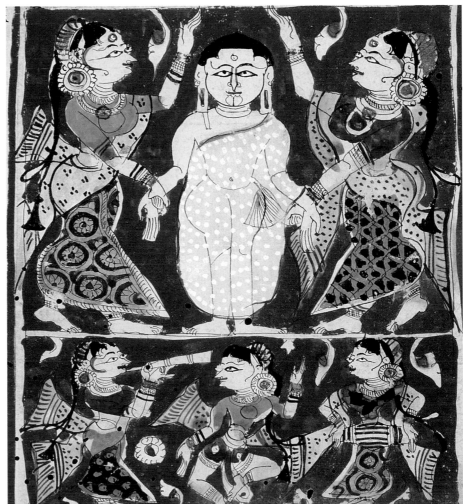

Figure 6
A chaste monk avoids the lures of women (detail).
Folio from a *Uttaradhyayanasutra* manuscript.
Gujarat, Cambay; c1450
Opaque watercolour on paper; 11.4 × 29.4
Victoria and Albert Musuem, London.

from images of Vishnu taking his three strides to encircle the earth (*trivikrama*), and Krishna as the cowherd playing the flute [Venugopala, 36a-d] and subduing the *naga* Kaliya [33], to representations of Shaivite saints such as Sambandar who is often represented dancing whilst singing his hymns of praise [94a-c]. The ultimate expression of this life-giving energy is given visual form in the sculptural depictions of Shiva as the Supreme Dancer (fig 8) [2]. Shiva Nataraja embodies through the medium of dance the progenitive powers of cosmic energy, through whom, according to Nandikeswara's dance-treatise the *Abhinaya Darpana*, the entire phenomenal world is kindled into life.[9] The cosmic energy of this subject continued to enliven Hindu art throughout succeeding centuries.

In the devotional poetry dedicated to Shiva stress is placed on Shiva as the destroyer/creator. In the Hindu cyclical view of time Shiva's role is to destroy one era in order to create the next, a cosmic task given its clearest expression in the sculptural representations of Shiva as Lord of the Dance:

> *When our Lord who is both end and beginning*
> *dances to the deep sound of the mulavam drum,*
> *holding blazing fire in the hollow of his hand,*
> *as the mountain daughter watches,*
> *the Ganga's murmurimg stream with foaming waves*
> *flows over the cool crescent moon.*[10]

This devotion to Shiva as Lord of the Dance finds its ultimate expression in the Nataraja temple at Chidambaram, in Tamil Nadu. This temple is unique in that its central icon is a bronze image of Nataraja rather than, as Shaivite orthodoxy prescribes, a linga. The phallic linga is the ultimate physical expression of Shiva's identity linked to his role as the 'Giver-of Seed', whereas Nataraja is but one aspect of Shiva's complex cosmological personality. The temple at Chidambaram is unique in its primary veneration of Shiva as Lord of the Dance. Here a bronze image of Nataraja is housed in the central sanctum and worshipped as the primary cult image.[11] Seventh and eighth-century Shaivite saints (Nayanmar) composed hymns in praise of the Nataraja of Chidambaram, although the structures visible today are the legacy of Chola patronage in the twelfth and thirteenth centuries. The towering gateways (*gopuram*) were donated by various rulers, including the Vijayanagara king Krishna Deva Raya (r1509-1529) who built the northern gateway and was instrumental in the renovation of others. These gateways are important for the study of temple dance because they contain, corporately, a sculptural programme depicting the 108 *karana* or movements of dance laid down in the fourth chapter of the *Natyasastra*, the classic manual of Indian drama[12] (fig 9). Above each sculptural depiction of a dancer is an inscription quoting the appropriate verse from the text in which the required posture of body, movement of legs and gestures of hands are described.[13] Other depictions of these dance movements appear in temples at Thanjavur, Kumbakonam,

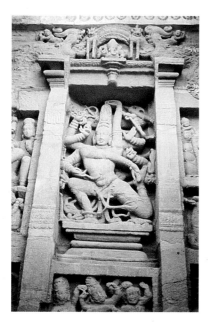

Figure 8
Nataraja, Kailasantha temple,
Kanchipuram, Tamil Nadu.
Pallava dynasty, c800CE.
Photograph John Guy, 1990.

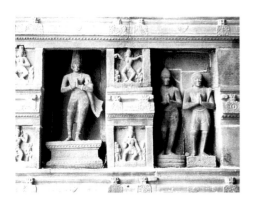

Figure 9
Dance movements (*karana*)
depicted on a northern gateway,
together with a portrait sculpture
of the Vijayanagara king Krishna Deva Raya,
Nataraja temple, Chidambaram,
Tamil Nadu, early 16th century.
Photograph John Guy, 1990.

Tiruvannamalai and Vriddhacalam, providing a comprehensive visual record of these forms of pure dance. The *karana* provide a catalogue of these standardised dance movements which were taught as the basis of South Indian temple dance and were absorbed into the Bharata Natyam dance tradition in which a solo dancer acts out a number of roles through a mixture of dance, gesture and mime. Many of the movements depicted in the *karana* at Chidambaram may be compared with contemporary mural paintings, such as the Vijayanagara and Nayak ceiling paintings to be seen at the Tirupparuttikkunram Jain temple, near Kanchipuram (fig 10).

THE NATYASASTRA AND THE SILPASASTRA

The *Natyasastra* of Bharata Muni represents the codification of Indian knowledge on the dramatic arts, dance, music and aesthetics. It is attributed in its present form to the fourth or fifth century CE. It recounts the divine origins of dance by Brahma, and the creation of celestial dancers (*apsara*) to perform this art for the first time; Visvakarma, the divine architect, was instructed to build a dance hall (*mandapa*), an integral part of every Hindu temple.

Dance is characterised in the *Natyasastra* as having two aspects, *natya* (mime) and *nritya* (pure dance); and its purpose is to give expression to those emotions and feelings (*bhava*) which best convey love of one's god. This is achieved through evoking a powerful *rasa* or mood, a response which should contain elements of both the emotional and the aesthetic. With such powers of expression at its disposal, it was appropriate that dance should form an integral part of religious worship.

If the *Natyasastra* defines the dramatic tools to be used in evoking emotional states appropriate to worship, then it was the role of the *Silpasastra*, a technical treatise on iconography and sculpture, to provide the visual language of expression. Both share in the use of a symbolic language of posture and gesture (*mudra*), with an elaborate system of attitudes which convey very specific sets of meanings.[14] Whilst the *Natyasastra* describes the expressive objectives of drama, of which dance forms an important part, the *Silpasastra* are the craft manuals which provide the prescriptive guidelines to be followed by artists creating religious images. The artist image-maker (*sthapathi*) who has understood these 'divine instructions', and has performed the appropriate rituals of self-purification through yogic discipline, will be granted the gift of endowing his work with 'rhythm' (*chandas*). The rituals of self-purification prescribed for the artist in the *Vastusastra*, a treatise on the science of architecture, are identical to those laid down for the dancer in the *Natyasastra*.[15]

The *Silpasastra* are contained principally in two works, the *Chitralakshana*[16] and the *Chitrasutra* section of the *Vishnudharmottara*, (a formal exposition on the canons and classifications of art, primarily focusing on painting, itself a supplement to the *Vishnupurana*) currently assigned to the fifth century CE.[17] These are texts of Indian aesthetic theory and are prescriptive in the sense that they describe the technical structure underpinning figurative representation in Indian arts. They are explicit about the physical aspects of image-making,

33

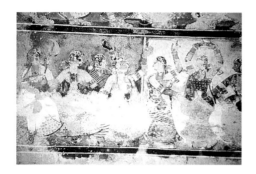

Figure 10
Temple dancers. Mural painting,
Tirupparuttikkunram Jain temple, near Kanchipuram,
Tamil Nadu. Nayak period, 17th century.
Photograph John Guy, 1990.

34

describing the system of measurements (*tala*), proportions (*mana*), the relationships of parts (iconometry) and the visual language of attributes, poses and gesture (iconography). The *Vishnudharmottara* states: 'When you gain from me the knowledge of the nature of the measurements and the characteristic attributes, the proportions and the forms, the ornamentation and the beauties, then you will be fully versed in all the skills and become a universally known and masterly expert in the art of sculpture.' [18]

What the *Vishnudharmottara* is not explicit about is the metaphysical symbolism which underpins these forms. An understanding of the underlying 'sacred geometry' may simply have been assumed as part of the cultural baggage of the day, the shared understanding of a common culture.

The written sources are emphatic about the interdependence of artistic activities in early India and the central role that the art of dance has in this scheme. Indeed, they are explicit in insisting that the painter or sculptor cannot begin to realise his goal without first mastering the expressive language embodied in dance. In the *Vishnudharmottara* the sage Markandeya says to King Vajra: 'without the knowledge of the art of dancing, the rules of chitra [visual arts] are very difficult to understand...In dancing the imitation of the three worlds [i.e. all things] are enjoined in tradition. The eyes and their expressions, the limbs and their parts all over and the hands have to be treated (oh) best of kings, as...in dance. They should be the same in chitra.'[19]

This intimate relationship between the arts of dance and image-making is fundamental and, as the above authoritative passage makes clear, dance is the ascendent art form which takes precedent, setting the measure for other media to follow. As has been suggested by Kapila Vatsyayan in her masterful *The Square and the Circle of the Indian Arts* it is most probable that the seeds of the codification of the arts of painting and sculpture are embedded in the *Natyasastra*,[20] or at least in the conventions of posture, gesture and movement that were established for this art and transmitted from teacher to pupil in an unbroken oral tradition. As with all prescriptive texts, they must have in their origins followed rather than led practice; that is, they began their existence by describing the established practice of the day. If this is so, then the language and conventions of dance must have been formulated before those of painting or sculpture. As we have some basis for dating the *Vishnudharmottara* to perhaps as early as the fifth century, this sets a terminus date before which the codification of dance in some form must have occurred. It has been argued, through reference to information pertaining to dance in the *Silappadikaram*, that the *Natyasastra* may have been written as early as the third century CE.[21]

The interdependence of dance and the visual arts, painting and sculpture, is made explicit in the earliest Indian sources on these subjects. Beauty is a quality required of both sculptural images (*murti*) and dancers because, as the *Vishnudharmottara* states, 'the divinity

draws near willingly if images are beautiful'.[22] The other great quality is the infusion of vital energy or breath (*prana*). Whilst in dance this is readily achieved through the medium of the dancer, in sculpture it is a far more difficult task.

The bringing of life to sculpture through the infusion of *prana* was the essential and ultimate challenge facing the traditional Indian sculptor. The *Agama* texts are explicit on this matter: the *Svacchanda Tantra IV, 306* stresses that 'all the activities ... relating to various arts (*kala*) and crafts (*silpa*) are functions of prana'[23] and the *Vishnudharmottara* states that this vital energy may be instilled in a stone sculpture by drawing the circle on the block of stone before commencing carving: 'The circle is the All [Universe]. The breath of life [*prana*] is in its form, even as the mind is in man'.[24] This ritual is still performed today by the stone sculptors of Mahabalipuram, Tamil Nadu, who enact these invocations before commencing work on a major image.

Religious sculpture must therefore conform to the sastric requirements of form, proportions and required marks or attributes (*lakshana*). Only in this way will the image be attractive to the deity represented and so allow the possibility of a divine visitation. It is through the enactment of certain rites that the image is then enlivened by the devotees' intense meditations on the deity.

The representation of the deity in human form is understood according to the ancient commentaries, the Upanisads, as a striving to give form to the formless, to make tangible that which is intangible. Both dance and sculptural images are conceived as aids to meditation upon the deity. The sculptured image is conceived as a visualised *yantra*, a sacred diagram, meditation upon which will bring the devotee closer to the divinity. The devotional dances of the *devadasi* were intended to celebrate the god and encourage the divinity to respond to the devotees' prayers for mystical union. The prevalence of dance themes in temple sculpture programmes underlines the importance of this form of worship.

The use of the human body as a vehicle for worship touches on another aspect of temple symbolism. The archetypal form for Indian sculpture is *purusha*, the primordial cosmic man. This concept was translated over time into the very form of the Hindu temple in which the constituent parts of the temple were conceived as elements of the body with the tower (*shikhara*) as the head and trunk, and the inner sanctum (*garbhagrha*, womb house) as its centre. The temple dancer in turn served as a metaphor for both the temple itself and the body of the deity. In this way dance and the temple were inexplicably bound together in a complex set of mythologies and metaphors which strove to give expression to the Indian cosmogony.

THE LEGACY TODAY

Today dance is no longer an integral part of temple worship, the link being broken by the Devadasi Bills enacted in the 1920s and 1930s, and the 1947 Act which finally outlawed the recruiting of temple dancers in Tamil Nadu.[25] Among the last major temples to employ *devadasi* as part of regular worship were the Minaksi temple in Madurai and the Brihadesvara

Figure 11
Uday Shankar and Anna Pavlova performing
Krishna and Radha, choreographed by Shankar
at Pavlova's request, 1923.
Photograph after H. Algeranoff,
My years with Pavlova, 1957.

Figure 12
Ram Gopal performing at the Channakesava temple, Belur, Karnataka, c1936. Photograph after Ram Gopal, *Rhythm in the Heavens*, 1957.

temple, Thanjavur, which finally abandoned the practice in the 1940s (fig 4).[26] A campaign to revitalise the tradition of classical temple dance was already underway, led by such Indian dancers as Uday Shankar and Krishna Iyer. Shankar, working both independently and with the Russian ballerina Anna Pavlova and her company in the 1920s (fig 11), had introduced Indian dance to the west, a process which had the effect of assisting in restoring its acceptability in India.[27] This impetus was continued by such dancers as Ram Gopal,[28] Shanta Rao, Rukmini Devi and Mrinalini Sarabhai, whose creative efforts stimulated a new generation of young dancers.

Modern Bharata Natyam is largely based on three principal sources: the codified movements as described in Thulaja's *Sangita Saramrta* (written at Thanjavur in the Maratha period) which drew on the *Natysasatra* and updated it, other movements which have evolved in dance practice since that time, and the movements and postures 'recovered' through the study of temple sculptures depicting dance themes (fig 12).

Today dance has regained respectability as a branch of liberal education, studied and performed by the daughters of the educated classes. It has been the task of secular dance academies in India to restore and revitalise the dance traditions which were once so integral to the ritual life of a temple. In centres such as Madras this is happening. It is even the case that temples are serving again as dance venues, as recent performances at the Brihadisvara temple at Thanjavur, at the Nataraja temple at Chidambaram, and at Kanchipuram, have demonstrated.[29] It is the secular dance academies which are providing the skills and the temples the venues. This situation is not far removed from the ancient practice described in the manuals on the dramatic arts which speak of temples providing the settings for the great dramatic performances of the day. As the sculptural legacy testifies, the dialogue between the secular and sacred realms, between dance and the temple arts, generated a remarkable tradition.

Notes

1. Ayar, 1920,193.
2. For a fascinating history of this tradition, see Penzer and Tawney (trans), 1922.
3. Danielou (trans), 1965, 15.
4. Edgar Thurston in his study recorded seven classes of *devadasi*; 1909, vol II, 125.
5. Hultzsch, 1895, vol 11, part III, 259 - 303.
6. Grey, (ed) and Havers (trans),1892, vol 1, 259.
7. Dubois and Beauchamp (trans), 1906, 585.
8. See Peterson, 1989, and Dehejia, 1988.
9. Ghosh, (ed), 1957.
10. Peterson, 1989, 118.
11. Smith in Michell (ed), 1989, 58 - 75.
12. Ghosh (trans and ed), 1967, vol 1, chapters I - XXVII.
13. These *karana* were first fully described in Naidu, Naidu and Pantulu, 1936.
14. The specific meanings of gestures, postures and *mudra* in dance are described by Banerji, 1942, chapters IV and V.
15. Vatsyayan, 1983, 106.

16. Goswamy and Dahmen-Dallapiccola (trans), 1976.
17. Kramrisch, 1928.
18. Ibid.
19. Ibid.
20. Vatsyayan, 1983, 104.
21. Ramachandran, 1969, vol II, 381 - 2; Ghosh, 1967, argues for a 500BCE date. This is an improbably early date for the work as it now stands, although elements of the text may indeed be of that antiquity; pp l ix - l xv.
22. Kramrisch, 1928, 1.8.
23. Svacchanda Tantra, iv, 306.
24. Vishnu Upanisad, II. 6 - 7, in Vatsyayan (ed), 1988, 114.
25. Madras Devadasi (Prevention of Dedication) Act, 1947.
26. Fuller, 1984, 40.
27. Algeranoff, 1957.
28. Gopal, 1957.
29. Subramaniam, *The Hindu*, 17 March 1985, 11 May 1985.
30. For the origins of this form of dance-drama, see Kothari, 1979, 109-117.

CATALOGUE

187 Kedara raga

Realm *of the* Gods

THE CIRCLE OF SHIVA

Pratapaditya Pal

O Please dance [my lord] in jewelled shoes in my heart
and do not hurt your feet on the rocks.
(Shankaracharya 788-820CE)

In most Shaiva temples Shiva is worshipped in his symbolic form known as the linga, except in the famous temple at Chidambaram (Tamil Nadu), where the principal icon is a magnificent silver dancing Shiva like the one in bronze in the exhibition [3a]. While this remains the best known of all forms of the dancing god, artists of all ages have represented him in diverse images both in sculpture and painting; there are conceptual, contextual and iconographic differences among the figures. For instance, all the stone sculptures included here [1-2, 3b, 5] were placed in subsidiary shrines on external walls of temples and were not directly worshipped by the devotee. The bronze examples [3a and 7a] were used as processional images during festivals, and the paintings [4, 6, 7b, 8] served didactic rather than devotional purposes.

The representations differ in their symbolic significance as well. The familiar image type [3-4], invented by Chola artists sometime in the ninth century, depicts a dance of far greater cosmic and cosmological import than the northern forms and represents the god at once as the creator, the destroyer and the supreme source of salvation. Known as the Nadanta, Shiva performed the dance before an audience of gods and sages [4] in the golden assembly hall of Chidambaram or Tillai, the centre of the universe. He dances away the old and ushers in the new age and hence he is the god of both the end as well as the beginning. While in the stone steles the form is presented in relief, in these bronzes the figure, encircled but not limited by the ring of fire, symbolising the phenomenal world, is presented in the round. It is an image of extraordinary vitality and poise, of unlimited energy and tranquillity, of destructive force as well as grace. As the devout saint Manikkavachakar (c850) sings (Yocum, 1982, 158):

Let us praise
the dancer (kuttan)
who in good Tillai's hall
dances (atu) with fire
who sports (vilaiyatu)
creating
protecting
destroying
this heaven and earth
and all else.

Noteworthy is the word *vilaiyattu* in the verse which clearly makes the dance of Shiva also an act of divine play or *lila*, (see section: The world of Vishnu/Krishna). This idea is emphasised by other poets, as first pointed out by Ananda Coomaraswamy (1924, 91). For instance, Tirumular writes: 'The perpetual dance is his play.'

Although in Tamil the form is known as Kuttan Niruttan or Natamati, generally he is identified by the Sanskrit expression Nataraja, which literally means King of Dance. In the north of the subcontinent, he is commonly given the title Natyesvara, Natesvara or Narttesvara, which means Lord of Dance. As may be seen from the two types of images [1-3], they are quite distinct both formally and iconographically. Moreover, there are noteworthy distinctions between the Dancing Shiva in Central and Eastern India as well. In the East Indian representations he prefers to dance on the back of his bull mount who also is shown dancing sometimes but in the Central Indian images he dances on the ground. In Northern India Shiva is also seen leading the dancing mothers [16] in sculpture and he also dances with Kali in paintings [9]. Whether he dances alone or in company, the dance did not inspire the kind of effusive literary expressions or symbolic significance, as has the Nataraja image of the South.

In a rare painting from Andhra Pradesh [8] Shiva vigorously dances over a demonic figure while Vishnu provides the rhythm and Brahma watches. This is the form of dance known as *sandhya-tandava* (twilight frenzy) in which whirling gyrations and tempestuous movements emphasise the god's role as the destroyer of the cosmic process. This is all nature dancing as in a hurricane or typhoon. Both in the dramatic tension and vigorous movement this twilight dance of deluge is related to that when he slays the elephant [7a]. As the poet Kalidasa advises the cloud messenger upon his arrival at Ujjaini to visit the temple of Mahakala:

> *Then, alight in that forest of His mandala-like arms*
> *And assume the red glow of the fresh china-roses*
> *Restrain your desire for the wet elephant hide as He begins to dance,*
> *And the becalmed Bhavani will appreciate your devotion.*
> (Meghaduta 1,32)

One of the most exciting representations of the dancing Bhairava may be seen, however, in a unique Orissan sculpture [5]. Here the god is both the dancer and the musician and the sculptor appears to have used the model of an itinerant village musician called *baul*, common in both Bengal and Orissa, to portray the divine archetypal beggar. The stringed instrument in his hand appears to be the one-stringed *ektara* of the *baul*. The mound of heads below his foot clearly emphasises the tantric nature of the image and may also symbolise the cremation ground which Shiva haunts and where he performs his *tandava* dance.

Apart from being the Lord of Dance, Shiva is also regarded as the Lord of Music. The kettledrum is his most common attribute but he also plays the vina like Sarasvati [45-47]. In this form he is known as Vinadhara Shiva or Shiva the Holder of the Vina. In the north he is generally shown with the vina while leading the group of mothers, but in Bengal [2] he

dances with it. In the south independent images of the form, especially for religious processions, again testify to the creative genius of the Chola artists. In one of the finest realisations of the subject [10], a youthful Shiva gracefully plays the invisible vina with his principal hands. In Stella Kramrisch's inimitable language (1981, 104), 'By imponderable nuances of modelling, the rendering of the boyish figure conveys a weightless serenity as if waves of bliss were the support of Vinadhara's limbs.'

The musician Shiva is also a part of a small but unique bronze from Kerala [11]. The figure combines the forms of Shiva and his spouse Parvati, which is not uncommon. What is rare is that it shows Shiva as the Lord of Music as well. Such androgynous forms of Shiva and Parvati first appear in Kushan Mathura and unambiguously dispense with gender distinctions of the Absolute. They emphasise the concept of non-duality and hence the name Ardhanarisvara (the lord who is half woman). The great Sanskrit poet Kalidasa (5th century) eulogises this form by stating that just as the word cannot be separated from its meaning, so also Shiva and Parvati cannot be detached.

This idea has its earthly counterpart in the concept of *ardhangini* (the notion of a 'better half') applied to an ideal couple. Shiva and Parvati, of course, are the divine exemplars of conjugal love and are frequently represented as such in art. In a well-carved sandstone relief from Sikar in Rajasthan [12], the pair sit intimately on the bull and accept the offering of dance and music. Or again the two sit in royal majesty in an impressive bronze tableau [13] and watch their child Skanda dance. And in two lyrical eighteenth-century pictures, we see the divine couple being entertained while bathing [14] and travelling down the mountains in the autumn [15].

Indeed, frolicking, cavorting, singing and dancing seem to be the principal preoccupations of Shiva's hosts known as *gana*. Usually dwarfish and unprepossessing in their appearance, these impish fellows provide some of the most amusing scenes in Indian art. The earliest of such figures included here [19-20] are not necessarily *gana* but certainly they are the predecessors of Shiva's attendants. Made of terracotta at the fecund site of Chandraketugarh (north of Calcutta) in the first century before the Common Era, they are among the most lively and whimsical objects to have been created in early India. The later stone sculpture from Uttar Pradesh [21], portraying a drummer, certainly represents a *gana* and probably graced a Shaiva temple.

But the *gana* par excellence is, of course, Ganesh (Ganesha), whose name literally means lord of the *gana*. Distinguished by his elephant head, he was singled out by the Gupta period (300-600CE) and became the son of Shiva and Parvati. He has remained an important figure in the Hindu pantheon in his own right (worshipped by Buddhists and Jains as well) and is known as the god of auspicious beginnings and the remover of obstacles.

Like his father, he also dances but with a more sportive intent than cosmic. There has been no greater admirer of the dancing form of Ganesh than the Kashmiri poet Somadeva. In his *Kathasaritsagara* (c1070) he has included a number of eulogistic invocatory

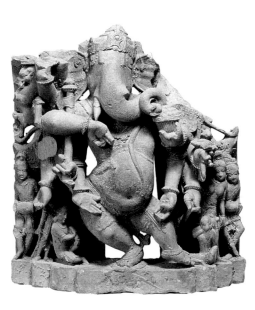

22b Dancing Ganesh

verses in which he seems to emphasise the joyousness of the god's dance and its association
with the sky and the stars. In one he says, 'I adore thy trunk flung up straight in the joy of the
dance, so as to sweep the clouds' (symbolising darkness or obstacles?). Elsewhere Somadeva
sings: 'Victory to Ganesha who when dancing makes a shower of stars, resembling a rain of
flowers, fall from the sky by a blow of his trunk.' Here clearly the poet is alluding to the
joyful habit of elephants frolicking in water and plucking lotuses with their trunks to hurl at
one another. The same idea is expressed in another way in the following verse:

> *May Ganesa, who at night seems,*
> *with the spray blown forth from his hissing trunk uplifted in the tumultuous dance,*
> *to be feeding the stars, dispel your darkness.*

(Pal, 1995, 43)

The examples of dancing Ganesh included in this exhibition clearly demonstrate
the various modes preferred by artists in the different regions of the subcontinent. In stone
steles [22-23] he is usually accompanied by two or more musicians, while in the solitary
bronze from the south (rarely does one come across a dancing Ganesh in bronze in north
India), he dances alone [24]. In the Central Indian compositions he is clearly a bulky fellow
and seemingly of slow gait. Accompanied by a large orchestra, he does two very different
steps. The arms are also differently disposed in the two sculptures, reflecting a certain amount
of freedom enjoyed by the artists.

In the two examples from Eastern India [23], not only does the god dance on his
rodent mount but also with different steps. Clearly here again he is imitating his father, who
also dances on the bull in that part of the subcontinent. However, the artists of the region
seem unconcerned about the incongruity, if not absurdity, of placing a Goliath over a David.
One wonders whether the rodent looks adoringly at his merry master or is trying to tell him
that the honour is dubious.

In neighbouring Orissa as well the god dances sometimes on the rodent's back and
at others, as in a rare painting [25], with one leg on the animal. Moreover, he is surrounded
here by ten goddesses, who form the group of ten Mahavidya, important in tantric religion.
Often in Central Indian reliefs of the seven mothers (*saptamatrika*), both Shiva and Ganesh are
positioned at either end [16]. However, I know of no other representation of Ganesh being in
the centre of a mandala of the ten Mahavidyas, none of whom are dancing. Outside, however,
the four goddesses Sarasvati and Lakshmi on top and Ganga and Yamuna at the bottom are
shown in dancing postures.

Representing the southern tradition is a late but impressive bronze from Karnataka
[24]. While in all the sculptures, the god's boyishness is emphasised, here the childishness is
even more prominent, partly because of the treatment of the form and partly due to fewer
arms than the north Indian figures. His plump, childish legs seem almost unable to carry the
burden of his ample belly bloated with the sweets he constantly devours and is busy eating

here. Despite his bulk, however, he seems a buoyant figure because of the way in which he raises his right foot away from the lotus supporting the left. Another unusual feature is the bunch of mangoes he holds with his outstretched left hand. This may be a trait borrowed from the much earlier Eastern Indian images where a similar bunch of mangoes, symbolising fertility, hangs above the god's head [23].

It is common to depict Shiva dancing with the Mothers but rarely does he dance with his spouse Parvati. Parvati does occasionally dance alone, although no representation is included here. In fact, Shiva is her teacher or guru and in due course she proved to be just as skillful. Once they did enter into a competition but Shiva won it by trickery.

The most famous image of the goddess is that in which she is engaged in a deadly duel with the titan called Mahisha or Buffalo. In the luxuriously carved example in the exhibition [18], she stands gracefully with one leg on her lion's back as she pierces the titan with her trident. This tableau is also recreated by the dancers when they present the incident on the stage. It is a moot point whether the stylised posture was borrowed by the sculptor from the dancer's repertoire or vice versa. In either case it is art imitating art rather than life. Music too plays a role in this theme of death and salvation. Two of the goddess' attributes are musical instruments: the bell and the conch shell, the latter borrowed from Vishnu [27]. In fact, she blows on it frequently during her battle with the titan.

If Durga's association with the dance is subtle, much more graphic is the image of dancing Kali or Chamunda [17]. She, of course, is included among the Dancing Mothers [16], but also has independent images in which she dances on the shoulders of a male. As the eminent Sanskrit poet Bhavabhuti writes:

> I praise your dance, Chamunda
> so perfectly performed it wins applause in Siva's court.
> The Whirling of your bold nisumbha
> Has pressed earth's ball upon the turtle's shell
> until he shakes the framework of the universe
> and all the seven seas well up to fill, instead of Hades,
> the yawning caverns of your cheeks.
> (Ingalls, 1965, 97)

While Parvati dwells on mount Kailash taking care of the family, Kali's habitat is the cremation ground which is also the favorite haunt of Shiva. She likes to roam the battlegrounds as well, and plays a major role in destroying the titans. According to legend she was created from Durga's wrath in the battlefield to be a sort of a troubleshooter. She is, moreover, the goddess of death or time, Mahakali, just as Shiva is Mahakala. And so it is not inappropriate that in a Pahari picture [9] the two are shown in a grand ballet with their companions dancing and singing in a charnel field littered with skulls, bones, and skeletons.

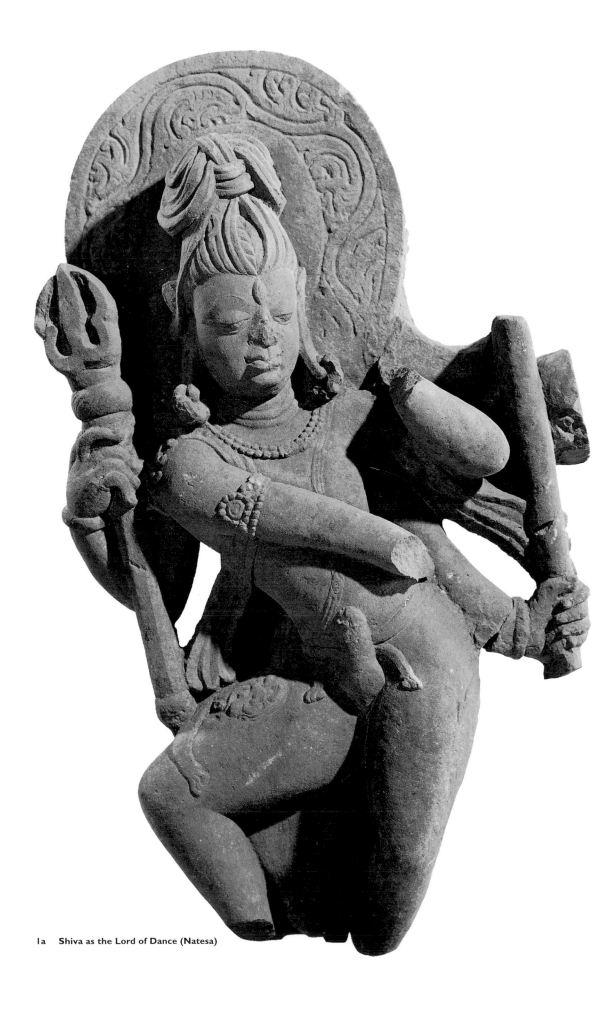

1a Shiva as the Lord of Dance (Natesa)

1 **Shiva as the Lord of Dance (Natesa)**

a) Madhya Pradesh; c800; rust coloured sandstone; 74.9

Los Angeles County Museum of Art; Nasli and Alice Heeramaneck Collection;
Museum Associates purchase

b) Madhya Pradesh or Rajasthan; c900; sandstone; 43.1 *(see page 11)*

Museum of Fine Arts, Boston; purchase Frederick L. Jack Fund

a) When complete the feet of Shiva would have been placed in the *chatura* mode,
with one leg upright (*samapada*) and the other bent with raised heel (*kunchita*). The two
principal arms make gestures of the dance, one being held across the chest in *dolahasta* or
karihasta. The trident is held by the second right hand and only a staff remains in the second
left hand. He wears a tiger skin, is ithyphallic as befitting a yogi with self control, and has the
third eye. His handsome face with the elegant chignon is set off against a nimbus adorned
with a meandering creeper motif.

b) In this more complete stele, Shiva strikes the same pose as in (a) but has more
arms which seem to be all over the place. The number of arms has increased to eight, all of
which hold various attributes and make gestures drawn from the dancer's repertoire. With his
uppermost arms he stretches out the serpent as if displaying it as a trophy. This will remain a
popular feature of such forms across northern India [2, 6] and will be copied by his son [22].
This vivacious tableau includes a drummer playing the double drums and the bull who turns
his neck to look up in wonder at his nimble-footed master.

(see page 61)

2 **Shiva as the Lord of Dance (Natesa)**

West Bengal or Bangladesh; 11th century; chlorite schist; 55.9

The Alsdorf Collection, Chicago

The dancing god is here portrayed as a colossal figure. Not only are the figures on
the base diminutive but his bull and the four-armed goddess on the left, by their relative sizes,
emphasise his gigantic proportions and clearly announce his cosmic nature. Usually in this
region he dances on the bull, but here the animal joins in the dance as he looks up adoringly
at his master.

Generally Shiva is ithyphallic and is given ten arms in such images, but here he has
twelve. The fact that he holds the vina with the two principal hands makes him the Lord of
Music as well [10]. As usual he dances in the *chatura* mode and two of his arms form a circle
overhead as they stretch the snake. Unusual, however, is the gesture of the second lower left
hand for it caresses the chin of the goddess. She must represent his spouse Uma or Parvati,
though it is rare to find her with four arms when they are portrayed together. Nevertheless, it is
common in images from this region to show Shiva expressing his affection by touching her chin.

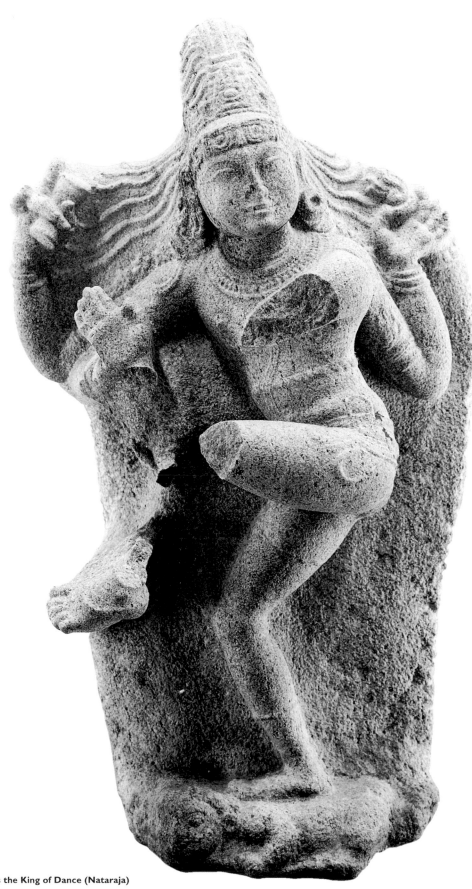

3b Shiva as the King of Dance (Nataraja)

3 **Shiva as the King of Dance (Nataraja)**

a) Tamil Nadu; 12th century; bronze; 74.3

The Asia Society Galleries; Mr and Mrs John D. Rockefeller 3rd Collection

b) Tamil Nadu; c1100; granulite; 83.8

Los Angeles County Museum of Art; gift of Mr & Mrs Harry Lenart

a) With his right foot crushing the dwarf of ignorance crouching on the lotus, Shiva throws up his left leg (*urdhvajanu*) across his body. With one of his right hands, he reassures the devotee, while the corresponding left arm is brought across the body in *karihasta* to point to the raised left foot as the source of salvation. The second right hand plays the small hand drum (*damaru*) to signify the rhythm of creation, while fire in the corresponding left hand exhibiting the half-moon gesture is the agent of destruction as well as purification. The surrounding ring of fire represents the cyclical motion of the cosmos.

Apart from the legs and arms, the sense of movement is graphically conveyed by the stylised hair flying on both sides of the head and the long end of the sash, which also fills some of the empty space. It should be noted further that the hair gives the impression of waves because lodged in his flying tresses is the tiny adoring figure of the river goddess Ganga.

b) This deeply carved relief probably once graced a niche high up on the facade of a Shiva temple facing the south. Generally visitors to museums outside India are familiar with metal images of Nataraja, but the form has a permanent position on temple walls as well. The principal differences with the bronze may be noted in the less elaborate but delicate, string-like design of the flying hair, the absence of the river goddess and the broad, square shape of the face. Stone images of the theme rarely include the surrounding ring of fire.

4 **Dancing Shiva with Shivakami** (*see page 55*)

Tamil Nadu, Thanjavur (Tanjore); 1775-1800; gesso on wood, paint, glass and semi-precious stones; 111.8 x 93.9

The Freeman-Khendry Collection, Toronto

A fine example of Tanjore painting, this shows a complete tableau of Shiva's dance at Perumbarrappuliyur. And as he should be, he is accompanied by Parvati who is known in this form as Shivakami or Desirous of Shiva. She is described in the text both as the inspirer of and witness to this cosmic dance (see Sivaramamurti, 1972 and Coomaraswamy, 1924). Characteristically, Shiva is fair but Parvati is dark skinned. It should also be noted that images are clothed and ornamented in this elaborate fashion in temples.

Also included in the composition are various priests and yogis, as well as Ganesh between his parents on the altar itself. Below, in a single register are various Hindu deities forming a divine orchestra. For instance, in the centre while the dark Vasudeva plays the flute, Sarasvati is shown with a violin rather than the usual vina [45]. Obviously by this time, it had become more customary for a violinist rather than a vina player to accompany a performer.

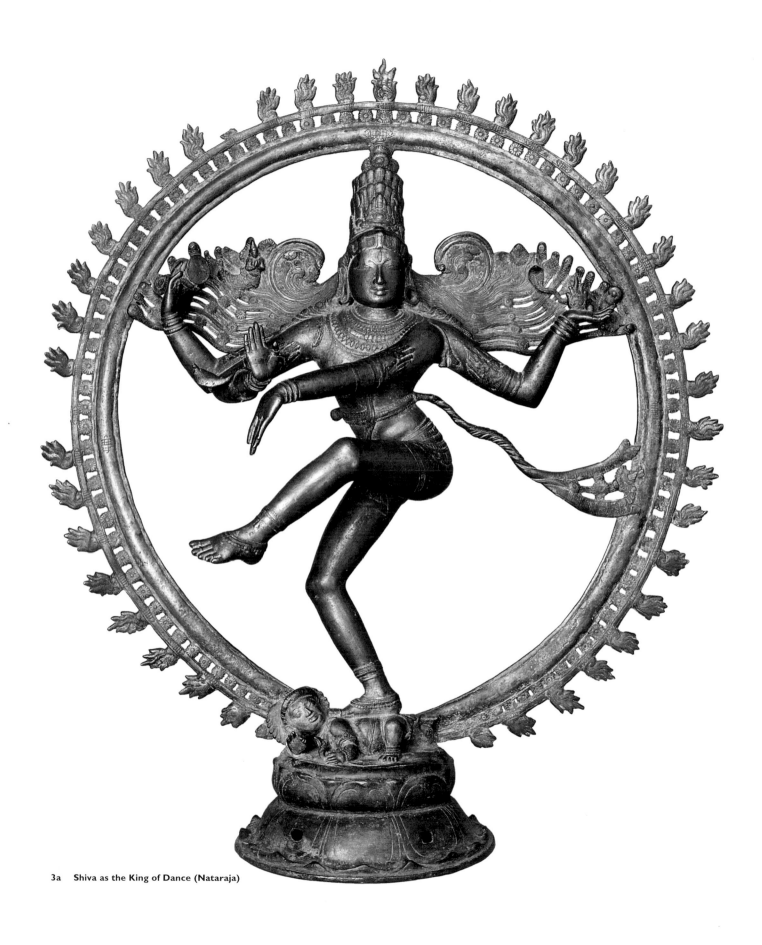

3a **Shiva as the King of Dance (Nataraja)**

5 **Dancing Bhairava**

Orissa; 11th-12th century; sandstone; 114.3

The Norton Simon Foundation, California

Bhairava (The Howling One) is one of the many epithets of Shiva and is generally applied to his terrifying or angry form. As Bhairava he may be shown as an emaciated figure, generally in the north, and as a youthful naked beggar in the south. In this stele an unknown Orissan sculptor has not only given us an original version of the theme, but an arresting composition.

Unusually, the god is dancing atop a pyramid of five severed heads arranged on a lotus. While skulls are closely associated with Bhairava, such strange heads with deep sunken eyes are rarely encountered. (In Java Bhairava does dance and stand on skulls.) These heads may symbolise the cremation ground where five heads are offered to Chamunda [17] or, according to R. Nagaswamy (verbal communication) they may represent the five forms of Shiva himself.

Although he does dance here basically in the *chatura* mode, he does so on his toes with both feet raised, the legs forming pronounced angles. The arm stretched in *karihasta* holds the drum and the stringed instrument is held with only one hand exactly as the *baul* or itinerant singers grasp their *ektar* (one-stringed instrument) as they sing and dance. The tilt of the head, the distinctive treatment of the hairstyle and the garment are some of the other features that make this a unique sculpture.

6 **Dancing Shiva**

Folio from *Balgopalastuti* Manuscript

Gujarat; c1450; 10.5 x 23.3

Navin Kumar Gallery, New York

This miniature representation of a dancing Shiva not only provides interesting iconographic variations but it is included in a manuscript of the *Balagopalastuti* (eulogy to child Gopala = Krishna). Although this is a Vaishnava devotional text composed by the saint Vilvamangala (c1250-1350), it is extremely popular with the Jains in Gujarat and Rajasthan.

Shiva is obviously dancing his *sandhya-tandava* but unusually he does so on the back of his bull, which looks up in amazement at his master. As far as is known, only in Eastern Indian sculpture does Shiva dance on the bull. Secondly, with one of his left hands he holds an elephant as if it is a toy, thereby clearly emphasising his cosmic proportions. It has been suggested by John Guy (Pal, 1994, 207) that this is the elephant mount of Indra but more likely it is Gajasura after killing whom Shiva did perform a dance of victory [7]. Perhaps the artist may have felt that a dead animal would offend a Jain. Another interesting touch is the addition of a dancing peacock on the god's left and a lady offering him a floral crown on the right. This is unlikely to be a milkmaid, as the dance did not take place in Brindaban, but Uma or Parvati who may be offering him the victor's crown.

5 Dancing Bhairava

7b **Shiva's victory dance**

7 **Shiva's victory dance**
a) Tamil Nadu; c1700; bronze; 89
Museum of Fine Arts, Boston; Marshall H. Gould Fund

b) Rajasthan, Mewar; 1750-1775; 19.7 x 13.4
Santa Barbara Museum of Art; gift of Julia Emerson

In both Shiva does a victory dance after triumphing over a demon who appeared in the guise of an elephant. Shiva destroyed the elephant and made himself a garment with the flayed skin. In both versions, however, artists have given different interpretations of the theme, usually known as *gajantaka* or the destroyer of the elephant.

In (a) the god dances vigorously balancing himself on the head of the slain demon and dramatically stretches the skin above his head to form a circle or aureole. The violence of the occasion is expressed both by the forceful twist of the body and the young terrified Skanda who clutches on to his mother. Furthermore, with rolling eyes, protruding fangs and flying hair this is clearly the Bhairava form of the god. Undoubtedly this is one of the most dynamic of all forms of Shiva's dance and continues an image created in the Chola period (see Sivaramamurti, 1974, fig 9).

In (b) in rather a stark composition a Mewar artist gives us an unorthodox interpretation of the myth. Despite the garland of skulls, Shiva is a gentle figure who seems to be pointing at the docile elephant above his head with his left hand as the right grasps the rosary around his neck. Indeed, except for the golden halo of emanating rays behind his head, Shiva's is essentially a human figure.

Balancing the ash-besmeared and iconic figure of Shiva are Brahma playing the drum and Indra the cymbals. From the sky above two celestials riding their bird-shaped flying machines shower flowers on Shiva for his heroic feat. Hindus believe that divine acts are greeted by floral showers (*pushpavrishti*).

8 **Shiva's twilight dance of frenzy**
Andhra Pradesh; 1750-1775; 21.9 x 37.7
Los Angeles County Museum of Art; Indian Art Discretionary Fund

Clearly this is a more energised version of Shiva's *tandava* dance and is known as *sandhya-tandava*. The titan below his feet is not the usual timid dwarf of ignorance but a dagger-bearing antagonist. The fact that his tongue hangs out leaves no doubt of his defeat. Shiva too strikes a most unconventional posture with a twisted or contorted body, as if running across the titan's back. His mendacity is clearly evident from the sword he brandishes above his head. With all those weapon-laden arms, the titan has no chance.

As in the Mewar picture [7], the witnesses to this dance are Brahma and Vishnu. Vishnu's is the more active figure as he too dances while playing on a drum with two hands;

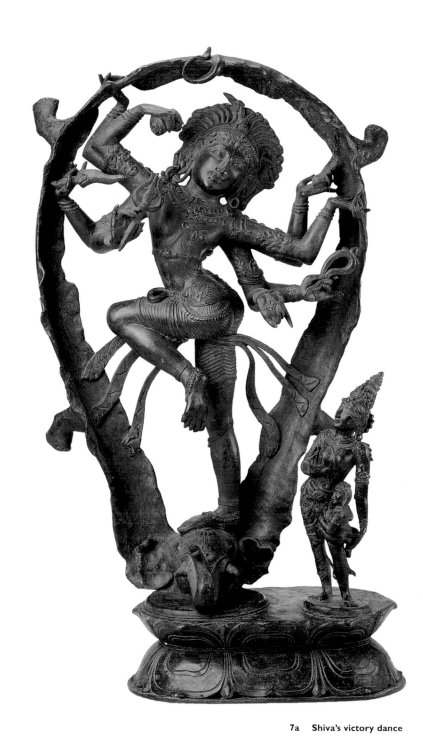

6 Dancing Shiva

7a Shiva's victory dance

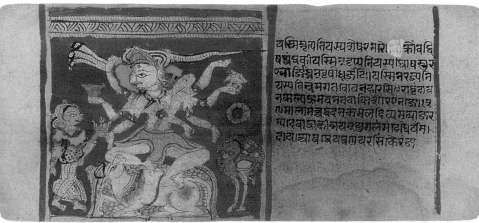

the other attributes are the wheel and the conch shell. While he interacts with Shiva, Brahma stands timidly looking at the audience with the squinting eyes of his front face. The composition can be traced back at least to the fourteenth century in a rock-cut relief at Srisailam (Sivaramamurti, 1974, fig 138).

9 **Divine pas-de-deux**
 Himachal Pradesh, Guler; 1775-1800; 27.5 x 20.2
 Kapoor Galleries Inc, New York

The setting is a hilly battlefield. Graphic evidence of slaughter – severed and half-chewed limbs, skulls and skeletons – are strewn all over. In this killing field Mahakali along with her bloodthirsty companions are engaged in a dance macabre. Not to be outdone, Shiva has also joined the gory celebrations and dances while providing rhythm for the spirited Kali. He has discarded his tiger skin and uses the snake as a scanty garment while she covers her modesty with the hide of a cheetah. Behind Shiva his animal-headed minions form an orchestra.

Another version of the theme in a simpler composition is published in Kramrisch (1981, 23) who suggests that the scene probably depicts the dance of joy that followed Kali's destruction of the titan Daruka. Whatever the reason, it is a fine example of a *danse macabre*, chillingly lively.

10 **Shiva holding the vina (Vinadhara)**
 Tamil Nadu; 975-1000; bronze; 61
 Mr and Mrs Lawrence R. Phillips, New York

Just as Shiva is considered to be the Lord of Dance, he is also declared to be the archetypal musician. Unlike Krishna who charms the human soul with the sound of his flute, Shiva is a teacher of music. Independent images emphasising this aspect were more popular in the south than in the north [cf 16]. In Tamil Nadu in particular, he is depicted both on temples and in bronzes. This particular example not only delineates the iconography of the form with articulate details but is also one of the finest expressions of early Chola art.

With his well-proportioned and compactly modelled body, the rather youthful god stands gracefully on a lotus. The smooth plastic mass, contained within mellifluous contours, is discreetly adorned. Typical of most Tamil representations of the peaceful Shiva, his two upper arms hold the battle-axe, which severs all knots of ignorance, and the antelope, which symbolises all creatures (*pasu*) as well as illusion. It may be recalled that one of Shiva's epithets is Pasupati or Lord of Creatures. The two principal hands are deployed in the position in which a vina is usually held [see 2, 11], and rarely included in these bronzes.

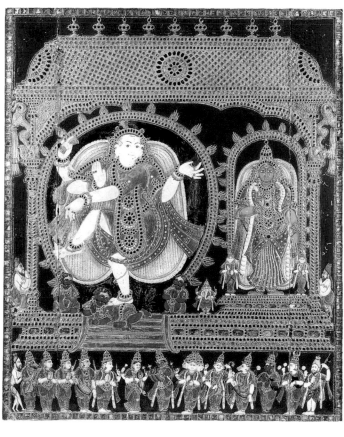

4 Dancing Shiva with Shivakami

9 Divine pas-de-deux

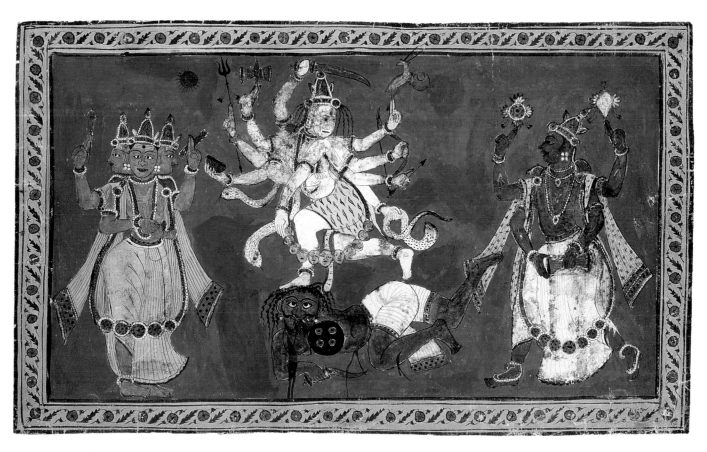

8 Shiva's twilight dance of frenzy

11 **The androgynous form of Shiva and Parvati**

11 The androgynous form of Shiva and Parvati

Kerala; c1200; bronze; 11.8

The Metropolitan Museum of Art, New York

Samuel Eilenberg Collection, gift of Samuel Eilenberg, 1987

This diminutive but charming bronze is a significant work of art for several reasons. It introduces us to a very profound theological concept of the Hindus who believe that the Supreme Being is of both genders; it is the earliest known representation of the theme from Kerala; and more relevant for this exhibition, it shows the androgynous figure playing the vina, an iconographic rarity.

Such forms are known as Ardhanarisvara (the lord whose half is female) in Sanskrit. The right half is always of Shiva and the left of Parvati. In this instance, Shiva's upper hand holds the battle-axe and she has a parrot in hers. The two normal hands hold the vina and presumably both are playing it together, thereby adding a musical dimension to Parvati's abilities.

12 **Shiva and Parvati being entertained**

Rajasthan, Sikar; c973; cream coloured sandstone (quartz arenite); 45.7

The Nelson-Atkins Museum of Art, Kansas City, Missouri

In this relief the figures are placed in a single row on a narrow ledge decorated below. Shiva and Parvati are seated together on the bull, who has a bowl of grain at his mouth. Shiva holds the trident and a flower on the right. One left hand grasps the serpent and the other circles her waist. She holds a mirror with the left hand and places the right around his neck in a gesture of intimacy. The flower in Shiva's hand is called a *lilakamala* and symbolises his playful, relaxed mood.

Five dancers and musicians, four male and one female, entertain the divine couple. The figure immediately on Shiva's right is an ascetic while that beside Parvati is a female garland bearer. The male behind her has a bell and the other two play the drum and the cymbals. The two on the couple's left strike identical postures but the two musicians at the other end do different steps. Apart from the graceful postures of these lithe figures, the expressive gestures of their hands are clearly taken from life.

13 **Shiva and Uma watch Skanda dance**

Tamil Nadu; c1400; bronze; 63.5

The Art Institute of Chicago; Robert Allerton Collection

Such images in which Shiva and Parvati are seated with their son Skanda or Kumara between them are known as Somaskanda (Shiva with Uma and Skanda). Like the Chola Vinadhara figure [10], this popular theme too was made for processional purposes, although images of the trio are also installed in shrines and worshipped daily.

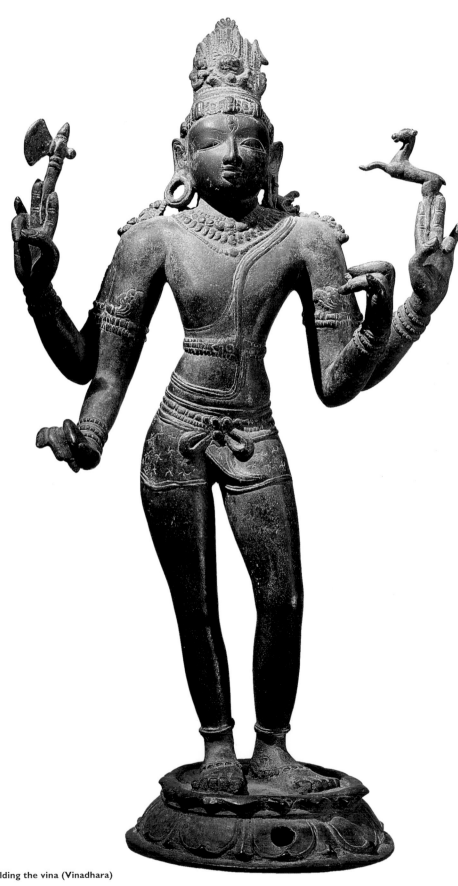

10 Shiva holding the vina (Vinadhara)

While the subject is common in Chola and Vijayanagara period art, this particular example is important for two reasons. It shows the peacock mount of Skanda below his lotus, a detail rarely encountered in such tableaus, and it definitely portrays the child in a dancing posture. In Indian art Skanda is rarely shown dancing by himself but in Tamil Somaskanda representations he is often depicted entertaining his doting parents.

14 Shiva and Parvati bathing
detail

14 Shiva and Parvati bathing *(frontispiece)*

Attributed to Kushala and Kama

Himachal Pradesh, Kangra; 1775-1800; 22.3 x 32.4

Paul F. Walter Collection, New York

The unusual subject matter of this picture not only makes it rare but also intriguing for its literary source. It shows Shiva and Parvati bathing in a lotus pool. How wonderfully intimate is the playfulness of the two divine lovers and with what genteel restraint the companions betray their emotions. While their privacy is assured as far as the dancing and singing villagers beyond the red fence are concerned, certainly their companions in the grove of trees seem surprised and astonished. Judging from the fact that their clothes are in a heap on the tiger skin on the left of the picture, it would seem as if they had impulsively decided to go skinny dipping and hence the expression on the faces of the companions. In scenes of revelry beyond the fence, three women dance while two groups of musicians play.

A mate to this picture is in a private collection in Philadelphia (see Kramrisch, 1986, no. 122). It has an inscription on the back informing us that it is one of a series of twenty-two pictures painted by Kushala and Kama. There can be no doubt of the stylistic kinship of the two pictures. Kushala was the son of Manaku [41b] and Kama his cousin.

15 The Holy Family on the move *(see page 71)*

Himachal Pradesh, Kangra; c1800; 25 x 19.4

Dr and Mrs Narendra Parson, California

According to mythology, Shiva and Parvati live in Mount Kailash in the Himalayas. It is understandable therefore that Pahari (hill) artists should have been especially fond of representing the divine couple in their habitat. Indeed, between 1775 and 1825 they appear to have been particularly active in creating a great variety of pictures depicting the holy family either in their mountain abode engaged in domestic chores, or on the move. It is not clear where they are moving to, but very likely the idea was inspired by that of nomadic shepherds such as the *gaddi*, who migrate annually to warmer climes with the approach of winter.

In this 'framed' picture, characteristic of the school, the dwelling on Kailash is shown fortlike atop an escarpment on the upper right. The divine caravan includes Shiva on his bull, Parvati on her tiger (common in the hills), Kumara on his peacock and Ganesh on a colossal rat. In front of the rodent walks the monkey faced Nandikeshvara, Shiva's chief

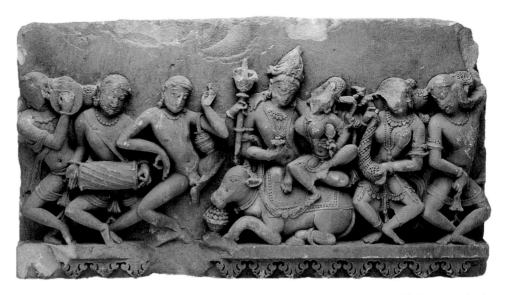

12 Shiva and Parvati being entertained

59

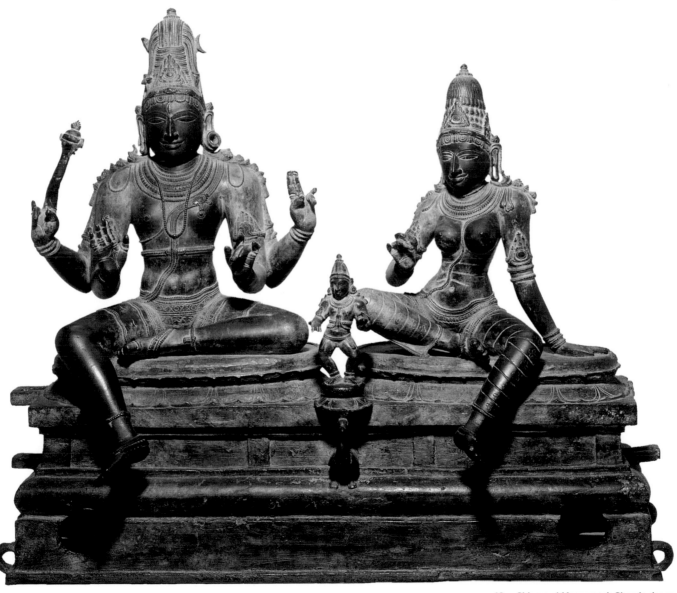

13 Shiva and Uma watch Skanda dance

factotum. The group is led by other attendants, all of whom are playing on various instruments. In other published renderings of the subject these companions are excluded and no music enlivens the journey. A group of forest-dwelling ascetics in the grove bow deeply.

Two details are of particular interest. One is the crowned figure just ahead of the bull. He holds a stick and his crown and complexion are reminiscent of Krishna. His inclusion remains a mystery. The other is the fact that Parvati is holding a snake. Considering that the youthful Shiva has no snake around his neck, one would presume that during the move the serpent had somehow disappeared. Once on the way Shiva misses his pet reptile and turns to Parvati who reassures him by pulling it out of her basket.

16 Dancing Mothers with Shiva and Ganesh
Uttar Pradesh; c800; sandstone; 50.8 x 134.6
Dorothy Sherwood, California

Nine dancing figures are represented in this relief. Basically they all dance in slight variations of the *chatura* mode. The group's leader is Vinadhara Shiva, known also as Virabhadra, at the far left, while Ganesh brings up the rear at the far right. The mothers can be recognised by their mounts and their emblems. Following Shiva are Brahmani, Mahesvari, Kaumari, Vaishnavi, Varahi, Indrani, and Chamunda. Except Chamunda, all are personifications of the energy of the following gods: Brahma, Maheshvara or Shiva, Kumara, Vishnu, Varaha (an avatar of Vishnu) and Indra. Therefore, each has the principal attributes of the respective male deities, except Varahi and Indrani. Varahi is given the skull-cup and a fish, while Indrani carries a child in addition to Indra's thunderbolt. Thus she is the only goddess expressing the nurturing aspect of the mother.

As embodiments of the energy of the gods, the Mother goddesses are created in the battlefield to help Durga [18] overcome the titans. They celebrate their victory by dancing. According to at least one poet they also danced for joy when Kumara was born. Such reliefs of dancing mothers appear to have become popular in Central India by about the time this well-preserved example was sculpted, probably to be placed over the entrance of a subsidiary shrine. The strongly modelled forms, the rhythmic movement of their postures and the varied tilts of their heads make this a particularly animated composition.

17 Dancing Chamunda
West Bengal or Bangladesh; 11th century; black stone; 61
Los Angeles County Museum of Art

Apart from inclusion in reliefs of dancing mothers [16], Chamunda was also honoured with independent images both in Central India and in the Bengali-speaking region of the east. This particular example may have in fact been carved in the northern parts of undivided Bengal (cf Haque, 1992, fig 219). The goddess is none other than Kali

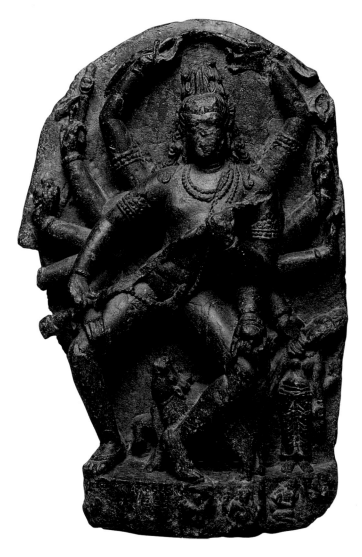

17 Dancing Chamunda

2 Shiva as the Lord of Dance (Natesa)

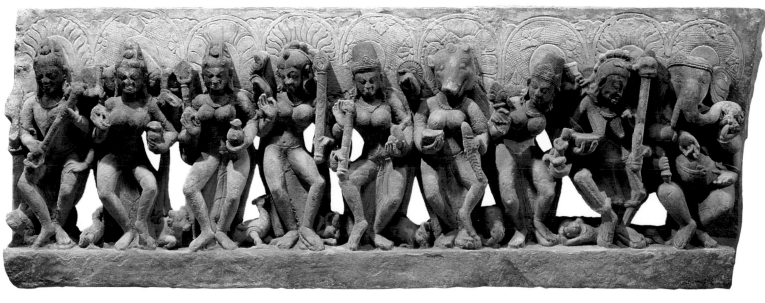

16 Dancing Mothers with Shiva and Ganesh

[9] who was given the sobriquet Chamunda, apparently after destroying two titans named Chanda and Munda, associates of Mahishasura [see 18].

Chamunda's mount is a man (*nara*) and so she is dancing on the shoulders of a youth who dances as well. The locale is clearly a cremation ground which is her habitat (*smasanavsini*), shown along the base with scavenging birds and animals pecking away at severed limbs and skulls. Five skulls (*panchamunda*) are offered to the goddess in a bowl in the centre. She is accompanied by two other dancing skeletal figures who appear to be male and are probably denizens of the cremation ground (known as *chitipati* in Tibet). The emaciated Chamunda makes a striking, though macabre, figure with her eighteen arms equipped with various weapons and together the four figures synchronise their movements with grace and rhythm.

18 **Durga killing the buffalo titan**

Karnataka; 12th century; chlorite schist; 86.4

Los Angeles County Museum of Art; Nasli and Alice Heeramaneck Collection

Museum Associates purchase

The great Hindu goddess is worshipped every autumn for several days in an image that depicts her as killing the titan (*asura*) called Mahisha (buffalo). It has been a favorite theme with sculptors for almost two thousand years and is represented both in stone and metal. This particularly busy tableau with its luxuriantly carved details and ornamental motifs once graced a subsidiary shrine in a Shaiva temple in Karnataka.

In this classic composition the goddess stands with the grace of a dancer with her right leg on the ground and the left on the back of the buffalo and thrusts the trident into the hapless titan's chest as he emerges from the buffalo's shoulders. A second titan has been pinned down at the other end by the goddess' sword. Among her attributes is the large bell with a trident finial which she holds with one of her hands and which she rings to frighten the enemy. Anyone who has seen this theme performed by Indian dancers need hardly be reminded that the stylised movement of the figures closely imitate those of the dancers. That the goddess is modelled on a dancer is also evident from the anklets she wears.

19 **Drummer**

West Bengal, Chandraketugarh; 1st century BCE; terracotta; 10.2

Art of the Past Inc, New York

An unclothed but adorned drummer holds the drum in the crook of his left arm and the beater in his right hand. He is adorned with a chain around his waist, a crossbelt (*channavira*) across his chest and large earplugs in what appear to be rabbit ears. He has a peaked hat on his head and either his face is painted or he is wearing a mask. He could represent a tribal performer but even if modelled from life, he is probably of the *yaksha* class and a forbearer of the later *gana* [21].

19 Drummer

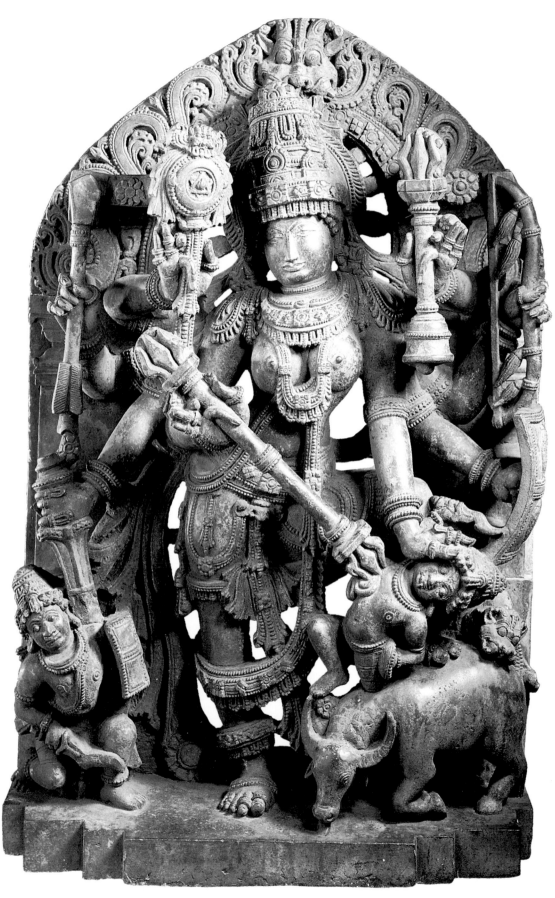

18 Durga killing the buffalo titan

20 A rattling yaksha

20 **A rattling yaksha**

West Bengal, Chandraketugarh; 1st century BCE; terracotta; 12.1

Art of the Past Inc, New York

Seated on his haunches, the figure is clad in a dhoti but his ample stomach is prominently displayed. He has no neck and the large head is provided with an expressive face. Apart from being copiously wrinkled, he has an open mouth with conspicuously displayed teeth. Usually such figures are identified as *yaksha*.

Interesting as its form is, even more intriguing is the fact that most of them are hollow and are filled with some kind of tiny chips. Consequently, they make a noise when shaken and are therefore thought to have been used as rattles for children. While this is possible, their remarkably good condition indicates how well behaved the infants in ancient Chandraketugarh must have been.

21 **A dwarf drummer** *(see page 69)*

Uttar Pradesh; c500; buff sandstone; 62.9

Los Angeles County Museum of Art; Nasli and Alice Heeramanek Collection

Almost certainly this sculpture once formed one of a group of Shiva's dwarf attendants (*gana*) cavorting for the entertainment of their master and Parvati. Carved in deep relief, the spirited figure dances as he is about to beat vigorously on the drum tied to his naked belly with two sticks. A bell around his neck and two large earrings are his only adornments.

He is clearly a descendant of the earlier Chandraketugarh figure [19], but with a more handsome appearance. His round, smiling countenance with wide open eyes is framed by beautifully cascading locks that are characteristic of Gupta period art.

22 **Dancing Ganesh**

a) Madhya or Uttar Pradesh; 9th century; sandstone; 82

Mr and Mrs Michael Pucker, Chicago

b) Orissa; c10th-11th century; buff sandstone, 50.8 *(see page 43)*

Asian Art Museum of San Francisco; Avery Brundage Collection

In both steles Ganesh dances gracefully while fairly large orchestras provide the music. In both the stone immediately behind Ganesh has been completely cut away to provide his bulky form with clearer definition but the backs are unfinished. The columns and the lion subduing the elephant motif (*gajasimha*) are better preserved in the ninth century sculpture (a) than in the later example (b). Everything else about the two sculptures are different.

The principal difference is of course in the postures of the god. In (b) he strikes the

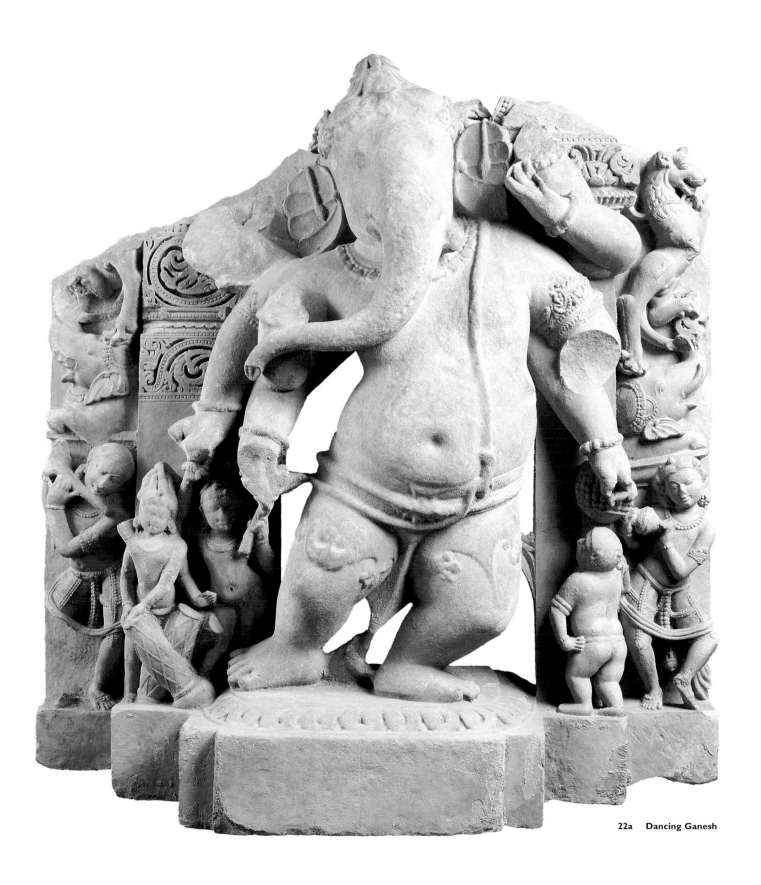

22a Dancing Ganesh

more conventional posture while in (a) not only does the body swing in the opposite direction but the steps are quite different. This piece is closer in its pose and style to the well-known example of dancing Ganesh in the Rockefeller Collection (Desai and Mason, no. 16). In the later sculpture Ganesh has ten arms but in (a) only six, most of which are broken. Interestingly also, in the earlier sculpture he is not eating sweets from a bowl as he normally does (b). The uppermost right hand of the later figure clearly shows that he is stretching the snake above his head like his father [1-2]. The dance gestures are common to both figures.

Varied also are the dispositions and postures of the musicians in the two steles. They are depicted with much greater clarity in the earlier composition, appearing rather crowded in the later work. In each the two musicians at the two ends are clearly dancing as well. What is interesting is that both steles include two other figures, a short, chubby male in (a) and a female in (b). She may be a musician but the dwarf clearly is watching the divine dance. Very likely he is a *gana*, rendered with remarkable naturalism.

23 **Dancing Ganesh**

 a) Bangladesh; c1100; black stone; 86.4

 Private collection

 b) Bangladesh; c1150; phyllite; 65.8

 Los Angeles County Museum of Art; Phil Berg Collection

Although both steles have several features in common they are quite distinct stylistically and iconographically. They are probably from diverse regions of Bangladesh and of different dates. The more ornate stele (b) is likely from the Dinajpur district (cf. Haque, fig 256) and was perhaps carved sometime between 1150 and 1200, while the other may have been executed closer to the beginning of the century in the Dhaka district (ibid, 258).

In both, Ganesh dances on his rat, as does Shiva on his bull in this region. However, while in (b) the rodent is proportionately small, in (a) the animal is not only much larger but combines the hind part of a lion with the forepart of a gigantic, conceptual rat. In (a) the two musicians also dance but in (b) they are seated. In both, however, one has elephant's ears and the other bovine ears. Very likely they are Gajakarna and Gokarna, two of the god's impish companions. While a lotus rhizome adorns the base of (b) the other has two bowls of offerings. At the top of both are the cloud-borne celestials, with swords in (a) but with garlands in (b). As is often the case with the Bengal images, a bunch of mangoes, symbolising plenitude, is depicted at the apex of each stele.

The two figures, however, differ significantly in the plasticity of their forms, their postures and the gestures of their arms. The bodies swing in opposite directions and while the later figure shows the more conventional disposition of arms and attributes, the earlier figure differs notably. The battle-axe, the rosary, the lotus and the bowl of sweets are common to

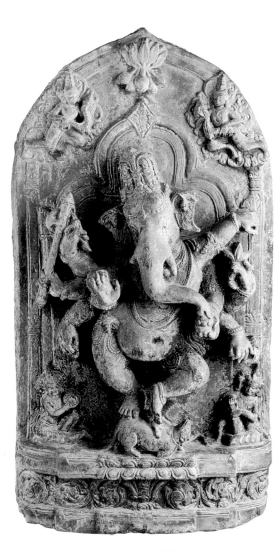

23b Dancing Ganesh

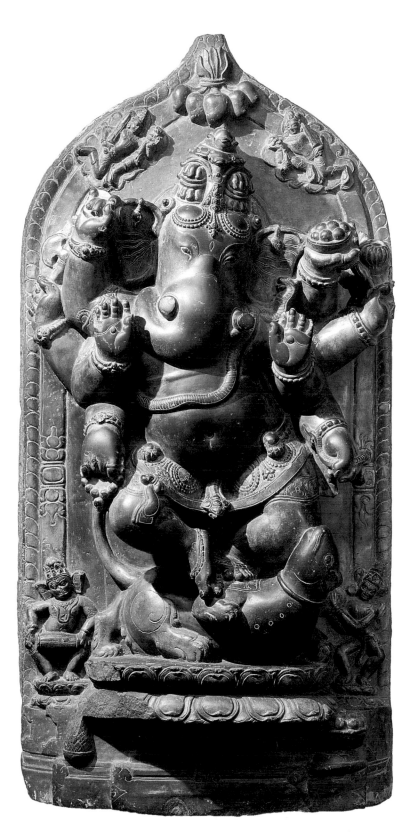

23a Dancing Ganesh

both, but the earlier figure does not hold either the broken tusk or the radish. Instead, two of his hands are in the gesture of fearlessness raised to the same height as in Thai Buddha images, one holds a snake and a third (the uppermost right hand) holds his right ear, as if he is scratching it. As in the earlier central Indian stele [22a] he also is not eating sweets (a). Finally, in neither stele is the god stretching the serpent above his head.

24 **Dancing Ganesh**
 Karnataka; 16th century; copper alloy; 50.3
 Los Angeles County Museum of Art; purchased with funds provided by Harry and
 Yvonne Lenart

According to the inscription on the lotus and the base, this charming figure of the dancing child god was dedicated by Ramappa, about whom nothing is known. However, that he as well as the artist he commissioned were men of taste is clear from the high quality of this processional bronze. Either the donor or the artist, or perhaps both, wanted to emphasise the childishness of the god, as is evident from the anatomical features. In order to give a solid sense of volume and yet convey the buoyancy of the figure, the sculptor has placed his left foot firmly in the center of the lotus with the right half of the body extending well beyond the flowers circumference. As is also customary with such bronzes, the figure is modelled in the round.

The unusual feature of his iconography is the bunch of mangoes he carries in the left hand that stretches in *dolahasta*. Although not held as an attribute, a bunch of mangoes occurs in Bengali images [23], from where this could be an iconographic borrowing. Also like his father, he is given the third eye.

25 **Dancing Ganesh and the Mahavidyas**
 Orissa, Puri; 19th century; 82.6 x 81.4
 Gerry and Pamela Virtue, Sydney

It is common to see Ganesh dancing with the seven Mothers, but extremely rare to see him dancing with a group of goddesses called the Mahavidyas (the Great Knowledge). Even rarer is such a representation of a *yantra* or mandala (a mystical diagram) with Ganesh as the central figure. Perhaps it reflects the influence of Rasamandala [45] in the city of Jagannath, although it is an essential element in tantric ritual.

That this was meant for tantric worship is clear from the inclusion of the ten Mahavidya goddesses whose cult has remained especially popular in Bengal and Orissa. They are of course all emanations of the Great Goddess and include such well-known Buddhist deities as Tara and Chinnamasta. Indeed, some are also included among the Jain Vidyadevis. Thus, it seems that they are a syncretic group created when Buddhism was disintegrating after the twelfth century.

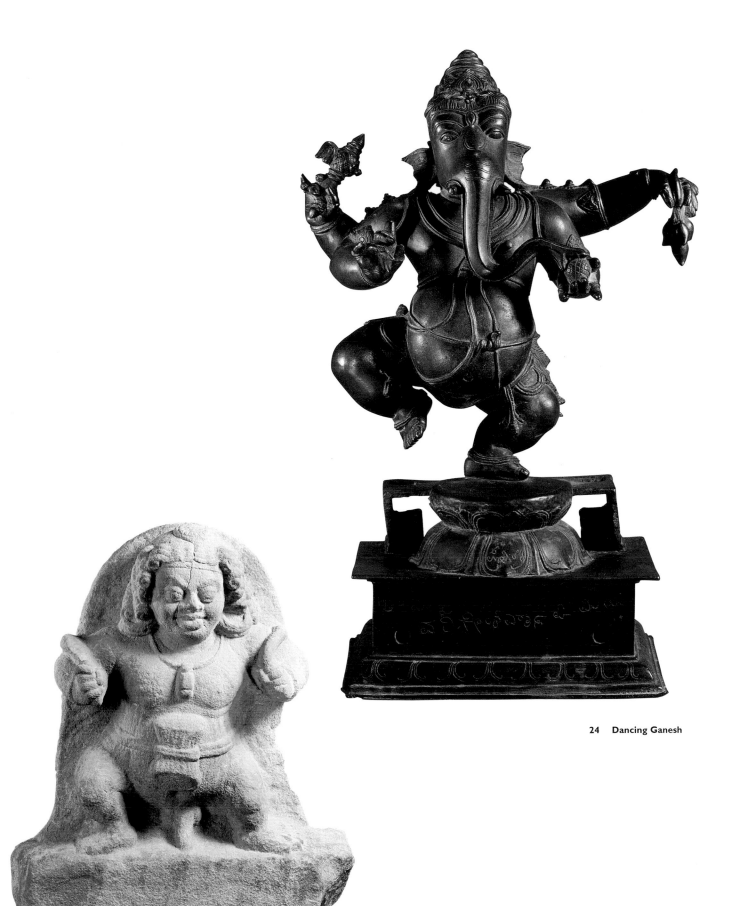

24 **Dancing Ganesh**

21 **A dwarf drummer**

There is nothing unusual about the figure of dancing Ganesh except that no bowl of sweets is included. Instead, his trunk grasps his broken right tusk, which seems to be an iconographic innovation by this artist. According to the myth Ganesh did break the tusk and hurled it at the moon which had dared laugh at his antics. Hence, the marks on the moon. The four goddesses in the four corners – Ganga and Yamuna at the bottom and Sarasvati and Lakshmi at the top – also dance in poses from the Odissi dance.

26 **Dancing serpents** *(see page 12)*

Andhra Pradesh; 10th century; sandstone, 71.8
Los Angeles County Museum of Art; Ancient Art Council

Two adult snakes (*naga*) are involved in a pas-de-deux in full upright position, balancing on their curling tails. It could be interpreted as a mating dance of a cobra couple. However, the dance seems to be taking place in the water, for a number of smaller reptiles, either intended to be children or perhaps simply other snakes, are slithering on the surface. Taming a snake and making the snakes dance is a very common form of entertainment in India but here the tableau certainly had a sacred intent.

Snakes are accorded divine status in India and their shrines are visible in most villages. Because they shed their skin annually they are of course ideal symbols for regeneration for the Hindus, whose souls similarly leave one body to enter another until final liberation. Snakes are also a popular divine attribute and are particularly associated with Shiva. Usually the *naga* couple is shown with their bodies intertwined and their hoods facing the worshipper. In this stele all the serpents are depicted in profile and clearly the two larger reptiles are interacting with one another.

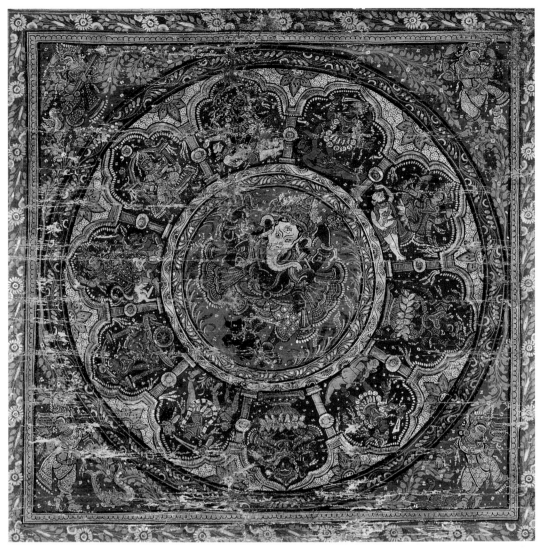

25 Dancing Ganesh and the Mahavidyas

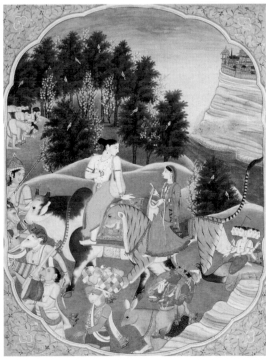

15 The Holy Family on the move

THE WORLD OF VISHNU/KRISHNA

Pratapaditya Pal

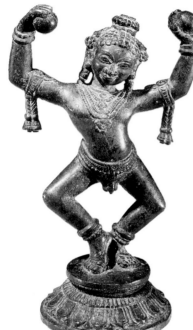

32c The jubilant butter-thief

I am forever blessed!
For I am his own breath, within his flute!
And if that breath is used up in one song
I shall not mourn.
The joy of all the worlds is in his flute,
And I his breath!

(form a Baul song as cited in Spink, 1971, 62)

Music and dance play as important a role in Vaishnava theology and mythology as they do in Shaivite thought, though perhaps at a more grass-roots level. The image of the fluting Krishna as Venugopala is certainly more familiar to Hindus than that of Shiva as Nataraja. And the Vaishnava festival Holi [42] is more popular and egalitarian than any Shaiva festival. The saviour deity of the Hindu triad, Vishnu, is the god to whom all devout Hindus offer final ablutions at Gaya to liberate the souls of their ancestors. Rama, the hero of the immensely popular epic *Ramayana*, vernacular versions of which are sung all over the country, is an avatar of Vishnu, and Krishna, one of the central figures of the other epic, is regarded as Vishnu himself.

Vishnu is a cosmic deity of some importance in the Vedas. While he is not specifically mentioned as a dancing god, the Vedic deities are often described as dancing as has been discussed in the general introduction. By the time Bharata wrote his treatise all three gods — Brahma, Vishnu and Shiva — came to be regarded as masters of dance and music. Bharata in fact characterises Vishnu as the originator of the four styles (*vritti*) of elocution in *natya* (drama) and by extension *nritya* or dance. So Vishnu is not only seen playing the drum but also dancing while Shiva performs his twilight dance of frenzy [8].

In more formal icons, from about the Kushan period, Vishnu invariably carries the conch shell, which is an instrument of great significance in both the religious and secular lives of the Hindu. Blown in all religious ceremonies as well as all rites of passages, it is sounded in battle and every evening in traditional homes for apotropaic purposes. Indeed, its sound denotes the transition from the inauspicious to the auspicious. It is also used by Durga during her battles with titans [18]. Later, in the eastern region of the country, Vishnu takes Sarasvati, the goddess of music and learning, as a co-wife [27].

Dance and music, however, are much more closely associated with Krishna than with Vishnu. Unquestionably, Krishna is one of the most complex personalities in the Hindu pantheon. He is a Machiavellian statesman as well as a philosopher par excellence in the *Mahabharata*. In the *Bhagavatapurana* he is the cowherder god, at once a child hero and a slayer

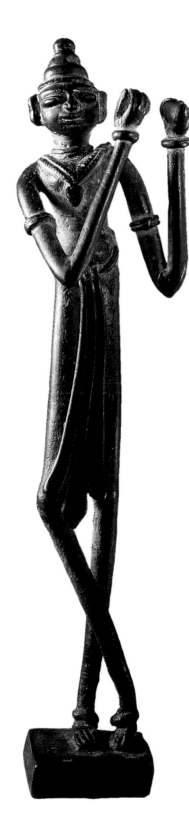

36c Krishna fluting (Venugopala)

of demons, and the romantic shepherd boy who charms the milkmaids of Braj in Brindaban with his sexuality as well as song and dance. The life of this bucolic hero, with its strongly erotic flavor and mystical nuances, became the basis of the *Bhagavatapurana*. Unlike any other god, he has remained the focus of impassioned personal devotion (*bhakti*). It is this Krishna who has continued to fascinate poets and saints both in the north and the south and who has become the central figure in most forms of poetical and rhetorical literature as well as music and dance. Whether the songs are devotional or romantic, the words often express the themes in terms of the love between Krishna and Radha, the milkmaid most dear to the divine cowherder, or the extraordinary exploits of the divine child.

One of the most familiar images in all Indian art is that of the fluting Krishna. An early reference to the enchanting flute player occurs in the well-known Tamil epic *Silappadikaram* (c450CE):

> If Mayavan (Krishna) who knocked down the fruit using a calf for a club,
> Comes into our cowherd village today,
> Won't we hear at his lips, O ladies,
> the sweet flute of the cassia stem?
> (Dchcjia, 1988, 149)

Much more personal and passionate is the following devotional lyric (*bhajan*) by the Rajput poet-saint Mirabai [99 a, b]:

> I am fascinated by the beauty of Mohan
> In the bazaar and by the way he teases me.
> I have not learned the sweet desire of my beloved.
> His body is beautiful and his eyes are lotus flowers.
> His glance is very pleasing, and his smile is very sweet.
> Near the bank of the river Jumna he is grazing the cows,
> And sings a sweet song to the flute.
> I surrender myself, body and soul and wealth, to the Mountain-holder. [35]
> Mira clasps his lotus feet.
> (Alphonso-Karkala, 1971, 540)

On rare occasions Krishna also plays the vina, most notably in Ragamala pictures as is seen in a beautiful painting of the Vasant ragini in the exhibition [185]. In this instance, he is also engaged in a vivacious dance, an art in which he too excels. While Shiva is the exponent of the classical mode (*marga*) of dance, Krishna's dance is considered to be of the popular or folk variety (*hallisalasya*). Shiva's dance symbolises a cosmic process, Krishna's dance, by comparison, is more spontaneous and expressive often of pure joy.

Like Shiva, Krishna also performs a victory dance but as a boy when he subdued Kaliya, the water snake [33]. In fact, according to the textual description, he did so by dancing rather than violent action.

73

Laying hold of the middle hand of Kaliya with both his hands, he bent it down and set his
foot upon it, and danced upon it in triumph. Trampled upon by the feet of Krishna, as they
changed position in the dance, the snake fainted, and vomited forth much blood.
(Spink, 1971, 24)

And so in a small but rare bronze in the exhibition [43], an unknown artist has
given Krishna three legs to demonstrate this change of position. The figure may have been
attached to the hood of a serpent.

Unlike Shiva, in several instances Krishna dances spontaneously, and for the simple
joys of life. The eighth-century poet Svayambhu writes with an erotic flavor:

The breasts of Radha made Krishna dance in the courtyard, and people were amazed.
Now it no longer can matter what happens to these lovely breasts.
(Singer, 1966, 182)

This is of course the flavor that is dominant in such pictures as the Vasant Ragini
[184] or the revelry of the Holi festival, [42].

The image of dancing Krishna that is most popular in sculpture is when he is
shown as a naked boy dancing for joy for successfully raiding his mother's larder for his
favourite butter. Very likely this form was invented in Tamil Nadu from where it was adopted
in Orissa [32]. Curiously, it does not appear to have captured the imagination of artists in
other areas of the subcontinent, although the image of the crawling butter-thief (*makkan-chor*)
did. In some areas such as Bengal, he is called Nadugopal (Gopal with *laddu* or sweetmeat)
rather than butter-thief.

One reason why such forms of this child Krishna appear so frequently in South
Indian art is because of the Tamil Vaishnava saints' fondness for the mischievous and heroic
exploits of the divine child. The most engaging and popular are the *Tirumozhi* poems about infant
Krishna by Priyalvar (c800). With warmth and tenderness, the poet expresses his devotion
through the filial mode (*vatsalya bhava*), where he is the exasperated mother of a precocious and
rambunctious boy. To cite only one example, like a doting mother Periyal chides the child:

You played in the dust —
it's all over you —
The dabs of butter
on your face
are caked with mud —
how can I allow you thus
to sleep by my side tonight
(Dehejia, 1988, 100)

Obviously the exasperated Yasoda is not impressed with her child's antics.

Philosophically the most important dance of Krishna is the Rasamandala, meaning
circle of delight or ecstasy, when he dances with the milkmaids on the night of the full moon

in autumn (in the month of Karttika – October-November) in the celestial Brindaban as well as in the human heart [44]. It should be noted, however, that the dance is not described in the *Bhagavatapurana* but has an important place in later devotional literature, which is what inspired numerous artistic versions in painting. Perhaps the most elaborate and impassioned description of the dance occurs in the *Premsagar* (Sea of love) of the blind poet Surdas (1478-c1580):

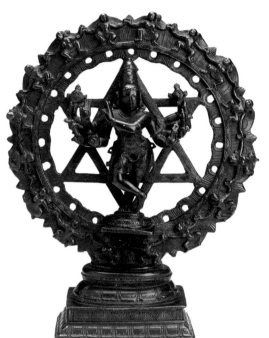

44a Circular dance of Krishna and the milkmaids

> *Krishna used the Yoga-illusion*
> *and his body became many parts;*
> *To all, the pleasure they were wishing he gave,*
> *sport and the highest affection.*
> *As many cowherdesses as were there,*
> *just so many bodies Shri Krishna Chandra assumed;*
> *And taking all of them on the terrace of the dancing ring,*
> *again began to dance and sport.*
> *And there was such harmony of the Ragas and Raginis,*
> *that, hearing it wind and water also no longer flowed;*
> *And the moon*
> *together with the starry firmament,*
> *Being astonished,*
> *rained down nectar with its rays.*
> *Meanwhile night advanced;*
> *then six months had passed away*
> *And no one was aware of it.*
> *From that time,*
> *The name of that night has been*
> *The Night of Brahma.*
> (Spink, 1971, 99)

Clearly such verses emphasise, however circumspectly, the cosmic nature of the circular dance bringing it conceptually closer to Shiva's *ananda tandava*. In this dance of delight, Krishna is the source of eternal bliss and the gopi represents the individual human soul longing for salvation. Visually too, the form is closer to that of dancing Shiva than one might think at first. Just as Shiva dances in the centre of the universe symbolised by the ring of fire, so also Krishna does surrounded by the milkmaids. The *Svetasvatara Upanishad* (cited in Spink, 1971, 101) states: 'The vast universe is a wheel. Upon it are all creatures that are subject to birth, death and rebirth. Round and round it turns and never stops. It is the wheel of Brahman. As long as the individual self thinks it is separate from Brahman, it revolves upon the wheel in bondage to the laws of birth, death and rebirth. But when through the grace of Brahman it realises its identity with him it revolves upon the wheel no longer. It achieves immortality.'

27 **God Vishnu with retinue**

West Bengal or Bangladesh; c1000; black basalt; 96.5

The Art Institute of Chicago; gift of Miss Alice Boney

Music plays a noteworthy role in this classic Bengali stele representing Vishnu and his retinue. The god himself holds the conch shell which he blows. His other attributes are the gesture of charity, the wheel and the club. The conch shell and the wheel are also included as personified beings behind the two goddesses who are wives of Vishnu. On his right is the flywhisk-bearing Lakshmi, the goddess of wealth, and on the other side is Sarasvati playing a vina [see 46].

A third reference to music can be observed in the half-human, half-mythical creatures (*kinnara/kinnari*) on the brackets of the throne back on either side of the god's upper hands. With their leaping, luxuriantly scrolling tails, one plays the cymbals and the other the vina. Two more celestial couples hover above in cloud cartouches and the auspicious face of glory (*kirtimukha*) — a stylised lion's face — is at the apex. Below on the base is the genuflecting Garuda, the god's mount and a donatrix with a garland behind whom is a bowl with heaped grain (*naivedya*).

28 **The gods eulogise cosmic Vishnu**

Karnataka, Mysore; c1850; 46.3 x 56.4; inscribed: Shreemad Anant Padmanabha

Portvale Collection

In this cosmic form Vishnu is known as Narayana, literally one who abides in the waters, or as Seshasayi or Anantasayi, one who lies on the serpent called Sesha (end or remainder) or Ananta (eternity). In the south, the epithets Padmanabha (one with the lotus navel) or Ranganatha (the playful one) are preferred. Either way, there can be no doubt about the cosmogonic import of this Hindu myth. It will not be possible to discuss the many features that distinguish this version of the myth, but a few pertinent remarks are necessary.

Clearly, all the denizens of paradise have turned out to witness and eulogise the cosmic event when the supreme deity rises from his periodic sleep and Brahma emerges from his navel to begin the creative process. Apart from saints (Alvar) and sages, the group includes the vina-playing Sarasvati (lower left) and the horse-headed Tumburu, the leader of *gandharva* who are celestial musicians (upper right). Interesting, however, are the facts that Vishnu is two-armed and white and the right hand is placing a flower on a tiny Shiva-linga. The close relationship between Shiva and this form of Vishnu is discussed extensively by Sivaramamurti (1974, 38-41).

A close stylistic and iconographical parallel is published in Rao and Shastri (1980, black and white pl. 32). In that painting the god is four-armed and is not adoring the linga which is included in a similar fashion. This is also compositionally more interesting than the published version.

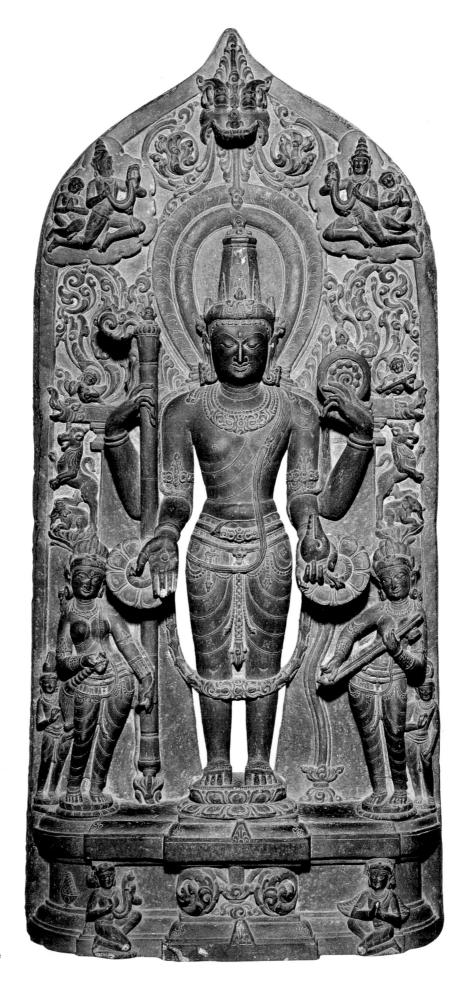

27 God Vishnu with retinue

29 Man-lion incarnation of Vishnu
Karnataka; c1825; reverse painting on glass with cut glass embellishment;
58.5 x 43.2
Portvale Collection

The lion's head of the otherwise anthropomorphic deity identifies the figure as
Narasimha or Man-Lion. In one of his avatars, Vishnu assumed this form to destroy
Hiranyakasipu, the titan who worshipped Shiva, whose son Prahlada was a devotee of Vishnu.
Here, however, we are not given the gory details of the story but an iconic representation of the
god seated against a huge bolster in the graceful posture known as *lalitasana*. His wife Lakshmi
sits on his left lap and stares at him as she sniffs a flower. The two normal hands exhibit the
reassurance (right) and the gift-bestowing gestures. The upper right balances a wheel, and the
conch shell in the corresponding left hand is obscured by her head. His rage is indicated by his
open mouth and the leaping tongues of flame that form a nimbus behind his head.

The two adorants flanking him are probably Prahlada on his right and an ascetic
musician on his left. The pot-bellied figure, however, could be a priest or a royal adorant.
That he is a Vaishnava is clear from the prominent sectarian mark on his forehead.
Noteworthy is the way the red cloth is wrapped around the head. The other figure could be
Narada, the celestial messenger who is also a musician, a bard, a gossip and a spy. Bowls with
offerings in front also include two bunches of bananas. (For the style, see Rao and Shastry,
1980, colour pl. 32 and black and white pl. 7).

30 Rama and Sita being entertained
Rajasthan, Jaipur; c1800; 28 x 35.5
Spink and Son Limited, London

This spectacular painting with sumptuous use of gold shows Rama and Sita
enthroned on a terrace watching a nautch. The divinity of both is emphasised by the haloes
behind their heads and the seated Garuda in front. Rama is considered by Hindus to be an
avatar of Vishnu. The other semi-kneeling figure is Hanuman, the devoted simian companion
of Rama. Between them is a low table with weapons as offerings, which may indicate that the
occasion is Dussera when arms are formally worshipped and dedicated to the gods. This is a
custom still followed in some Rajput courts. Behind the regal couple are the three siblings of
Rama: Lakshmana, Bharata and Satrughna. While Rama and Bharata have the same faces and
complexions, the other two seem to be clones except for their sizes. On the other side is a
dancer with a large group of musicians, all of whom are female.

The red and gold carpet on the terrace is brilliantly painted as are the colorful
costumes of the figures. Immediately behind the terrace is a band of green foliage followed by
a large watertank in deep bright blue filled with pink and red waterlilies. The tank is

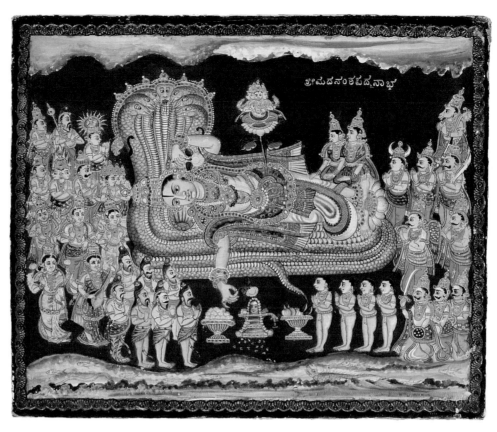

श्रीमदनंतपद्मनाभ

28 The gods eulogise cosmic Vishnu

29 Man-lion incarnation of Vishnu

surrounded on three sides with dazzling golden mansions that vividly express the artist's nostalgia for 'golden' Ayodhya, the capital of Rama. Interestingly, the faces of both Lakshmana and Satrughna closely resemble those of Pratap Singh (r1779-1803), the ruler of Jaipur. This picture could have been painted by his leading artist Sahib Ram.

31 **Casting Krishna's horoscope**
 Rajasthan or Uttar Pradesh; c1550; 18.4 x 23.8
 Collection of Gursharan and Elvira Sidhu, California

The picture really depicts two scenes from the early infancy of Krishna. In the bottom register the cows in the left panel indicate that the scene is a cowherder's house in Brindaban where Krishna was transferred soon after birth. In the larger panel, as the trumpet blasts and the drums thunder, the ladies give the new born a bath. In the upper register as Krishna sleeps on a cot within the pavilion, watched by Yasoda, Garga and companions cast his horoscope before the foster-father Nanda. On this occasion too, two musicians blow wind instruments like the *shehnai*.

The painting is from a large dispersed album depicting the life of Krishna as recounted in the tenth book of the *Bhagavatapurana*, holiest of the Vaishnava texts. Scholars disagree about the date of the series, assigning it to a seventy-five year stretch from 1500. Whatever its exact date or provenance, it constitutes an important document of Hindu painting of the pre-Mughal period.

32 **The jubilant butter-thief**
 a) Tamil Nadu; 15th century; bronze; ~~64.6~~ 51. 11 7 (see page 97)
 Seattle Art Museum; Eugene Fuller Memorial Collection

 b) East India, Orissa; 18th century; brass with traces of polychromy; 21.9
 Los Angeles County Museum of Art; purchased with funds provided by
 Mrs Burton M. Fletcher

 c) Orissa, 17th century; copper alloy; 21 (see page 72)
 Philadelphia Museum of Art; bequest of Stella Kramrisch

As a young child Krishna was very fond of milk products but particularly butter, which he devoured voraciously. His mother, therefore, would store the butter in a container and hang it up from the ceiling far beyond the child's reach. Undeterred, the precocious child would pile up a number of pots, climb on top and steal the butter. He then danced joyously before his exasperated mother with a ball of butter in his hand.

The theme of Krishna dancing with a butter ball is seen first in the art of the Vijayanagara period, mostly in bronze. This fine example (a), robustly modelled, is a characteristic Tamil version. Standing on his left foot on a lotus and with his raised right foot

32b The jubilant butter-thief

80

30 Rama and Sita being entertained

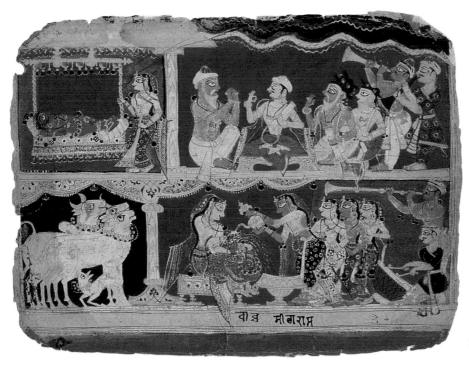

वीर मीगराग्र

31 Casting Krishna's horoscope

bent (ardhajanu), the naked boy balances his posture with his left arm outstretched in dolahasta. The right holds the butter ball as if he is proffering it to the devotee.

The idea appears to have appealed to the imagination of the Vaishnavas in the coastal state of Orissa, the only region in the north where the form is popular as opposed to the crawling butter thief which is more widely depicted. In (b) we have a more faithful adaptation of the Tamil composition except the addition of a lotus flower below Krishna's right foot. Whether this is a support for the foot or a literal expression of the metaphor 'lotus-feet', a demonstration of Krishna's nimbleness, or simply a touch of whimsy by the artist is anybody's guess. In the second and rarer composition (c), an inventive Orissan artist has portrayed an ecstatic boy dancing in the chatura mode with both hands raised above in a circular motion and with two balls of butter, almost as if taunting his exasperated mother.

33 **Krishna dances over Kaliya**
 Tamil Nadu; 16th century; bronze; 66
 Victoria and Albert Museum, London; gift of Mrs Lionel Wynch and Lady Herbert

This composition differs from that of the dancing butter thief in two ways. First, between Krishna's left foot and the lotus are the fanned-out multiple hoods of a serpent. Secondly, while the daring boy holds the reptile's tail by his outstretched left hand, the right forms the gesture of reassurance (abhayamudra). Here also Krishna is a naked child, adorned only with ornaments, as small children often are in village India.

The serpent is called Kaliya and he lived in the river Yamuna (Jumna). Once it was brought to Krishna's attention that the reptilian titan was polluting the waters of the river which made it hazardous for everybody else. So Krishna decided to teach the titan a lesson and after subduing him performed a victory dance on his hood to the amazement of all inhabitants of Braj. Clearly Krishna's right hand reassures both the inhabitants of Braj and the devotees who behold the figure. The name of the serpent Kaliya (=Kala) makes this a dance of victory over time and death as well.

34 **Krishna kills Aghasura**
 Folio from the Bhagavatapurana manuscript
 Madhya Pradesh, Malwa; 1675-1700; 23.5 x 36
 Mr and Mrs John Gilmore Ford, Maryland

Most of Krishna's heroic deeds in early life, as recounted in the tenth book of the Bhagavatapurana, concerns the destructions of various titans. One such was Aghasura who tried to kill a five-year old Krishna as well as the cowherders and the cows. Aghasura transformed himself into a gigantic reptile and opened his mouth wide. Mistaking it to be a cave, the cows and cowherders entered it, but Krishna followed them in and choked the monster to death.

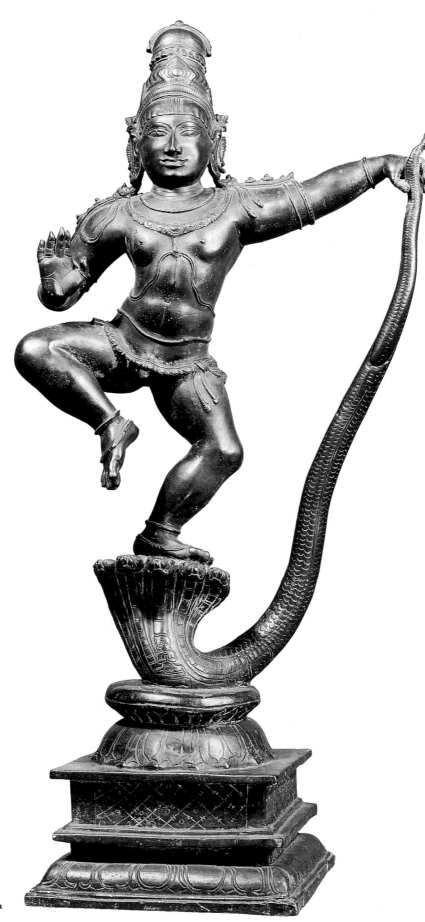

33 Krishna dances over Kaliya

The artist of this Malwa picture has emphasised the boy's victory over other elements of the story. The cows, cowherders and Krishna are seen rushing into the cavernous mouth of the reptile and then a triumphant Krishna stands with outstretched arms behind the shoulder of Aghasura. Everything else is left to the viewer's imagination. However, in the heavens above, separated from the earth by a white line, a more literal interpretation of the following passage from the *Bhagavatapurana* (Spink, 1971, 19) is given:

'Thereupon (after the victory) the celestials were greatly delighted, and they worshiped Hari (Krishna)...with showering of flowers; the Apsarases (celestial maidens) with graceful dancing and the Brahmanas with the chanting of his glories...Even Brahma (the multi-headed figure on the picture's right corner) the creator immediately came there and was greatly surprised on seeing the wonderful feat of the Lord.'

35 Krishna lifting Mount Govardhana
Rajasthan, Sirohi; c1800; 19.7 x 17.2
Portvale Collection

84

Young Krishna's miraculous feat of raising Mount Goverdhana to protect his cowherders and their cows from a torrential storm unleashed by Indra, the king of the gods, has remained a popular myth with Rajput artists. Apart from the drama of the myth itself, it is the source of the inspiration for the popular image of the god known as Sri Nathji, the focus of veneration by the Vallabhacharya sect of Vaishnavas [90c].

In this folkish but colourful picture from the Sirohi school, the artist has given us an engaging surrealistic representation. While the two cows are accommodated on the lower border and wrong side of the conceptual river filled with fish, Krishna's is an iconic figure, distinguished by his lotus, his posture and four arms. Usually in representations of this theme he is not shown fluting with legs crossed and wearing wooden sandals on his feet. However, true to the text he uplifts the hill with the small finger of his left hand. Strangely, though, the four companions wearing hooded raincoats also help him with their shepherd's sticks, and no attempt has been made to depict rain or clouds.

36 Krishna fluting (Venugopala)
a) Tamil Nadu; 15th century; granite; 119.4
Asian Art Museum of San Francisco; Avery Brundage Collection

b) Orissa; 15th century; bronze; 45
Catherine and Lewis J. Burger, MD, Florida

c) Gujarat; 18th century; bronze; 18.4
Private collection

(see page 73)

d) Rajasthan, Jaipur; c1800; ink on paper; 48.8 x 33.5
Paul F. Walter Collection, New York

36b Krishna fluting (Venugopala)

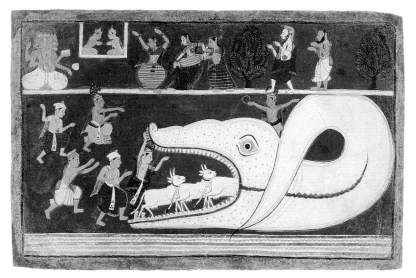

34 Krishna kills Aghasura

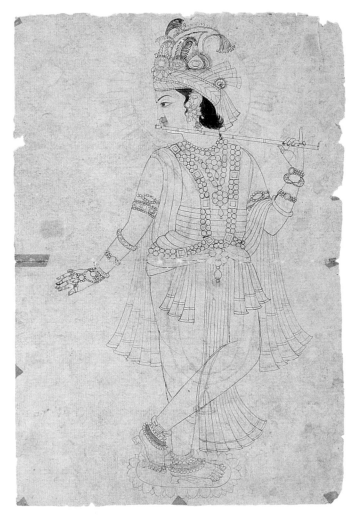

36d Krishna fluting (Venugopala)

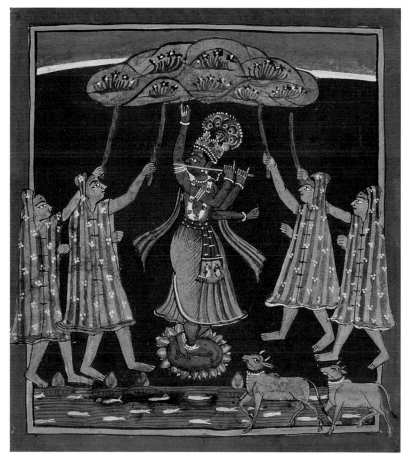

35 Krishna lifting Mount Govardhana

One of the most abiding images in Indian art is that of Krishna the flautist standing with his legs crossed at the ankles and playing the flute. The image appears rather late in Indian literature and art and it has been suggested that the classical myth of Orpheus may have exerted some influence. Be that as it may, the figure of the fluting Krishna has fired the imagination of both the poet and the artist who have left behind a plethora of images of extraordinary rhetorical and visual richness.

The idea really derives from that of the lonely shepherd who plays his bamboo flute (*venu*) while tending his flock. While other cowherders of Braj hold a shepherd's staff, Krishna's staff is also his flute. He, however, does not play upon it to please the cows, but to charm the gopis or the cowherdesses. Metaphorically, he is, of course, the supreme being, the great soul, into which the individual soul (*atma*) represented by the gopi, will merge, drawn by the enchanting magic of his flute. He is the great ocean into which all rivers must lose their identity.

In an impressive stone sculpture in the exhibition (a), meant for a subshrine of a Vaishnava temple, the god is shown in his characteristic pose but with four arms. While the two principal arms hold the flute horizontally beside his chin, the two upper hands hold the wheel on the right and the conch shell on the left. These are of course the classic attributes of Vishnu [27] and so this image unambiguously establishes the fusion of the deified hero Krishna and the Vedic god Vishnu. The intensity of this devotion can be gleaned from the verses from a tribal song, at left, in which the poet talks of Radha, the beloved of Krishna.

In a fifteenth-century Orissan metal sculpture of outstanding quality (b) Krishna strikes the elegant pose on a lotus. So graceful and refined are the gestures, movement and expression that one would think the artist had modelled the sculpture on a great master of the Odissi dance form.

He has roused such passion in my life,
I can bear it no more.
My ribs are aching in pain
I can live no more in separation.
Rai Hariram (the poet) implores,
Do not burn my life any more.
Now that you have opened the door,
Don't cast me adrift.
(cited in Singer, 1966, 83)

86

37 **Screen with Vaishnava themes** (see page 185)
Kerala; c1700; polychrome wood; 262 x 181
The Christensen Fund, California

Six carved and polychromed panels form a screen for temporary use in temple ceremonies. The figures and themes are drawn from both the life of Krishna and the *Ramayana*. Along the bottom are six panels, the one on the extreme left with three figures being a later replacement. The other five depict scenes from the *Ramayana*, only two of which can be identified with certainty. The dark-blue demonic figure is the ogress Tadaka who fell in love with Rama and tried to kill Sita. Instead, Rama killed Tadaka. In the second tier the two end figures are seated fluting Krishnas. He appears again twice standing and fluting in a tree with naked gopis below. Clearly these two segments represent the story when Krishna removed the clothes of the bathing milkmaids to a tree and enchanted them with the sound of his music.

The two terrifying figures enmeshed in snakes and standing above the flute-playing Krishna depict Garuda. The other two crowned figures standing rigidly above the naked gopis

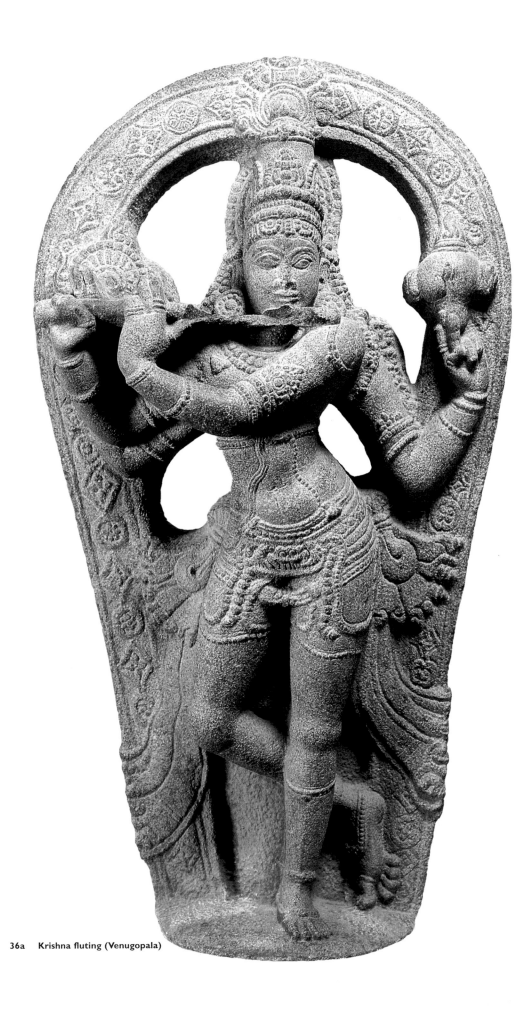

36a Krishna fluting (Venugopala)

trying to cover their nakedness with one hand and reaching out for the clothes with the other, have been identified as Rama.

38 **The month of Ashadha (June-July)**

From a *Baramasa* series

Rajasthan, Bundi; c1675; 23.4 x 17.8

Art Gallery of New South Wales, Sydney; gift of the Margaret Olley Trust 1991

Furiously blow the whirlwinds.
Only the demented leave their homes
and loved ones to go out.
Even the wandering ascetic stays put, birds
are afraid to stir out of their nests, let alone
the human being.
Vishnu rests at this time in the
ocean of cream with Lakshmi.
Says the poet Kesavadasa
neither the Vedas nor tradition
approves leaving home
in the month of Ashadha.

Baramasa or 'Songs of the twelve months' is a poetic genre that describes each of the months of the Indian calendar in terms of love and its rhetoric. Composed in Hindi and other regional languages, these lyrics are sung, mostly by women. This verse, from the well known *Rasikapriya* of Keshavadasa composed in the 1690s, is translated at left.

The iconography of this beautiful Bundi picture is even more complex than the verse. The burden of the poem is expressed largely on the lower panel with the ominous sky at the top. Along the 'ocean of cream' with lotuses and aquatic birds, a temple of Krishna and Radha is on the top left. Then below a banana tree is the sleeping Vishnu beside whom is a prince with bow and arrow whose size is completely disproportionate to everything around him. Does he represent a demented human or is he returning home? Next in a small hut an ascetic sits on a tiger skin in a yogic posture and converses with another.

In the middle ground is a palace scene that is not described in the text. A princely Krishna is being escorted by a maid to the prepared bed with bolsters, flowers and bottles below a canopy. Another maid waits on the other side as Radha appears through a door on the far right for the tryst. It is possible that this composition represents an anticipatory love scene enacted in the mind of the prince returning home at the start of the rainy season when lovers are united.

39 **Krishna serenades Radha** *(see page 13)*

Himachal Pradesh, Mankot; c1725; 22.5 x 15.9

Los Angeles County Museum of Art; gift of Jane Greenough Green in memory of Thomas Pelton Green

How can I describe his relentless flute,
which pulls virtuous women from their homes
Chaste ladies forget their lords,
wise men forget their wisdom,
and clinging vines shake loose from their trees,
hearing that music.
Then how shall a simple dairymaid
withstand its call.
(cited in Spink, 1971, 61)

Standing below drooping, flowering vine-like branches, Krishna plays his flute and looks up at the fair lady looking down from a first-storey window. Krishna's companion cowherder holding a lotus and a shepherd's crook also looks up at the lady. The lady is very likely Radha who was constantly enchanted by the sound of Krishna's flute, in which case this cannot be an illustration of the *Bhagavatapurana*, as she is not included as the beloved in that text. The picture could illustrate a poem such the one by the fifteenth-century poet Chandidas quoted at left.

88

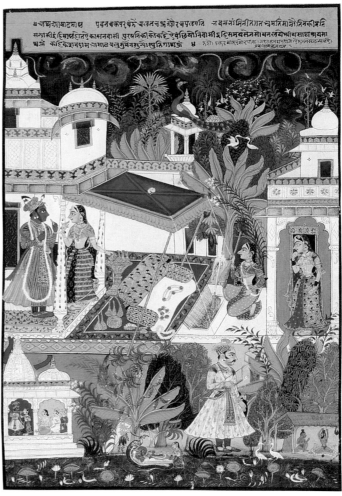

38 The month of Ashadha (June-July)

40 Radha imitating Krishna

Oh Lord, I would play on your flute!
Oh beloved, those same notes which
I heard you playing I would also play!
I will put on your jewellery,
and will put on my jewellery on you...
You become Radha and I will become
Madhava (Krishna), lovely Madhava,
is the reversal which I shall produce.
(cited in Spink, 1971, 88)

40 **Radha imitating Krishna**
Rajasthan, Kota; 1775-1800; 26.7 x 16.9
Maximilian Hughes, Sydney

The figure wearing blue, flaring skirts and emerging from the doors of the mansion on the left is not Krishna but Radha. This is evident from her features and white complexion, even though she wears his distinctive peacock feather headdress and plays upon a flute. While the relaxed cows seem unconcerned, the other milkmaids are probably saying, 'Look at this woman, she has gone mad with love for Krishna.' Radha's fantasy, as captured in the words of the blind poet Surdas, is written left in the margin.

Such transposition of roles may seem curious to some, but in the Indian devotional world it is simply another manifestation of divine play or *lila*. It is a way to emphasise the unity of the two even as they are different as is understood by the philosophical expression *bheda-abheda* (identity in difference).

41 **Four illustrations from Jayadeva's Gitagovinda**
 a) Krishna and Radha embrace
 Rajasthan or Maharashtra; c1650; 14 x 15.2
 Private collection

 b) Krishna, Radha and gopis;
 by Manaku of Guler (fl. first half of 18th century)
 Himachal Pradesh, Basholi; 1730; 15.6 x 25.5
 Paul F. Walter Collection, New York

 c) Jayadeva's vision of Radha and Krishna
 Himachal Pradesh, Guler; c1775; 16.5 x 26.7
 The Kronos Collections, New York

 d) Companion persuading Radha as Krishna flutes
 Himachal Pradesh, Kangra; c1825; 27.3 x 34.9
 Los Angeles County Museum of Art; gift of Michael J. Connell Foundation

Your garlands fall on Krishna's chest
like white cranes on a dark cloud.
Shining lightning over him, Radha,
you rule in the climax of love.
(cited in Miller, 1977, 80)

The beautiful, lyrical poems of Jayadeva's *Gitagovinda* have inspired the four series of paintings from which these examples are taken. Except for (a), the others are from three of the best-known Pahari series of the subject. However, the stylistically ambiguous picture (a), largely reflecting traits of the Mewar school, does indicate the earlier popularity of the subject in Rajasthan rather than in the hills. It also does not include the text on the reverse but the composition matches this verse from the text reproduced at left.

The contrast between the dark Krishna and the fair Radha is also emphasised by the blue sky with the silver moon, which unfortunately has oxidised.

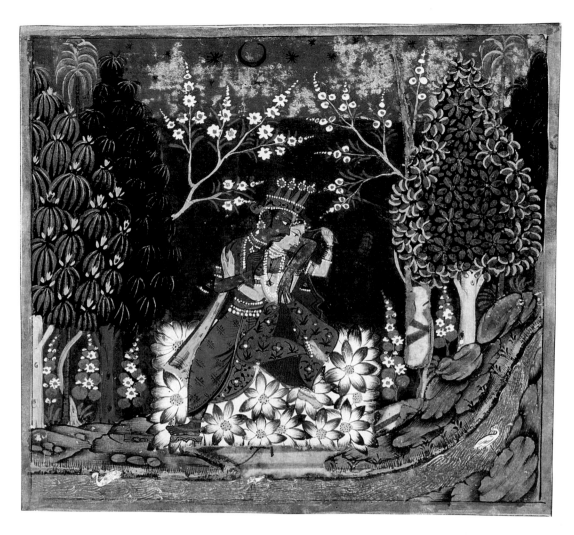

41a Illustration from Jayadeva's Gitagovinda

41b Illustration from Jayadeva's Gitagovinda

Trying to protect you from
the endless fall of love's arrows,
She shields her heart's soft mortal
core with moist lotus petals.

(ibid, 86)

He (Krishna) made himself
soothe you with flattery
He made himself fall limp at your feet.
Now he waits for sensual play in his bed
On a bank of sweet swamp reeds.
Madhu's tormentor
Is faithful to you, fool.
Follow him, Radhika.

(ibid, 115)

The second illustration (b) is from a series that was painted in 1730 by Manaku, son of the famous Pandit Seu of Guler, who flourished in the first quarter of the eighteenth century. Here Manaku has adopted a style with bold, virile figures, prop-like stylised trees and bright monochromatic background of deep yellows and oranges which conveys the emotional mood with 'a bang rather than a whimper'. The lower verse at left, describes Radha's condition as Krishna waits 'reeling under the burden of love'.

Two different generations of artists, probably of the same family, were responsible for the two remaining pictures (c and d) which are characterised by a naturalistic treatment of landscape elements as well as the subtle interaction of the two figures. In fact, Jayadeva's portrait carries conviction, not necessarily in its fidelity but as someone steeped in 'meditation on Vishnu,' though with a regal bearing. However, here the erotic mood is subdued to create a composition that emanates serenity and bliss.

In the later picture (d) the artist has created a more dramatic effect by placing his 'spot-lighted' figures against the dark and dense foliage of a luxuriant tropical paradise. It is an idyllic landscape of perpetual spring and even though the delicate figures appear fragile and vulnerable in the scenes of lovemaking they are anything but bashful. In this picture the companion urges Radha to go to Krishna quickly, as described in the verse at left.

42 Krishna, Radha and companions play Holi

a) Himachal Pradesh, Kangra; c1800; 33.65 x 39.4
The Freeman-Khendry Collection, Toronto

b) by Bhimras Paramanando (fl. c1850)
Rajasthan, Nathdvara; c1850; 40 x 57
Paul F. Walter Collection, New York

Holi is the spring festival or bacchanalia that is observed with much gusto in India [158-160]. It usually takes place in the month of Phalguna (February – March) and both men and women take part in it. The primary object is to douse each other with colours, whether in powder form or water. It is said to commemorate the destruction of the demoness called Holika and to usher in spring.

In a ravishingly colourful picture from Kangra (a) the cowboys and the milkmaids confront each other as if in battle. Krishna aims his spraygun at Radha like a shotgun spewing forth red fiery sparks while the demure and shy Radha in blazing red throws a handful of red powder at him. The companions do participate in the revelry but from behind the divine couple. In both groups some are engaged in providing music to make the occasion more jolly. Even today music continues to be an important part of Holi celebrations.

A completely different flavour charcterises Paramanada's work (b). The drama and excitement of the Pahari picture is replaced here by a more formal arrangement of figures and a

41c Illustration from Jayadeva's Gitagovinda

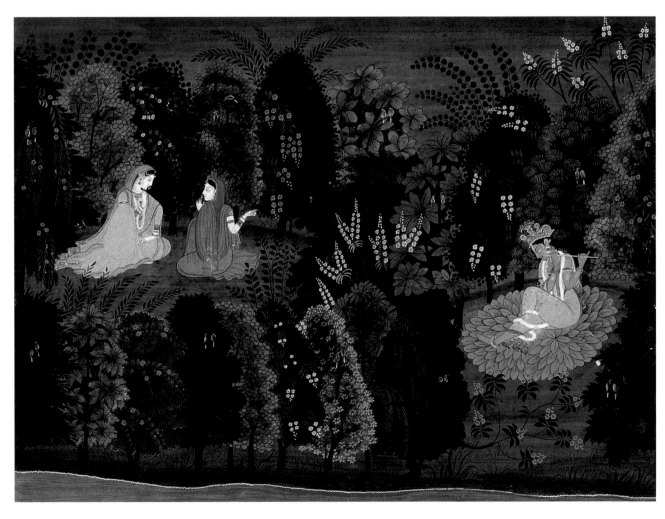

41d Illustration from Jayadeva's Gitagovinda

surrealistic atmosphere. The scene takes place in the courtyard of a palace where the architectural elements appear like a painted backdrop in a photographer's studio. From their floating boats in the sky the gods witness the scene below. Krishna as Nathji cuts an imperious figure as he stands with his left arm raised and faces Radha. Both the protagonists and most of the others hold little plates of powder which is being thrown discreetly. In fact, the motionless figures towards the middle of the terrace are all enveloped in a misty spray of red powder. Only in the foreground is there some activity as the women on the left and the males on the right fill their sprayguns with coloured water from the enormous tanks. Musicians are of course included in both groups.

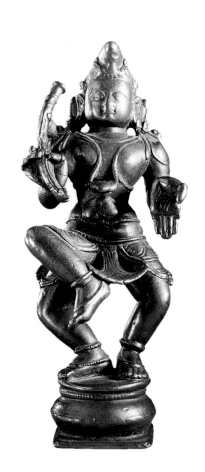

94

43 **Dancing shepherd boy**

43 Dancing shepherd boy
Tamil Nadu, c1600; copper alloy; 12.5
Private collection

In this rare and unusual bronze Krishna is portrayed as a teenage cowherder dancing with three instead of two legs. However, he has two normal hands, one of which carries the vina and the other exhibits the gesture of blessing. He is dressed in a short dhoti, adorned with ornaments and has the distinctive hairdo of a shepherd boy. Clearly, therefore, the cowherder is here depicted as both a musician and a dancer.

The three legs are meant to demonstrate two different modes, the *chatura* and *urdhvajanu*, in a single composition. This dance of the cowherder is probably an example of what is considered to be a folk dance (*ballisalasya*) influenced by the more classical mode. It may also be pointed out that in ragamala paintings Krishna is often shown dancing with a vina [185].

44 **Circular dance of Krishna and the milkmaids**

a) Tamil Nadu; 17th century; bronze; 19.7 (see page 75)
Asian Art Museum of San Francisco; Avery Brundage Collection

b) Himachal Pradesh, Chamba; c1800; (see page 232)
embroidery on silk cloth, *rumal*; 87.6 x 91.4
Zimmerman Family Collection

c) Rajasthan, Bundi; c1850; 61 x 80 (see page 9)
Art Gallery of New South Wales, Sydney

d) Gujarat; early 20th century (see page 233)
embroidered wedding canopy; 68 x 71
Portvale Collection

Although these four objects served diverse functions, they all depict the circular dance of Krishna and the gopis. One of the few three-dimensional representations of the theme, the bronze (a), was commissioned for a temple and probably used in religious

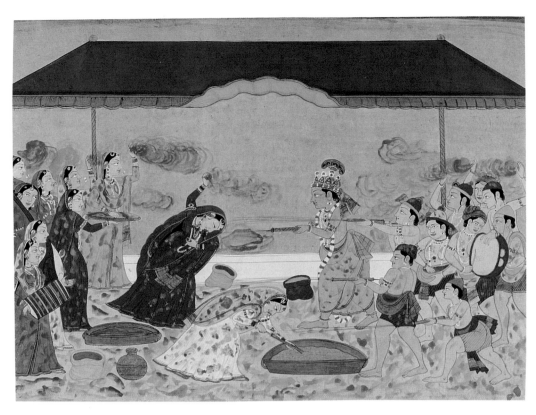

42a Krishna, Radha and companions play Holi

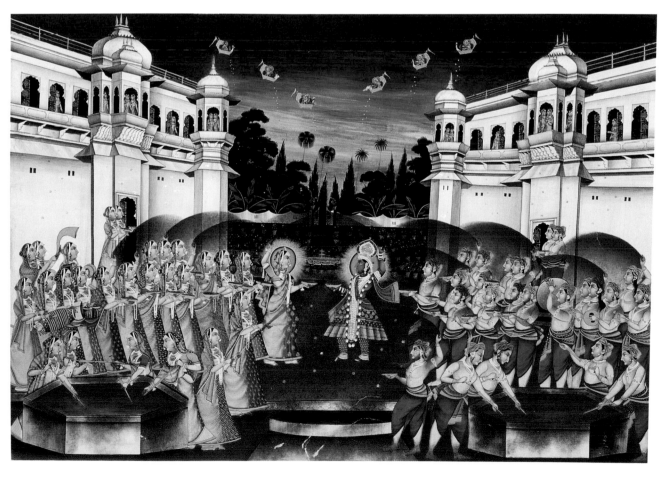

42b Krishna, Radha and companions play Holi

processions. The large painting (c) may have been dedicated on the annual festival of the circular dance to a Bundi prince or to a shrine. The embroidery from Chamba (b), known as a *rumal*, would have been part of a bridal trousseau, while the second embroidery from Gujarat (d) served as a wedding canopy.

The bronze (a) is a rare object and depicts an eight-armed Krishna standing in the centre against the mystic diagram of the hexagon formed by two intersecting triangles, symbolising the male and the female. The image clearly represents both the Vishnu and Krishna aspects of the god. Surrounding this fluting figure is a wide circle that contains alternate dancing figures of Krishna as a cowherd boy dancing and milkmaids. Indeed, like the boy dancing alone in another bronze [43], one of the attributes in the fluting deity's hand is a vina.

In the Chamba *rumal* as well Krishna's blue figure alternates with those of gopis as they form an uneven circle around a four-armed Vasudeva seated with Lakshmi in a banana grove. A solitary female seated between two cows is playing the vina and two cowboys play horns. Also included is a peacock and his mate, further emphasising the idea of romantic love.

The Bundi painting (c) portrays a more regular circle with Sri Nathji dancing in the centre with Radha. Surrounding the couple is a row of dancing peacocks, each flanked by two excited hens. In the third circle Sri Nathji is shown dancing with gopis but in a different arrangement from the other two (a and b). Around the mandala among lush tropical vegetation are a large group of court musicians at the bottom and admiring devotees all around.

In the wedding canopy (d) Krishna and the gopis do a stick (*kathi*) dance, a popular form of folk (*desi*) dance around a circle of flowers. Surrounding them is a third circle of dancers with peacocks in the cardinal directions and flowerpots with pairs of parrots and monkeys at each corner. Each pair includes Krishna and Radha, dancing as they churn buttermilk, a favorite activity of the milkmaids.

44d Circular dance of Krishna and the milkmaids
detail

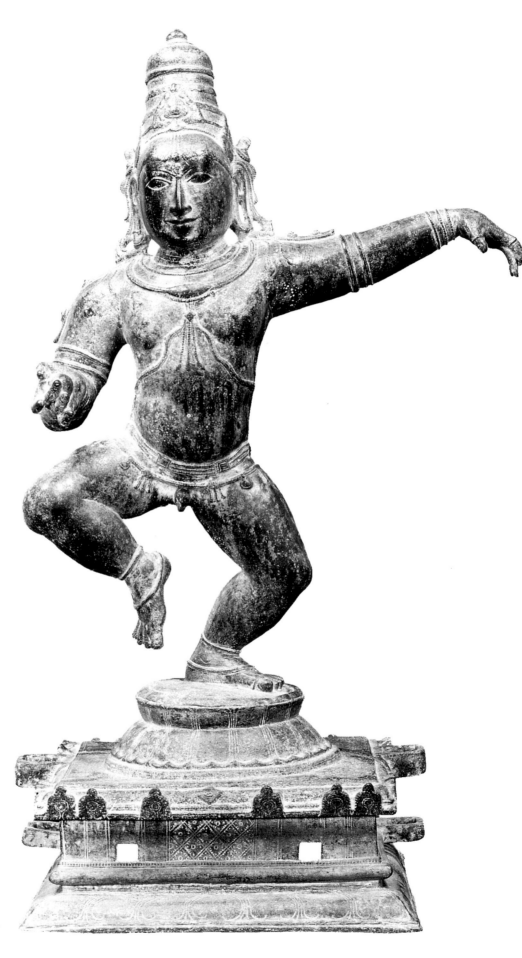

32a The jubilant butter-thief

OTHER DEITIES AND CELESTIALS

Pratapaditya Pal

54c Lute player

*With their music, song, dance as well as their laughter and charm hundreds of gandharva
and apsarases enliven that (divine) assembly all the time.*
(*Mahabharata* 2: 8.35)

Among the other Hindu deities who are closely associated with music, the most
prominent is Sarasvati. Regarded as the goddess of learning including music, she is revered by
the Buddhists and the Jains as well. While the Buddhists depict her usually as the vina-playing
figure, thereby stressing her role as the mistress of music, in Hindu and Jain art she is generally
shown with a book as well, her role as the dispenser of wisdom and knowledge. In fact, in the
Jain pantheon Sarasvati is only one of a group of female deities known as Vidyadevi.

Sarasvati's annual festival is observed either in January or February with special fervor
and celebration by the Bengali speaking Hindu community. Millions of clay images of the
goddess are produced for temporary use and then immersed in water. Although not of clay, one
such image, created by the traditional artists Srish Chandra Pal and his son Nikhil of Calcutta, is
included here [47]. In most such images she is shown playing the vina and is accompanied by
her mount the goose, the symbol of wisdom.

The goose is also the mount of the creator deity Brahma, with whom Sarasvati
became associated as both spouse and daughter. Earlier still, in Vedic literature, Sarasvati is
the name of a sacred river whose sanctity was later transferred to the Ganges. She also
appears as the goddess of speech known as Vac and is even eulogised as a supreme deity. In
later mythology she became affiliated with Shiva as his daughter and with Vishnu as his
spouse [27]. From the Pala period she is frequently included with images of Vishnu, and later
on, always in clay images of Durga, worshipped annually in autumn. In either instance she is
always the player of the vina.

Although a deity of great antiquity, Sarasvati does not appear in art until the
Kushan period. Significantly her earliest image is a Jain dedication and depicts her as the
goddess of learning with a book in her hand (Pal, 1994, fig 12, no 55). In a spectacular
image of the Gupta period [45], clearly the artist has emphasised her musical rather than
literary connection. Here she is unquestionably the patron deity of both music and dance.
Usually she herself does not dance but in Hoysala art she is frequently depicted as a spirited
dancer. As a Vidyadevi she is also shown dancing on the walls of the well-known Jain
temples at Mount Abu in Rajasthan. In a late Orissa painting, however, both she and her
sibling Lakshmi are portrayed as dancers [25] and in South India she sometimes plays the
violin instead of the vina [4].

Surrounding Sarasvati in the Gupta period relief [45] and accompanying the hunter god Revanta [48] are groups of celestial musicians, who form the subject matter of the bulk of the artworks in this section. The selection here is not only varied in style and function but also in context. While most of the sculptures are from Hindu, Buddhist and Jain monuments, at least three works are representative of Islamic culture.

One painting [65] illustrates an Indian story but the celestial angel, combining human, animal and avian features, follows an Islamic model. In the second Mughal painting [67], the ascension of Solomon is depicted with a great deal of angelic merriment. Among the divine creatures or houris escorting Solomon to paradise are trumpet-blowers and tambourine players. It might be stressed that in other pictures the Day of Judgement is usually announced by blowing the trumpet. The idea of the crowned, winged angel in Islamic art is clearly adapted from Christian art. In a nineteenth-century design for a ceremonial chair, probably meant for a Hindu maharaja, the same trumpet-blowing angels served as armrests, probably without their specific Islamic significance.

In the third example, a spectacular textile [66], we are given a glimpse of the paradise that awaits the faithful. It is understandable why paradise should be conceived as a 'garden of delight' by a religion that originated in the arid and inhospitable deserts of Saudi Arabia. How much more comforting and joyful to know that death is merely a passage to these gardens with flowing rivers, verdant meadows and delicious fruit trees, as well as beautiful houris and 'spouses purified' where one can dwell forever.

Music and dancing are not exclusive to Islamic paradise. Hindu, Jain and even Buddhist paradises also are modelled after earthly courts resonating with sweet sounds produced by the musical instruments and the tiny bells of the dancer's anklets. Indra's heavenly court is always filled with beautiful celestial nymphs known as *apsara* who are expert dancers. In fact, one of the earliest Hindu myths in the *Rigveda* is concerned about one such *apsara* Urvasi being banished to earth, which was considered the ultimate punishment for a sloppy or careless performance. And on the temple is a microcosm of the celestial mansion, it is only appropriate that its walls be filled with figures of divinities as well as celestial dancers and musicians. Looking at the wonderful variety of such celestial figures from different periods there can be little doubt about the Indian sculptor's intimate knowledge of the dancer's repertoire and about woman being the muse of both the poet and the artist.

45 Sarasvati, goddess of wisdom and music
Uttar Pradesh; 6th century; buff sandstone; 83.8
R. Hatfield Ellsworth, New York

Aesthetically this is one of the finest representations of the goddess Sarasvati that
has survived. It is also of unusual iconographic interest as she has only two arms which hold
the vina. Together with her companions, the composition certainly emphasises her role as the
patron deity of music. Although the instrument is broken, one can clearly see that her right
hand was busy plucking the strings. Two male musicians with animal heads, and hence
representing *gandharva* or celestial musicians, play a drum and a flute on either side. Above the
flute player is a dancing cymbalist, while on the other side is a danseuse. They have halos
while the males do not.

The elegant goddess with her expansive hips sits gracefully in *lalitasana* on a lotus
whose petals are carved with crisp simplicity, as one sees in Gupta period images. By contrast,
the foliage below and the halo above are flamboyant and luxuriant. Noteworthy are the varied
postures of the four companions, which not only reveal the unknown master sculptor's keen
sense of observation but contribute significantly to a vibrant and lively composition.

46 a) Worship of Sarasvati
Maharashtra or Karnataka; c1850; 29.2 x 41.9
Philadelphia Museum of Art; Stella Kramrisch Collection

b) The goddess Sarasvati
Calcutta, Kalighat; c1875-1900; 42.8 x 27.9
Inscription in upper left in Bengali: *vinapani* (one who holds the vina)
Inscription in upper right in English: *Beenapani. The goddess of learning and music*
Art Gallery of South Australia, Adelaide; Morgan Thomas Bequest Fund, 1936

a) The goddess is seated here on her left and is blessing a devotee who touches her
feet. A second worshipper blows a trumpet. The goddess holds two of her common attributes:
the book and a stringed instrument. Her mount (*vahana*), here a peacock, is given even greater
importance, occupying as it does half the composition.

This arresting picture is rendered in a distinctive style that was prevalent among
itinerant artists of the Deccan in the last century. A large group of pictures illustrating heroic
stories were recovered from the Maharashtra town of Paithan. Storytellers used them to
illustrate their narration. With bold heroic images, limited but vibrant palette and
compositions that are infused with dramatic action, they are among the most striking
examples of narrative painting.

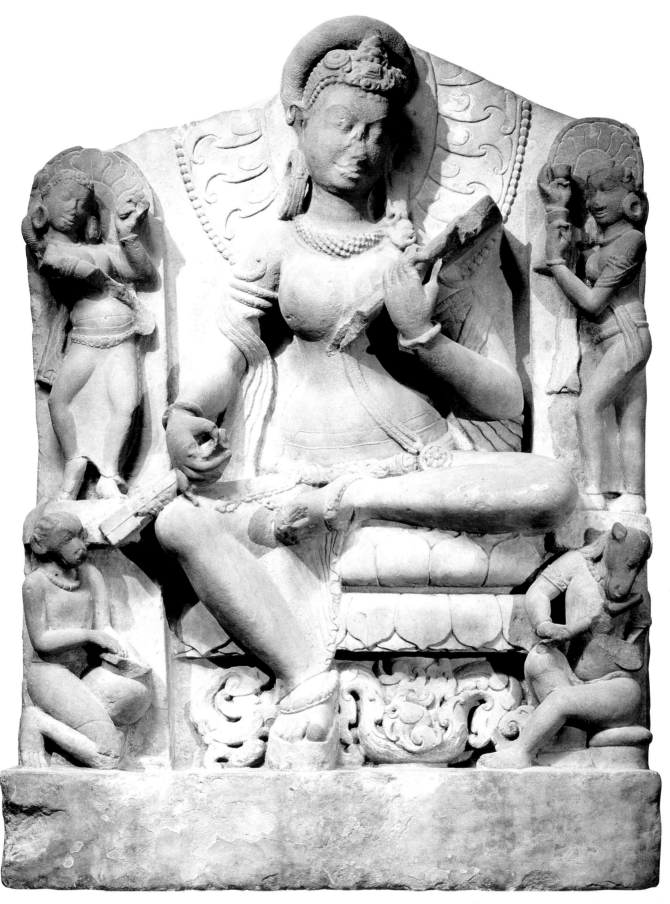

45 Sarasvati, goddess of wisdom and music

47 **Goddess Sarasvati**

b) The goddess Sarasvati is depicted here seated among lotuses in a pool representing perhaps the celestial lake Manas-sarovar. Characteristically she plays her vina and therefore continues the iconographic tradition well established by the Gupta period [45]. However, she is attired more decorously in this lively picture in the mode in which rich ladies of contemporary Calcutta dressed.

The painting is more important for its style than iconography. It introduces a very distinctive style of painting that developed in Calcutta in the nineteenth century. Originating perhaps around the celebrated temple of Kalighat in south Calcutta, these watercolours on paper were rendered at first for the pilgrims. However, they were collected by both Indian and European citizens of the capital and are still popular as examples of a highly original school of art. Unlike other traditional styles, they are distinguished by bold images, fluent outlines and vivacious colours.

47 **Goddess Sarasvati**

 by Srish Chandra Pal and Nikhil Pal; West Bengal, Calcutta; 1995; papiermache, polychrome and brocade; 125

 Private collection

In this contemporary image made for annual worship, the goddess, dressed in rich brocade, plays the vina. Her mount here is the traditional gander or *hamsa*, which is also the vehicle of Brahma and symbolic of wisdom.

Srish Chandra Pal and his son Nikhil are traditional professional artists who live in Calcutta and earn their living by making temporary images of the gods and goddesses for periodic yearly festivities. The images are generally made in clay but many other materials are used as well.

48 **The god Revanta celebrating after a hunt**

 Uttar Pradesh, Sarnath; 7th century; sandstone; 58.4

 Los Angeles County Museum of Art; gift of Harry and Yvonne Lenart

In the larger segment a princely figure is seated on a horse with a cup in his right hand. As the animal moves from left to right his retinue moves on foot. One attendant above the horse's neck holds a flask to pour wine and another at the back carries the prize, a dead boar. A hunting dog licks his master's shod foot. The celebration is made merrier with a group of flying musicians in the recessed area on the base.

The god is Revanta who became a patron deity for hunters and is related to the sun-god Surya. With pointed cap and boots, he and his companions are dressed partly in the Scythian fashion. The scene could well represent princely revelry after the hunt.

46b The goddess Sarasvati

46a Worship of Sarasvati

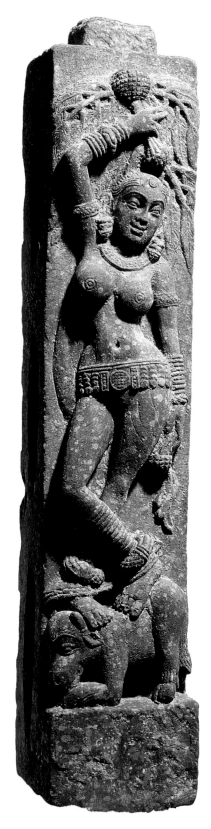

49 Post with yakshi

Uttar Pradesh; 2nd century; spotted red sandstone; 58.4

Doris Wiener Gallery, New York

The post once formed the upright of a railing, probably surrounding a stupa of the Kushan period in the Mathura region. Such square or rectangular columns carved with figures, mostly of sensuous females engaged in various mundane activities, are common features of such railings, used especially in Buddhist monuments.

The young, slim woman with heavy breasts stands languidly on the back of a crouching animal that may be a goat. This animal mount gives her a divine status. She is a *yakshi*, a class of nature spirits that live in trees, groves and mountains. Otherwise she is a *shalabhanjika*, a young girl busy plucking flowers and displaying her physical charms. Her posture, known in dance as *svastika*, and the raised upper arm clearly indicate that a dancer has been used for a model.

50 Musicians on stair-riser reliefs

a) Pakistan, (Ancient Gandhara);1st century; schist; 17.1 x 44.5

The Cleveland Museum of Art; Dudley P. Allen Fund

b) Pakistan (Ancient Gandhara); 1st century schist; 18.5 x 42.8

Royal Ontario Museum, Toronto

These two panels are from a group of well-known stair-riser reliefs that are now divided among several Western museums. They are said to be from Buner, south of the Swat Valley in Pakistan, and are among the finest examples of early Gandhara relief sculpture. The figures are given utmost clarity of definition against the plain background. The figural types as well as their modelling and costumes reflect strong Hellenistic or early Roman influences, and the carving is of exceptionally high quality.

The two panels included here show groups of musicians and merrymakers flanked on one side by pseudo-Corinthian columns with acanthus capitals. In the Cleveland panel (a) are a half dozen men wearing Central Asian or Iranian costume, consisting of Phyrigian caps, tunics and tight pyjamas. One plays a zither-like stringed instrument and another a tablet-like instrument. The drum seems to consist of a pot covered in leather like the left hand unit of a pair of tabla. The other three are clearly clapping their hands and dancing. Very likely they represent a group of Scythian or Central Asian itinerant entertainers.

In the Toronto relief (b) a woman drinks from a wine goblet while five male musicians sing and play. Again as in the Cleveland relief, the two central figures are probably singing as they clap their hands and interacting with one another. The musicians hold the zither, cymbals and a tambourine. Unlike the Cleveland relief here the figures are dressed in classical attire. In both reliefs the diversified postures and gestures of the group make the compositions both animated and engaging.

49 Post with yakshi

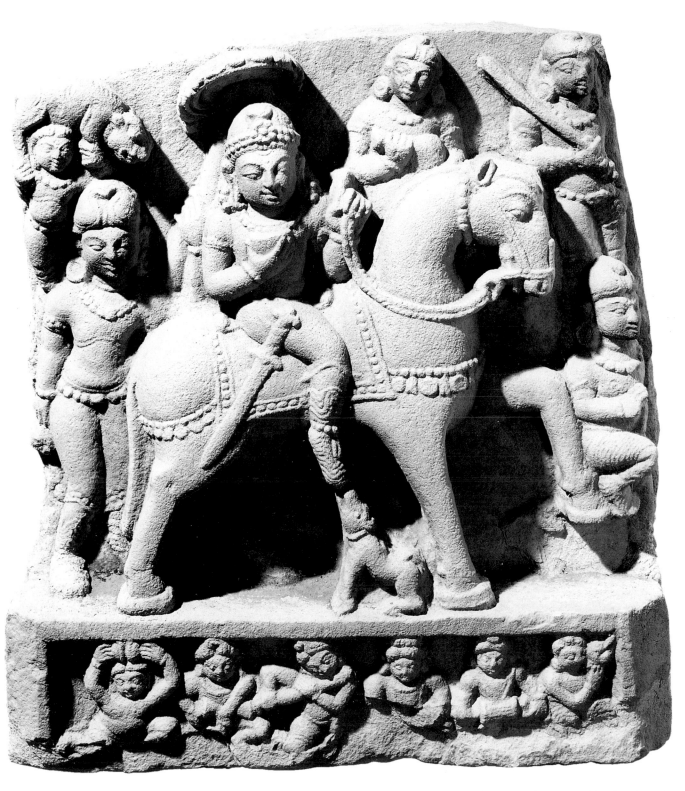

48 The god Revanta celebrating after a hunt

51 Relief with music and dance

Pakistan (Ancient Gandhara); 2nd century; grey schist; 17.1 x 40.6

The Metropolitan Museum of Art, New York; Rogers Fund, 1913

It is not improbable that this relief too served as a stair-riser to a Buddhist monument. All six figures (the one on the extreme right is partially preserved) here are female and they are much more ecstatic about their task than the male musicians in the Buner reliefs. Thus, what they lack in refinement of form and articulation of details, is compensated by a display of verve and energy. Interestingly, while all five figures, including the three musicians, are dancing, the two dancers seem especially spirited as they hold hands and dance with bold, vigorous steps. Also, both figures strike unusual postures for so early a representation, which certainly makes this an important relief for the history of dancing.

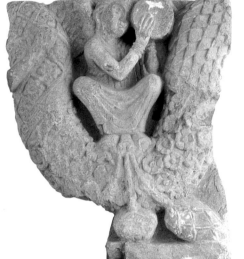

52 A tambourine player

Pakistan, Swat Valley; 2nd-3rd century; green schist; 31

Portvale Collection

This segment was once part of a larger relief showing an undulating garland interspersed with figures. Here the usual cherubic, naked *erotes* of classical art have been replaced by an adult musician. Perched comfortably within the loop of the thick garland, she sits as if in a cave playing her tambourine. Rather large buds of the lotus rest on the base, indicating her aquatic association. The sculpture is very likely from the Swat Valley in Pakistan as is clear from the style and the greenish schist.

52 A tambourine player

53 Woman playing a lute *(see page 111)*

Andhra Pradesh, Amaravati; 2nd century; white limestone; 37

The Museum of Fine Arts, Boston; gift of the Government Museum, Madras, 1921

This segment of a larger relief depicts a female musician playing a lute. It could have formed part of an encasing of the great stupa at Amaravati, which was the most important centre of early Buddhism in the south. It was also one of the three major schools of Buddhist art that flourished in the first three centuries of the common era. The sculptures at the site are distinguished by their material – which is limestone but mistaken often for marble – and the highly naturalistic and vivacious style of carving.

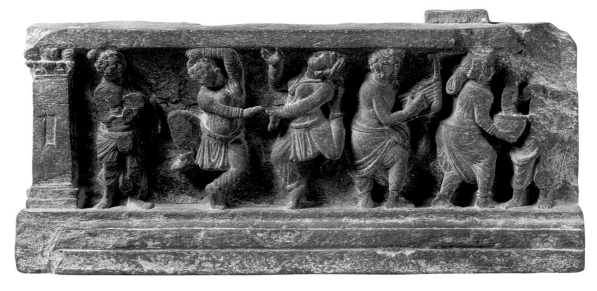

51 Relief with music and dance

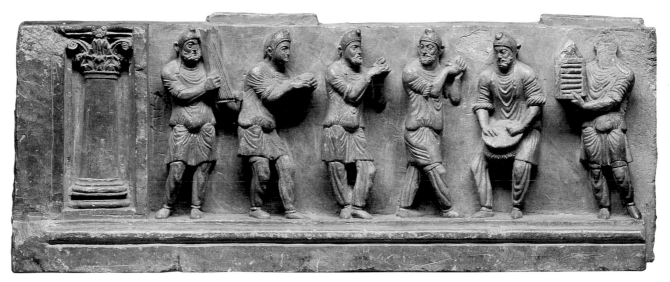

50a Musicians on stair-riser relief

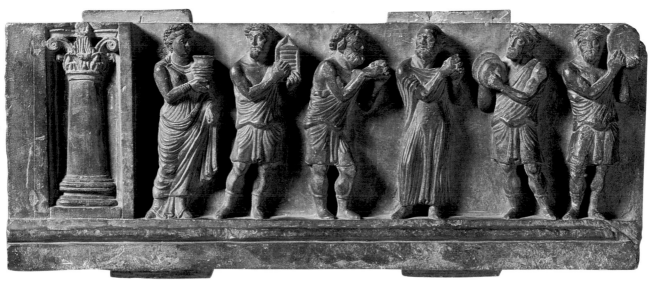

50b Musicians on stair-riser relief

54b Chimes player

54 A celestial orchestra

Pakistan, Swat Valley; 4th-5th century; schist

a) Bull-headed flute player; 47

b) Lion-headed chimes player; 44.8

c) Lute player; 25.7 (*see page 98*)

d) Percussionist; 54.6

e) Drummer; 47

Los Angeles County Museum of Art; purchased with funds provided by
Harry and Yvonne Lenart

The exact function or religious affiliation of this remarkable group of celestial
musicians is unknown. At least three (a, c, e) with their undressed tangs were probably
inserted into some kind of pedestals. One (b) has a long rectangular base carved with floral
decorations and another (d) is broken from the ankles down. Two have animal heads (a and
b), which makes it tempting to identify them as Shiva's *gana*. However, they could have been
used in a Buddhist context as well, which is more likely in Swat Valley.

Whatever their function and whether the group is complete or not, they are
among the most remarkable representations of musicians in early art from the subcontinent.
Intriguing as they are art-historically, they should also be of considerable interest to
musicologists and historians of musical instruments. All five play their instruments with great
poise and naturalistic grace.

55 Mirror handle with musician

Kashmir; 7th century; schist; 9.5

The Metropolitan Museum of Art, New York; gift of Samuel Eilenberg, 1987

In the northwest of the subcontinent mirrors were usually made of metal but their
handles were at times made of stone. Whether in metal or stone, these handles were often
shaped into beautiful figures of women engaged in various mundane activities including
dancing and playing music. In this finely carved stone example, probably from seventh-
century Kashmir, we see a female musician seated on a wicker stool. She wears a long dress, a
local version of the classical chiton, that drapes her feet completely, although her torso seems
uncovered. She is busy playing a harp-like instrument and a parrot perched on the arm band
of her left arm is her only audience. A parrot was not only a pet but often a companion of
lonely ladies. A metaphor for love and passion, parrots figure frequently in Sanskrit literature
as narrators of romantic tales. The garland behind her head doubles as a nimbus and together
with the surrounding vegetation make her a celestial rather than a mortal nymph. In either
case she is a *virahi*, or one who is separated from her lover.

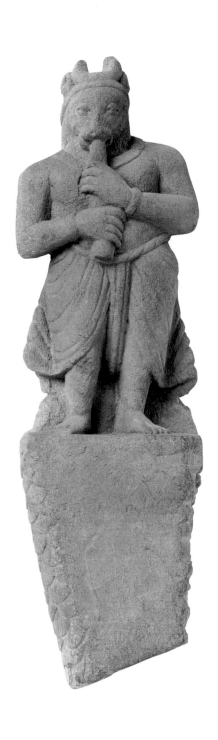

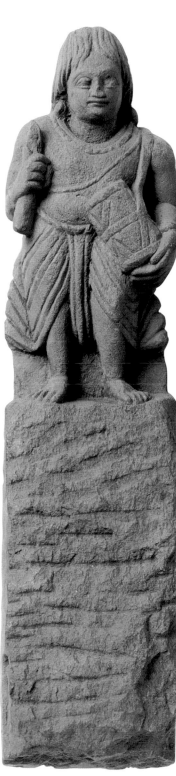

54a,d,e A celestial orchestra

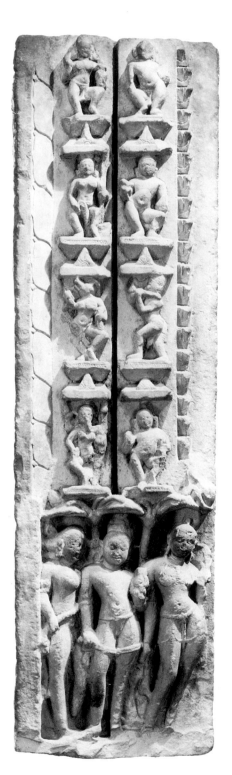

56 **Door jamb with celestial dancers**

56 Door jamb with celestial dancers

Madhya Pradesh; 10th-11th century; sandstone; 89 x 25.5

Navin Kumar Gallery, New York

The most sacred river in India is the Ganga or Ganges but its tributary the Yamuna is also regarded as holy and is closely associated with Krishna. Both rivers are worshipped by Hindus as goddesses and usually their images grace the door jambs of the temple entrance. It is believed that bathing at the confluence of these two rivers (the two meet at Allahabad in Uttar Pradesh) leads to liberation (*moksha*) and so metaphorically the presence of the deities make the passage through the entrance a purifying spiritual experience leading towards *moksha*.

Usually the river goddess (in this instance Ganga on her *makara* mount) stands gracefully at the bottom of the panel. Above her are two rows of figures welcoming the visitor to the temple. On the left are the Dancing Mothers [see 16] and on the right, dancing boys.

57 Frieze with celestial performers

Gujarat, Palitana; 11th century; sandstone; 29.8 x 77

Victoria and Albert Museum, London; gift of the Architectural Association

This frieze with both male and female dancers is from a temple at Palitana near the important Jain pilgrimage site of Satrunjaya. Most temples in and around Satrunjaya were destroyed in the fourteenth and fifteenth centuries. In the mid-nineteenth century some fragments were retrieved from the area and are now housed in the Victoria and Albert Museum in London. There is no certainty that this frieze comes from a Jain temple, but Jainism is the predominant religion in the region.

Male and female figures alternate in deep recesses between circular columns. Curiously, while the males are dancing vigorously in a variety of postures and gestures, the females stand gracefully. From the left, the first stands in the *svastika* posture and holds a pot with both hands, the second stands with her right hips thrust and holding the pot with the right hand only, the third strikes the familiar posture of removing a thorn from her foot as she grasps perhaps a branch with her left arm and the fourth dangles a branch of mangoes with her right hand. These activities clearly make them *alasakanya* or indolent girls seen in such provocative abundance in the better known temples of Khajuraho.

58 Celestial musicians

Rajasthan; 10th century; wood; 37

David Nalin Collection, Pennsylvania

These two brackets with two celestial musicians, although rubbed with age and use, are rare examples of surviving wood sculpture from that age. Despite the popularity of brick and stone, much architecture in ancient India continued to be made in wood, most of which

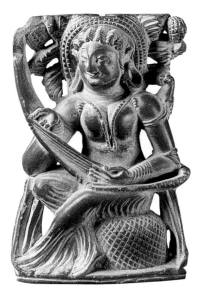

55 Mirror handle with musician

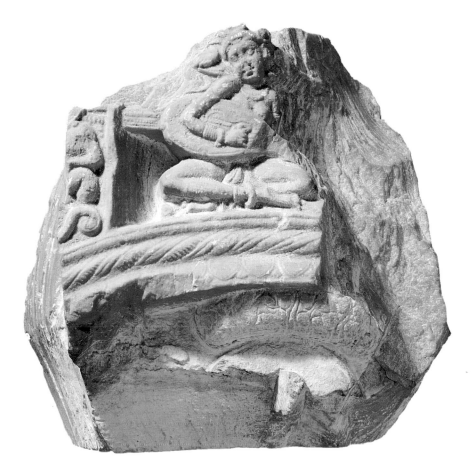

53 Woman playing a lute

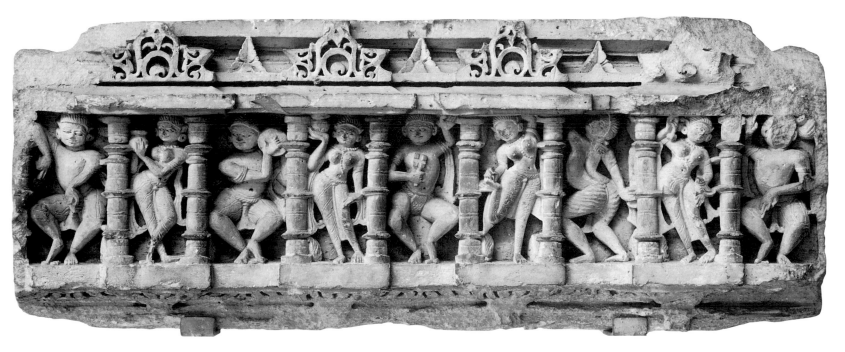

57 Frieze with celestial performers

58 Celestial musicians

has now been destroyed. The chance survival of these two beautifully carved brackets, probably used in a small shrine or furniture, is therefore of great art-historical significance. Indeed, they could have been part of a backrest of a chair (cf Desai and Mason, no 33) or the headboard of a bed.

The close conceptual and thematic kinship with the stone baluster from Orissa [59] is self-evident. Here, however, the two male musicians, one a drummer and the other a flautist, stand not on lotuses but on animal mounts, clearly continuing the early *yaksha/yakshi* tradition of Kushan Mathura [49]. Stylistically, the closest parallels for the figures as well as the decorative pattern above and below can be seen in sculptures from Rajasthan (cf ibid, nos 33, 64-65).

The swaying postures of the musicians are repeated in the forms of the scarves and the sinuous stalks of the lotus. Together with the rich scrolling designs at the top and the bottom, the sense of rhythmic motion resonates across the surface of each composition.

59 A celestial flautist (see page 305)

Orissa; 11th century; stone; 53.4

Victoria and Albert Museum, London

In this baluster from an Orissan temple, a male flautist stands gracefully on a lotus with foliage and plays upon a bamboo flute. A leafy branch rises behind him sinuously to add to the sense of movement and to form a canopy above the musician's head. He was clearly part of a celestial orchestra that was attached to the temple wall to entertain permanently the deity of the shrine.

60 A celestial dancer

Uttar Pradesh; 11th century; sandstone; 75.5

R. Hatfield Ellsworth, New York

Full of vigour and vitality, the lady dances with almost violent motion under a mango tree. The bunch of mangoes has been so symmetrically arranged as to form a canopy over the dancer. Symbolically, they emphasise the fecund aspects of both nature and woman. The sculptor has almost freed the form from the plane of the relief so that the figure seems to be freestanding. The sense of drama and dynamic movement are also enhanced by the twisting and turning posture, as if she is flying through space.

Stylistically the sculpture is close to similar bracket figures recovered from Jamsot in Uttar Pradesh (P. Chandra, 1970, figs 333-7). Females with ample bosoms and buttocks, adorned with articulately rendered jewellery, slender arms and legs and wasp waists are hallmarks of Jamsot sculptures.

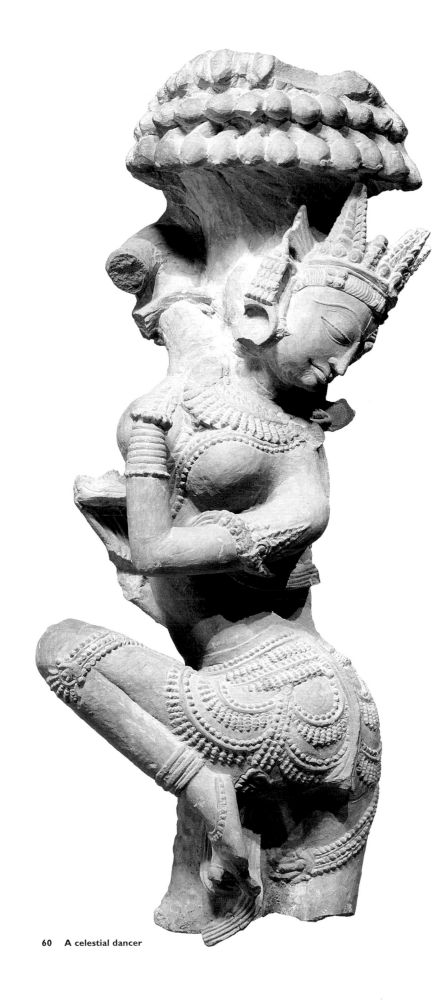

113

60 A celestial dancer

61b Celestial cymbalist

61 **Celestial cymbalists**

a) Karnataka, Dharwar district; c1100; metasilstone; 114.3

Los Angeles County Museum of Art; Nasli and Alice Heeramaneck Collection

Museum Associate purchase

b) Gujarat; 13th century; marble; 91.5

Collection of Dr and Mrs Harsha and Srilatha Reddy, New York

Both sculptures once served as brackets, one (a) supporting the sloping roof outside a temple hall, and the other (b) within at the base of a dome. Clearly the lithic forms continue the original wooden tradition [58]. Rendered in different stones and style, both are excellent examples of their respective artistic traditions. Almost certainly the marble piece is from a Jain temple.

Both cymbalists are also dancers but strike different postures. The Karnataka lady (a) stands with her legs crossed in the *svastika* posture, while the more energetic Gujarati damsel twists her body around not only to display her curvaceous form but to interact with the diminutive musician who looks up at her admiringly. His size does not imply that he is a dwarf but simply emphasises the difference between a celestial and a mortal. A monkey perched on the sketchily rendered foliage above the lady adds to the animation of the composition.

The difference between the two is evident not only in their postures, but also in matters of proportions, physiognomies and ornamentations. Especially noteworthy is the realistic rendering of the Karnataka cymbalist's adornments which do not rest flatly on the body but have their own volume. While she is an embodiment of poise and grace, the other celestial is a superb realisation of the elegant motion of an accomplished dancer.

62 **A celestial nymph with attendant**

Karnataka, Belur district; 12th century; black chlorite schist; 87

National Gallery of Victoria, Melbourne; Felton Bequest 1963

While the cymbalist [61a] is actively engaged in dancing, here the nymph is in a stationary and reposeful posture, as if about to go on stage. In point of fact, she is a direct descendent of the Mathura Yakshi [49] except that she has no animal mount but an attendant. Indeed, this is the configuration that was adopted by the artists in early India to represent Maya giving birth to Gautama Buddha [see 73, 75].

With her right hip thrust in an exaggerated manner the lady stands with her legs crossed and holds the flowering branch of the bower above her as one grasps a strap in a bus or a train. Her broken left arm once rested on the shoulder of her companion who strikes the same posture but in reverse. The carving is as luxuriant as her form is opulent, characteristic of the Hoysala temples in the Belur district. Apart from depicting the figures completely in the round, the sculptor has displayed his mastery over the material by swirling the narrow scarf around the

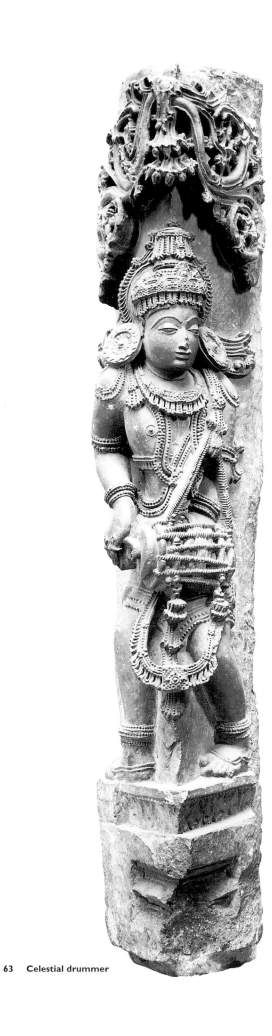

63 Celestial drummer

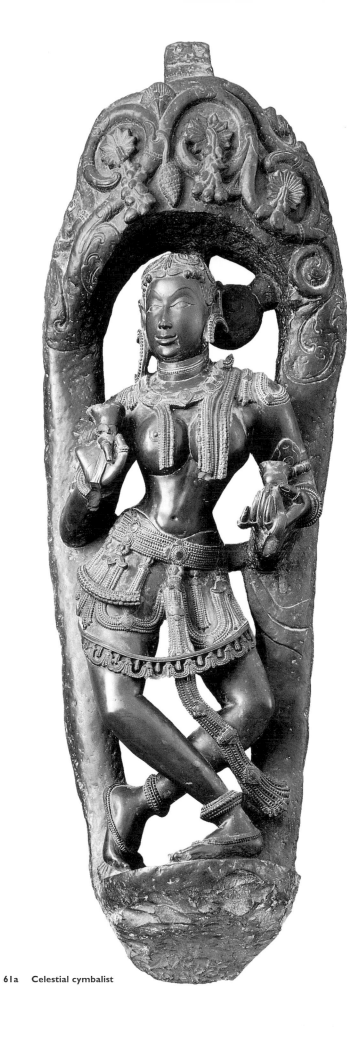

61a Celestial cymbalist

115

body – and mostly detached from it – as if it were a separate piece of cloth. All the jewellery and the stylised flowers that form an arch above are carved with finesse and in exquisite detail.

63 Celestial drummer
Karnataka, Halebid; 13th century; potstone; 139.1
Victoria and Albert Museum, London

This unusual sculpture is a cornerpiece rather than the more common brackets included in the exhibition [61, 62]. Clearly, the adroit artist has ingeniously accommodated the form in such a way that the figure is clearly visible from both sides. This may explain why the drummer seemingly strikes a slightly awkward posture in the illustration. Supporting his drum with his left thigh, he grasps it with his left hand, beating the instrument only with the right hand.

The detailed and articulate carving of the figure's ornaments and the convoluting foliage above leave no doubt that the sculpture once graced a Hoysala temple of the thirteenth century. It is believed that this cornerpiece belonged to a Jain temple built rather late in the thirteenth century.

64 A temple guardian
Kerala; c1600; carved wood; 88
Art Gallery of New South Wales, Sydney; purchase 1994

The tradition of building and carving in wood has always been popular in Kerala. It has also retained its creative vitality for a long period as is clear from this lively and pleasing figure of a *dvarapala* or doorkeeper. Generally, doorkeepers are more solemn imposing figures who strike more reposeful postures. But in the south they are sometimes shown as dancing, as is suggested by the posture and gestures of this guardian.

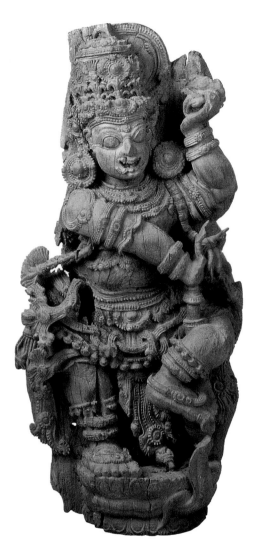

64 A temple guardian

Despite the fact that he is enmeshed in twisting and interlocking jewelleries of all kinds and swirling scarves and tassels, his powerful form is not obscured nor his vigour diminished. He wraps his plump left leg around his club, the toes resting on the hood of a cobra. His right arm swings across his chest and the bent left arm is held up. The gestures of both hands are exquisitely graceful, and his face with bulging eyes and open mouth is expressive.

65 Celestial nymphs listen to earthly music
North India, Imperial Mughal; c1590; 13 x 13.7
Los Angeles County Museum of Art; Nasli and Alice Heeramaneck Collection
Museum Associates purchase

The *Kathasaritasagara* (Ocean of streams of stories) was compiled and written by the Sanskrit poet Somadeva (11th century) for the diversion of Suryamati, queen of King Ananta of Kashmir (r1028-1063). Parts of this vast compendium were apparently translated into

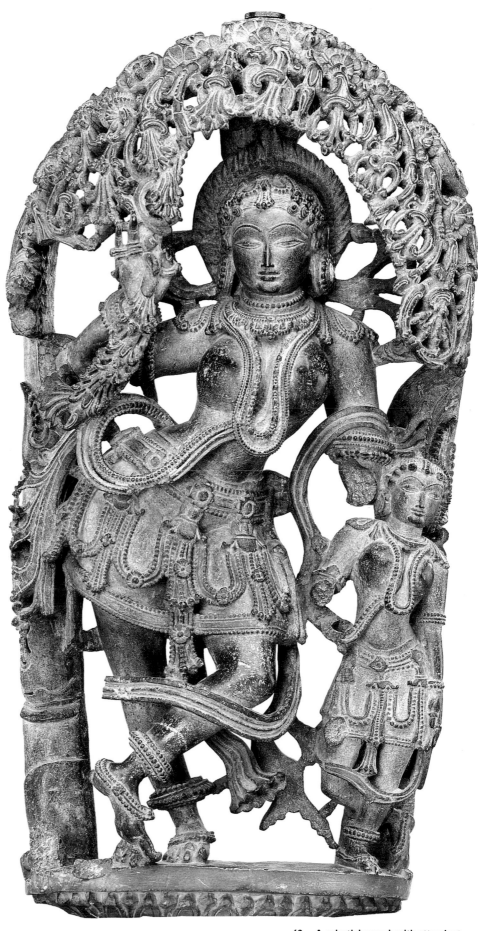

62 A celestial nymph with attendant

Persian for the Mughal emperor Akbar (r1556-1605), and at least one illustrated manuscript was prepared in the imperial workshop, from which comes this delicately painted illustration encapsulating the story of Somaprabha.

Because of a curse, the celestial Somaprabha was born on earth and given in marriage to a merchant Guhachandra. Somaprabha, however, refused to consummate the marriage and disappeared every night to return at dawn. The suspicious husband consulted a brahmin who gave Guhachandra a charm through which he acquired the cooperation of the fire god Agni. Disguised as bees, shown prominently close to the platform on the tree, they watched Somaprabha drinking with another celestial and listening to music. Even though it has no relevance here, the end of the story is interesting. Agni advises the merchant to take a mistress which promptly leads to Somaprabha's compliance with her conjugal duties.

Thus, the picture really depicts two celestials being enchanted by earthly music. From her companion who has a hairy body, wings and the hooves on the feet, we can imagine how Somaprabha looked originally. What is of particular interest are the accurate representations of the various instruments: flute, a *sarod*, tambourine, a *sarangi* and a *rabab*. It is not improbable that the musicians were also drawn from life.

66 **A garden of delight**
 North India, Mughal; c1650
 painted, mordant and resist-dyed, cotton *rumal*; 67.3 x 82.3
 Museum of Fine Arts, Boston; gift of John Goelet

This beautiful dyed cotton textile probably served as a cover or a kerchief (*rumal*). Surrounded by a wide border with alternating cross and lozenge shaped motifs filled with rich scrolling and arabesque patterns, the central panel consists of a garden with a variety of shrubs and foliage and a merry group of winged angels dancing, playing instruments and singing. They are watched by a couple of seated deer among an outcrop of rocks in the lower right hand corner of the *rumal*.

Clearly the garden represents the Islamic paradise [cf 71], even if the four rivers are not included and the design is spontaneous rather than formal. Even though music-making is not included in the description of the Garden of Delight in the Koran, paradisaical scenes in Islamic art often include musicians (cf Blair and Bloom, 106-109).

67 **The ascension of Solomon**
 Deccan, Golconda; 1675-1700; 31.2 x 18.6
 Navin Kumar Gallery, New York

This sparkling and engaging picture depicts the ascension of Solomon, the Biblical ruler famed for his sense of justice, to paradise. The bearded monarch is seated on his throne

65 Celestial nymphs listen to earthly music

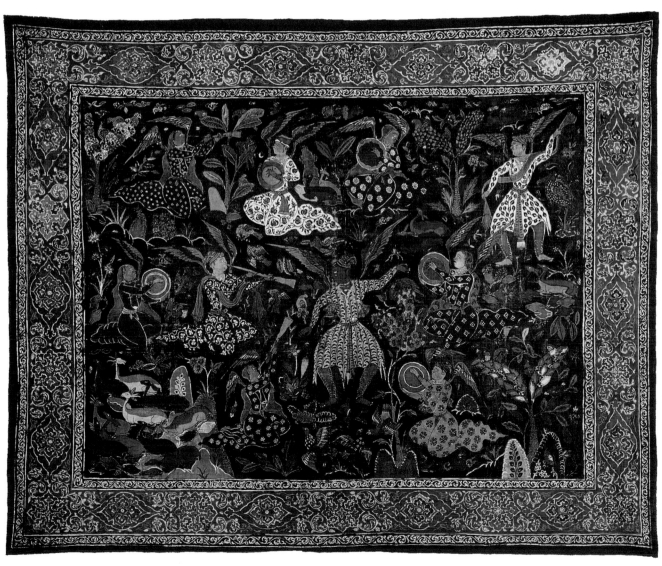

66 A garden of delight

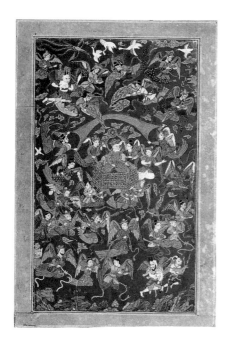

67 The ascension of Solomon

which is being carried across the dark sky by a group of angels. Others hold a green baldachin over his head and some carry royal insignia and various gifts. Even the monarch's horse is not forgotten but included in the upper left behind the celestials. At the bottom immediately above the stylised, multi-hued rocks fly a group of angels with various birds and animals. In the row above are musicians with lutes, tambourines and trumpets. The Indian crane and the *simurgh*, the bird of paradise, fly gracefully at the top.

The accomplished artist has deftly suggested the idea of a mandala in the way Solomon is surrounded by angels. However, this is not achieved at the cost of spontaneity and sense of movement emphasised by the flying scarves, bent wings and floating bits of stylised clouds rendered with arabesque rhythm and whimsicality.

68 **Celebrations in a celestial palace**
Himachal Pradesh, Guler; 1800-1825; 36.5 x 49.8
Los Angeles County Museum of Art; gift of Paul F. Walter

Several other examples of the series to which this picture belonged are known (see Kramrisch 1981, 52), but the identification of the narrative remains elusive. Of large format, the pictures are characterised by complex compositions including numerous figures with either landscape or architectural elements or a generous admixture of both. This particular example is also striking for the abundant use of gold, leaving no doubt that a celestial mansion is indicated.

It will not be possible here to describe or sort out all the entangled episodes depicted in the picture. What is relevant for our theme is the frequent and prominent part played by music and dance. In the upper right a ritual of some kind is being performed below a tree on an island with two dancers and a group of musicians of both sexes. Rather interesting is the inclusion of more women and pendant flywhisks among the foliage of the tree. The two dancers are engaged in conversation in a pavilion at the upper left of the picture. The entire group of performers are shown again in the courtyard below before the five seated young Shaiva ascetics who are the heroes of the narrative. And just outside the wall behind a pavilion two women blow trumpets and a third welcomes, perhaps with an eulogistic song, the five ascetics. Apparently the young ascetics arrived earlier at the gate at the bottom right corner, then rested in a garden surrounded by women, after which they were accorded a warm welcome twice before moving into the court.

69 **An aerial procession with celestials** (see page 125)
Himachal Pradesh, Guler; c1780; 31.5 x 44.5
Art of the Past Inc, New York

This composition probably belongs to a series, depicting the marriage of Shiva and Parvati. Flying high on clouds and conveyances, the celestials have taken off from the

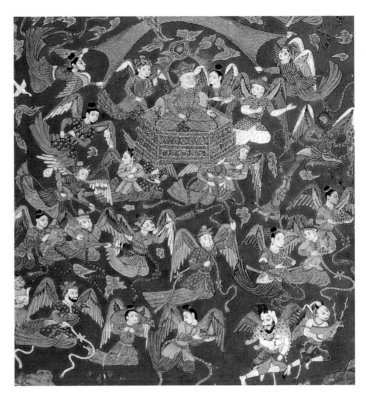

67 The ascension of Solomon
detail

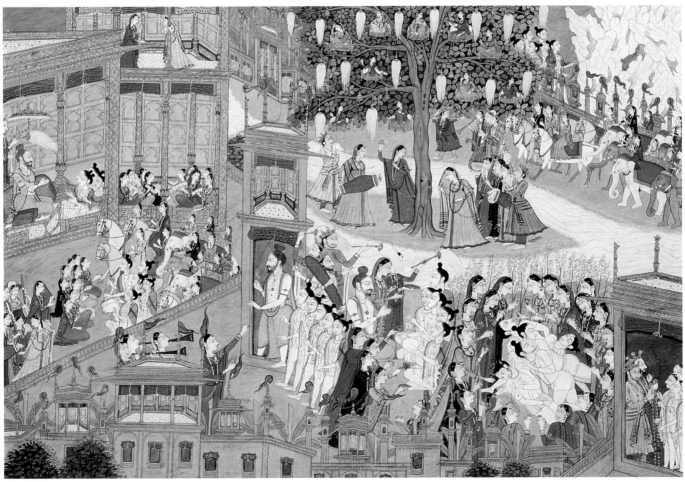

68 Celebrations in a celestial palace

mansion depicted on the upper left corner of the picture after saying farewell to their women. The four figures in the foreground are clearly important persons as each is in a chariot provided with a driver. It is tempting to identify them as four of the regents of directions but their iconography differs from prescribed descriptions. The four are led by three groups of figures in tub-like conveyances. Two contain bodyguards and standard bearers and the third musicians. Above in the clouds are the servants carrying diverse gifts that are customarily sent to the groom's house by the bride's family on the day of the wedding.

70 **Perennial performance in Paradise**
 Rajasthan, Jaipur; 1825-1850; 57.5 x 80.4
 Los Angeles County Museum of Art; gift of Paul F. Walter

This striking picture may recount a specific myth but without a text or the context, an identification is difficult. What is certain is that it represents scenes in a paradise – very likely Indra's court at Amaravati – all of which seem to do with celestial 'nautch' girls. Indeed, one of the chief activities at Indra's court is dancing performed by different *apsara*. The minute they make an error, as punishment they are banished to the mortal realm for a spell.

Whatever the exact import of this painting, visually it is a tour de force of bold imagination with surrealistic aplomb. Celestial space is indicated by a brilliant, white bulbous area in the centre fringed by seven golden palace courtyards. Shiva is at the centre, but Garuda bears an empty throne without Vishnu, and Brahma is represented by his gander. Facing them is a spaceship with the seven sages (*saptarishi*) of the asterism Orion's belt and Kumara riding his peacock. Seven of the eight celestial guardians of the directions ride smaller spaceships, Indra himself being the eighth.

71 **Canopy with dancing celestials**
 Deccan, probably Burhanpur; early 19th century; cotton, painted, printed and dyed;
 293 x 144 (irregular)
 National Gallery of Australia, Canberra

The images depicted on this painted and printed textile – a large section of what was once a huge ceilng canopy for a shrine – are drawn from the celestial realm. Another large section of the original cloth, including the original canopy's large central roundel, is in the Jagdish and Kamla Mittal Museum of Indian Art in Hyderabad (see Gittinger, 1982, 87). A further section was acquired by the Victoria and Albert Museum in London in 1983 (V & A 1984, 20-21).

Across the canopy's broad surface, groups of winged dancers and musicians (*apsara* and *gandharva*) appear within scalloped cartouches and crowd the intervening spaces. Singing, clapping and dancing in single file, the heavenly beings form a mandala, encircling small

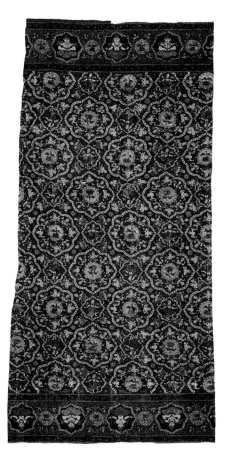

71 Canopy with dancing celestials

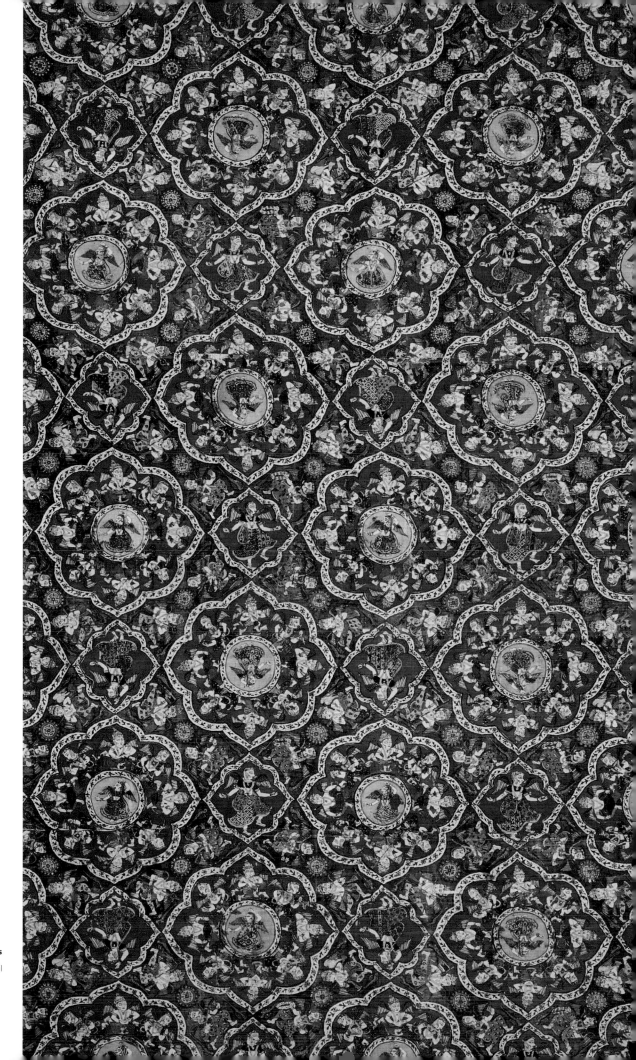

71 Canopy with dancing celestials

detail

roundels in which a central *apsara* figure is highlighted against pale grounds of soft indigo blue. Slightly larger female dancers in elaborately patterned cloth swirl within lozenges that link the seething mass into an elaborate patterned grid.

The musicians, both male and female, play a range of traditonal Indian instruments. Percussion, wind and string players abound, swirling with drums and lutes of different types, cymbals and trumpets. The active poses of both dancers and musicians reveal flashes of vividly decorated cloth. In fact their costumes and jewellery are carefully articulated, with females in skirts, short *choli* blouses, and *odhni* headcloth, while the celestial males wear dhoti and *patka* sashes in a meeting of northern and southern Indian styles typical of the Deccan where the textile centre, Burhanpur, is situated. The gender of the celestial beings is further distinguished in their facial depictions, with the females shown in profile while their male counterparts appear in full frontal position.

Similar small images of nymphs are also repeated in the wide borders between seated winged figures whose serene contemplation contrasts with the vibrant activity depicted in the main field of the textile. Celestial *apsara* and *gandharva* are often associated with the pleasures of Indra's heaven, fitting imagery for a sacred sky cloth. [RM]

72 **Design for Maharaja's throne**

72 **Design for Maharaja's throne**

Rajasthan; 19th century; ink and colour on paper; 33 x 19.3

Paul F. Walter Collection, New York

This design was prepared for either a silver or gilded chair for a maharaja. Here also musicians, especially of the celestial kind, are a prominent part of the design. Two trumpet-blowing nymphs emerge from the mouth of an aquatic creature vaguely resembling an alligator and perhaps representing a *makara*, with their wings forming the armrest. Clearly the ruler was being invested with a divine aura by this imaginative design.

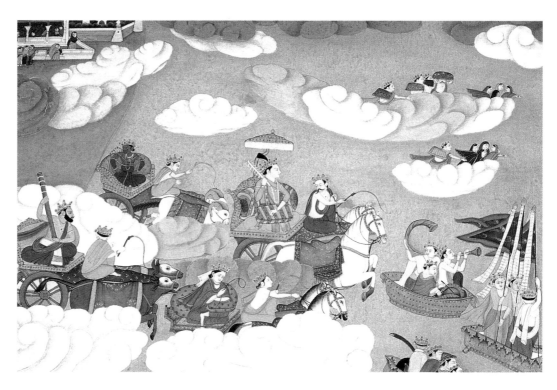

69 An aerial procession with celestials

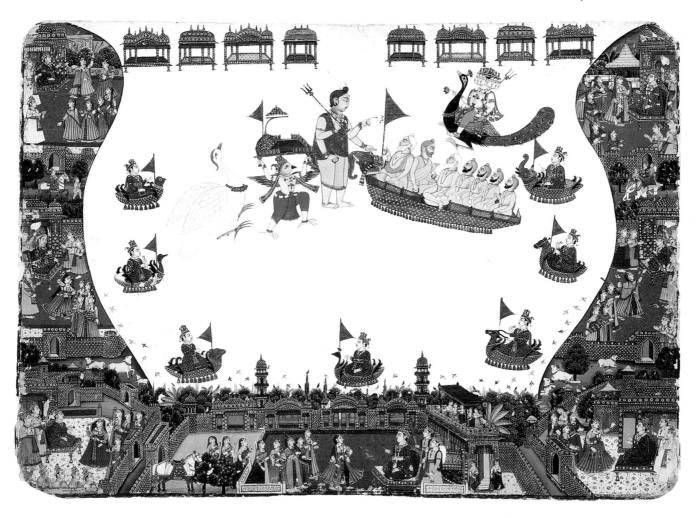

70 Perennial performance in Paradise

BUDDHIST AND JAIN REALMS

Pratapaditya Pal

Buddhism and Jainism are the two Indian religions that owe their origins to known historical founders, unlike Hinduism which derives its authority from ancient, divinely revealed scriptures called Veda. In Hinduism the Supreme Being is called Brahman and hence the religion is also designated as Brahmanism. Both Buddhism and Jainism deny the existence of Brahman and are regarded as non-Brahmanical. Because of their emphasis on renunciation and mendicancy they are said to belong to the *Sramanical* (*sramana* = ascetic) tradition.

Jainism is the older of the two religions. Its adherents believe in a series of twenty-four enlightened teachers called Jina (victor) or Thirthankara (forder), the last of whom Vardhamana Mahavira (6th-5th century) is the most important. A slightly elder contemporary of Buddha Sakyamuni (d c480), Mahavira lived a harsh, austere life himself and literally preached what he practised. Buddha Sakyamuni advised against any kind of extremes and recommended moderation known as the middle path. Neither admitted the existence of God but in due course both religions evolved a rich mythology and pantheon, sharing similar theological and conceptual ideas as well as rituals with Hinduism.

Deities such as Ganesh, Lakshmi and Sarasvati are worshipped by Hindus, Buddhists and Jains alike. In Rajasthan the Jains came to worship even the goddess Durga. Many of the Buddhist deities such as Samvara and Heruka share iconographic features with Hindu deities. The same architectural forms are common to all three religions, although the iconographic programmes differ. The same aesthetic norms and iconometric theories govern the divine images of all three religions.

Hence *apsaras* and *gandharva* have remained favorite themes in both Buddhist and Jain art. Several of the reliefs and sculptures [49-53, 61-63] in the exhibition belonged to Buddhist or Jain temples. Entertainment with music and dance plays an important role not only in Buddhist and Jain mythology but also in the pre-renunciate lives of the two leaders. Even after the Buddha's enlightenment one of his principal patrons was Amrapali, a courtesan skilled in the various arts. And in the Jain canonical text the *Kalpasutra* one of the most poignant didactic stories concerns the pontiff Sthulabhadra and the courtesan Kosha [84].

The births of both the Buddha [73] and Mahavira were accompanied by music, as were their weddings. Buddha's father, however, kept him constantly surrounded by pleasures in order to dislodge him from his resolve to renounce the world [74]. During his enlightenment Mara too sent his lascivious daughters to distract him with their dance and song [75]. This episode simply reiterates what the gods resort to in Hindu mythology whenever they feel threatened by the austerities of mortals. They send their divine courtesans, the *apsaras*, to distract the sages.

facing page
86 Letter of invitation to a monk
detail

With regard to the birth of Mahavira, in her twelfth dream, Trisala, the Jina's mother, saw a celestial palace that resounded with music made by celestial musicians (*gandharva*). 'It reverberated with the tumultuous sounds produced by celestial drums which sounded like thunder caused by dense, moist, rain-laden clouds and echoed throughout the world (Sagar, Lath and Singh, 1977, 83). An even more pertinent description of the entertainment that the king ordered to celebrate the hero's birth occurs in the text (ibid, 149):

> Go and arrange for play-actors, dancers,
> ropestricters (jalla), wrestlers, boxers,
> jumping acrobats, clowns, story-tellers,
> ballad-singers, folk-dancers (lasaka),
> narrators (acakhyaka), stilt dancers,
> Picture-canvas-bearers (mankha), tua-players,
> tumba-vina players and narrators who sing ballads with
> drum playing.

Some of this jolly activity is included in the letter of invitation sent out to eminent monks by the lay community to demonstrate their sophistication [86] rather than as inducements to the sramana. Indeed, as an illustration from the *Uttaradhyayana* manuscript shows it is forbidden for the monks either to participate in or watch dances [82].

Some of the finest examples of celestial dancers and musicians grace the monuments of both the Jains and the Buddhists. Whether identified as *yakshi* or *shalabhanjika* [49], the voluptuous females of early Buddhist art, and to a lesser degree, early Jain art, are among the most admired forms of Indian sculpture. Unfortunately, few Buddhist temples have survived in India but by studying their shrines in other countries such as Nepal, there is no doubt that those in India were also adorned with nubile *apsaras* and *gandharva* musicians. Indeed, two of the most well-known scenes of dancing occur in Buddhist monuments of the Gupta period – at Ajanta and Aurangabad.

When it comes to the divinities themselves however, the Buddhists appear to have been more fond of representing them as dancing than the Jains. Several of the deities, especially of the later tantric pantheon, are portrayed as dancing [76-79]. In some there can be little doubt that the dancing deities of Shaivism exerted a strong influence. In some instances, such as Padmanarttesvara, the influence is more direct. In addition, the Buddhist goddesses known as *dakini* play an important role in tantric Buddhist ritual and religious praxis and they are often portrayed as dancing. Indeed, the similarity of Buddhist and Hindu concepts of divine play is clear from the following passage (*Hevajratantra* in Snellgrove, 1959, 110). Hevajra says:

> There at the centre am I, O Fair One, together with you. The Joy Innate I am in essence,
> and impassioned with great passion...Fear am I to fear itself, with my necklace made of
> strings of heads, and dancing furiously on a solar disk...In that fair citadel we play together
> with much delight...

73 Birth of Siddhartha (Buddha)

Pakistan (Ancient Gandhara), 2nd-3rd century; grey schist; 27.3

Art Institute of Chicago; Samuel M. Nickerson Collection

The two episodes represented in this deeply carved relief that must once have decorated a stupa are the birth and first step of Siddhartha, the given name of Buddha Sakyamuni. The story goes that he was born in the *sala* grove at Lumbini. As Maya stood holding the branch of a *sala* tree and supported by her sister Mahaprajapati, seen here pressing Maya's stomach, the infant emerged from her right hip. He was at once received in a swaddling cloth by Indra, the king of the gods. Two more female companions are included in this relief, one behind Indra picking flowers (?) and the other beside the *sala* tree with a fan and a pot. Near Maya's feet the infant Buddha again taking the seven symbolic steps to declare his spiritual sovereignty over the seven continents.

What is particularly relevant for us is Maya's posture like a dancer with legs crossed in the *svastika* [see 49] and the two drums above the heads of Indra and Mahaprajapati. One drum is even provided with two sticks. These floating drums of course symbolise celestial musicians celebrating the occasion, as is also the case in the mortal realm. Their celebratory joy is captured in the verse at left.

Devas in their mansions,
resplendent in gold and silver and gems,
to the sound of musical instruments
looked on the Conqueror's auspicious birth.
They lit up the sky with its moon,
sun and stars.
(Jones, vol. 2, 21)

128

74 Entertainment in the boudoir

Pakistan (Ancient Gandhara), 1st-2nd century; grey schist; ~~39.4~~ 39.34

Seattle Art Museum; Eugene Fuller Memorial Collection

Probably used to decorate a stupa, the relief is divided into two panels portraying two different scenes in Siddhartha's palace. In the upper panel Siddhartha and his wife Yasodhara seated on a throne in the centre are being entertained by dancers and musicians. At the two extremities are a female flautist and another playing a pair of drums. Unfortunately the instruments in the other musicians' hands are broken but one may have been playing a tambourine. A few may simply be attendants. The two dancers are quite buxom and vigorous and strike postures not usually seen in sculptures.

The scene below takes place in the bedroom of the couple. Yashodhara is asleep on the bed and the maid on the floor. Siddhartha, however, is seated and seems to be accepting water poured from a jug held by an attendant. Unfortunately Siddhartha's outstretched hand is broken. The exact significance of this act is uncertain. He may simply be washing his hand or sealing a gift in the traditional Indian mode. Several other attendants watch from behind as do the two Amazonian door keepers. Clearly the scene is preparatory to Siddhartha's departure in search of enlightenment.

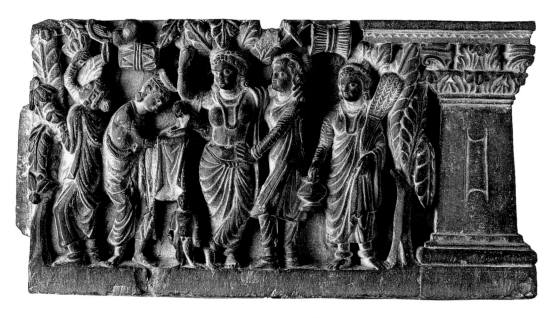

73 Birth of Siddhartha (Buddha)

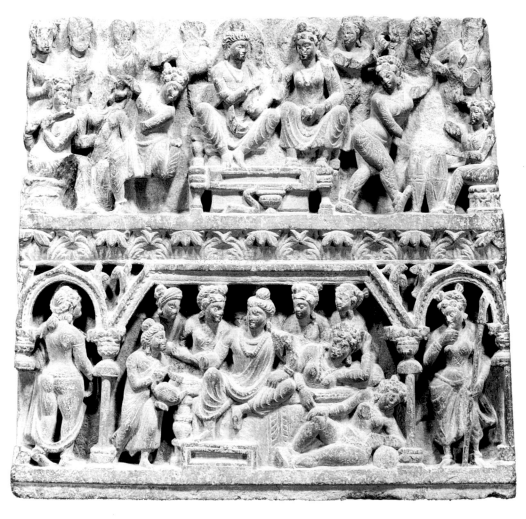

74 Entertainment in the boudoir

75 Scenes from the life of Buddha Sakyamuni

Central Tibet (?); 12th century; opaque watercolor on cotton; 76.5 x 58.4

Zimmerman Family Collection

This well-known religious painting (known as a *thanka* in Tibet) is included here for two reasons. Although it has been regarded as a fine example of early Tibetan painting, it is perhaps more faithful to the Indian model than any other similar *thanka* of this style and period. Indeed, the obligatory effigy of a Tibetan monk is conspicuous by its absence and not a single motif betrays any Tibetan peculiarity. Thus, it may well be the only early surviving example of an Indian Buddhist painting on cloth (*pata*) of the Pala period.

The painting has been described elsewhere in detail (see Pal, 1991, no. 81) and so only its relevance for this exhibition will be pointed out. The central panel of the *thanka* represents both the temple at Bodhgaya and the enlightenment of the Buddha. While Buddha was meditating under the Bodhi tree, he was assaulted by Mara, the god of desire, and his retinue, which included his beautiful daughters. Having failed to dissuade Buddha verbally, Mara instructed his daughters to distract the master from his concentration with a lascivious dance. That is precisely what the daughters are engaged in doing in the register immediately below Sakyamuni. While Mara (= Kama = Eros) shoots arrows of love or desire at the Buddha, his daughters and their companions engage in their hopeless task.

76 God Samvara

Kashmir, 9th century; brass inlaid with silver; 21.6

Los Angeles County Museum of Art; Nasli and Alice Heeramaneck Collection

This unique and visually arresting bronze depicts the important deity of esoteric Buddhism known as Samvara, the presiding figure of the teaching contained in the text known as *Samvaratantra*. The three Buddhas against his chignon clearly announce his Buddhist identity. Despite the fact that he tramples upon Bhairava [5] and Kalaratri (=Kali), he borrows most of his attributes from Shiva.

Relevant for us is the manner in which he raises two of his arms to display the elephant hide in imitation of Shiva's who also displays the skin of the elephant demon Gajasura in a victory dance [7]. Moreover, the god's posture known as *pratyalidha* is no different from the same posture described in texts on dancing. In both artistic forms it is used to display aggression or militancy.

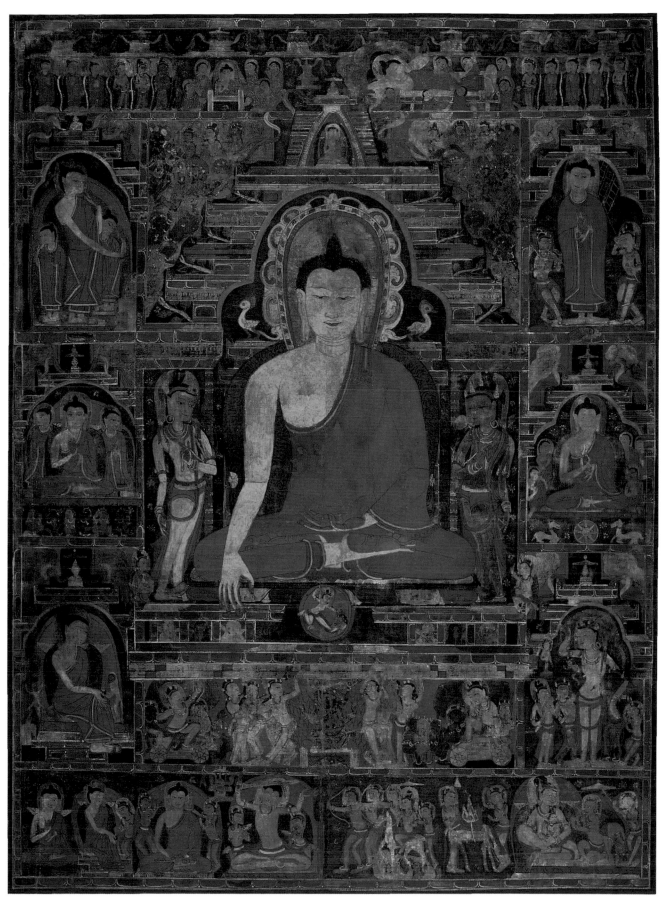

75 Scenes from the life of Buddha Sakyamuni

77 **Goddess Marichi**

Bihar, 10th century; chloritic schist; 69.8

Asian Art Museum of San Francisco; Avery Brundage Collection

The goddess here strikes the same posture as Samvara in the Kashmiri bronze [76]. In the context of a female, according to Bharata, the posture is known as *ayata* rather than *pratyalidha*. Bharata prescribes both *alidha* and *pratyalidha* for the male (Vatsyayan, 1968, 307). There can be little doubt that despite the multiple arms this is a compelling portrayal of a dancer engaged in a vigorous dance. No sculptor could have captured the movement and rhythm so graphically without being familiar with the art of dancing. Apart from her graceful posture, all her slender arms display gestures borrowed from a dancer's repertoire.

The goddess with two porcine faces is Marichi, a solar deity in the Buddhist pantheon. Her chariot is drawn by seven pigs. Her militancy, as well as that of the two diminutive attendants below, is against the forces of darkness which they dispel by shooting arrows symbolising shafts of light.

78 **God Heruka/Hevajra**

Bangladesh, c1100; gilt copper alloy; 15.9

Los Angeles County Museum of Art; purchased with Harry and Yvonne Lenart Funds

The three-headed and two-armed god wearing a garland of decapitated heads dances on four corpses piled up on a lotus. He balances skilfully on the toes of his left foot, while the right is raised and bent inward. In iconographic texts this posture is known as *ardhaparyaka* but in the dancer's parlance the left leg is in *kunchita* and the right in the *urdhvajanu* positions. Shiva often dances in this position in the south, but usually one foot rests on the ground flatly (*samapada*).

The god here, however, is not Shiva but a Buddhist deity called Hevajra/Heruka. He is the presiding deity of the important esoteric empowerment text known as *Hevajratantra* and *Herukatantra*. Again, as is the case with Samvara, his iconography also is influenced by that of Shiva. Among these are his third eye, garland of severed heads, the rising hair and the skull-bearing staff, all of which are attributes of Bhairava. His principal hands hold the bell and the thunderbolt and are crossed against the chest in the typically Buddhist gesture of *vajrahumkara* or adamantine sound.

78 **God Heruka/Hevajra**

79 **Lotus mandala with Buddhist deities**

West Bengal or Bangladesh, 11th-12th century; brass; 27.9

David Nalin Collection, Pennsylvania

Executed in several parts and deftly assembled, this brass lotus with figures is a fine example of a three-dimensional mandala. It was used in esoteric rituals dedicated to the god

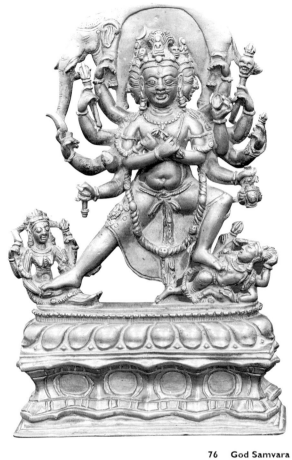

133

76 God Samvara

79 Lotus mandala with Buddhist deities

Samvara [76]. The lotus also symbolises the human heart where really the god is supposed to descend and dwell. When not in use the lotus would be closed and the petals held together with string through the double rings.

In the centre of the mandala is the embracing figures of Samvara and Nairatma and of dancing females known as *dakini*. A *dakini* is a celestial figure who is supposed to help the adept to reach his goal via the tantric path. Usually in art, they are depicted dancing. On the outside of the petals are portrayals of enlightened mystical teachers of such paths known as Mahasiddha.

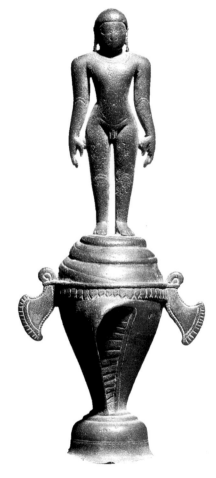

80 **Jina Neminatha on conch shell**

Tamil Nadu, 10th century; copper alloy; 22

Private collection of Stan Czuma, Cleveland

On a giant festooned conch-shell rising vertically from a bell-shaped base, a naked Jina stands erect with his arms in the *kayotsarga* or body-abandonment posture. In this yogic posture, given only to Jinas, the arms hang loosely down the side without touching the body. Not only does the reversal of dimensions introduce a surrealistic element to the representation, but the Jina seems like a child rather than an adult. Occasionally one does come across a bronze in this region in which the Jina is shown as a child, perhaps due to the strong influences of the concept of child Krishna. Incidentally, Krishna is considered to be a cousin of Neminatha, which is why the conch shell, an attribute of Vishnu [27] may have been given to this Jina as a cognisance. Shrines where he is installed are known as *sankhjinalaya* or the abode of the conch shell Jina or *sankhbasti* or conch shell habitat.

81 **Throne-back with celestial musicians**

West India, c15th century; brass; 71

Kapoor Galleries, New York

80 Jina Neminatha on Conch-shell

The throne-back once belonged to an image of Ambika, the Jain mother goddess who is worshipped specifically for fertility and generally for well-being. Each branch of the stylised tree carries a bunch of three mangoes at its end. As a symbol of fecundity, the mango is intimately associated with Ambika. In this instance the tree also serves as the wondrous wish-fulfilling tree (*Kalpavriksha*) which too is associated with the goddess (see Pal, 1994, 179).

Of greater interest for us are the eleven females seated in niches of the nimbus surrounding the tree. Some of them have musical instruments in their hands, now missing in the case of others. Ambika is frequently associated with musicians in the Western Indian tradition, especially in the temples of Mount Abu, but the reasons for this association are not clear.

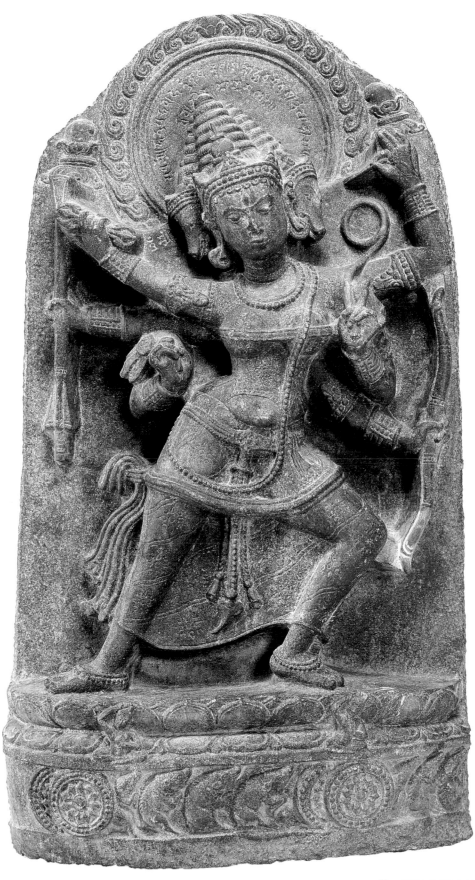

77 Goddess Marichi

82 **A dancing duo**
An illustrated page from an *Uttaradhyayanasutra* manuscript
Gujarat, Cambay; c1450; 11.4 x 29.4
Victoria and Albert Museum, London

A canonical text of the Svetambara Jains, the *Uttaradhyayanasutra* contains the last teachings of Mahavira and is concerned mostly with rules and regulations governing monastic life. This particular folio is from one of the earliest-known illustrated books of this text with pictures of fine quality and luminous colors. There can be little doubt that a master artist was responsible for executing the brilliant illuminations.

This particular composition is divided into two parts. In the lower segment a monk wearing the white garment of the Svetambaras is stretched out on a couch and is being massaged by two men. One attends to his hands and the other, his head surrounded by a blue nimbus, to his feet. In the upper register the monk and one of the males perform a duet in perfect rhythmic unison while the nimbate man watches.

83 **Entertainment in Indra's court**
Folio from a *Kalpasutra* manuscript
Gujarat, late 15th century; 11.5 x 27
National Gallery of Australia, Canberra

This folio is from a manuscript of the *Kalpasutra*, the most revered canonical text of the Svetambara Jains. It recounts the lives of the twenty-four Jinas with special emphasis on that of Mahavira. The book was frequently copied and illustrated by devout Jains and given to monks and temples as an act of piety.

In this almost full-page composition we are given an unknown artist's view of an entertainment in progress in Indra's court [see 70]. Eight male musicians, larger than the dancers, stand on the side and provide the music. The bearded figure at bottom is Narada. In the centre in four registers celestials of both sexes do a vivacious and colorful group dance with perfect rhythm and timing. Interestingly, they are represented as couples who face each other in a pas-de-deux.

84 **The contest between Kosha and the charioteer**
Folio from a *Kalpasutra* manuscript
Gujarat, c1500; 11.4 x 8.3
Los Angeles County Museum of Art; Nasli and Alice Heeramaneck Collection, Museum Associates purchase

This picture illustrates an episode recounted in the life of Sthulabhadra, one of the Jain pontiffs whose hagiographies are included in the second book of the *Kalpasutra*. Upon his

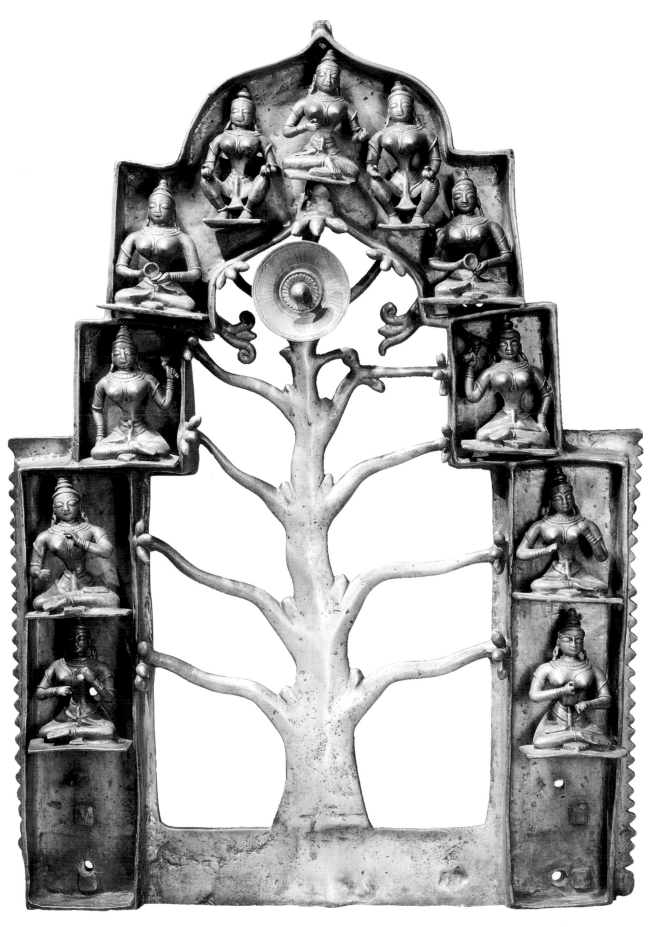

81 Throne-back with celestial musicians

84 The contest between Kosha and the charioteer

conversion, Sthulabhadra ended his relationship with Kosha, his mistress of twelve years, who was given by the monarch to his own charioteer. In order to impress Kosha the charioteer tried to show off his skill in archery. Not to be outdone Kosha danced before him on the tip of a needle placed on a heap of mustard seeds covered with petals. Kosha then told the impressed charioteer of Sthulabhandra's achievements which were of higher order than her own, and both took the religious vows.

The contest is shown simultaneously and with utmost brevity in rather a freehand style which accounts for much of the liveliness of the composition. As the charioteer shoots his arrow at a mango tree without any fruit, Kosha dances with her right foot placed on top of a needle rising from a white bulge representing the petal covered mustard seed.

85 **The heavenly assembly of a Jina**
 Folio from a *Laghu Samgrahanisutra* manuscript
 Gujarat; c1575; 11.4 x 26.2
 Gursharan and Elvira Sidhu Collection

The *Laghu Samgrahanisutra* (the shorter book of compilation) is a cosmological text composed in 1136 by Sri Chandrasuri and has entered the canon of the Svetambara Jains. Not until the sixteenth century, however, did it become a popular text for copying and illustrating.

In this folio we are given a picture of the heavenly assembly of a Jina, known as a *samavasarana*. Upon attaining enlightenment a Jina delivers a sermon before an assembly of all creatures, gods, humans and animals. Here a very succinct version of this special occasion is provided with the Jina seated in the centre on a throne within a circular citadel-like mandala with four gateways. The crowned and adorned Jina has two attendants who use their flywhisks to keep him cool. All around, however, instead of an audience, is a group of lively dancers and musicians either entertaining the Jina or celebrating the occasion. Two brief inscriptions at the top describe the Jina as a *gunavano* (possessor of qualities) and *kevalajna* (the enlightened one).

86 **Letter of invitation to a monk**
 Rajasthan, Jodhpur; 1806; 948 x 27.5
 Gerry and Pamela Virtue, Sydney

This long, narrow scroll with both pictures and texts is really a letter of invitation to a Jain monk. Known as *vijnaptipatra*, it also serves as a sort of thumbnail portrait of the community that sends the letter. Such letters are sent annually to eminent monks inviting them to spend the rainy season in the host community, a prosperous village or a town. The practice seems to have been limited to only the Svetambara Jains of Western India and one wonders how old the tradition is.

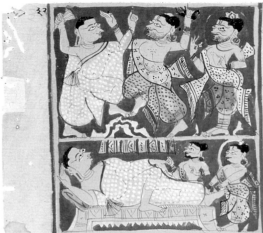

82 A dancing duo

83 Entertainment in Indra's court

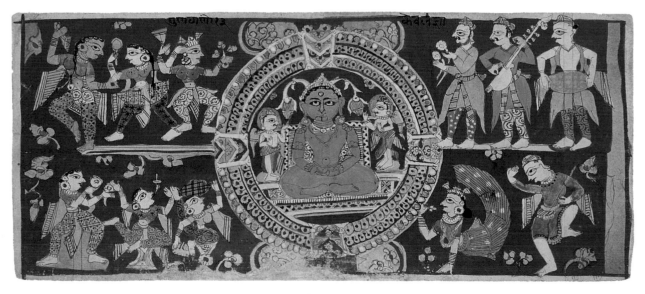

85 The heavenly assembly of a Jina

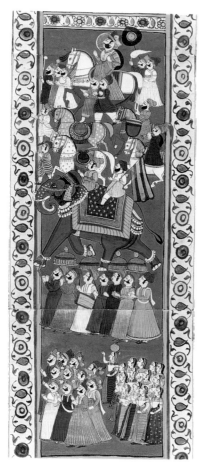

86　Letter of invitation to a monk

detail

By the time this letter was carefully written in very legible script and painted, the format was well-established. The scroll begins with stereotypical frontispieces representing the various auspicious symbols, followed by formulaic 'promotional pictures' emphasising the attractions of the community, such as bazaars (for prosperity), various branches of the army, demonstrating stability and security, and dancers and musicians indicating entertainment, not that any of this should interest a monk.

The compositions that are of particular interest to us are the three that follow the first showing the worship of the auspicious waterpot. In each of these three panels pairs of female musicians pay musical homage to a parasol – the three together representing the Jina. Moreover, instead of some of the conventional subjects here the artist has included scenes of worship at a Jain shrine and at one of Nathji. These are obviously to demonstrate to the invitee the devotional attitude of the community, while the procession with musicians would provide him with the kind of royal reception he might receive (see Shah, 1978, for other examples of such letters).

87　　**A Jain Paradise**

　　　Rajasthan, Pali; 1801 (samwat 1858); opaque watercolor on cloth; 101 x 62.3
　　　Portvale Collection

The Jain faith has thrived in Marwar, and especially in Pali. As a result, the town has been a flourishing centre of painting and illustrated books. Such works were often deposited in the store-rooms (*bhandara*) of Jain religious establishments where they often remained unseen and untouched. Hence, they are often in remarkably good condition as is this painting.

Rendered in the vibrant and colorful Jodhpur style with characteristic scrolling clouds above the line of festive flags, the picture represents a six-storied celestial palace with temples and gateway set in a garden with lush vegetation. A number of lay persons are emerging from the portal at lower left. In the towering palace, a monk rests in the central room on the first tier. Above him is a four-armed deity, perhaps Indra, watching female dancers perform. A second four-armed deity is seated in audience at the next level. In the remaining two tiers, the central figures, attended by women, appear to be mortals and are given only two arms each.

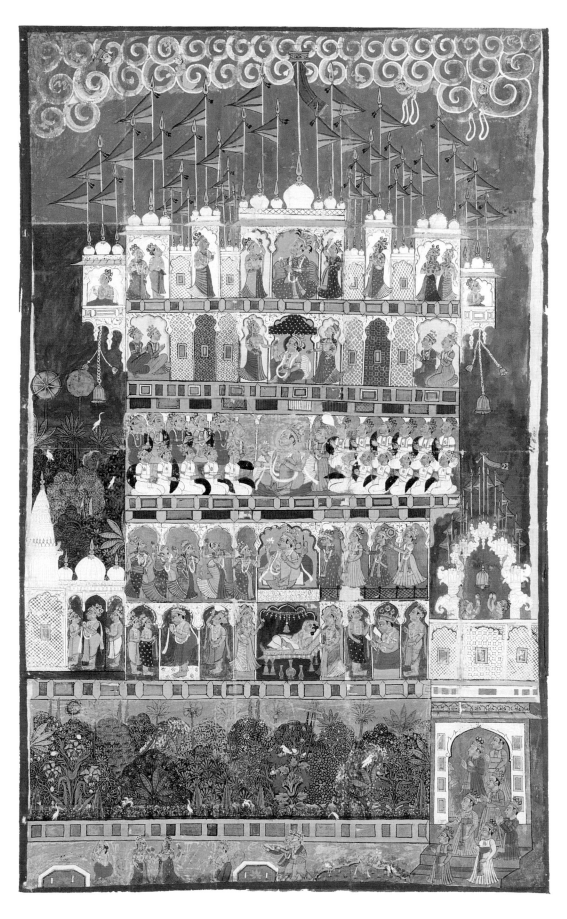

87 A Jain Paradise

Realm *of the* Mortals

WORSHIP AND DEVOTION

Jim Masselos

Worship and devotion are interwoven and merge into one another, permeating all facets of religious experience. Whether it be the performing of ritual worship. or the expressing of total devotion – an absorbed intensity in a personified god – music and dance have been integral in the process. The first part of this section focuses on worship and the second on devotion, though it should be understood that the division is arbitrary and that both are elements in the immense variety of ways in which religious practice has taken shape on the subcontinent.

The earliest forms of worship, in the early Vedic period, involved a sacred fire, ritual sacrifice, and the chanting of Sanskrit texts to personified gods who were not represented iconically. Buddhist rituals initially followed a similar pattern, privileging the teachings of a great philosopher, but as Buddhism too became a religion, the sanctity of the Buddha and of the objects associated with him came to represent his teachings and were reverenced accordingly as illustrated in the rare Gandharan frieze of devotees [88].

Later, in the Hindu tradition, worship of iconic deities became the norm, either through the intermediary of priests or else by individual worship. The great Ragini Bhairavi [180] shows a woman chanting and playing cymbals as part of her worship (*puja*).

Other aspects of worship took place during religious festivals and processions. An example is the Bengali festival honouring Shiva where devotees show their devotion by performing various austerities, all to the accompaniment of music and dance [91]. In the South Indian procession of Vishnu and his devotees [92] the importance of the event is underscored by the accompanying musicians while drums reinforce the sombre quality of a Muslim Mohurrum procession [93].

Music and dance were means whereby devotees could express their love for God, and absorb themselves in the deity, losing all sense of self and individuality. Devotion or *bhakti* marked a change in the direction of religious practice. It opposed Brahmanical forms of worship based on religious ritual and symbolic sacrifice and substituted a form of religion where the individual devotee achieved an immediate rapport with God. No longer was the intermediary of a priest needed to mediate between worshippers and God. *Bhakti* developed as a movement in South India from about the sixth century, promoted by worshippers who composed hymns and songs in the regional Dravidian languages, especially Tamil. Tamil *bhakti* saints devoted themselves exclusively to the devotion of either Shiva or Vishnu, composing songs and dancing their love for God. Their songs and hymns, their music and chants, their dance – all were performed with an absorbed intensity which focused on a god who was

everywhere but was also present, personified and alive in the icons in the temples.

Vishnu's twelve main *bhakti* saints are traditionally known as Alvar while Shiva's sixty-three saints are known as Nayanmar. They were from all classes and castes of society and included women and brahmins. They carried the message of devotion throughout southern India and are credited with having converted Tamil kings from Jainism or Buddhism to Hinduism (see section: 'Buddhist and Jain realms'). Apart from conversions, the *bhakti* saints are said to have performed miracles. Statues of Shiva's sixty-three Nayanmar saints are often installed in temples and are reverenced almost as deities in themselves. The hymns they composed were later brought together in what is loosely known as the Tamil Veda and were used in temple ritual.

Amongst the most prominent Shaivite saints was Sambandar, represented in the exhibition by three splendid and different Chola images [94]. More intense in the introspection of her devotion is the mother of Karaikkal, singing in the esctasy of her vision of Shiva [95]. There are two other depictions of Nayanmar saints – Saint Appar in prayer [96] and Saint Sundara playing a stringed instrument [97].

When *bhakti* began its spread in West and North India from the thirteenth and fourteenth centuries, a new and lyrical role had been added to the religious repertoire. Deriving from Jayadeva's *Gitagovinda* [41] which had expanded the idea of union and absorption with God through the metaphor of Radha's intense longing to be with Krishna, and of her total love for him, *bhakti* incorporated love/devotion and the imagery that went with it. The great Hindu poet, Surdas, in the sixteenth century created songs of love and longing which used the sensuous to express the transcendental [98].

The most romantic figure among the *bhakti* saints was the Rajasthani princess, Mirabai [99], who gave up everything to devote herself to Krishna. In songs that are still sung to the present day (such as the one at left), she used the imagery of the divine lover as her consort/husband to convey the notion of longing for union.

The movement began to develop first in Western India in Maharashtra and in East India in Bengal and Orissa and later in North India and Rajasthan. There too individuals gave up their everyday affairs to devote themselves to singing and dancing the praises of God. In these areas the focus was upon Krishna and on other of the avatars of god Vishnu. The songs and hymns were composed in the vernacular languages of the various regions, thus ensuring they reached a wide popular audience. By this stage Muslims had begun to establish their hegemony over the subcontinent and they too had their own unorthodox movements. Their sufi saints preached a doctrine of transcendence and absorption with the Ultimate, a process in which dance and music played an important part. There was also an interaction between sufis and *bhakti* followers. Equally significant was the interest the great Mughal emperors took in the religious experiences of their new subjects.

Come, here in the courtyard,
Dark Lord,
The women are singing
auspicious wedding songs;
My eyes have fashioned
an altar of pearl tears,
And here is my sacrifice:
the body and mind
of Mira
(cited in Embree, 1988, 366)

Pichhavai [90] are paintings associated with the important devotional movement begun by the great teacher and saint Vallabhacharya in the sixteenth century and developed around a particular icon of Krishna, Sri Nathji, whose temple (*haveli*) is located in a small town, Nathdvara, near Udaipur in Rajasthan. There descendants of Vallabhacharya as spiritual leaders and head priests (*tilakayat*) continue taking care of Sri Nathji and of the followers who flock to his temple. His icon is a bas-relief which emerges from a rectangular stone stele. It represents Krishna at the moment when he lifted up Mount Goverdhana to shelter the people of Brindaban from the torrents of rain sent by the wrathful God Indra. Therefore Sri Nathji at Nathdvara has his left hand raised, balancing the mountain on his little finger [35]. But because of the particular form of the *bhakti* teachings of Vallabhacharya and his successors, Sri Nathji encompasses and absorbs the whole Krishna story.

The spreading of the message of *bhakti* is the subject of the portrait of the Vaishnava Gosain [101], authoritative but not at all authoritarian, as he sits delicately plucking a *bin* and singing a hymn of devotion [103]. The same intensity is present in the Mughal painting of dervishes, sufi devotees [102]. Here, the interconnectedness of the Islamic experience of the sufi religious search with the Hindu is suggested by the line of Hindu *bhakti* saints at the bottom of the painting. An echo of the dervish abandonment in dance occurs in the Guler painting of villagers dancing in ecstasy [104].

Finally, the section concludes with a group of Mughal paintings which record the Mughal concern with documenting the varieties of religious experience to be found on the subcontinent, and in trying to understand it. Paintings of groups of ascetics [106, 107] show meetings with Muslim princes – and in each the necessary element is the way in which music constitutes an integral part of the religious quest.

The works of art in this section present some of the critical ways in which music and dance were part of the spread of new religious ideas, both Hindu and Muslim.

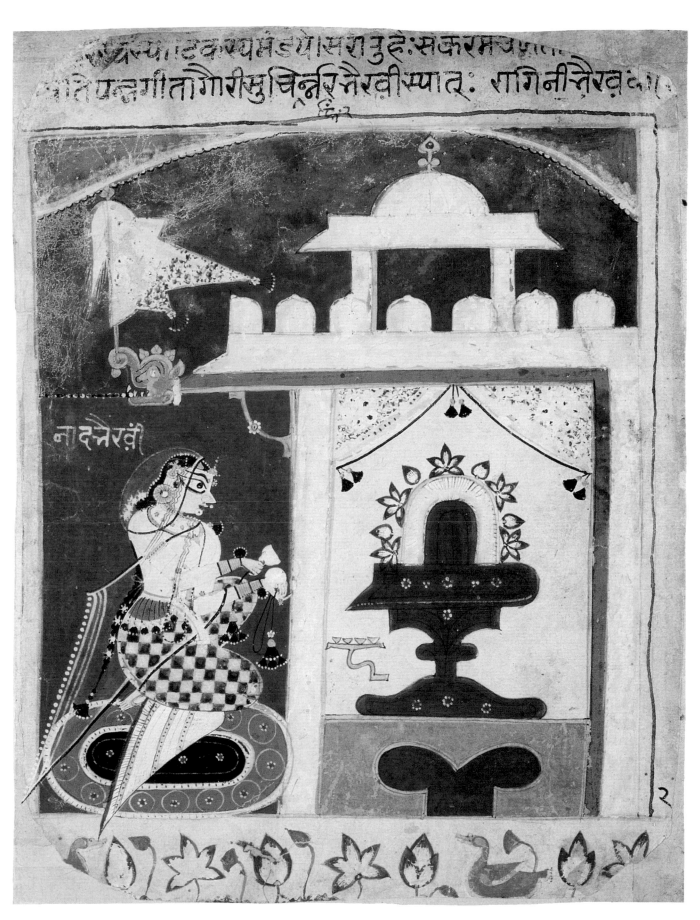

180 A devotee performing puja: Bhairavi ragini

WORSHIP

88 **Worship of the Buddha's turban**
Pakistan (Ancient Gandhara); 1st century; schist; 65.4 wide
Royal Ontario Museum, Toronto

This rare Gandharan frieze shows a group of devotees venerating the Buddha. On one side a woman is dancing in time to the music provided by a group of musicians. The two figures at either end are either clapping in time to the music or are in an attitude of homage. Together the figures represent the joy and reverence for the Buddha and His Enlightenment as expressed through dance and music. The Buddha and his achievement of nirvana is represented symbolically by the stupa rising above the draped throne and aureoled by a many-headed *naga*, a snake god, fanned above the stupa. The music, which may derive from Central Asian or Hellenistic influences, represents a mixture of sounds, different qualities blended together from the three different kinds of instruments. To the left one musician plays an arched harp by plucking with a plectrum, next to him the drummer beats a double-headed barrel-shaped drum (whose crossed lacing is clearly visible), and the flautist blows into a transverse bamboo flute.

89 **Worship in a palace**
Datia, c1720; 37.4 x 50.2
The Art Institute of Chicago; Art Rental and Sales Committee restricted gift

The painting's time is twilight – candelabra are in place ready for use but are not yet needed. The myriad activities that occur simultaneously in various parts of a palace at such a time are presented here in the different fields of the painting. Dominating the image is what is happening in the women's quarter of the palace, which occupies the middle band of the composition and is controlled by the central doorway being opened by a half-hidden woman in the middle of the painting. On the left at an angle is a pavilion where a lord and a lady sit talking intimately. The main focus of attention, however, is on the pavilion to the right. It contains a group of women who are offering evening *puja* (worship) to a god who is installed in their midst. The raised, richly decorated blinds add a suggestion of the performative importance of the action of the *puja* as does the detailing on the columns of the pavilion, all reinforcing the notion of a frame.

Below the *puja* group another party of women watch a woman dancing. Accompanying her are three women musicians: a drummer, a woman playing cymbals and a woman who is probably singing. Their concentration has a parallel provided by the men sitting outside the women's section in the public spaces of the palace. On a green lawn between low pavilions they listen to a group of musicians – or at least some of them are

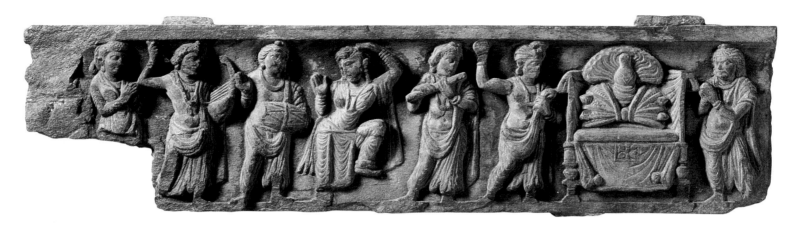

88 Worship of the Buddha's turban

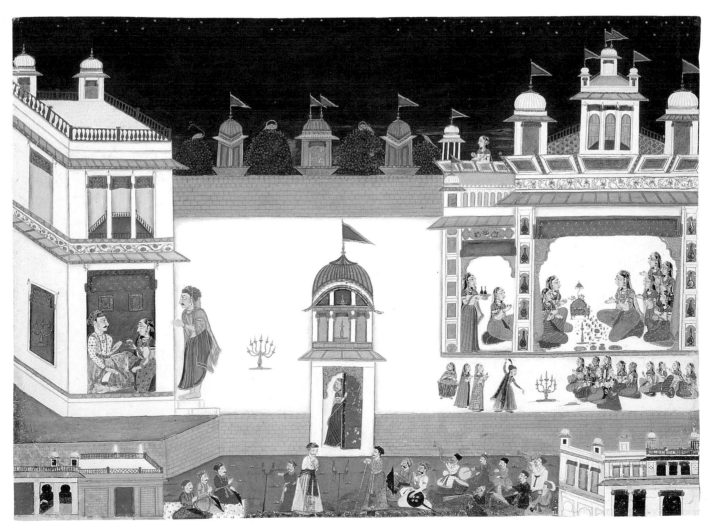

89 Worship in a palace

listening: others are engaged in matters of their own, possibly the welcoming or entertaining of an important dignitary. The music is the ceremonial music of the *naubat* ensemble, here including characteristically long, curved trumpets and drums.

90 **Three pichhavai**

a) Adoration through dance
Rajasthan, Kishangarh; c1725; gouache on cloth; 182.3 x 167.6
Howard Hodgkin Collection, London

b) Adoration through music
Deccan; c1800; pigment and gold on cloth; 183 x 178
Doris Wiener Gallery, New York

c) The festival of Nanda (Nandamahotsava)
Rajasthan, Kota; c1910; pigment on cloth; 198 x 137
Zimmerman Family Collection

These three large cloth paintings or *pichhavai* present different reasons for dance or music. The first two paintings express the mood of the gopis as they proceed towards Krishna. The sensual imagery is a foil for the notion of transcendental absorption which is the underlying idea of these images. In the third painting, the reason for dance and music is joyful celebration.

The term, *pichhavai*, literally means 'that which is behind' or 'at the back'. *Pichhavai* were changed according to season and even the daily ritual event. They inevitably had a rectangular section in the middle cut out, so that they did not cover the statue. Over time some *pichhavai* were cut in half or otherwise fragmented and developed an existence independent of the shrine. (For a detailed analysis of *pichhavai* see Talwar and Kalyan, 1979, Ch.1; Skelton, 1973, and Ambalal, 1987).

A languorous and highly charged mood pervades *pichhavai* (a). It evokes all the magic of the Kishangarh elongated style of painting at its best. The time is evening, the stars can be seen in the background. The maidens hold hands as they walk or perhaps slowly dance towards the glade. They move along a river bank with ducks and fish and lotus flowers in the water below them; above them in boats floating in the heavens are princes and ladies watching the events. In the last boat on the right is a *naubat* ensemble with a man playing a large kettle drum, another blowing a long, straight trumpet, and a woman playing large cymbals and, most unusually, another woman playing a *shehnai* wind type instrument.

The dark background of the Deccani *pichhavai* (b) is characteristic of *pichhavai* from the region. It is also reminiscent of the monsoon which was the season when the dallying with the gopis, the Rasalila, took place. The whole image is lush and fecund: the mangoes hanging in pairs are ripe and ready to be taken; flowers and creepers make an intricately

90a Adoration through dance

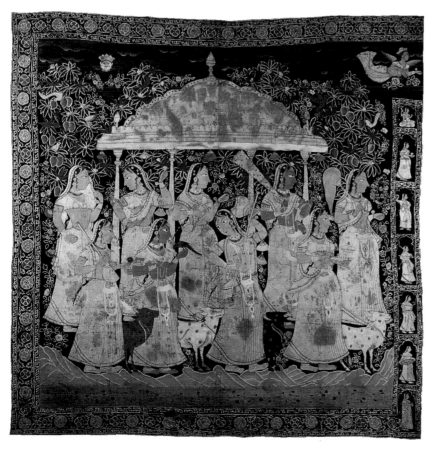

90b Adoration through music

swirled background – a foil for the women as they move into the glade accompanied by the sounds from a tambura and a vina. In the vertical frieze which faces right, a woman at the top sits playing a plucked stringed instrument, below her a woman makes an offering, and below her is a woman dancing, then there is a woman playing a tambura, and two sections down a woman is playing a double-headed barrel-shaped drum.

The third *pichhavai* (c) shows the performance of an annual celebration surrounding the joy of Krishna's adopted parents, Nanda and Yashoda, over his birth. The events depicted take place on the day after Krishna's actual birth: on that day Janmasthami, Krishna's father, had carried him secretly and at dead of night across the river to prevent him from being killed by the wicked monarch of the region. Krishna was taken to Nanda and Yashoda who unknowingly became his foster parents. It is their celebration over his birth, the birth of a son, that is the subject of the *pichhavai*. In the top middle of the painting Sri Nathji is shown dressed as is customary for this occasion, wearing a four-pointed *jama* (*chakdarjama*) and a turban with peacock feathers. Offering him *arati* (worship) on the left is the late nineteenth-century *tilakayat* or head of the sect, Govardhanlalji (1862-1934), while his son, Damodarlal (1897-1936) fans Sri Nathji.

The painting brings together elements that are disparate in time and space. In the celebration in the bottom panel Nanda is gathered into a joyous celebration with *tilakayat* going back over the previous century; they join with him and the maidens in dancing in a circle to celebrate Krishna's birth. Present from left to right in the circle are probably Girdharji (1843-1903), Govindji (1729-1774), Dauji II (1797-1826), Nanda, Govardhanlalji (1862-1934), Girdharji (1769-1807) and Govindji (1821-1844). Priests on the side are lustrating the dancers and on the left two musicians are playing gongs, and on the right there is a drummer beating a double-headed drum and three men playing cymbals (*tala*).

It was customary during the festival of Nanda for two priests to dress up as Nanda and Yashoda and play their roles as part of the ritual before Sri Nathji (Ambalal, 1987, 29). In this painting the artist has depicted a ritual performance and celebration but has turned from actors to representations of specific personages. Presumably Govardhanlalji was alive at the time when this *pichhavai* was painted and it represents a record of an actual ceremonial Nandamahotsava, painted for installation in another temple of the sect.

91 **Religious festival in honour of Shiva**
West Bengal; 19th century; 19.5 x 26
Private collection

Musicians provide a backdrop of sound for a kaleidoscope of rituals and celebrations at an annual festival in Bengal during the nineteenth century. In the centre of the drawing two worshippers, hands upraised, dance to the beat of the music.

The festival, devoted to God Shiva, was distinguished by the enthusiasm of devotees in displaying the intensity of their commitment to Shiva. They did so by performing a range of

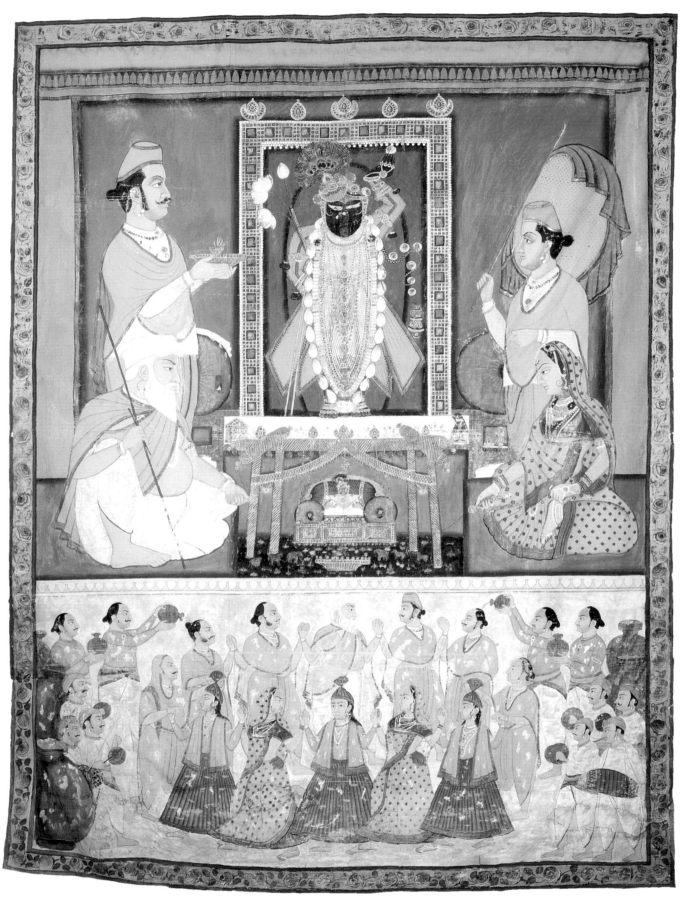

153

90c The festival of Nanda

practices specific to the festival and the locality. One such austerity, *jhamp sanyas* (Oddie, 1995, 50-51, 152-153), is presented at the right of the picture. A group of men stand waiting at the top of a bamboo platform for their turn to follow the man who is plunging off the platform and who will be caught on the spiked woven bamboo shield-mattress being held by four men on the ground below him. Another form of devotion (*jhula sanyasa*) practised by such *sannyasin* (holy men) is illustrated by the man who hangs, head down, swinging from the platform over a smoky fire, praying as he does so. In the foreground two devotees proceed to the temple by repeatedly measuring their length on the ground.

The painting locates the place of music in the rural milieu of nineteenth-century Bengali festivals as an important accompaniment for other agendas (note the class contrast between observers and participants). The drawing shows an influence from European drawing and watercolour techniques, laid over a distinctly Indian vision and of course a distinctive Indian subject matter.

92 **Procession with Vishnu image**
Karnataka; 19th century; 20.3 x 28.9
Private collection

A drummer and two musicians playing reed pipes (possibly one a melody pipe and the other a drone) provide the musical accompaniment for God Vishnu as he is taken out from his temple in a public procession. Leading the procession are two caparisoned elephants, followed by banner bearers, musicians, and finally a palanquin-platform carried by eight men. On the platform is a large wooden anthropomorphic figure of Garuda, with pointed nose and moustache, in a kneeling posture, typical of such carvings in South India. (For similar Garudas see Michell, 1992, 22,131). On his back, between his wings he carries a large figure of Vishnu, dressed and garlanded. Four men flank the platform carrying tall ritual umbrellas (*chhatra*) which signal the sanctity of the images and demarcate the sacral space on and around the platform. The sacral quality of the procession is further signified by the dress of the men taking out the procession: following South Indian temple entry codes they all wear dhotis and are stripped to the waist. In contrast are the observers/worshippers who have come across the procession during their usual daily activities. In consequence they are fully clothed, in everyday attire. They stand in prayer, both men and women, looking towards the god and taking *darshan* of Him.

93 **Mohurrum procession** (*see page 165*)
North India; c1850; mica; 15 x 19.5
Portvale Collection

Drummers establish the beat in an annual Mohurrum procession in North India. Two kinds of drums are visible: kettle drums suspended from the drummer's neck, and large *dhol*, played with a stick. Others in the parade pound their breasts in lament for the

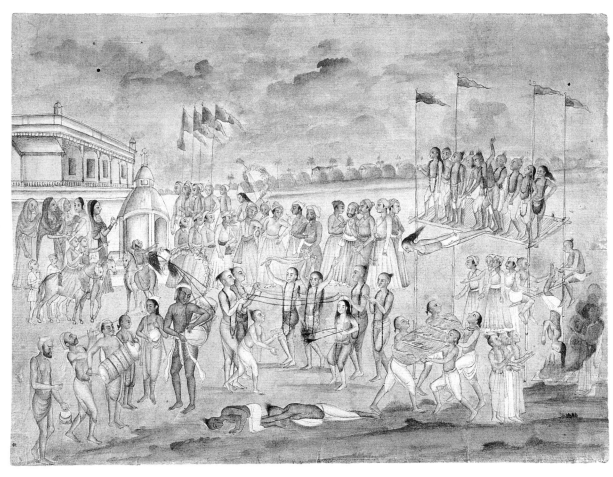

91 **Religious festival in honour of Shiva**

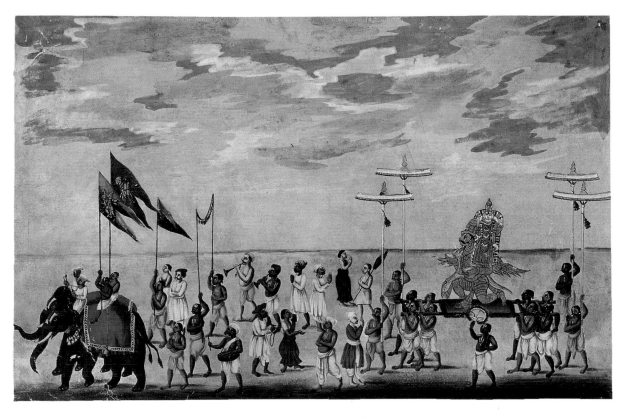

92 **Procession with Vishnu image**

martyrdom of Husain, the grandson of the Prophet, Mohammed. The Mohurrum commemoration occupies the first ten days of the lunar month of Mohurrum; each day's ritual echoes and remembers the events of the days before the final destruction of Husain and his forces in 680. The ritual concludes on the tenth day with a procession. During the nineteenth century the final day's parade was a grand occasion which was observed almost everywhere on the Indian subcontinent. It attracted immense crowds. In some cities the procession was so large it took two or three hours to pass a given point (Masselos, 1982).

What dominates this parade however are the two large structures, one of a mythical bird and other of a tomb, both marvels of construction out of plywood, tinsel and paper. Of particular importance is the very large model of the tomb (*tabut* or *tazia*) which was that for Husain. Such model tombs were the key feature of the Mohurrum processions and provided the concluding moment, the closure of the event. After the parade had wended its way through the streets it would head towards a nearby lake, pond, river or seashore. There, the *tabut* would be immersed in the water, or it would be buried, and the festival would conclude. The following year new *tabut* would be made and the process repeated.

The painting is done on a thin sliver of mica. Such mica painting required special techniques and skills as it was painted on the back of the sheet.

SAINTS AND DEVOTEES

94 **Saint Sambandar**

a) Tamil Nadu; 12th century; cast bronze; 55.9
National Gallery of Australia, Canberra

b) Tamil Nadu; 12th century; copper alloy; 47.9 *(see page 15)*
The Asia Society Galleries; Mr and Mrs John D. Rockefeller 3rd Collection

c) Tamil Nadu; late 13th century; bronze; 66
The Nelson-Atkins Museum of Art, Missouri; purchase: Nelson Trust

Sambandar was a child saint of the late seventh century. He had become a devotee of the god Shiva when as a three-year-old he had been left hungry beside a pond while his father took a ritual bath. Parvati, Shiva's consort, appeared and gave him milk. By the time of his death at sixteen, Sambandar is said to have converted a king of Madurai from Jainism, had performed many miracles and had composed over four hundred hymns in praise of Shiva. In one he wrote of Shiva: 'He bestowed his grace upon all. He is indeed the thief who has stolen my soul away' (Embree, ed., 1972, 239).

The National Gallery of Australia bronze (a) shows the child saint, Sambandar, standing holding a cup, symbolising the milk which Parvati had given him. From his necklace

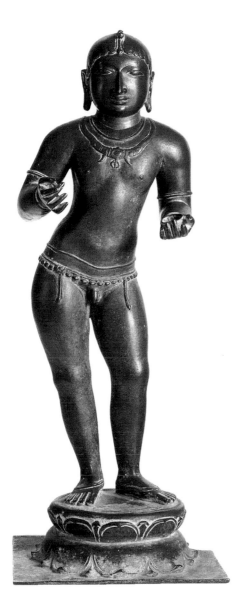

94a Saint Sambandar

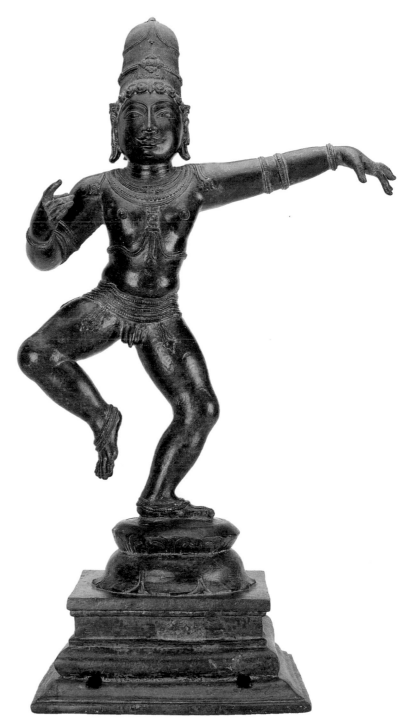

94c Saint Sambandar

hangs a trident, the symbol of Shiva, and flanked on either side are tiger teeth worn as protection by children.

More commonly Sambandar is depicted dancing [b) and c)]. The pose is reminiscent of bronzes of the infant Krishna dancing with glee with a ball of stolen butter in one hand. But the infant Sambandar dancing in these two bronzes conveys a different message. He does not hold butter, instead he points a finger towards the heavens, the other hand is outstretched and one foot is flat on the ground in typical dancer's position. The bronzes capture a sense of the movement of dance as religious exultation and linking with God. The message may have been ambiguous in that what was conveyed was as much an idea of the dances performed to Sambandar's songs as it was of Sambandar himself dancing.

95 Saint Karaikkal Ammaiyar
 (The mother of Karaikkal)
 Tamil Nadu; 14th century; copper alloy; 23.2
 The Metropolitan Museum of Art, New York; purchase, Edward J. Gallagher Jr
 Bequest, in memory of his father, Edward Joseph Gallagher, his mother, Ann Hay
 Gallagher, and his son, Edward Joseph Gallagher III, 1982

Through music and dance, through their poems, the *bhakti* saints expressed their total concentration on god and in the moment of the music and performance they approached spiritual union. It is this moment that is often captured in the bronzes as here where the Shaivite saint, Karaikkal Ammaiyar, is shown with a pair of cymbals, singing so as to see a vision of Shiva dancing. She is smiling in a trance-like ecstasy, her thin semi-naked body is bowed, her head cropped, and her breasts pointed and jutting, in marked difference to their usual rounded depiction on the bodies of beautiful women. She represents the antithesis of traditional female beauty and its stereotypes but she still has her own internal beauty which radiates from this bronze. (See Dehejia, 1988).

Karaikkal Ammaiyar was one who did not want beauty for herself. She came from Karaikal, a Tamil village, where she developed a reputation as a devotee of Shiva and gained miraculous powers through her austerities. Her husband left her since he was afraid of consorting with someone so closely linked with Shiva. She begged Shiva to take away her beauty and he granted her wish. Thereafter she devoted her life to him and became associated with him; later she was often located as one of his attendants or companions. In other bronzes she is depicted in a more angular and more emaciated form which highlights her transposition into virtual deified status (Pal, 1977,143) but in this Metropolitan Museum bronze she is represented as a person caught in a withdrawn transcendent moment in which music and devotion intermarry.

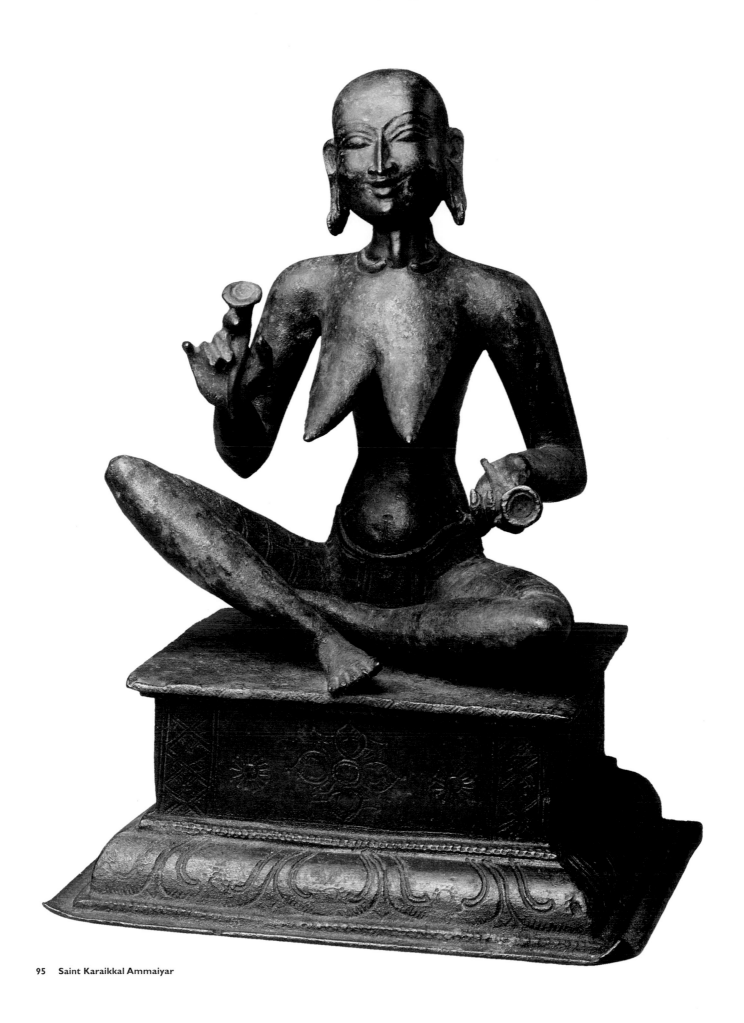

95 Saint Karaikkal Ammaiyar

Wicked am I and foolish not to
unite myself with the good.
No animal am I,
yet I cannot help behaving like an animal.
I can preach at men to hate what is wrong,
but such a miserable sinner am I
that I can only beg and never give.
(cited in Brockington, 1992, 131)

160

96 Saint Appar

Tamil Nadu; 15th century; bronze; 51.5

The Norton Simon Foundation, California

Another early South Indian devotee of the god Shiva, Appar, appears in this Vijayanagara period bronze in an attitude of adoration, wearing a simple cloth around his waist. His palms are together with a narrow spade (or spud) crocked in his arms. While the image as a created object suggests the reverence in which he himself was subsequently held throughout South India, the bronze also captures Appar's own profound sense of humility which he felt before Shiva, as shown in the poem at left.

Appar had a chequered religious life. Born in the seventh century as a Hindu he converted to Jainism and became a monk and teacher. However he soon reconverted to Hinduism after his sister's prayers to Shiva rescued him from an incurable disease. Thereafter he travelled around South India, sometimes with Sambandar, on a self-imposed task of conversion, the two together often being subsequently considered as responsible for the return of Hinduism to South India. His hymns and songs are emotional in their adoration for Shiva, they show a deep humbleness on his part as devotee and they also have a strong anti-ritual and anti-religious establishment tone, an underlying feature of most *bhakti* poetry of the time (See Dehejia, 1988).

97 Saint Sundara

Tamil Nadu; 16th century; bronze; 81.3

The Norton Simon Foundation, California

Sundara stands relaxed with his weight resting on one foot, his hands holding and playing a stringed musical instrument. One of the few brahmins among the Shaivite *bhakti* saints from South India, his sacred caste thread descends from his left shoulder to his right hip. The rings at the base of his lotus pedestal were for rods to be inserted so that his statue could be carried in religious processions during festivals.

Ah sinful, I have left the path
of love and service pure!
Now know I well the meaning
of my sickness and my pain.
I will go worship.
Fool! how long can I so far remain
From Him, my pearl, my diamond rare...
(in Embree, 1972, 242)

This ninth century saint, like the other devotees of Shiva, had a chequered early life. Though of high caste, Sundara married two low caste wives, one of whom was a temple dancer; it was said that Shiva mediated between the two women in their quarrels. Sundara is himself credited with having performed many miracles. He composed hymns in which he sang of his devotion and love for Shiva and of the places associated with Him.

98 Surdas

Rajasthan, Mewar; 18th century; 25.7 x 32.4

Portvale Collection

A song by the blind poet-singer Surdas, from his famous anthology *Sursagar* (Sur's ocean), makes explicit the relation between songs of devotion and salvation (see left). In the

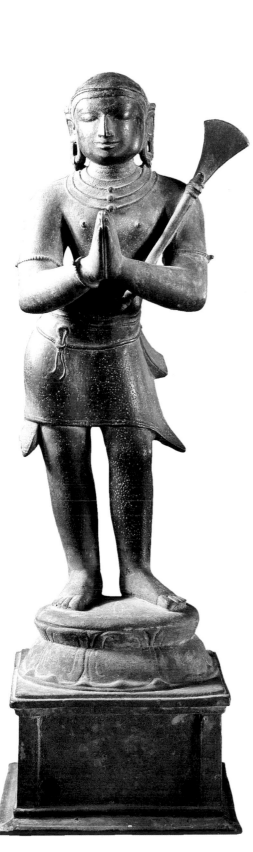

96 **Saint Appar**

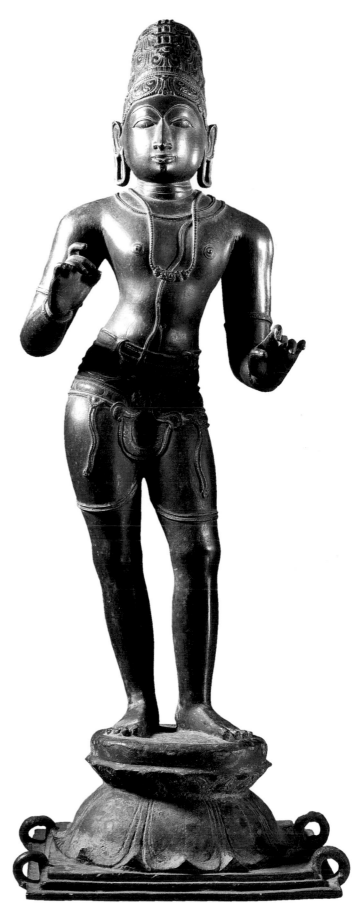

97 **Saint Sundara**

Songs to Hari [Vishnu] work great wonders:
They elevate the lowly of the world,
who celebrate their lofty climb with drums.
To come to the feet of the Lord in song
is enough to make stones float on the sea.
The Vedas are verses, testaments to God —
they make the saints saintly and wise —
And what about Sur? I sing too.
O Hari, my shelter, I've come for your care.

(cited in Embree, 1988, 362)

painting Surdas sits with cymbals in his hands singing a song of devotion in the upper left corner while incidents from his songs are illustrated in the rest of the painting. Surdas was a devotee of Krishna and his songs celebrated incidents in Krishna's life. The painting shows Krishna with Radha in a flowery bower and other gopis coming to him. Above, seated in front of a cave entrance are Shiva and Parvati. The god of love, Kama, sits near them and is about to shoot them with the arrow of love, an image repeated below where Kama is again about to shoot Radha and Krishna with the arrow of love. The image presents simultaneously incidents depicted sequentially within Surdas' songs. It was a convention of the genre in which Surdas composed that the last couplet of the verse invariably included the name of the poet, a convention echoed pictorially by the inclusion of the poet in the painting. Surprisingly little is known of the historical Surdas apart from the the fact that he lived in North India in the neighbourhood of Brindaban sometime in the sixteenth century. His songs have earned him a position as one of the greatest literary figures in the Hindi language although the collection now attributed to him was added to after his death.

99b Saint Mirabai

99 Mirabai

a) The life of Mirabai
Rajasthan, Kota; late 18th-early 19th century; illustrated book, each page 29 x 23
Dr and Mrs Narenda Parson, California

b) Saint Mirabai
by Pemji of Chitod
Rajasthan, Mewar; dated 1838; 22 x 9.5
Private collection

Mirabai is regarded as one of India's greatest *bhakta* poets, and is the best known of all women poets, with her songs still sung in different dialects across India. A sixteenth century princess from Rajasthan, Mirabai presents herself in her songs as having become so enamoured of Krishna that she was totally obsessed with him, worshipping him unswervingly. She composed numerous songs of her love for him. In her songs, the metaphor by which she conveyed her longing is that of a wife's love for her husband; they are of desire and love. She sang: 'I am maddened by love; no one knows my pain' (Singer, ed, 1966, 199). Sometimes she used the motifs of dance and of being dyed with the colour of devotion to the Dark Lord, common in *bhakti* poetry, to express her love.

Single paintings of Mirabai are uncommon; an illustrated manuscript such as (a) is rare. It recounts some of the most important legends about Mirabai, including songs (*pada*) attributed to her, with commentaries in Rajasthani Hindi. The twenty full-page miniatures include scenes from before her marriage, of her life in her husband's castle, as well as several scenes of her worshipping an image of Krishna and of her husband, the king, in his castle.

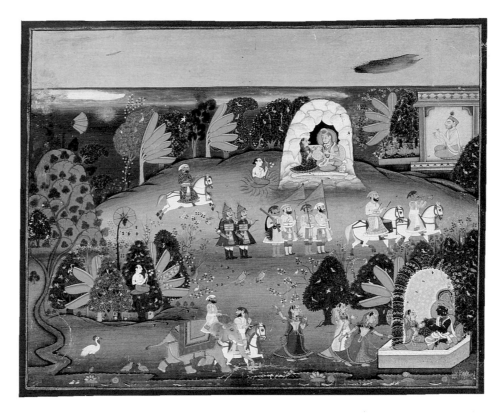

98 Surdas

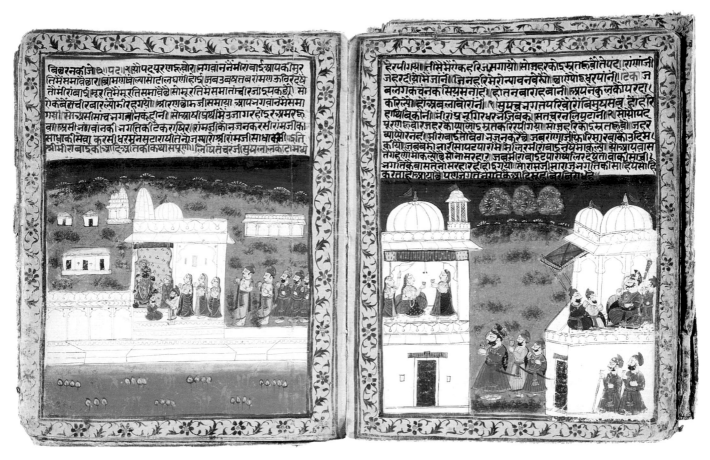

99a The life of Mirabai

Drumming out the rhythm on the drums,
I danced, dancing in the presence of the saints,
coloured with the colour of my Lord.
They thought me mad for the Wily One,
raw for my dear dark love,
coloured with the colour of my Lord.
(cited in Embree, 1988, 366)

Her husband's brother, after she was widowed, opposed her devotion to Krishna and tried to kill her in various ways. Two of the paintings depict her drinking a cup of poison and surviving a snake attack, both of which her husband's brother had sent. Her devotion to Krishna saved her and proved her extraordinariness. Eventually Mirabai became an ascetic.

In the second painting (b) Mirabai is shown performing ritual worship (*puja*) presumably in front of an image of Krishna, although he is not within the frame of the painting. In this rare depiction from Mewar, completed some three centuries after she lived, she is presented as an imposing figure moving, as the words written on the painting state, to perform devotion. She is performing *arati*, a ritual in which flames are moved in circular motion in front of an image of god. The idea of her approaching God, rather than reaching him, even in a worship/temple situation is suggested as is the intense concentration of her devotion.

100 Kabir tending a loom

North India, Mughal; c1740; 21.8 x 12.7

Art Gallery of New South Wales, Sydney; bequest of Mr J. Kitto, 1986

In the song (*pada*) at left, the mystic poet Kabir (1440-1518), one of the best known poets in North India, and a pioneer of Hindi devotional verse, has used the dancer as a metaphor for the overcoming of desire. In another song, similarly reflective of his wise teaching, he uses the musk deer, searching for the fragrance of the musk without realising it emanates from itself, as a metaphor for the finding of god within oneself.

164

Too many, many roles,
these parts I've played,
and now I'll part from them.
Too tired of all pretense,
tuning, tuning the strings,
and now it's over, done –
thanks to the name of Ram [God],
I haven't another dance to dance and my mind
can no longer manoeuver the drum.
Life's postures, love, hate –
lost to the flames:
the craving-filled kettle drum finally burst.
(in Embree, 1988, 374)

By tradition a low caste weaver from Benares, Kabir became a symbol for self-respect movements amongst the lower castes – their guru who taught them using the vernacular. He is also the founder and one of the greatest figures of the Sant tradition, a counterpart of the *bhakti* movement which, like it, emphasised love as the characteristic emotion of true religion. The Sant rejected all Hindu ceremonies, scriptures, and caste distinctions, teaching that the path to enlightenment was within oneself.

Paintings of Kabir are rare, and this modest example depicts him weaving in humble surroundings. Kabir's teachings reflect both Hindu and Muslim traditions and one of the many legends about him (as also related of Guru Nanak) concerns his death at which time his Hindu followers wanted to cremate his body, but the Muslims insisted on burial. When they drew back the sheet over the corpse, it had turned to flowers. [JM]

101 Vaishnava gosain (Brahmin pontiff)

Himachal Pradesh, Guler(?); c1775; 21 x 16.6

Mr and Mrs John Gilmore Ford, Maryland

The *gosain*, a preacher of the path of devotion to Vishnu or one of his incarnations, sits cross legged, plucking at an elaborately decorated single-stringed zither (or *bin*) as

100 Kabir tending a loom

165

101 Vaishnava gosain (Brahmin pontiff)

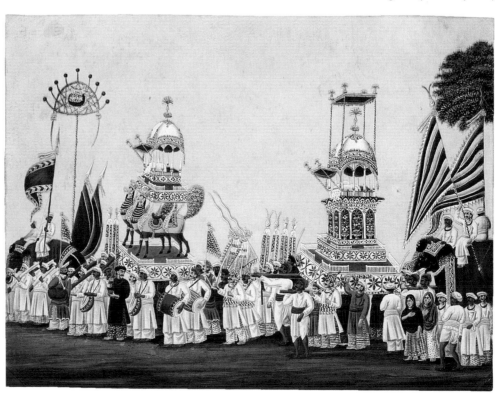

93 Mohurrum procession

accompaniment to a hymn of devotion. The instrument is stylised and it is placed in a symbolic position with the gourd over his right shoulder; unusually the *gosain* is stopping the strings with his right hand and plucking with his left. It is possible the artist was more concerned with suggesting a sense of the event, rather than with the accuracy of a performance. In any case, the portrait is a typically subtle treatment from the Pahari region and is possibly from the Guler school. The importance of the *gosain* and of the moment at which he is painted is indicated by the quality of his fine clothing, even extending to his patchworked shawl, and by his location in a marbled palace.

102 Mystics in ecstasy

Northern India, Imperial Mughal; c1650-1655; 41.5 x 21.4

Victoria and Albert Museum, London

Bequeathed by Captain E.G. Spencer-Churchill, MC

A group of dancers in the mid ground dominate this superb Mughal painting. To the beat of handheld frame drums and a plucked string instrument (a *rabab*), the dancers have been swirling around, repeating the name of God and praises of God, until some have collapsed in a swoon of ecstasy. They are dervishes, followers of Sufism, a mystical form of Islam which began in west Asia and spread to India along with the Muslim conquests of the subcontinent (Rizvi, 1978). One of the ways by which the sufi's inward esoteric search for apprehension of the ultimate non-sensuous unity in all things could be achieved was through *sama*, a gathering to chant the name of God and to dance. In such dance, an initially slow repetitive turning to music, the sufi could reach a state in which individual consciousness would dissolve.

The painting is probably set in Ajmer at the tomb (*dargah*) of Mu'in ad-Din Chishti, one of the great sufi saints. Clever use of European Renaissance-derived notions of perspective and spatial fields establishes a separation of the religious space of the sufi experience from the mundane world outside. Observing and encircling the sufi dancers at the top of the mid register is a line of Muslims. Three have been identified as significant sufi saints (Gadon, 1986, 153). The bearded figure leaning on a stick is Qutb ad-Din Bakhtiyar Kaki (d.1235); the dark-robed figure opposite him and the man on his right with the light-coloured shawl are Mu'in ad-Din Chishti (d.1235) and Mullah Shah Badakshi (d1661). The line of Muslim divines then is an allegory establishing a lineage from the time of the painting itself, back into the past to the founders of the sufi orders and possibly by implication to Muhammad himself who could not be depicted.

A further subtext is provided by the line of twelve seated figures at the bottom of the painting. Eleven have been identified by inscriptions on the painting (Gadon, 1986, 155) as representing Hindu saints (*bhakti* saints) and yogis. From the left they are Ravidas (a cobbler and teacher of Mirabai), Pipa, Namdev, Sena, Kamal, Aughar, Kabir, Pir Muchhandar, Gorakh, Jadrup,

166

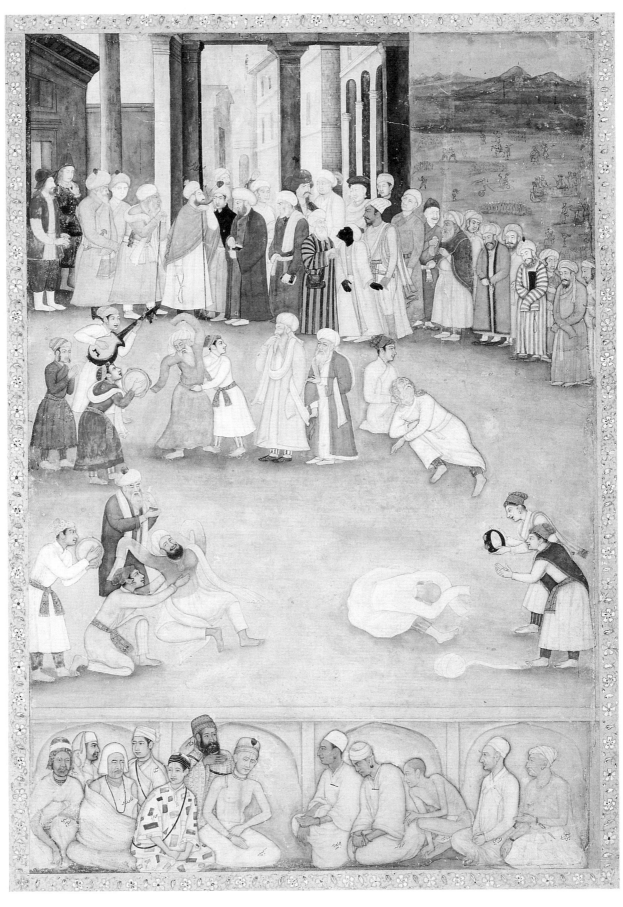

102 Mystics in ecstasy

Lal Swami and a final swami whose name is no longer clear. The painting incorporates them within the religious space by containing them within the same tonal spectrum. The idea perhaps being conveyed is the notion of the sharing of a common religious search. Like the sufi line, the Hindu line of divines presents an allegory and a lineage. The notion of religious toleration, both between religions, and within religions through endorsing the various paths and doctrines of different orders of sufi and *bhakti* saints, locates the painting, as much as do its specific stylistic elements, to the mid seventeenth century, to the reign of Shah Jahan, and perhaps even to his son's atelier, the ill-starred but remarkably eclectic and sophisticated Dara Shikuh.

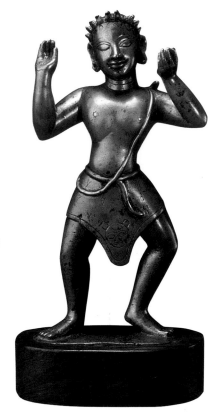

168

103 Shaiva devotee in ecstasy

103 Shaiva devotee in ecstasy
Himachal Pradesh, Chamba; c1800; bronze; 22.4
Dr Leo S. Figiel, Florida

This devotee of Shiva is caught in the moment of dance, hands raised and one leg lifting. His tiger(?) skin loin cloth, his naked torso (relieved only by an upper caste sacred thread) and his spiked hair all suggest he is a wandering ascetic or sadhu. The moulding of his face parallels the treatment of mask-icons from the same Chamba region, helping to give the image a religious resonance – and a strength of purpose and involvement in the moment of dance as religious expression and experience.

104 Villagers in ecstasy
attributed to Pandit Seu
Himachal Pradesh, Guler; 1725-1750; 24.8 x 36.2
Los Angeles County Museum of Art

Seven men dance to music played by a group of four musicians: two drummers, one on kettle drum, the other on *dhol*; a greying *shehnai* player; and a trumpeter. All are totally absorbed in the moment of music and dance. Each of the dancers is in a different position, each at a different moment of dance: no position is repeated. Apart from variety the painting conveys an idea of the intensity of the dance, rather than its joyousness: the total self-absorption and seriousness of purpose of the dancers – each of whom is dancing for himself rather than participating in a group or a co-ordinated dance. It has been suggested (Goswamy and Fischer, 1992, 226) that the scene represents Hindus dancing at a village hill fair. However, the extended *jama* sleeves of the middle top dancer echo similar representations of sufi dervish dances (*sama*) in Mughal paintings.

The painting is masterly and subtle in its drawing of the dancers and musicians. Showing the naturalist influence of the Mughal style of art, all the figures are portraits, ranging from the youth in the green *jama* in the bottom row through to the old man holding his scarf in one upraised hand.

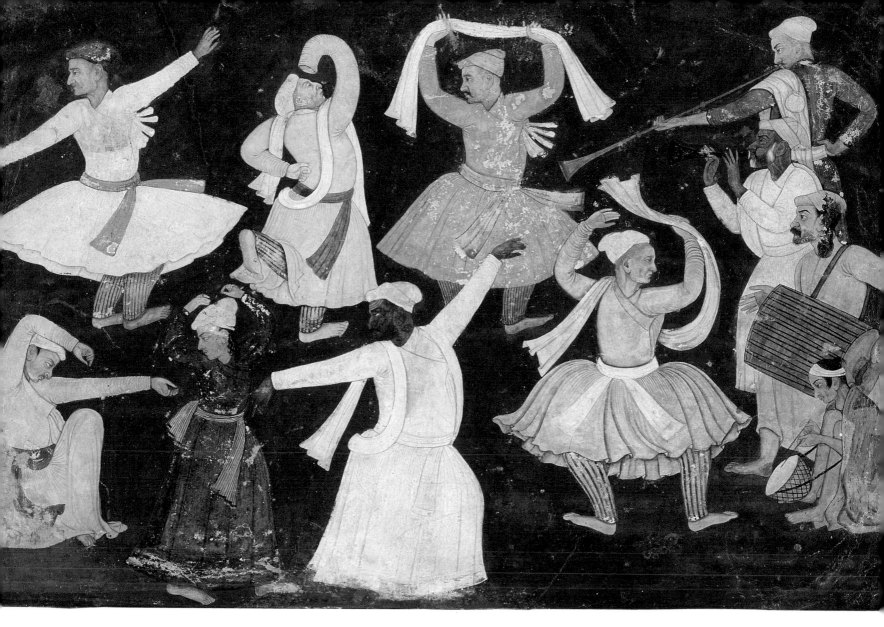

104 Villagers in ecstasy

105 Female ascetics in a landscape

The painting comes from Guler, one of the great centres of Pahari painting in the foot-hills of the Himalayas. It was probably by Pandit Seu who lived between c1680 and c1740. He was from a carpenter-ironsmith caste and his family were painters as were his descendants (Goswamy and Fischer, 1992, 212-213).

105 Female ascetics (yogini) in a landscape

North India, Imperial Mughal; c1625; 32.15 x 24

Navin Kumar Gallery, New York

In this painting a group of yogini, stand listening as one of them sings and accompanies herself on a four-stringed plucked instrument, a tambura. Their simple white clothing, covered by diaphanous muslin, stands out against an uncluttered landscape. Its gentle hillocks stretched horizontally across the upper part of the painting help concentrate attention to the middle field in which the yoginis are standing. They are the main subject of the painting and nothing is allowed to distract attention from them, joined together as they are in concentration on the music and its religious meaning. The approach reflects the curiosity of the Muslim rulers about the religions of the subcontinent, not least its yoginis (for other examples, see Pal, 1993, 320-321).

This painting contains a Persian text which has embedded in it a reference to the artist Kesu. The text may be a later addition as the painting seems to bear little relation to the work of the great Mughal painter of the same name.

106 Prince and ascetic listen to music

A page from the Late *Shahjahan* album by Govardhan (fl. c1600-1660)

Imperial Mughal; c1630-1640; 20.3 x 14.3

The Cleveland Museum of Art; Andrew R. and Martha Holden Jennings Fund

Through its three figures, this painting summarises the Mughal fascination with the Hindu ascetic. A sadhu plucks at a *rudra vina* and sings. The dominant figure is an ascetic whose austere life is indicated by the conch shell and water container beside him. The prince, somewhat idealised, was perhaps loosely modelled on the son of the Emperor Shah Jahan, Dara Shikuh, who had a long involvement with ascetics (Leach, 1986, 96). However it is the hermit who dominates and has knowledge as suggested through the quality of his portrait and by the overall composition, itself showing European influence in its perspective and figure drawing. This peaceful and serene painting, which blends portrait and landscape brilliantly together with the idea of the mood of music into something more than the sum of its parts, has been ascribed to Govardhan, one of the greatest of the Mughal court painters of the seventeenth century. The son of a painter in Akbar's court, he painted for Akbar and his successors, Jahangir and Shah Jahan. and was noted for his portraits of holy men, dervishes

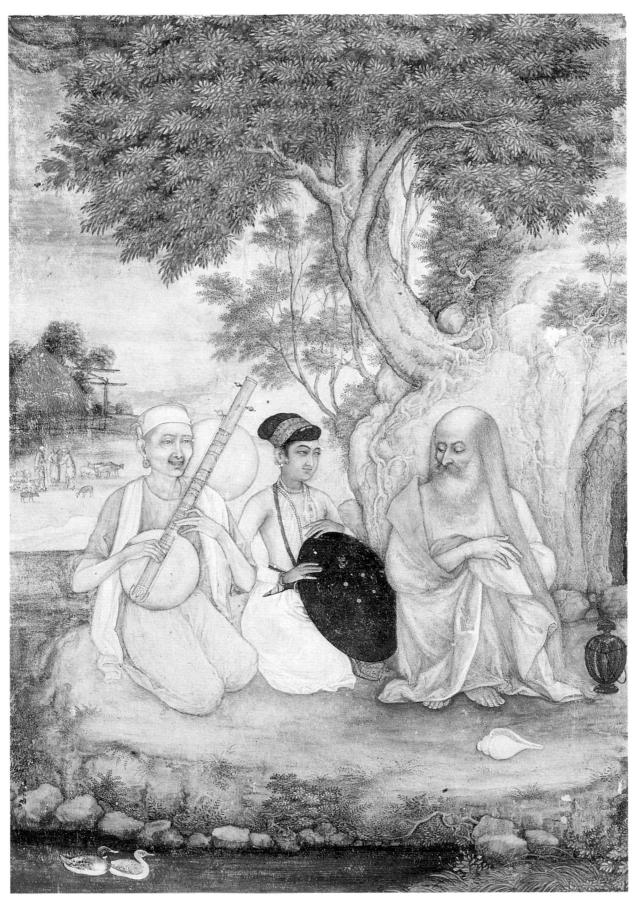

106 Prince and ascetic listen to music

and ascetics although he did paint numerous other subjects. (Okada, 1992, 196-197). The marginal figures that constitute the border frame of the painting are attributed to another equally distinguished Mughal artist, Payag. (Beach, 1978, 72-3).

107 Mughal prince visits Hindu ascetics
North India, Imperial Mughal; 1685; tinted drawing; 19.1 x 13.3
Victoria and Albert Museum, London

A Mughal prince, appropriately haloed, sits on the ground, watching four sadhus encamped around a fire underneath a sparsely leafed tree. As always with Mughal painting, each sadhu has a distinctive persona though here all are followers of Shiva as indicated by their beads and forehead markings. One has a long beard and even longer strands of hair that presumably have not been cut since he became a sadhu. His emaciation contrasts with another whose fatness is sharply delineated. The prince is positioned a little apart from the group, observing them. In worldly terms he is the most important, but in pictorial terms it is the elongated sadhu who is central. The prince has a place in the scene as one who searches after a knowledge which the sadhu possess. Hence were Akbar's attempts to establish a religion which synthesised various religious notions and also Dara Shikuh's similar search for religious commonality a half century later.

108 Group of ascetics before a hut
North India, Mughal; 18th century; 40.3 x 26.6
Victoria and Albert Museum, London; gift of Colonel T.G. Gayer-Anderson, CMG, DSO, and his twin brother, Major R.G. Gayer-Anderson, Pasha.

This and the two previous paintings exemplify the Mughal encounter with Hindu ascetics, those Hindu wanderers who took vows of poverty and abstinence and who practised austerities in order to achieve religious salvation. They moved together in groups from place to place in a world of their own, setting up camp in the wild, beside a stream, underneath a tree, beside a cave. Music was an expression of their search and one of the ways of achieving the objective, as illustrated in this late Mughal example where each sadhu is a distinctive personality, not an alien, stereotyped other.

The genre began with Akbar and continued for some two centuries. (For other examples see Pal, 1991, 14-16 and 130-131 and Welch,1978, 24-5). The interest may have been an echo of the Persian notion of the ruler's search for wisdom but was also part of the same curiosity that drove the Mughals to commission depictions of the strange world they had conquered and to try and understand its religious ideas.

107 Mughal prince visits Hindu ascetics

108 Group of ascetics before a hut

MUSICAL INSTRUMENTS AND MASKS FOR DANCERS

Reis Flora

This section presents a selection of musical instruments that complement the variety of instruments and performance contexts illustrated in the other sections. In addition to the value for music history of musical instruments and the performance of music and dance being illustrated in visual art, a musical instrument is in its own right an artefact. It often carries important cultural and historical information. In this instance, it serves as a medium through which a variety of cultural ideas and values may be given visual expression. Additionally, visual ornamentation *per se*, for the sheer delight of it, may also find expression on a musical instrument. The musical instruments here amply illustrate both of these aspects – cultural ideas and values, and delight in visual ornamentation. Nineteen musical instruments are discussed in eight groups according to type.

109 **Three hand bells (ghanti)**
a) Bell with Shiva's bull
South India; 19th century or earlier; brass; 33
Private collection

b) Temple bell with Vishnu's Garuda and monkeys
North India; 18th century; bronze; 38.1
Art of the Past Inc, New York

c) Bell with Hanuman
North India; last half 19th century; brass; 30.5
The Metropolitan Museum of Art, New York; Crosby Brown Collection of Musical Instruments, 1889

Something inherent in the sound of a bell seems to inspire reverence and worship. One is reminded, for instance, of the very large bells found in Buddhist temples in Japan and Korea or the large cathedral bells of Europe. The many bells in Indian temples also have the same aura. The visitor to a temple complex is immediately aware of the continual ringing of bells as devotees arrive and depart, ringing large and medium hanging bells (*ghanta*) generally, and similarly before particular shrines. Additionally, smaller hand bells (*ghanti*) are also used by priests during specific times of *puja*. This worship may occur in the public domain of the temple, or in a more private ceremony at home before the household shrine.

109a Bell with Shiva's bull

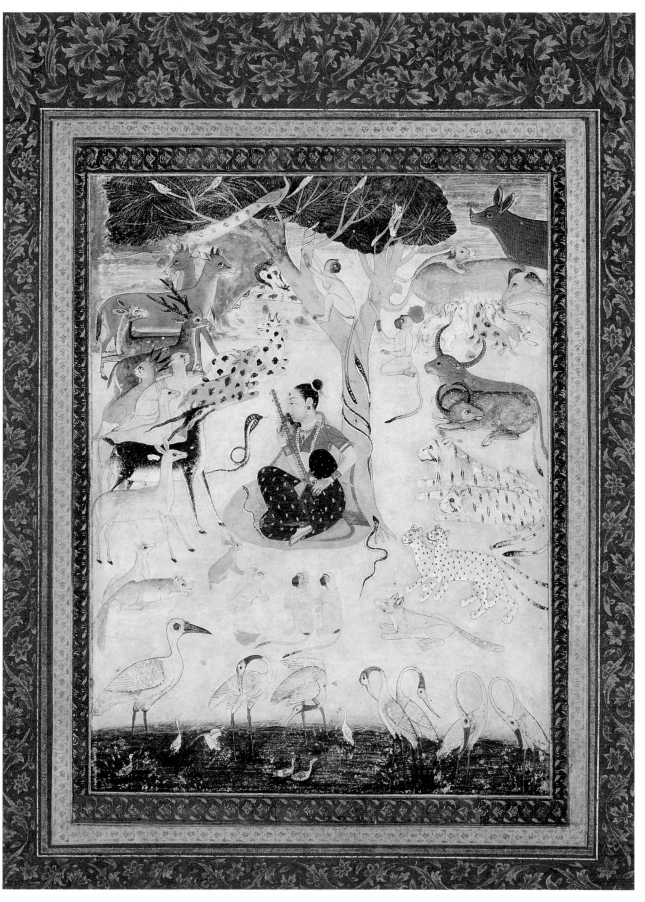

200 The attractions of music

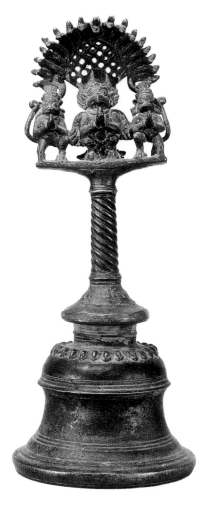

109b Temple bell with Vishnu's Garuda and monkeys

The three hand bells represent and symbolise different aspects of the rich complex of Hinduism. The handle of one bell displays Nandi the bull, the vehicle of Shiva. The handle of another bell shows the bird Garuda, the vehicle of Vishnu, together with two monkeys. The handle of the third bell consists of a finely wrought figure of Hanuman, the famous monkey general who led the army that helped Rama rescue Sita from Ravana. The body of this bell is richly engraved with additional figures and floral designs.

110 **Conch shell trumpet (sankh)**

Kerala; 19th century; shell and brass; 23 x 42.5

The Metropolitan Museum of Art, New York; gift of the Barrington Foundation Inc, 1986

The conch shell trumpet has a long history in India. The name appears very early in the *Atharvaveda* of c1000BCE. The *sankh* is represented in iconography as early as the second century BCE in sculpture from Amaravati in South India. Early representations show the instrument with what appears to be a relatively long insufflation tube.

In early times it was sounded at the commencement of battle. Many deities are associated with a specific conch trumpet with a distinctive name, as are the main opposing protagonists in the great epic *Mahabharata*. These days the rich resonant sound of the conch is an important element of Hindu ceremony, worship and festivals. Additionally for the Hindu, the conch is important as a vessel for holding sacred water.

When a conch is fashioned into a trumpet in India, on most instruments the end is cut off and polished. This end serves as the mouthpiece. Outside India the mouthhole is fashioned into the side of some conch trumpets. In both types the conical bore of the internal spiral gives ample scope for producing a loud resonant pitch.

This instrument shows two additions. Firstly, a simple conch is fitted at the tip of its spiral with a moderately extended mouthpiece in the form of a stylised lotus. This device will lower the basic pitch of the conch. Secondly, at its distal or open end, the instrument is fitted with an elaborate brass ornament. Unlike the extended mouthpiece, this addition has no musical function. On this instrument the distal ornament features several symbols associated with Hinduism, more particularly with Shiva: snakes (*naga*), the face of glory (*kirtimukha*), and *yoni* and linga (symbols respectively of female and male principles). This magnificently decorated conch terminates with a dramatic *makara* spewing forth a vegetal design. It is surmounted by an elephant/lion monster (*yali*), and at the upper edge of the shell opening are situated three protrusions: a lingam, Ganesh, the elephant-headed deity, and Shiva's vehicle Nandi, the bull. The conch rests on a tripod with hooved feet representing a linga with a face (*mukhalingam*), which is engraved in a protrusion.

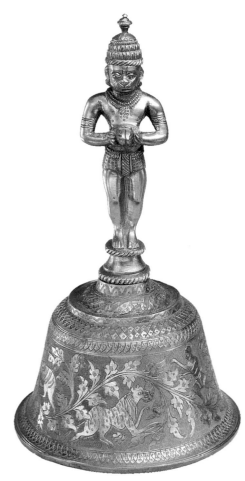

109c Bell with Hanuman

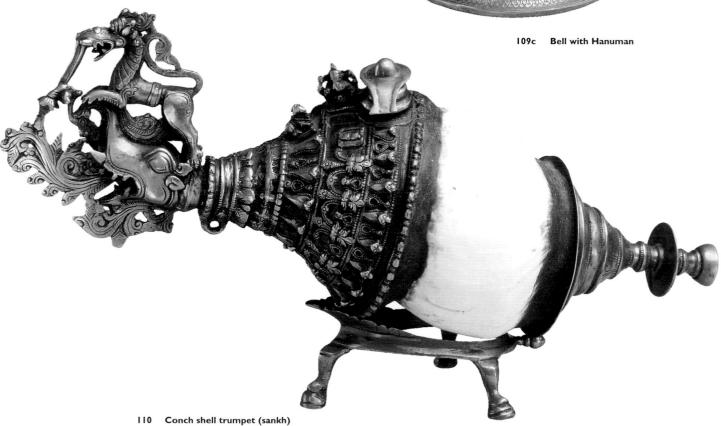

110 Conch shell trumpet (sankh)

111 Two tamburas

a) Pandharpuri tambura

South India or Maharashtra; 19th century; gourd resonator, wooden
soundboard, metal strings, ivory inlay; 94

The Metropolitan Museum of Art, New York; gift of Mr and Mrs Sidney Bressler,
1994

b) Tambura with inlay

South India; 20th century; wooden soundboard, metal strings, ivory
inlay; 101.9; manufacturer's emblem (small metal plate with the image of the dance
of Shiva) on peg box

The Metropolitan Museum of Art, New York; gift of the Todes Family, 1986

During the last four centuries the tambura has been fundamental in providing the
very important drone pitch of classical music. A slightly different tambura is widely used in
folk music as well. In classical music the tambura has been used to accompany a solo vocalist,
or a musician playing a stringed instrument or a flute. The presence of a drone instrument,
however, has not always been necessary. According to B.C. Deva, the drone, a constant
sounding pitch in Indian music, so capably provided by the tambura, is a relatively recent
phenomenon from five or six hundred years ago. This view is supported by research by
Richard Widdess, and re-affirmed by Bonnie C. Wade who has concluded from a study based
on Mughal miniatures that only 'at the beginning of the seventeenth century did the
continuous drone become a definite component in the performance of North Indian classical
music' (1996, 65).

These two tambura are exceptional due to their visual ornamentation, especially
on the wooden soundboard and the neck. Another notable feature of each instrument is a
wide, rectangular bridge which is slightly curved across the width of its surface. Often a
short thread of cotton is placed between the metal string and the bridge at a crucial point
that maximises the complex tone quality desired. This type of bridge, also an important part
of other stringed instruments in Indian tradition, produces a rich drone sound characteristic

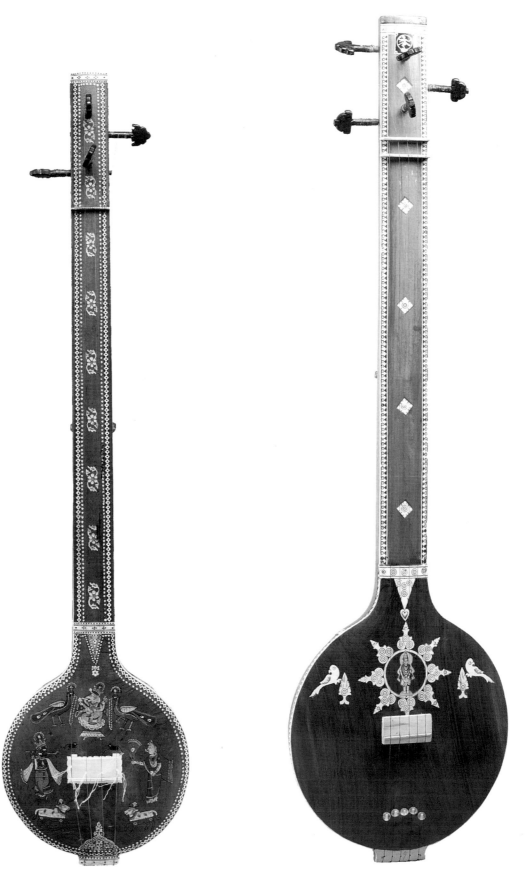

111a **Pandharpuri tambura**

111b **Tambura with inlay**

of Indian music. The all-important constant pitch or sound (*nada*) of the drone, continuous and unchanging through time, is an aural representation or manifestation of the concept of Brahman, that in the universe which is permanent and does not change. The tambura provides *Brahma-nada*, the source of sound from which pitch variety and different measurements of time emanate.

112 **Bin**

North India; late 19th century; wood, metal; 126.5
National Gallery of Victoria, Melbourne; presented to the Melbourne
International Exhibition by Raja S.M. Tagore, Mus. Doc; Companion of the
Order of the Indian Empire; Founder President, Bengal Music School, 1881

This instrument was sent to Melbourne in the late 1870s by Raja Sourindo Mohun Tagore of Calcutta. It is part of a large group of Indian musical instruments donated by Tagore, together with several books about Indian music, to the Melbourne Philharmonic Society. Though clearly not a professional instrument, it nonetheless shows the basic elements of the *bin* of North India This type is depicted in many miniature paintings from the sixteenth century onward. Tagore's purpose in sending musical instruments and books about Indian music to Melbourne and various institutions in Europe and North America was to disperse information about what to him was Hindu music. His activities were part of the larger picture of the Bengali renaissance of the nineteenth century.

In showing the basic features of the *bin*, the crux of the instrument consists of a long hollow tube, to which two large gourd resonators are attached, one at each end. Another important feature is the wide curved Indian bridge, also seen on the tambura, and underneath certain sympathetic strings on the Hindustani *sarangi*. Each of the nineteen frets on this *bin* is secured to the tube by a string fastened around the back. Though this manner of attaching frets is used on the sitar, on a professional *bin* the frets are permanently set in wax. More realistic is the rather complicated bridge arrangement at the lower end of the instrument. The main bridge is mounted onto the back of a piece of wood carved as the chest and head of a bird, often a peacock. This bridge is used by the main melody strings. Similar but smaller bridges on each side, imitating the 'wings', serve the three extra strings. They are used for reinforcing the drone pitch, and for rhythmic punctuation. All three bridges have the gently arched surface common in the South Asian tradition, which provides a distinctive tone quality. The *bin* is associated historically with Mughal court music, especially the majestic *dhrupad* style of performance. Though the *bin* is not as much in vogue these days as earlier, its tradition is still maintained and supported by dedicated musicians and connoisseurs.

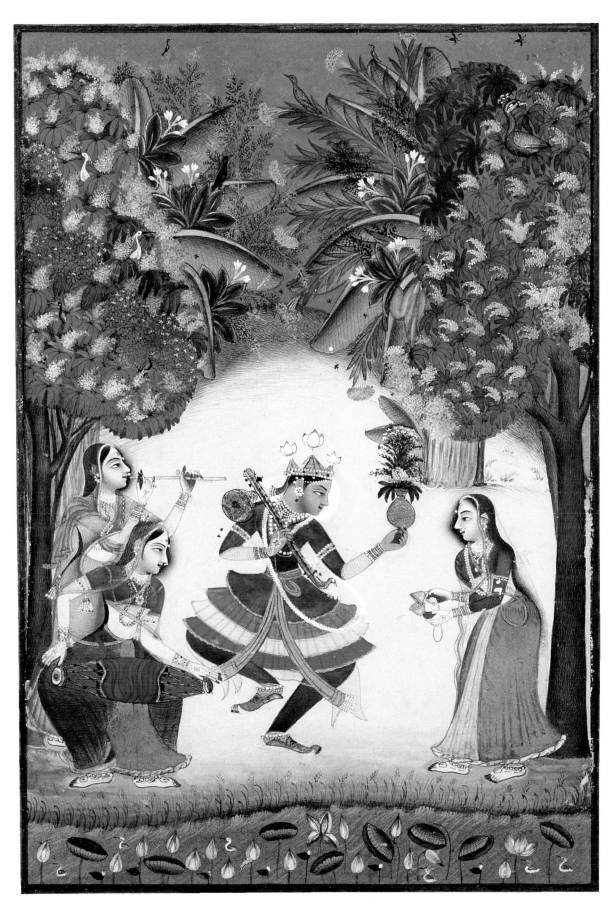

184 Vasant ragini

113 **Two drums**

a) Karam

Assam, North Cachar Hills, Kacheri people; mid-20th century

wood, deer skin heads; 80

Australian Museum, Sydney

b) Pakhavaj

North India; late 19th century; wood, leather; 58

National Gallery of Victoria, Melbourne; presented to the Melbourne

International Exhibition 1880-1881 by the Raja S.M. Tagore, Mus. Doc;

Companion of the Order of the Indian Empire; Founder President, Bengal Music

School, 1881

It is reasonable to assume that drums were played in South Asia from the earliest times of recorded history and even earlier. A small representation from the ancient Harappan culture (c2400-1700BCE) shows a figure playing a relatively elongated double-headed drum before a large ferocious animal, probably a tiger. Names for various types of drums appear in Vedic literature of the subsequent epoch, and numerous types of drum are consistently represented in Indian iconography from the late centuries BCE onward. Drums are played in a great variety of contexts in India today: ritual music, processional music and as an accompaniment to dance, whether of 'classical', folk, or tribal origin. According to evidence in iconography and data from Sanskrit texts, the important musical role accorded to drums in India has a very long tradition.

The two drums in the exhibition represent opposite ends of a notable continuum. The *karam* of the Kacheri tribe in East India, dramatic in its elongated shape and in the simple manner with which the two uncomplicated heads are laced by thong onto the drum body, has very probably assisted in numerous communal dances and festivities. The diameter of one drumhead is slightly smaller which seems to link the *karam* morphologically to the *madar* (*madal*) type found in other parts of India. The *pakhavaj* of North India, by comparison, is shorter, and has composite heads, with a tuning paste permanently attached to the right drumhead. Solid spools inserted beneath the lacing assists in controlling the pitch of the instrument. The *pakhavaj* may be perceived as the northern version of the South Indian *mridangam*. In recent centuries the *pakhavaj* has been associated with the august *dhrupad* genre of the Mughal courts and subsequent court traditions. Its sound is deeply resonant and majestic, quite different from the well-known pair of North Indian drums known as the tabla. The *pakhavaj* appears in miniature paintings accompanying a singer who is usually entertaining a royal patron.

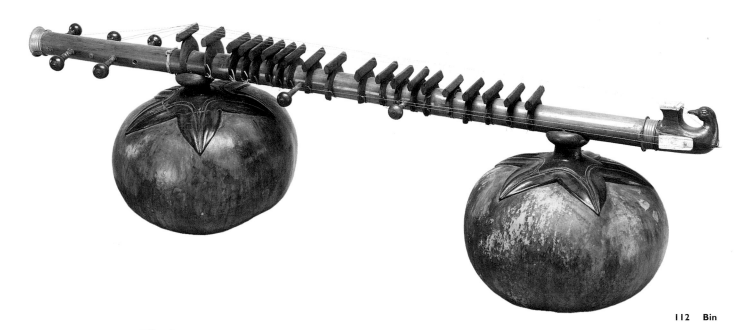

112 Bin

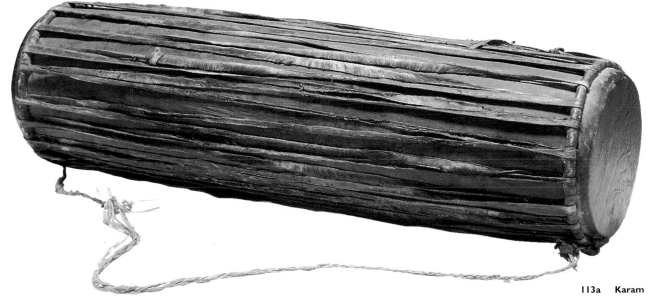

113a Karam

183

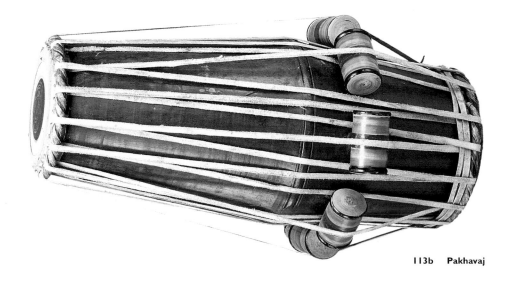

113b Pakhavaj

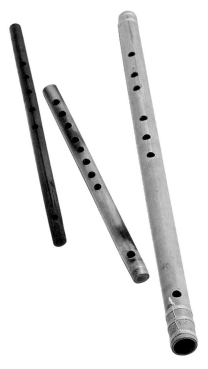

114c,b,a **Three bamboo flutes**

114 Three bamboo flutes

a) Bansuri

North India; 20th century; 76.5

Reis Flora Collection, Melbourne

b) Venu

South India; 20th century; 36.4

R. Suthanthiraraj, Sydney

c) Methium

Assam, North Cachar Hills, Haflong, Zemi Naga tribe, Impoi village; 46

Australian Museum, Sydney

The bamboo flutes of India are magnificent in their visual and morphological simplicity. The material itself is naturally hollow. All that is needed to fashion a flute is to cut out the embouchure or mouth hole, and the fingerholes. A natural node or an inserted plug closes the upper end of the instrument. The length of the tube determines its fundamental pitch. Nothing could be more simple and effective as a musical instrument.

The air inside the tube itself is the source for musical vibration. No other source of vibration exists, as with other instruments, such as a taut string or membrane, or an item of metal or wood. The air column is activated very simply, when the breath of the musician is directed at the sharp edge of the embouchure. There are no intervening accoutrements between the musician and the vibrating column of air. Such a direct relationship to the essence of musical activity is very appealing. For some it may even have deep mystical meaning. It increases one's sense of being in direct, uncomplicated touch with a mysterious and wondrous phenomenon.

Additionally in Hinduism, the breath and the control of breath carries profound meaning. At a subtle level, the bamboo flute and its sound are visual and audible symbols of existence itself. At another level, however, the sound of the flute a calls forth strong memories and images of a simple, idealised, and romantically blissful life, as is associated with the lifestyle of village India. Both the religious ideas concerning the breath and the ideal of a relatively uncomplicated and natural rural life are brought together in the most famous player of the flute in India, the divine cowherd, Krishna.

Before this image emerges in Indian culture, however, the transverse flute is to be seen in the earliest iconography of India, at Amaravati c200BCE in the South, and at Gandhara a few centuries later in the northwest, and elsewhere. Even very much earlier, small terracotta flutes in the shape of a bird, and other terracotta vessel flutes as well, have been excavated from the Harappan civilisation (c2400-1700BCE). The sound of the flute has been in the air for a long time in India.

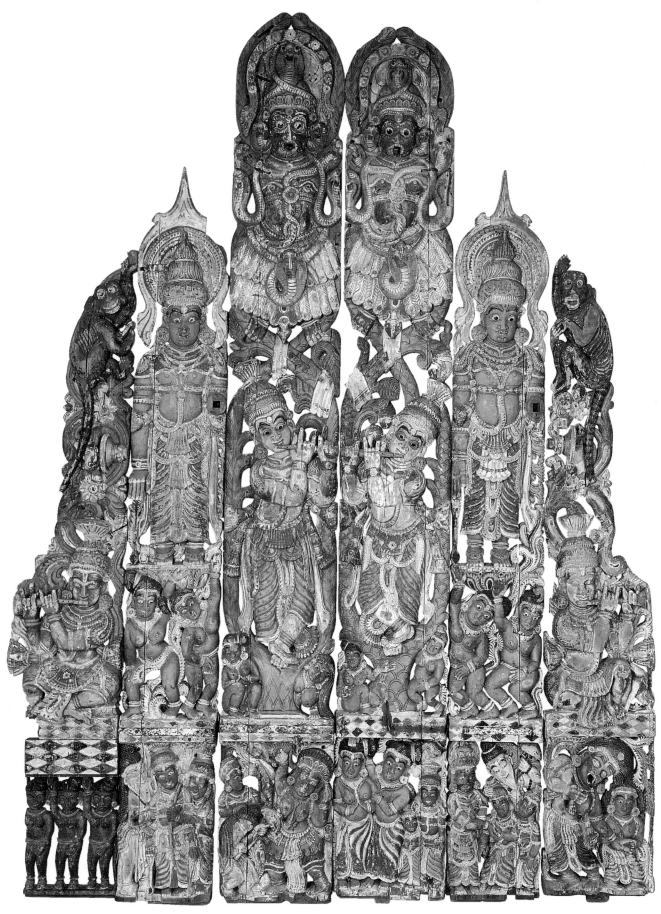

37 Screen with Vaishnava themes

The largest of these three transverse bamboo flutes (a) is from North India and is played in classical Hindustani music. Though a bamboo flute such as this is notably simple and straightforward, it is capable of obtaining all the notes and ornaments of raga music in India. This is accomplished by breath control, by a slight change of the position of the flute where it is held to the lips, and by very subtly controlling the opening of the fingerholes.

Concerning the other two flutes, the flute of classical Karnatic music in South India is smaller, and thus its fundamental level of pitch is higher. This flute is often played in the ensemble that accompanies Bharata Natyam. The *venu* is also used in a solo instrument in Karnatic music.

In the remote northeast, the *methium* of the Zemi Nagas attests to the use of the bamboo flute in a region of India far distant from the core of the Great Tradition. Its proximal end is naturally closed by a node of the bamboo tube. Minimal serrations around the distal end of this flute link it visually with the stringed instrument of the Zemi Nagas [116a].

115a Trumpet / bugle (muri)

115 Two trumpets

a) Trumpet/bugle (muri)
Assam, Mikir tribe; mid-20th century; wood with thread binding; 23
Australian Museum, Sydney; presented by Sir Iven Mackay, 1948

b) Hunter's horn (tori)
Madhya Pradesh, Bastar district; 19th century; bronze; 39.5
Dr Leo S. Figiel, Florida

The Sanskrit name for a trumpet made of horn, *sringa*, is found in the *Rigveda*, dating from c1500BCE. Since that time, and very probably even earlier, curved horns and straight trumpets no doubt have been used in a variety of contexts in India – in battle, as signals, for festival celebrations, and in religious and secular processions. Trumpets of various types may be seen in Indian iconography from approximately 200BCE. The type indicated in early iconography appears to be the shell trumpet. In more recent times, long straight trumpets known as *karna* are seen in many Mughal miniatures. The *karna* was an integral part of the royal *naubat* instrumental ensemble as depicted in [146] and [147].

The *naubat* also used a curved trumpet, which one Mughal source describes as 'of brass made in the form of a cow's horn'. Another type of curved horn in India is made in the shape of an 'S'. Today the *panchavadyam* ('five instruments') ensemble of Kerala includes a C-shaped metal trumpet known as *kombu*.

The straight and very short wooden *muri* of the Mikir people of Assam presents a dramatic impression. Clearly showing a widely flared conical bore, externally the *muri* is carved into several distinct contrasting ornamental sections. The projecting and pointed decorative rays near the middle of the instrument appear to be unique in the very large

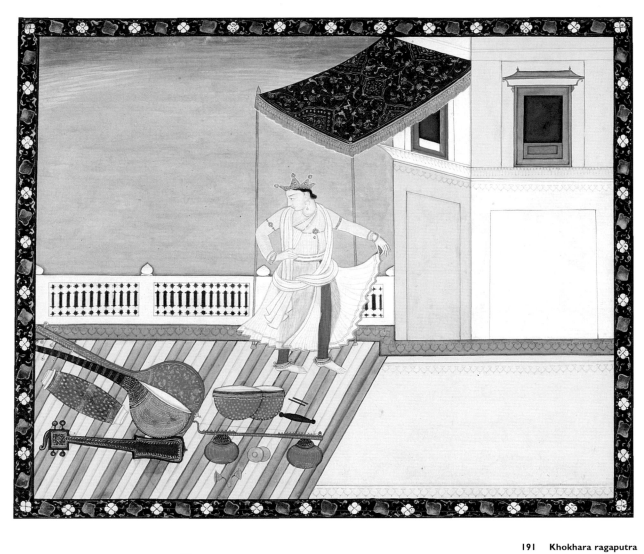

191 Khokhara ragaputra

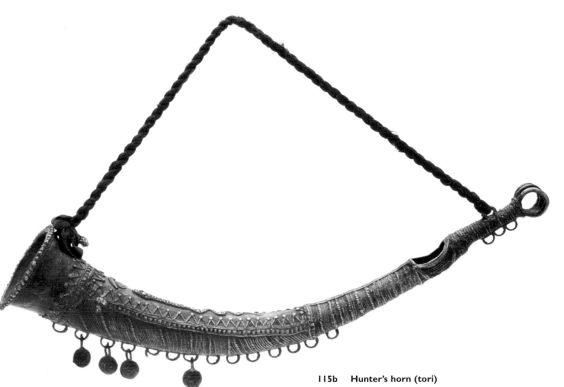

115b Hunter's horn (tori)

187

worldwide family of trumpet-type instruments. Its short length ensures that it produces a very high pitch. String is wrapped for several turns around the larger end. Though documented as a 'trumpet/bugle', it is possible that this item may be an elaborately ornamented distal section or flared 'bell' that was originally attached to the end of a narrow reedpipe. The Khasi in Meghalaya (formerly Assam) play a reedpipe known as *ka tang-muri*. *Muri* as a term seems to link the Khasi reedpipe and this item. It is possible that *muri* may be a regional term for wind instruments in general, which is also used specifically in some instances.

The curved metal *tori* of the Bastar district in Madhya Pradesh, also showing a conical bore, possibly dates from the nineteenth century. In imitation of a naturally curved animal horn – various examples of animal horns are also blown in some parts of India – it is made by the lost wax process. Small pellet bells hang from rings on the outer side of the instrument. A cord is also provided. As the mouthhole is fashioned in the inner side of the gently curved shape, the instrument is held transversely. Nonetheless, this instrument is still a trumpet in the technical sense, as buzzing lips cause sound vibration. It is side blown, not end blown. The ornamentation on the *tori* is elaborate and diverse. The *tori* is used by bachelors of the Muria people as part of the *gothul*, a socio-religious institution within Muria society.

116 **Five bowed musical instruments**
 a) Tingrabung
 Assam, North Cachar Hills, Haflong, Impoi village of Zemi Naga tribe;
 early-mid 20th century;
 coconut resonator covered with skin, laced with wicker, serrated wooden neck; 54
 Australian Museum, Sydney; presented by Sir Iven Mackay 1948

 b) Two single-stringed musical instruments (dhodro banam)
 Santal tribe, Bihar; mid-20th century; wood; 76 and 77
 Dr Siddharth Bhansali, New Orleans

 c) Sarinda
 Bengal, c1900; wood, metal; 73
 Inscription in Bengali: Sri Naba Kumar Sakar
 Plaque with inscription of maker: Rakhal
 Private collection

 d) Sarangi
 North India; c1970; wood, steel strings, goat skin; 89
 Department of Music, Monash University, Melbourne

The topology of stringed instruments played with a bow in India is interesting and complex. Any particular instrument will belong to one of three streams: the violin-type, those

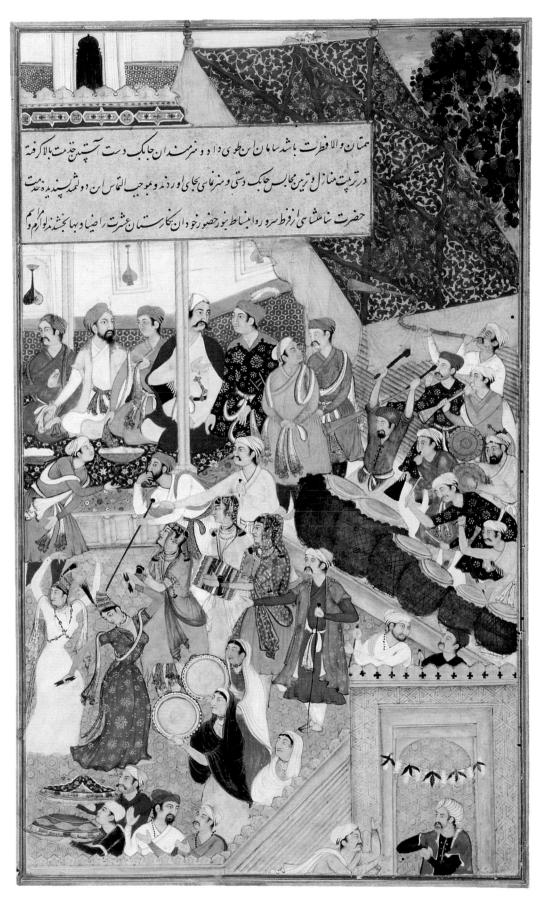

147 Celebrations at a royal wedding

116a Tingrabung

played vertically and the spike-fiddle type. The violin, a foreign arrival of relatively recent times, is now played in both Karnatic and Hindustani music. The two other basic types, each representing an older tradition, are illustrated by striking examples here. The shape of instruments played vertically is markedly unlike that of the violin. In this type the resonator is low, and the neck of the instrument, generally relatively wide and often short, is above. The instrument is often carved from a single piece of wood. The other type, known in general by the term 'spike fiddle', is relatively simple in construction and considered to be the oldest type. The vertical type, which is illustrated frequently in miniature paintings of the early seventeenth century, arrived in India overland from the northwest, and is the next oldest.

In the spike fiddle a separate neck, usually relatively long and thin, often a length of bamboo, pierces a round or hemispherical resonator, which is often made of coconut shell. It is held in a horizontal position with the resonator at a mid-chest level. The instrument from the Zemi Naga tribe of North-east India in the exhibition is a rare example consisting of a hemispherical resonator of coconut pierced by a long stick that serves as the neck. The resonator is covered with skin, possibly from a lizard, which is lashed to the coconut in an elaborate pattern with thin rattan. The resonator has a central hole at the back, and a smaller hole a short distance away from this. A string of animal hair is secured to the instrument at each end by a cotton thread. At the bottom the inverted V-shaped thread is attached to the neck that extends through the resonator and protrudes out the other side. At the opposite end, the thread is tied through the lower of two dorsal holes in the neck. Presumably this thread may be adjusted to change the basic pitch of the instrument. Some instruments of this type do not use a bridge, and the bow of this instrument is missing. The serrated edge of the neck, which is decorative and links the instrument with the flute of the Zemi Nagas in the exhibition, has no musical function.

The remaining four instruments all belong to the vertical category. Each is dramatic in its own way. Perhaps the simplest of these is the Santal instrument with the anthropomorphic pegbox [116b, right hand illustration]. The neck of the instrument, carved with two lizard-like animals facing each other, corresponds to the neck of the figure. The roughly rectangular resonator of the instrument corresponds to the body of the figure. The shape at the front of the upper part of the resonator suggests arms. The lower portion of the uninterrupted hollow body is covered by skin nailed laterally by small wooden pegs. The bridge of this instrument and its bow are missing.

The other Santal instrument is elaborately decorated with carved figures. Several occur on top of the instrument, one on each shoulder, and two more in the interior of the upper part of the resonator. The pegbox is cube shaped, with incised ornamentation. It contains holes for a single lateral peg. The resonator appears to represent a human body, as arms are carved on the two sides of the upper part. The instrument has a deep waist and a tear-

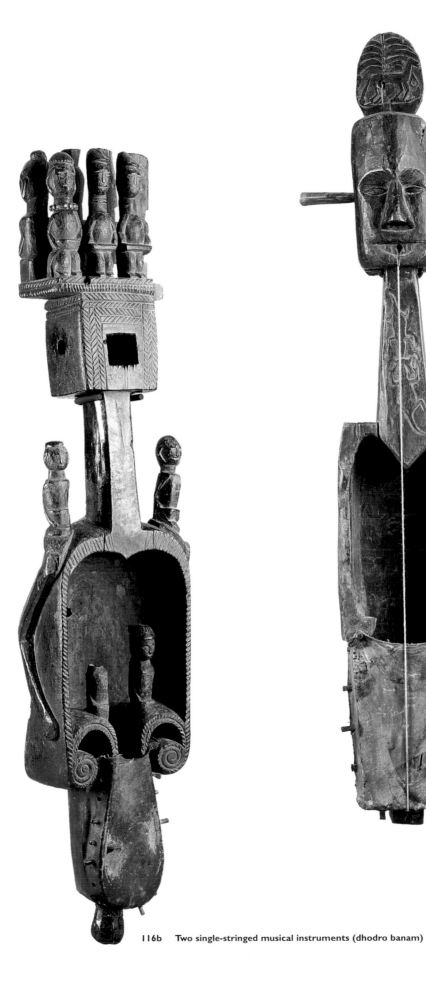

116b Two single-stringed musical instruments (dhodro banam)

drop outline below. Both of these morphological details are identifying features of the *sarinda* sub-class within the vertical family, noted subsequently. Thus, compared with the general rectangular appearance of the lower part of the resonator on the first Santal instrument, which is characteristic of several other Santal *dhodro banam* as well, the second Santal instrument shows very strong influence from the *sarinda* type. It appears that specific concepts about musical instrument construction from two different traditions – *dhodro banam* and *sarinda* – are combined here into one musical instrument. As on the other Santal instrument, skin covers the lower part of the resonator, and is secured laterally by small wooden pegs. The bridge, bow and string of this instrument are missing. Though these two Santal instruments are similar at a fundamental level – both are single-stringed vertical instruments played with a bow – their differences no doubt reflect important ethnographic data.

In the *sarinda* type the resonator is shaped into two clearly defined parts by a central waist as on the Bengali example here (c). The resonator of this type is also deeply convex along its anterior line. The lower part, the frontal outline of which is roughly in the shape of a tear drop, is covered with skin, on which the bridge of the instrument is positioned. On the *sarinda* here, only remnants of the original parchment covering the lower part remain. The upper part is notable for the very large bird mounted on top of the pegbox, an important feature of the *sarinda* type in the eastern regions of India. A crest seems to clearly identify this bird as a peacock, elaborately decorated with attached metal to highlight the beak, eyebrows and eyes. Incised feathers appear on the metal wings. On this Bengali instrument, three mechanical tuning devices have been attached for three strings. This feature seems to be a later modification. Holes in the pegbox to accommodate three lateral pegs, as might be expected on this type, have been filled with wooden plugs. This number of strings appears to be the norm in eastern India. The name 'Sri Naba Kumar Sakar' appears in Devanagari script across the top of the left of the resonator on the outside. Missing are the bridge, three strings and the bow.

The *sarangi* used in Hindustani music is the most complex of the vertical instruments that are bowed. Its resonator is completely covered with skin. Over the years its waist has become asymmetrical. By comparison, many folk *sarangi* of regional traditions retain a symmetrical appearance. A notable feature of the Hindustanis *sarangi* are the three playing strings of gut, tuned to the lower tonic (*sa*), and the fifth above (*pa*), and the basic tonic an octave above the lowest string. Equally notable are the numerous sympathetic strings, up to thirty-seven on some instruments. These strings, which vibrate to complement the music played on the melody strings, assist in providing the characteristic sound of 'a hundred colours' (*sarangi*) for which the instrument is justly famous. The thin main bridge mounted on the resonator is a feature of stringed instruments in Asian regions northwest of India. Notwithstanding its stylised elephant shape on the *sarangi*, this type of bridge suggests an

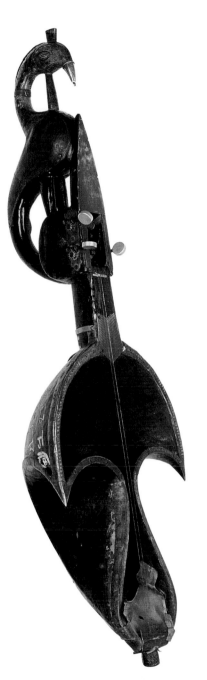

116c Sarinda

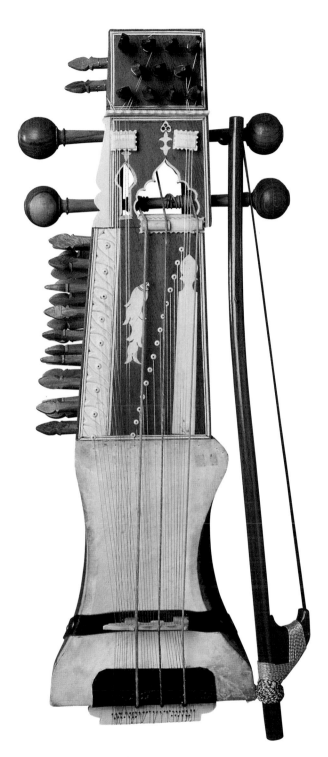

116d Sarangi

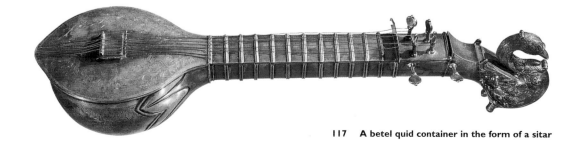

117 A betel quid container in the form of a sitar

origin for the *sarangi* type outside the subcontinent. By comparison, the two wide bridges at the top with their slightly arched surface are clear, additional evidence of the Indianisation of this Hindustani version. Once again, two different construction concepts are combined in one musical instrument. In this instance the two concepts represent two quite different approaches of how a string should be strung onto an instrument at the crucial point of contact with a bridge – across a narrow bridge or across a wide bridge. From this point the vibration of the string is transmitted to the resonator of the instrument. In general, a thin bridge identifies a Central Asian or a West Asian approach. A bridge with a wide and slightly curved surface identifies the Indian approach.

Earlier versions of this type of instrument may be seen in miniature paintings. When a musician is standing while playing, the instrument rests in a large sash at the waist of the performer. One will also observe the *sarangi* being played by both females and males. Males generally play this instrument today, in Hindustani raga music and in various regional traditions. The meaning of both genders being depicted playing *sarangi*-type instruments in miniature paintings still awaits scholarly interpretation. Within various court traditions of North India, the instrument has been used historically as part of an ensemble that accompanies dancing, and more recently, solo vocalists. During the twentieth century the *sarangi* has become a solo instrument in its own right, thanks to the unusual talent of several outstanding *sarangi* masters.

117 **A betel quid container in the form of a sitar**
Oudh, Sub-imperial Mughal; early 19th century; silver with gold gilding; 11 x 50
Kapoor Galleries Inc, New York

This unusual utensil contains elements of both fantasy and reality. That is its charm. Perhaps the unrealistic gander at the top of the sitar is meant to allude to one or two more subtle aspects in Indian culture. The gander (*hamsa*) is the vehicle of Brahma and Sarasvati [45-47]. Additionally, in exercises of breath control, the sound of inhalation and exhalation are thought to respectively articulate *ham* and *sa*. The word thus refers to the breath of life itself.

These possibilities for the presence of the gander aside, other aspects of the betel quid (*paan*) container are nearer to reality. The realistic, wide neck shows the frets of the sitar attached by thread around the back. This feature allows frets to be adjusted higher or lower on the neck depending on the basic notes of a particular raga chosen for performance. Another element of this novelty, however, is quite ambiguous. Though both dorsal and lateral pegs are used to secure the melody strings at the top of a sitar, their configuration is different from that seen here. Strings are provided with this sitar-like container, providing an element of realism. Nonetheless, they are not taut, and their configuration is also different on a real sitar. The shoulder and leaf arrangement of wood that appears where the neck of the sitar

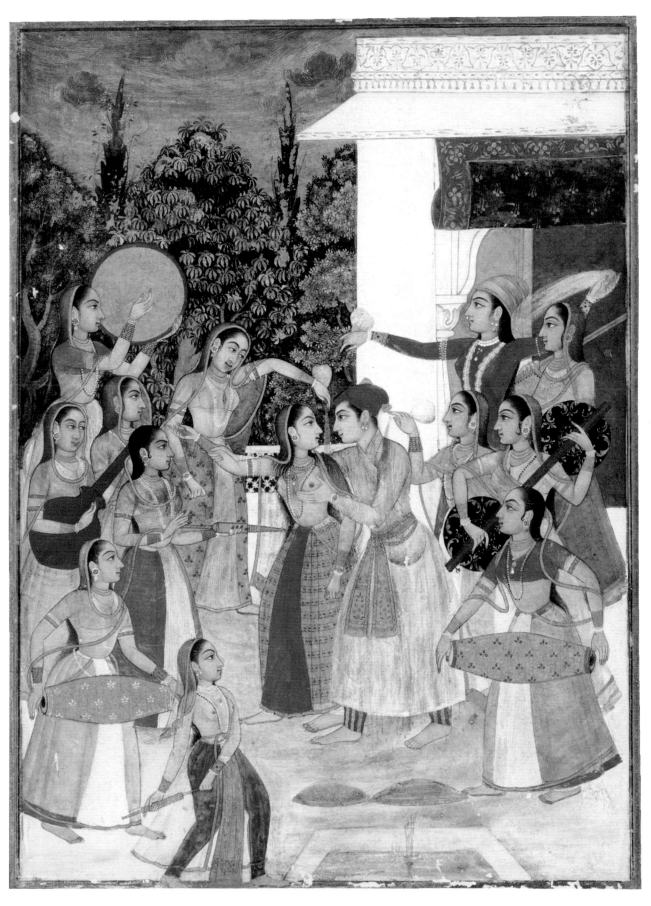

158 Prince celebrating Holi

joins the gourd resonator is suggested, but unrealistic in details. Finally, an image of the wide rectangular bridge of a sitar is present. Such a bridge is necessary for providing the rich vibrant sound characteristic of this instrument. Again, however, the details are unrealistic.

It may be argued that an analogy exists between the great variety and subtle tastes of paan and the great variety and subtle sounds and ornamentation of different ragas. One is very pleasing to the taste buds, the other to the ears.

118 **Durga mask**

Orissa, Chhau; early 20th century; papier mache, paint, plastic beads and tinsel; 94
Australian Museum, Sydney; presented by the ICCA, 1983

This mask of the goddess Durga is characteristic of masks used in Chhau dance, the highly spirited dance dramas common in West Bengal, Bihar and Orissa. The dances feature stories from the great epics, and present, in appropriately dramatic fashion, the successful battles of the gods in conquering evil in the shape of demons or other malevolent forces. The masks, made from layered paper, clay, and textile, are covered with coloured paint and varnish to produce smooth and shining surfaces which contrast with the texture of elaborate headdress and sparkling jewellery. Here, the treatment of Durga's features – her oval-shaped face and its colour, the staring almond eyes, stylised eyebrows and third eye – collectively establish the potency of the goddess and her supremacy. She embodies the archetypal notion of the supreme goddess as visualised throughout much of eastern India (Jain and Aggarwala, 1989, 196, 206 and Knizkova, 1992,128, 135-139). [JCM]

119 **Crown (mukuta)**

Uttar Pradesh, Brindaban; early-mid 20th century
sequins, bead and metal thread on velvet covered cardboard; 42
Joan Bowers Private Collection, Sydney

This dazzling multi-coloured Krishna headdress was worn in dramatisations of the Krishna story held in Brindavan. The stylised plumes represent Krishna's characteristic peacock plume. The two lotus *shast* (turban pins) and *prabha mandala* aureole are symbolic of the Goddess Jamnaji, the goddess of the Yamuna river which flows past Brindaban.

Such elaborate crowns used for performance or else for the dressing of Krishna icons installed in domestic shrines or public temples, are still created in Brindaban. They are part of a tradition going back to the Mughal period and its taste for lavish jewellery. [JCM]

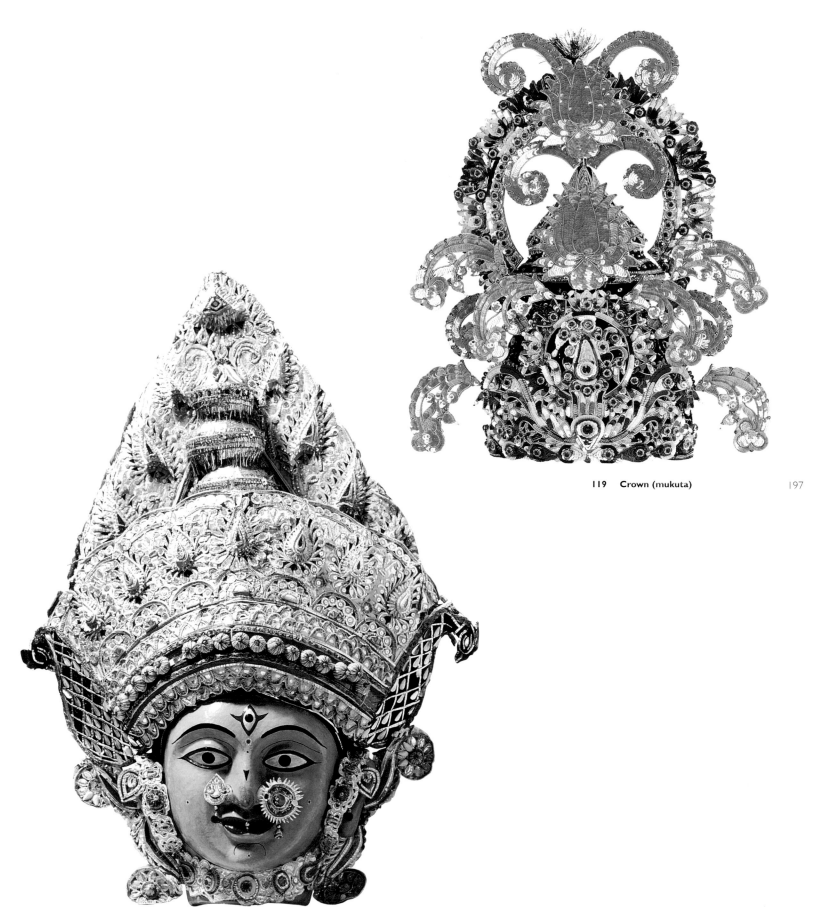

119 Crown (mukuta)

118 Durga mask

120 Two Bhuta masks

Malabar; 18th century; brass; 30 and 18.5

Dr Leo S. Figiel, Florida

A *bhuta* is a local spirit deity of the Malabar coast and Karnataka. The different forms include the boar-*bhuta*, Panjurli (from *panji*, a boar), the tiger-*bhuta*, Pilichaundi (from *pili*, a tiger), and the buffalo-*bhuta*, Maisandaye (from the Sanskrit root word for buffalo, *mahisa*). They are honoured and propitiated in annual festivals during which local performers dress in costume, put on masks representing the bhuta, and dance. The masks themselves and how they are worn in the performance ritual have a regional distinctiveness. While masks elsewhere are generally made from papier mache, clay or wood, these masks are made from metal; they are stylised in terms of the animal deity to whom they relate and have aureoles of raised cobra hoods attesting to the bhuta's power and importance. They are varied in their execution though they do of course conform to an overall ideal. In terms of the way the masks are used in a performance there is again some divergence from common practice elsewhere. While the masks may sometimes be worn over the face of the performer as masks usually are, these *bhuta* masks may also be worn on the top of the head of the performer or even carried by him. They are part of an overall context provided by the costume, the performance and by the event in which all meet (Mallebrein, 1993, 145-151 and Thurston cited in Jain and Aggarwala, 1989, 196). [JCM]

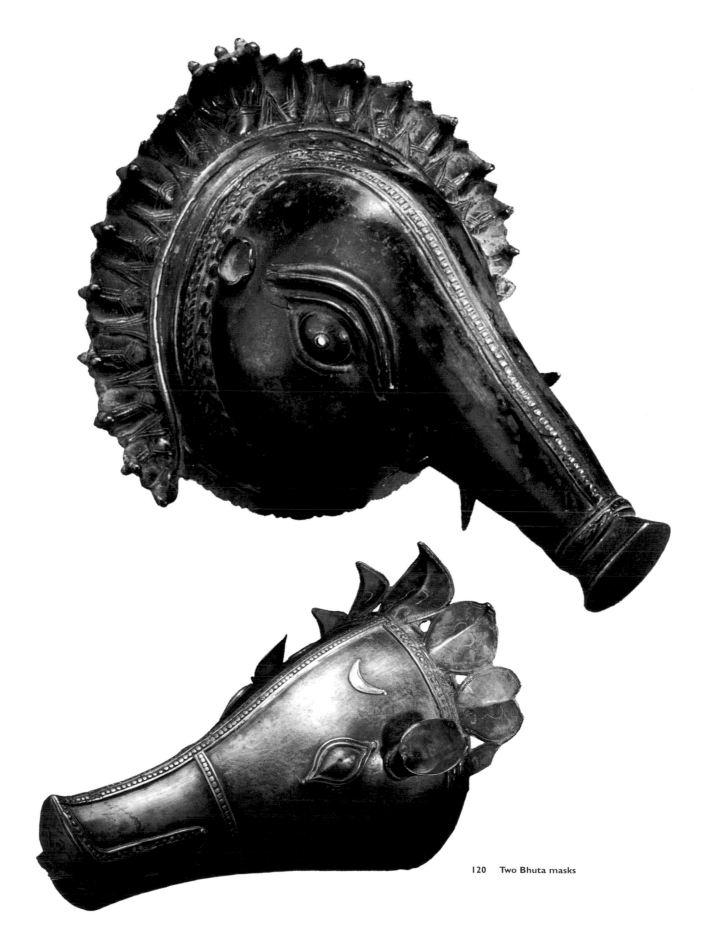

120 Two Bhuta masks

IMAGES OF MUSICIANS AND DANCERS

Jackie Menzies

In this section are images of individual courtly, folk and tribal exponents of music and dance as well as images of various dance types ranging from the classical Kathak [128] to jubiliant folk dances [125]. Both the folk (*desi*) and classical (*marga*) traditions are represented, and while most of the images are secular, there is still that interlacing with the sacred that is so distinctive to Indian art. Contemporary classical dance forms, for example, invariably had a religious or even folk origin.

The centrality of the musician and dancer to Indian society is constantly re-iterated through texts, inscriptions on temples, stone sculptures and wooden carvings, as well as archaelogical evidence. Excavations at the Indus Valley site of Mohenjo-daro proved the existence of a highly developed urban culture around 2000BCE and revealed flutes, drums and the famous copper figure of a slim, confident, dancing girl (fig 3). Early terracottas [121-122] emphasise the social importance of musicians and dancers, while the fourth-century Gupta king, Samudragupta, had struck coins depicting a vina player. Stone temple friezes [134], wooden architectural struts [127], chariot beams [125], textiles [124] and utensils [133] created in succeeding centuries in different parts of India prove how integral to everyday life were singers, dancers and instrumentalists. They were employed by temples and courts, while troupes of travelling musicians, dancers and storytellers were influential in spreading different conventions and thus infusing new vitality into local styles.

It would be impossible to represent the innumerable types of foreign, court, regional, folk and tribal singers and dancers active throughout India over the centuries, but the selection included, from an Abyssinian musician at Emperor Akbar's court [137], a South Indian snake charmer [140] and dancer [130], tribal musicians of Bastar and Kond [143, 144], and female folk dancers [125], at least conveys some of the enormous diversity of these traditions. Interestingly, individual portraits of famous practitioners are rare: images of saints such as Mirabai [99], Karaikkal [95], and Sambandar [94], famous for their devotional singing and dancing, are known, but, apart from Tansen [138], believed by many to be the greatest musician who ever lived, portraits of famous singers, musicians and musicologists (some of whom were rajas and sultans) are rare until later documentary paintings [141,142].

Women, whether *devadasi* [126], entertainers [121], or courtesans [131,132], were expected to be skilled at singing, dancing and playing an instrument, but depictions of identifiable individuals are rare. As John Guy in his essay points out, whether the origins of the *devadasi* lay in the court or the temple is obscure, but there is no doubt that the girls,

highly trained in music, dance and languages, were held in high regard for centuries. Courtesans, secular counterparts to *devadasi*, also were deeply involved in the arts of music, singing and dancing from the earliest times, often forming the nuclei of cultivated circles. Later on, during Muslim rule in north India, the courtesans of centres such as Delhi, Oudh, and Lucknow, were admired for their education and skill with the *tawaif* of Lucknow [131] being assessed particularly on their singing of the *ghazal* and *thumbri*.

Bharata in his seminal *Natyasastra* (Treatise of dramaturgy) stated that it was the responsibility of dancers and musicians (as well as painters and sculptors) to evoke *rasa*, the aesthetic emotion embodied in a work of art. *Rasa*, a key word in Indian aesthetics and culture, is variously interpreted as 'essence', 'taste', or 'sentiment'. Nine *rasa* have been identified: *sringara* (love), *hasya* (humour), *karuna* (pathos), *raudra* (violence), *vira* (heroism), *bhayanaka* (fear), *bibhatsa* (loathsomeness), *adbhuta* (wonder) and *shanta* (quiescence). In this section, divided into female and male musicians and dancers, are examples of those practitioners responsible for fulfilling Bharata's charter.

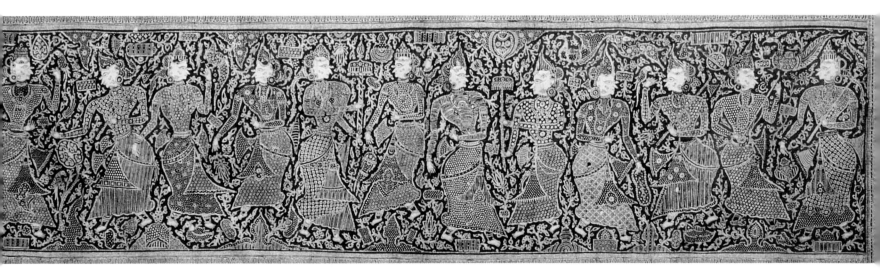

123 Heirloom textile (ma'a) with female dancers
detail

FEMALE MUSICIANS AND DANCERS

121 **Plaque with a dancer and a vina player**
Uttar Pradesh, Kaushambi (?); 1st century BCE; terracotta; 12.7
The Metropolitan Museum of Art, New York
Samuel Eilenberg Collection, gift of Samuel Eilenberg, 1987

Indian terracottas, baked clay objects made by a variety of techniques such as coiling, pressing and moulding, have a long tradition dating back several millennia. Pottery was one of the eighteen principal industries of ancient India, with potters organised into guilds with their own communities sited just outside the gates of towns (Poster, 1986, 30). During the Shunga period (c200-50BCE), rapid urbanisation saw the emergence of the urban leisured *nagaraka* class and an unprecedented growth in terracotta production. Subjects reflected the taste of this cultured class: an amazingly varied array of deities as well as secular scenes of social gatherings, wrestling, and ladies at their toilet. Details of all subjects were meticulously recorded onto the shallow frieze of the plaques which constitute the most common form of Shunga terracottas.

This plaque is an excellent example of Shunga terracottas, reflecting the central role of music and dance within Shunga society. The musician's clothing, bow, harp, vina and the plectrum in his hand are clearly articulated as is the dancer's costume, jewellery and dancing pose. He is seated on a cushion within a small pavilion closely watching the animated dancer, whose open mouth suggests she might be adding a vocal accent to the performance (Lerner and Kossak, 1991, 57). While it is unclear whether this scene is part of a religious ritual (as is often the case in India) or a joyous rendering of unfettered pleasure, there is no doubting the skill of the artist's rendering, the quality of the impression, and the excellent state of preservation of this plaque (ibid).

122 **a) Lady with an attendant**
West Bengal; Chandraketugarh; 1st century BCE; terracotta; 12.7
Los Angeles County Museum of Art; Indian Art Special Purpose Fund

b) Woman playing a drum
West Bengal, Chandraketugarh; 1st century BCE; terracotta; 19
Art Gallery of New South Wales, Sydney; purchased 1994

These figures are from the rich archaeological site of Chandraketugarh in West Bengal where many terracottas have been excavated. Plaque (a), contemporary with [121], depicts a female, most likely a dancer, admiring herself in a mirror held by an attendant. The woman strikes a dancer's pose, with her hands above her head, and her legs, with one knee bent, in a classic dance position. Rather than the exuberance of the Metropolitan plaque, this one conveys a quieter, more contemplative mood.

202

122b Woman playing a drum

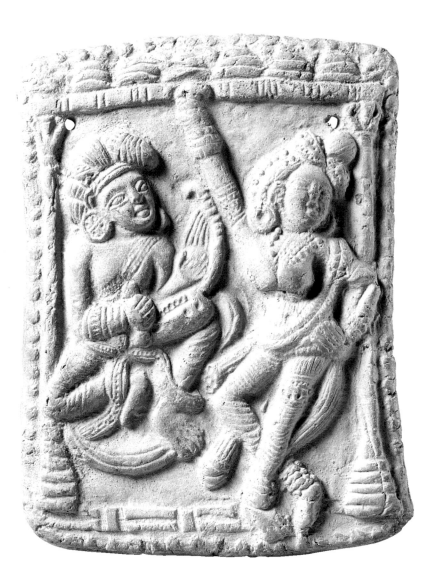

121 Plaque with a dancer and a vina player

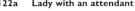

122a Lady with an attendant

An almost identical plaque, like (a) stylistically similar to ones from Kaushambi in Uttar Pradesh, was found in Haroa, a village not far from Chandraketugarh, and it has been suggested that although Kaushambi and Haroa are far apart, the figures were made at one of the two sites and transported to the other (Pal, 1986, 144).

Figure (b), a female holding a hide-covered drum resting on a cloth-draped stand, is hollow with a plain back and a base. Like several other pieces from this site, it seems to have been designed as a rattle because the hollow body deliberately contains what sounds like clay pellets.

(see page 201)

123 Heirloom textile (ma'a) with female dancers
Gujarat; 1634; handspun cotton, natural dyes, mordant painting, batik; 102 x 534
National Gallery of Australia, Canberra; gift of Michael and Mary Abbott, 1989

This textile was apparently created as an expensive trade item, intended for exchange for the legendary spices from the eastern islands of the Indonesian archipelago. The large stamps of the Gujarati workshop visible at one end of this cloth have been tentatively dated to 1634. Probably shipped by the Dutch East India Company to Makassar, its fortified trading post in South Sulawesi (Celebes), the textile passed into the hands of a noble Torajan family in the mountainous hinterland where, over centuries, it assumed the status of a sacred heirloom.

Indian mordant painted cotton cloths, widely known as chintz or *kalamkari*, were much admired in many parts of the world for their attractive designs and technical superiority. While Indian artists were particularly adept at creating patterns to suit foreign markets, the form and style of the images depicted on this textile are purely Indian. Six pairs of large and imposing female courtiers dominate the central field. In a style characteristic of early Western Indian miniature painting, the face of each woman is depicted in profile with the distinctive protruding far eye. In fact, the application of different mordants to the surface of the cloth with a pen-like stylus (*qalam*) before the textile is immersed in the dye bath is closely akin to other forms of drawing, permitting variations in rendition and fluidity of movement for each figure.

The figures move in an elegant procession – those unencumbererd in sinuous dance-like movements, while others bear the familiar attributes of court attendants – parasols, fly-whisks, fans, a water vessel in traditional leather form, garlands of blossoms and single blooms. Others hold beautiful birds on raised fingers. Second from the right is their musician who strums a stringed instrument (vina). The richness of their costume and adornment – the skirts, long-sleeved blouses and waist sashes of different patterned textiles, intricate jewellery on foreheads, ears, throats and ankles, with hair braided with flowers – bespeaks the elaborate taste of an affluent society.

The background is filled with stylised motifs, also reminiscent of painted scenes in courtly literature. Between the rocky outcrops underfoot and blocks of patterns suggesting rich canopies above, flowering plants and occassional birds and animals surround the

204

facing page
123 Heirloom textile (ma'a) with female dancers
detail

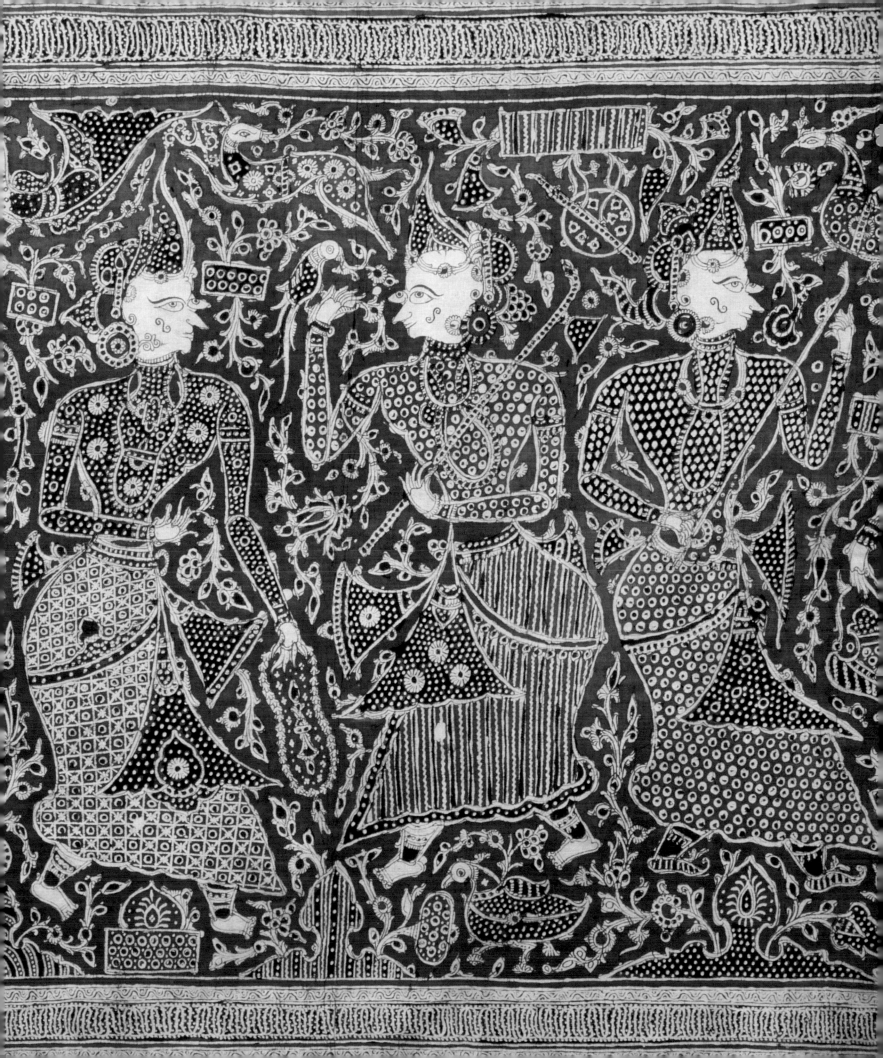

courtiers. Although an export item with the elaborate decorative end panels that have long been a favoured Southeast Asian design structure, the content of this textile – the procession of courtly attendants – may be derived from Indian sacred hangings. Similar scenes are common on the *pichhavai* temple hangings of the Krishna cults, although only rarely worked in the mordant-painted *kalamkari* technique. [RM]

124 Textile (odhni) depicting circular dance
a) Gujarat, Jamnagar; 1867
cotton, tie-dyed with gold brocade border; 200 x 274
Victoria and Albert Museum, London

This *odhni* (shawl or headcloth) is a testament to the crosslinking of the sacred and the secular as displayed in the finest art of the nineteenth-century textile. The *odhni* features a lively rendition of the circular dance of the gopis, using to superb effect the imagery of Krishna's Rasalila, the event of his forest dance with the gopis.

Surrounding the mandala (circle) is the traditional repertoire of associated imagery, of dancing girls, elephants and birds. Such *odhni* were not specifically religious or cult objects, rather, they were used in everyday life, even if on religious or festival occasions. They were secular, not sacral objects in which the sacral was celebrated by its usage in the everyday moment – and by allusion as much as by specific depiction.

This *odhni* from Jamnagar in Gujarat was in fact never used. It was created for display in the 1867 Paris exhibition, and acquired by the Victoria and Albert Museum for £20. A rare example of a precisely dated textile, it represents the very best of the art at the time. The quality of the tie-dying technique (*bandhani*) deployed here is exceptional. The process requires the tying of tiny knots on the cloth which is then dipped in dye. The knotted parts resist the colour of the dye and a basic pattern emerges; further knottings and dyeings provide complexity and additional colour until a complete composition is created. Here, the control of dots, the sharp distinction between the colours and their overall placement, produces a composition that is full of life and vigour. [JCM]

b) Gujarat, Saurashtra; late 19th century; silk, tie-dyed; 183 x 155
Art Gallery of New South Wales, Sydney; gift of Michael and Mary Abbott

The dramatic landscape of west India is a perfect foil for the shimmering silks created through the stippled patterning of *bandhani* tie-dyeing. Clear bright designs in auspicious reds and stark blacks predominate in these resist-dyed textiles, worn by the women of Gujarat on festive occasions. The addition of the luminous green band at each end of this textile may indicate that it was intended as a gift.

While a variety of garments are created by the tie-dyeing process, the most striking in Gujarat is the woman's headcloth (*odhni*). As in this example, the design often focuses on a

124b Textile (odhni) depicting circular dance

facing page
124a Textile (odhni) with circular dance
detail

central roundel of dancing female figures, each with one arm raised high above the head. Full skirts and flowing headcloths swirl as they form a circle of dancers (mandala) against the rich scarlet ground. At the centre is a multi-lobed form – possibly a flower or moon, ambiguous references to the Rasalila episode in the life of Krishna when, standing in the moonlight on a lotus by the river Yamuna, the god's magical presence in the midst of the encircling milkmaids (gopis) causes each gopi to imagine he dances only with her. In this rendition, the dancing figures are interspersed with the same emblem and another plant motif, probably depicting the kadamba tree, associated with the blue-skinned god.

The broad borders around four sides of the textile also contain many of the favourite motifs of the Saurashtra tie-dyed textiles. Following local custom, a wider border at one end of a headcloth also displays images of dancing women, each holding a flower in the pendant arm. Here the motifs are arranged around the central kadamba tree and interspersed with birds in branches, above a band of parrots.

The other borders enclose rows of peacocks, another symbol of Krishna, and elephants with parrots, punctuated by bright red rosettes which echo the form of the central roundel. A fourth border with elephants, inside the row of dancers, may be missing. Blocks of intricate tie-dye hatching however link the outer side patterns to the band of dancers. This *odhni* also features a figurative field design where the same images – dancing women, birds, and elephants – are largely concealed in the leafy mango forest. [RM]

125 **Dancing women** *(see page 221)*

Karnataka; 17th century; carved wooden chariot beams; each 29 x 242
Natesans' Galleries Inc, London

These two panels are from one of the magnificently carved wheeled chariots known as *ratha* that are used in the annual procession which climaxes the main temple festival in each town. The chariots are monumental wooden structures composed of innumerable frieze panels carved with densely packed depictions of gods and goddesses, attendant deities, musicians, dancers, animals and lotuses. The craftsmen who worked on chariots were as familiar as temple craftsmen with the relevant iconographic traditions for particular walls and panels. These two panels are typical of the ubiquitous subsidiary panels that comprise a profusion of musicians, dancers and singers.

On the morning of the festival, the processional deity, together with his female consorts, are all gorgeously dressed and jewelled before being placed in the chariot which is then pulled along the streets by as many as five hundred people in a clockwise direction around the temple to the accompaniment of a *nadasvaram* (woodwind) player on the chariot and a drummer below (Michell, 1992, 30-35). The chariot's clockwise movement around the temple is the same essential rite of circumambulation (*pradakshina*) that individual worshippers perform within a temple around the central image.

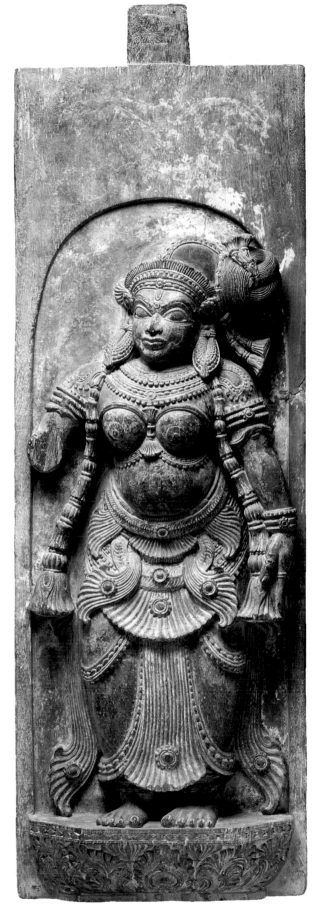

126 **Female attendant**

These panels are particularly of interest in their clearly articulated depictions of folk stick dances. Various types of stick dances are prevalent in almost all states of South India. Starting from late evening and continuing until dawn, they were held outdoors to celebrate festive occasions, harvests, heroic stories and even the advent of dawn.

The panels depict different dances: the top one of women dancing with crossed sticks, separated by hanging garlands, and wearing pleated skirts similar to those of Kathakali, could be Kodiattam, a version of Kathakali. The bottom panel could be a representation of Kolata, in Karnataka a popular group dance in which the dancers, wearing different coloured costumes, form concentric circles, holding sticks about forty-five centimetres long which they then beat against each other while they dance. The music comprises drums and singing; the music and movements of the dancers gradually increasing to a crescendo. The dancers on this frieze, realistically observed, form pairs either side of a central trio. Some pairs are full frontal; some face each other; others turn away from each other. Each is captured in spontaneous dance in an accurate observation of the reality of spirited dancing.

126 Female attendant

Kerala; 18th century; wooden wall panel; 114 x 37
Victoria and Albert Museum, London

This voluptuously carved figure, elaborately dressed with an ornate headdress and hairstyle, once brightly painted, is a splendid representation of the famous *devadasi*, 'servants of God', the professional caste of dancers and singers attached to temples (see John Guy's essay). In South India the courtesan was the centre of song and dance, and one of the genres that developed as part of the repertoire of a *devadasi* were *padam* poems which were sung and often danced to. Addressed to the god who is also the lover, these devotional poems, permeated by erotic themes and images, reflect the complexities of the relationship between the devotee and his god. The genre flourished in the seventeenth and eighteenth centuries, particularly with the contribution made by writers such as Ksetrayya (dates unknown). An excerpt from one of Ksetrayya's poems of a courtesan to her lover is at left.

You coax women's affections,
make them amorous and faint,
do things you shouldn't be doing,
confuse them, lie in bed with them,
and then you leave without a sound,
shaking your dust all over them.
(cited in Ramanujan et al, 1995, 98)

127 Female musician with male companion

Tamil Nadu; 18th century; wooden struts; 76.2 female and 82.5 male
Dr and Mrs Narendra Parson, California

South India, particularly the state of Kerala, is distinguished by the number of wooden temples, a testimony to the widespread piety and patronage of wealthy local individuals. The same craftsmen who built the temples worked on the carving of central panels depicting gods and goddesses, supplemented with horizontal friezes, struts, columns and architraves depicting dancers and musicians. The carving of the angled struts used to support the roof is the same as that on three-dimensional sculptures. The struts rest on small

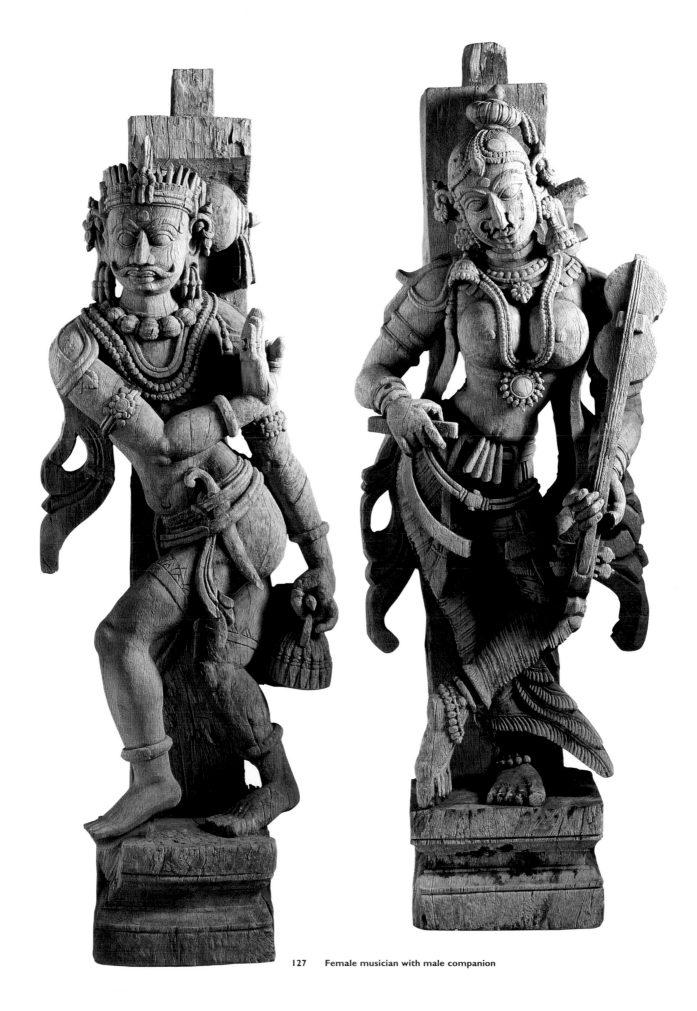

211

127 Female musician with male companion

brackets projecting from the walls to which they are secured by pegs; additional pegs at the top fit into holes in the underside of the sloping rafters.

These two architectural struts, carved by different hands in the naturalistic style characteristic of South Indian wooden sculpture, depict a female gypsy (Tamil: *kurathi*) musician and a dancing male gypsy (*kuravan*). She stands in a dance pose, holding a violin in her left hand and a palm-leaf book in her right. The violin is thought to have been introduced to South India during the British period (although it could have come earlier with the Portuguese), but this manner of holding it vertically is peculiarly Indian. The violin became part of the Karnatic tradition of music in which it is used as an accompaniment. He stands in a dance posture, one arm over his chest and the two feet poised to move sideways. He has prominent eyes and a long moustache, and is adorned with elaborate earrings and necklaces. He wears a curved dagger in his belt and carries a small pouch for rice or money.

128 **Girls dancing Kathak**

North India, Mughal; c1675; 31.8 x 24.2

The Art Institute of Chicago; Lucy Maud Buckingham Collection

Kathak is a North Indian dance style whose origins are obscure. The word 'Kathak' is derived from the Sanskrit meaning narrator, in reference to the temple brahmins who narrated stories from the *Mahabharata* and other epics, as well as instructing the *devadasi* in dance and music. However the Kathak dance form was shaped in the Mughal period by Muslim influence (including input from sufi singing and dance) and while its origins may have been in temple dance and worship, it soon became a secular entertainment of no religious or spiritual significance. The golden age of Kathak dancing was during the reign of Mughal emperors Akbar and Jahangir when it was performed by court dancers. The dancers, whether at the Mughal courts or the later courts of the nawabs of Oudh and the rajas of Rajasthan, were invariably women, and wore full diaphanous skirts that accentuated the whirling and spinning of Kathak as well their shapely figures.

In the Kathak tradition, as splendidly exemplified in this painting, the emphasis is on fast footwork and lively turns, to the accompaniment of Hindustani music. In the words of Welch (1985 (2), 61): 'Of all the great Indian dance forms, kathak demands mastery of the most elaborate rhythms, and the dancer's control of her feet must be total. In bravura passages of the performance, the dancer modulates her steps until the sound of her anklets descends from the clash of five hundred bells to the clear echo of a single bell. The dazzling display of footwork by the great exponents of kathak was reputed to have sent those who watched into a hypnotic trance.'

The motif of two women dancing was a popular one judging by the number of paintings depicting a couple twisting towards each other, the palms of their hands and bare feet dyed with henna, their gossamer pleated skirts, embroidered head scarves and shiny black

facing page
128 Girls dancing Kathak

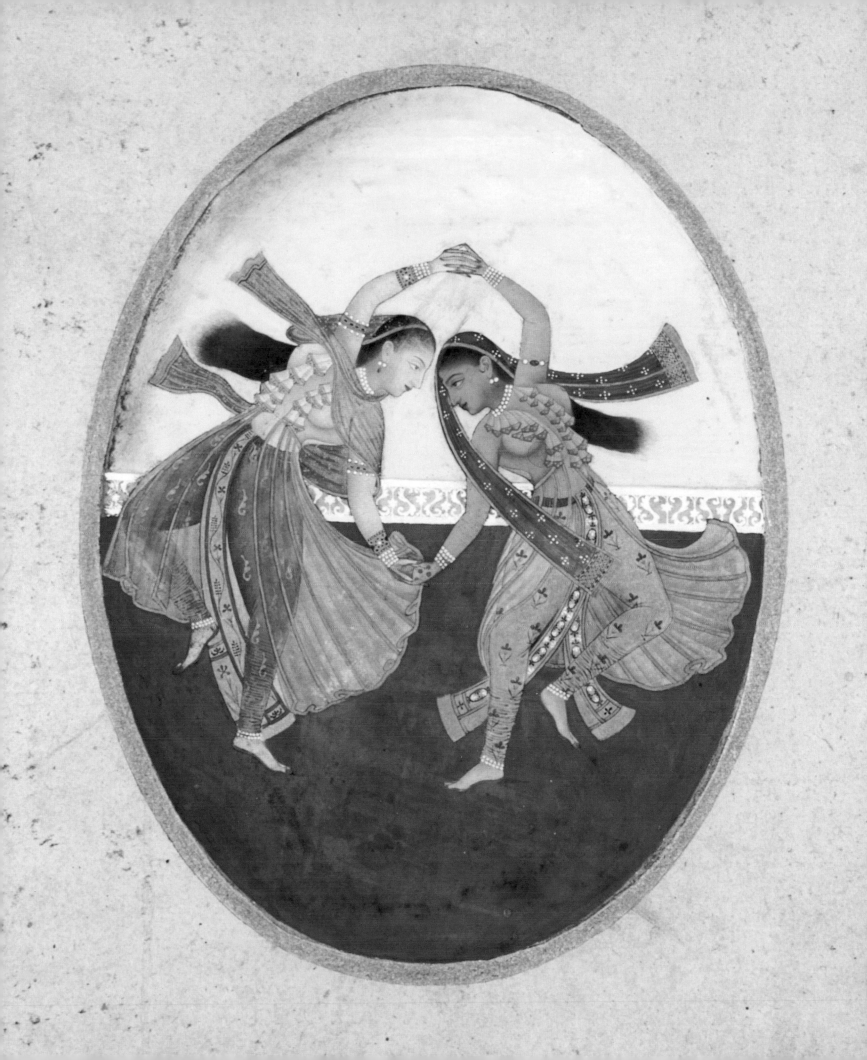

hair swirling around them. The oval frame serves to contain and focus their spirited steps and vivacity. The inherent abandon and freedom of Kathak saw it tend towards lasciviousness, until performers became notorious as women of easy virtue. It is this debased form of Kathak which European adventurers called 'nautch', a corruption of the Indian word *naach* meaning dance.

129 **Musician riding composite camel** *(see page 219)*

Rajasthan, Bundi; c1750; 27.2 x 23.2

Asian Art Museum of San Francisco; Avery Brundage Collection, gift of George Hopper Fitch

A lady playing a vertical arched harp is seated within a howdah atop a camel composed of a compact mass of musicians, animals and fish. A man plays a frame drum, three female musicians play different instruments, and fish, boar, deer and birds, compressed and twisted, fill the outline of a camel in a fantastic, imaginative concoction. The technique of composite painting came to India in the Mughal period through Persian painting. While the original meaning of the art is obscure, it had become quite popular by the late eighteenth century amongst artists of many different schools of painting, and has remained popular until today. Horses and elephants are the most popular shapes for composite animals, but it is not surprising a Rajasthani artist chose the camel, an ubiquitous sight in desert Rajasthan.

130 **A Tanjore dancing girl and her Tikataka men**

Tamil Nadu, Thanjavur (Tanjore); c1790; 28.3 x 21.5

Victoria and Albert Museum, London

From the time of the illustrious Chola dynasty (c850-1150), Thanjavur in Tamil Nadu has been a major political and cultural centre in South India. It was the capital for the Maratha dynasty (1675-1853), established when the Marathi warriors invaded from the north, and a base for the British as they fought their four Anglo-Mysore wars between 1780 and 1799.

This painting is a fine example of early paintings produced to suit the taste of British patrons, many of them army officers who spent only a few years serving in India, and were keen to collect pictures of local people and customs. Thanjavur was the first region in India to produce this genre of 'company paintings', its artists modifying their style and subject matter to suit British taste from the mid eighteenth century (Archer, 1972, 7). Amongst the vast repertoire of images produced, this one appears to have been a favourite, for several versions are known. It is proof of foreign fascination with Indian dance whilst reflecting the continuing popularity of dance in courts and temples, at all levels of Indian society.

The dancer and musicians appear to be outdoors, the bright blue background and contrasting shadows highlighting their performance. She wears a tight *choli* with half sleeves, and a pyjama underneath her full skirt which is fashionably tie-dyed with a pattern of dotted

214

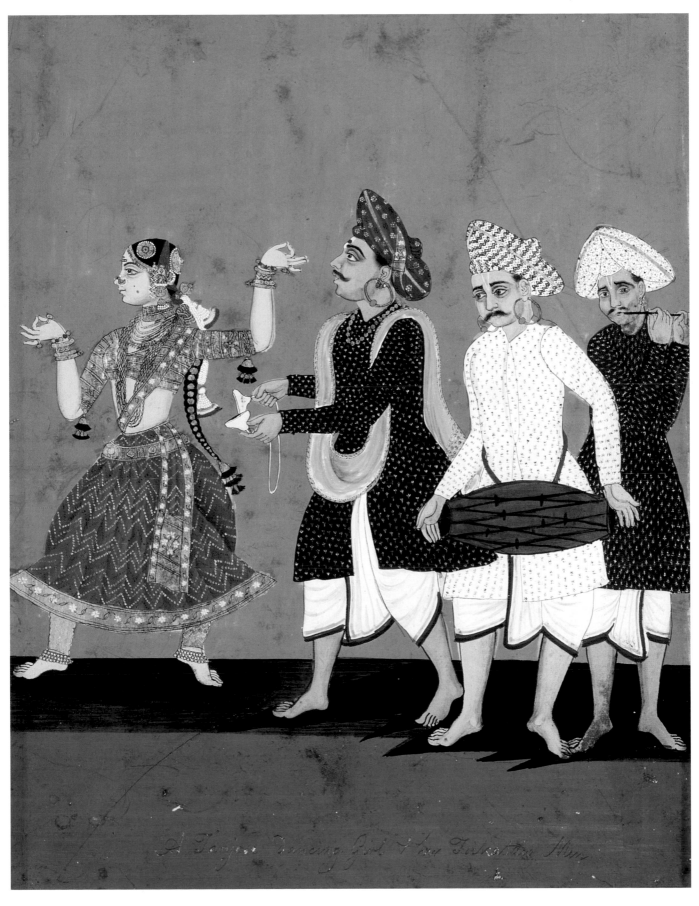

A Tanjore dancing Girl & her Tickating Men

130 A Tanjore dancing girl and her Tikataka men

chevrons. Her jewellery and headgear are seductively elaborate, and she is performing *natya*, the dance of mime as opposed to pure dance (*nritya*). In *natya*, as so beautifully captured here, emotion is conveyed through the expressive movement of the body with particular attention given to the gestures of the hands which are held in specific *hasta* or poses. Apart from her ankle bells, music is provided by her three male accompanists who play cymbals, a flute and a *mridangam*, the classical two-faced drum used as percussion in Karnatic music, and made from a single scooped-out block of wood.

131 **Portrait of a courtesan**
 North India; 19th century; 51 x 41.5
 Paul F. Walter Collection, New York

The serene and distinguished lady of this portrait is a courtesan or *tawaif* of Lucknow, the opulent capital of Oudh, a Muslim kingdom that flourished in the twilight of the Mughal. Before the British began to displace Indian rulers, the courtesans were an influential female elite entitled to the protection and patronage of the court. With the gradual loss of princely power in the colonial period, patronage was provided by the new urban elite, particularly in the wealthy, leisured capital of Lucknow whose merchants paid princely sums for the pleasure of the company of the courtesans.

Courtesans underwent rigorous training to ensure they would please and entertain their patrons. Many belonged to famous lineages and in the nineteenth century were in the highest tax bracket, with the largest incomes of anyone in Lucknow (Oldenburg, 1991, 27). While the names of some famous courtesans are known, this anonymous one, resplendent with elaborate earrings and necklaces in the Lucknow style, symbolises the beauty, confidence and power of the *tawaif* who were respected members of the community until the advent of the British who initiated the perception that they were disreputable.

The *tawaif* were recognised not only as preservers and performers of high culture, but also were actively involved in shaping developments in Hindustani music and Kathak dance styles. Much of late nineteenth-century Hindustani music was invented and transformed in their salons to accommodate the tastes of a changing patronage (ibid, 31). For example it was *tawaif* who popularised the romantic *ghazal* (a sung version of Urdu poetry) which only became familiar in Lucknow when Urdu poets migrated there from Delhi with the crumbling of the Mughal empire (Misra, 1991, 47). Similarly when the wealthy connoisseurs of Lucknow, steeped in romantic sensuality, welcomed the *thumri* style of music with its full expression of the singer's soul, they looked to the professional women-singers (mostly *tawaif*) to do the singing (ibid, 37).

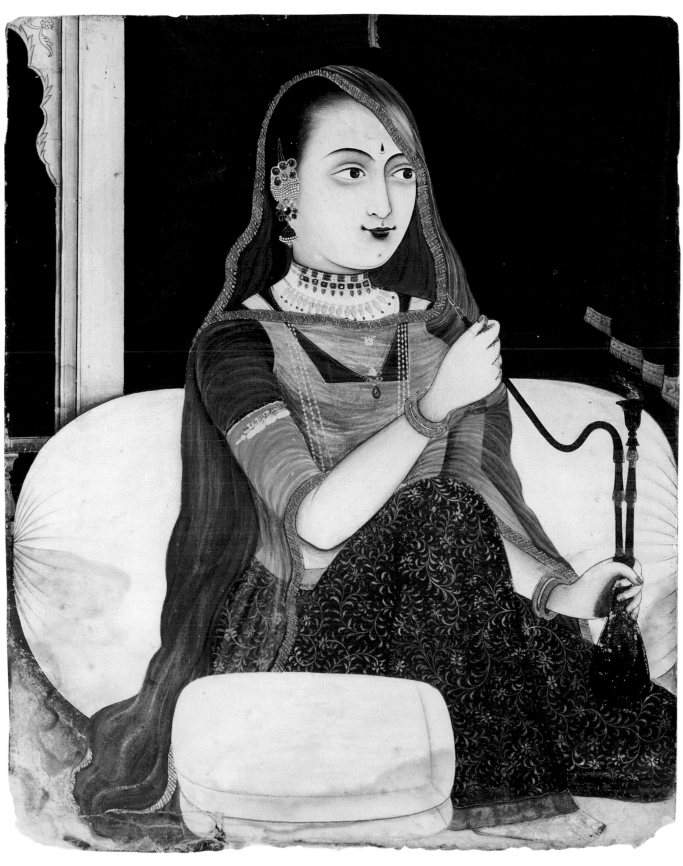

131 Portrait of a courtesan

132 Imitiazan

by Mahadev V. Dhurandhar (1867-1944)

from an album of illustrations for *By-Ways of Bombay*, by S.M. Edwardes

pen and ink; 25.5 x 18

Portvale Collection

Dhurandhar's imaginary portrait of a famous courtesan of Bombay suggests vulnerability as much as dancing brilliance. She is depicted in full flight, hand over head, eyes moving sideways, anklet bells stamping out the rhythm. Her accompanists, the tabla player and the two sarangi players, are clearly enjoying the session.

This is one of a series of pen and ink drawings used to illustrate the popular book of anecdotes *By-Ways of Bombay* written in 1907 by the British Police Commissioner of Bombay. He tells Imitiazan's story from the time when she was found, alone and destitute on the streets, by a famous dancing girl in Lahore who raised her as her own child. According to Edwardes (1912, 38), she did 'her duty by the child according to her lights. She engaged the best "gawayyas" to teach her music, the best "Kath-thaks" to teach her dancing, the best "Ustads" to teach her elocution and deportment, and the best of "Munshis" to ground her in Urdu and Persian belles lettres.'

Dhurandhar (1867-1944) was one of the first Indians to study European art formally at the Sir JJ School of Art in Bombay. He was brilliantly successful in terms of the times, winning a prize at his first showing in the Bombay Art Society in 1892 and a Gold Medal in 1895. He painted large oils of Indian subjects as well as working on water colours and was noted for his book illustrations and his designs for posters and postcards (Mitter, 1994, 90-94). He is part of that transition period for Indian artists when they acquired formal awareness of European art and its techniques but when they were also concerned with maintaining an Indian subject matter and the heritage of India's past art. [JCM]

133 **Huqqa base in the form of a dancing girl**

133 **Huqqa base in the form of a dancing girl**

Uttar Pradesh, Lucknow; 19th century; partially gilded brass with silver inlay; 15.2

Los Angeles County Museum of Art; Nasli and Alice Heeramaneck Collection

Museum Associates purchase

The origins of the *huqqa* (hookah or waterpipe) in India are difficult to trace. In painting the earliest representations, from about 1630, are in Mughal paintings of mystics and ascetics (Desai, 1985, 142). However, judging by the ubiquity of the *huqqa* in paintings after the early 1700s, it had become an essential requisite for everyone, including the nobles at the Rajput and Mughal courts. The *huqqa* comprises four or five parts of which the most important part is the base which was filled with water. Missing from this piece are the other necessary components: the central pipe through which the smoke passes over the water, the top bowl

218

129 Musician riding composite camel

132 Imitiazan

which holds the coal and tobacco (or hashish), and the flexible pipe. It is not clear what substance was smoked in the *huqqa*. For example, according to Desai (1985, 142), for the Rajputs the smoking substance was determined by the occasion: formal durbar and ceremonial occasions called for hashish or some other hallucinogen while for an evening in the *zenana* with the queen, tobacco was used.

Throughout India, the materials and shapes of *huqqa* varied, although many of the gold, silver and bronze ones have been melted down in keeping with the Indian penchant for recycling old artifacts into new (Welch, 1985, 379). The shape of this piece, in the form of a kneeling nautch girl, would appear to be unique, perhaps a special commission reflecting the opulence of the pleasure-loving court at Oudh.

MALE MUSICIANS AND DANCERS

134 **A frieze with male musicians**
Rajasthan, Harshagiri; c970; sandstone; 14.6 x 62.8
Los Angeles County Museum of Art; Los Angeles County Fund

The relevant details on this sculpture are contained in *Indian sculpture* (Pal, 1988, 128): The frieze once belonged to the Purana Mahadeva temple designed and constructed by the architect Chandasiva for a brahmin patron named Allata, as is known from a site inscription composed in 973. Because it is securely datable and for the fine quality of its sculptures, the Harshagiri temple is a significant Indian monument, although nothing further is known about either the patron or architect.

The deeply cut figures in this frieze depict a group of musicians which includes three transverse flute players (two of whom are seen from the back), a man playing a stringed instrument (a proto-vina with only one gourd), and a singer. The vocalist is the third person from the right with his left hand raised to his ear, a gesture characteristic of singers. On his left a female holds in her right hand a flask, very likely containing wine. The two men at the far left hold drinking cups. Thus the scene probable represents a convivial soiree.

Music and dancing seem to have played an important role in the artistic repertoire of Harshagiri, and several other lively panels are in various museums. As Lerner has pointed out (see Pal, 1988, 128), these celestial musicians are probably engaged in praising Shiva, presiding god of the temple at Harshagiri, Hill of Joy (see [12]).

135 **Kathakali dancers**
Kerala; 18th century; wooden carved and painted panel; 24.2 x 125.7
Natesans' Galleries Inc, London

This unusual panel would appear to be a rare sculptural depiction of the dance-drama Kathakali, whose present form came into being in the seventeenth century. Unique to

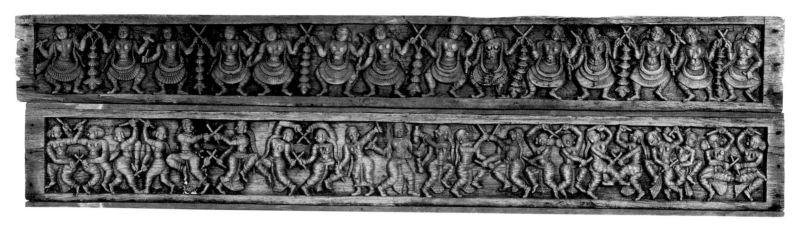

125 Dancing women

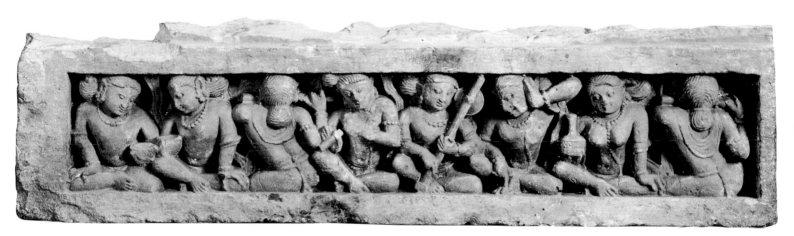

134 A frieze with male musicians

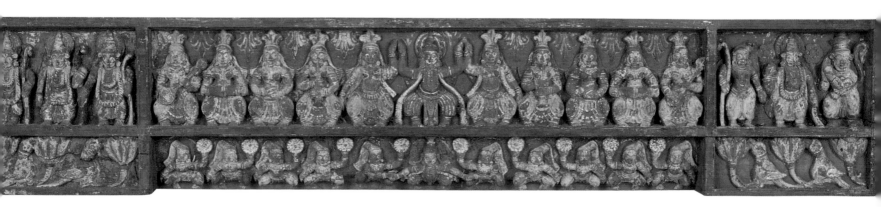

135 Kathakali dancers

135 Kathakali dancers

detail

Kerala, Kathakali ('story-telling') evolved from various indigenous traditions of ritual theatre. Its deepest roots are in Kutiyattam Sanskrit drama, as well as various versions of the Hindu epics the *Ramayana* and the *Mahabharata* written in the sixteenth century in Malayalam, the language of Kerala. In addition, important sources of choreographic patterns were the ritual dances of shaman priests (Jones, 1987, 27) while other elements derived from the military tradition of Kerala.

Traditionally, Kathakali performances were held in the courtyard of a temple or the patron family's home, beginning at nightfall and continuing until sunrise. They were performed during the harvest season, after the rains, to celebrate the new year, or simply as summer entertainment. The music is derived from indigenous traditions of ritual temple music. The style of singing for Kathakali is unique and the music (usually a bronze gong, cymbals, and drums) and singing emphasise the action, the emotional mood and the intensity of the dance-drama which invariably features valour in battle. Considering the importance of Kathakali in the lives of the people, it is unusual that there are not more depictions of it in the plastic arts.

The costumes are characterised by elaborate ornamentation and special headgear whose different shapes identify the hero and the demonic characters. The formality of the costumes, the stylised movements and the elaborate make-up in which green, red, yellow, black and white colours are used, are captured in this keenly observed panel.

222

136 **Musician in landscape**

North India, Imperial Mughal; 1600-1605

opaque watercolour, gold and ink on paper; 16.5 x 10.2

Los Angeles County Museum of Art; Nasli and Alice Heeramaneck Collection

This image is a most bizarre and intriguing depiction of a musician in a landscape. While there is a clear European influence in the Flemish-style backdrop and the European-style clothes of the man who himself seems to be a European, he sits barefooted on a tiger skin in a manner more appropriate to a Hindu ascetic. Rarely, however, do ascetics function as musicians, and certainly the attire is inappropriate for a Hindu or even a Muslim ascetic. (Pal, 1993, 240). He either holds a composite instrument, or three separate ones, namely a bagpipe (which he is blowing), a harp or lyre, and a *bin*.

As Pal has stated (1993, 240), the picture seems to be the kind of whimsical pastiche that Mughal artists loved to create, selecting from various European sources available to them, although the perceptively realistic rendering of the face could indicate a live model. The picture is surrounded by two narrow borders, the outer one of boldly rendered flowering plants probably dating to the nineteenth century.

136 Musician in landscape

137 **An Abyssinian musician**
 North India, Imperial Mughal; c1650-1675; 20.2 x 12
 National Gallery of Victoria, Melbourne; Felton Bequest, 1980

This graphic portrait reflects the taste of Emperor Shah Jahan who ascended the
Mughal throne in 1628, and continued to maintain the atelier of painters he inherited from
his connoisseur father, Jahangir. Like Jahangir, he loved paintings full of detailed naturalism:
images that captured his world of court life, hunting, entertaining, and portraits of family,
courtiers and exotics, and which could be bound into lavish albums. This lightly coloured
drawing, designed for inclusion in an album, is an unusually informal and lively depiction of a
negro who, singing and dancing in his loose garments, holding his strange instrument, would
foil the static formality of court portraits in the same album.

The instrument is, according to Dr J.R. Widdess (Topsfield, 1980, 32), a five-
stringed bowl-lyre of a type unknown in India but common in the ancient Mediterranean and
at the present day in parts of north-east Africa. 'Abyssinian' (*habshi*) slaves were common in
India, particularly in the Deccan, by the seventeenth century; evidently they brought their own
instruments with them (ibid).

138 **Mia Tansen and Swami Haridas**
 North India, late Mughal, 18th century; 11 x 15
 Private collection

This painting is a portrait of Tansen (?-1589), the illustrious Mughal musician,
together with Swami Haridas, a well-known musician saint who reputedly possessed a magical
voice and is credited with being Tansen's teacher. The two musicians were leading exponents
of the classical *dhrupad* style of singing associated with Gwalior.

According to Abu'l-Fazl, author of Emperor Akbar's biography, the *Akbarnama* (The
history of Akbar), Akbar summoned Tansen to his court just as Tansen was about to retire
from his service with Ram Chand, the Raja of Pannah: 'the knowledge which His Majesty has
of the niceties of music, as of other sciences, whether of the melodies of Persia, or the various
songs of India, both as regards theory and execution, is unique for all time. As the fame of
Tansen, who was the foremost of the age among the *kalawant* (noble musicians) of Gwalior
came to the royal hearing...His Majesty ordered that he should be enrolled among the court
musicians.' (Welch, 1985, 171). Tansen became one of the Nauratan (in Hindi, literally 'nine
jewels'), the nine specially selected members of Akbar's entourage.

The depiction of Tansen with Haridas probably derives from a legend concerning
the meeting of Tansen and Akbar with Haridas. In another version in the National Museum,
New Delhi, entitled 'Famous musician Swami Haridasa with Tansen and Emperor Akbar at
Vrindavan', Akbar is seen approaching the two musicians. According to this legend which had

137 **An Abyssinian musician**

138 **Mia Tansen and Swami Haridas**

gained currency by the mid-eighteenth century, Akbar, upon hearing of the beauty of Haridas'
singing, determined to hear him. However Haridas, a great devotee of Krishna and an
inhabitant of the Krishna centre of Brindaban, refused to proceed to Akbar's court at Fatehpur
Sikri. So Akbar, in the guise of a sadhu, and accompanied by Tansen, went to visit him. This
painting, depicting these two famous practioners of *dhrupad*, each playing his own tambura, is
a poignant tribute to two of India's greatest musicians.

139 **Snake charmer**

 Thanjavur (Tanjore); c1780; 27.8 x 20.2

 Inscribed: No.36 A man who catches and tames snakes Malabar

 Portvale Collection

Particularly popular among patrons of 'company paintings' depicting local people
and customs were sets showing a man and a woman of the various castes standing side by side
holding the implements of their occupation (Archer, 1972, 22). This painting, studiously
captioned by a contemporary English hand, resembles the folios of two incomplete sets in the
Victoria and Albert Museum, London (see Archer, 1955, 76). Stylistically it closely resembles
other paintings of pairs of figures posed against a flat background with a thin strip of cloud-
streaked sky along the top. Such works date to Thanjavur in the 1780s when the British were
still recent arrivals, and the artists who produced such paintings had not yet too fully adapted
their native styles to British taste. The artists produced paintings of the customs and trades of
different people in Thanjavur as well as in the surrounding district, in a dramatic colour range
and pandering to their patron's taste for 'low life'. There is great liveliness to this depiction of
a snake charmer, blowing on his pipe to charm the cobra his female companion holds. His
pipe is made from a small calabash to which are attached reed or bamboo pipes, and reflects
the same simple inventiveness as the three wooden puppets strung from his waist.

140 **Two princes and two musicians**

 Rajasthan; 18th century;15.3 x 9.9

 The Art Institute of Chicago; restricted bequest of Samuel Weingarten

Portraiture was a predominant genre in painting in Mughal courts, and the taste for
portraiture spread to other courts of India, closely linked to Mughal prototypes in the
attention to detail and aspirations to convey individuality. Many portraits were inscribed in
Urdu and Hindi with the names of subjects to ensure accurate recording for posterity.
Subjects were rulers (although not necessarily from life), nobles, religious leaders and other
notable figures, and the paintings were designed to form part of an album of portraits.

This painting depicts four men enjoying music: the upper two appear to be
clapping and their elaborate jewellery indicates they are rajas. The text identifies them as

139 Snake charmer

Khushal Khan on the left and Suhail Singh on the right. The two lower figures play a *bin* or rudra vina and a *rabab*, with the text identifying them as Sursen Binkar (=of the *bin*) on the left and Sen Rababi (=of the *rabab*) on the right (the translations of these names were provided by BN. Goswamy). The painting is a testament to the love and connoisseurship of music in Indian courts. It appears to be Rajasthani, maybe from Nagaur, or Bikaner.

141 **Shah Inayat Allah with his musician Makkhu**
 and his attendant Shaykh Qiyam al-Din
 from the Fraser Album
 Delhi; c1820; 30.5 x 41.4
 Identified in Persian: *shabih-i hazrat Shah 'Inayat Allah Mashayakh Kumhare bashanda-i*
 Lakhnau [inhabitant of Lucknow] *sakin-i qadim Shahjahanabad* [resident of old Delhi].
 The musician identified: *Makhu qawwal khitab Lagan Baras kih Firdaws manzil 'Inayat*
 farmuda budand [ie Makhu, a singer, called 'starts to rain', probably in reference to
 his style of singing]. (Archer and Falk, 1989, 106).
 The Art Institute of Chicago; S.M. Nickerson Collection

This 'company drawing' is one of a significant collection of over ninety coloured drawings by Indian artists found in Scotland in 1979 among the papers of the Fraser brothers – James Baillie (1783-1856) and William (1784-1835). James became a merchant in Calcutta while William took up a career with the East India Company, serving in the Delhi territory. It was William who was responsible for commissioning Indian artists for the images that comprise the important so-called Fraser Album, in which one encounters the musicians, soldiers, yogis, sufis, merchants, dancing girls and courtesans of the world they knew. The album leaves, dispersed at auction in London in 1980, have since been recognised as one of the finest groups of company pictures yet known, unsurpassed in the field of in terms of quality and subject matter (Archer and Falk, 1989, 44).

This drawing, and the Fraser Album in general, is considered significant on many counts apart from the quality. As explained by Archer and Falk (ibid, 45), the drawings were produced in Delhi, a region not taken over by the British administration until after 1803 and far from Calcutta where the finest company pictures had hitherto been produced; furthermore, until their advent, any company paintings from the Delhi region had been almost exclusively architectural subjects and these drawings depict Indian life, costumes and customs, before they were affected by Europeans; and they demonstrate the perfection by Indian artists of a technique of accurate coloured drawing that allowed for the further possibility of publishing books of colour plates. Although the individual artist is not known, on stylistic grounds we can be sure the Fraser pictures are the work of a single family, that of Ghulam Ali Khan, whom William commissioned for many drawings. (Many Indian painters

140　Two princes and two musicians

141　Shah Inayat Allah with his musician Makkhu and his attendant Shaykh Qiyam al-Din

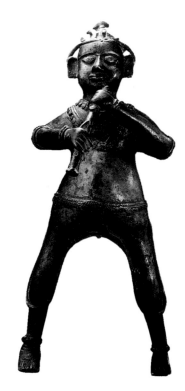

142 Flute player

were artists in accordance with the Indian caste system of hereditary professions.) This drawing is typical of many in the album: finely detailed, coloured, modelled figures against a blank page with minimal accessories.

142 Flute player

Madhya Pradesh, Bastar (?); 19th century; brass; 39

Dr Leo S. Figiel, Florida

Throughout rural India, itinerant metalsmiths moved from one region to another setting up their founderies for short periods to fulfil local needs for votive deities for household shrines, utensils, ornaments and toys. The technique they used was that of the lost wax or *cire perdue* process in which a beeswax image is first made and finished in detail, then covered with clay, usually mixed with rice husk, so that an impression of the wax replica is formed on the inner wall of the clay mould. A channel is left open on this outer clay mould so that molten metal can be poured in to replace the wax which flows out on being melted.

This simply modelled figure may be from Bastar where the tribal Gonds, of which there are various sub-groups, live. The Gonds are very fond of music and dance. They sing songs and dance on religious and ceremonial occasions to the accompaniment of various musical instruments, amongst which a vertical flute is common. Bastar figures are distinguished by a simplification of form, with the faces featuring large eyes, pouting lips and prominent ears. Amongst the many festivals the Gond celebrate is the Karma festival when group dances are performed. An excerpt from one of their songs is quoted at left.

143 Kond musicians, Orissa

a) Two musicians

19th century; bronze; 30

Dr Leo S. Figiel, Florida

b) Flute player

19th century; bronze; 19.1

Art of the Past Inc, New York

For the ancient tribe of the Konds, distributed in Andhra Pradesh and Madhya Pradesh, as well as Orissa, dance and music are their very life and breath. Propitiation dances, trance dances, fertility dances, and dances in imitation of animals and birds all feature in the repertoire of dances performed throughout the year, many at the time of major festivals which revolve around the agricultural cycle. In Orissa, where the music is a wonderful blend of the south and the north, and which is the home of many ragas which have the flavour of Karnatic and Hindustani music, the main musical accompaniments are a long bamboo flute called a *pirodi*, and small bells (*muyyanga*) worn on the dancers' ankles (Vatsyayan, 1976, 253 and 314).

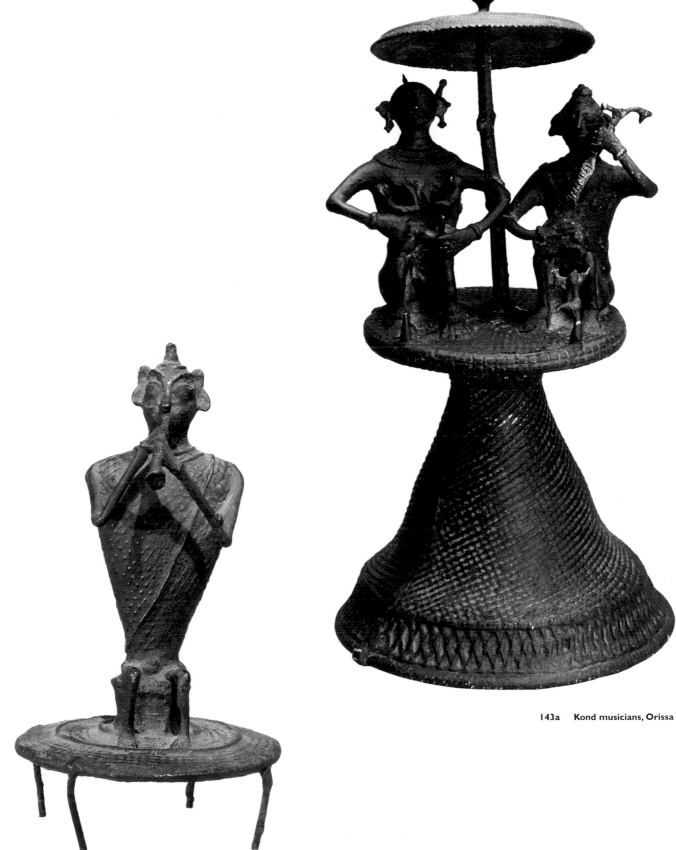

231

143a Kond musicians, Orissa

143b Kond flute player

Why did you leave?
The dance in the grove is yet to end.
The cocks yet to crow.
Dancing to the time
How gracefully you were floating along
Sweet as a song;
And the jingling of your bangles
Had the soft melody of hailstones
Falling in the dark.
(cited in Mahapatra, 1991, 9)

Often the music and dance are accompanied by singing, drawing on a repertoire of song-poems as extensive as the occasions they mark. There are life-cycle songs (songs of birth, marriage and death); festival songs, including songs of the agricultural cycle (such as the sowing of the seeds, the reploughing during rains, and harvesting); and invocatory songs to ancestors and the gods and goddesses. Intense love is naturally featured, as exemplified in the Kond song at left.

While Orissan tribes celebrate their culture more strongly through the performing arts than the visual arts, small bronzes such as these in the show convey their concern with music. These two figures are characteristic of the distinct style of metalwork developed by the Kond distinguished by the fine net-like surface pattern.

232

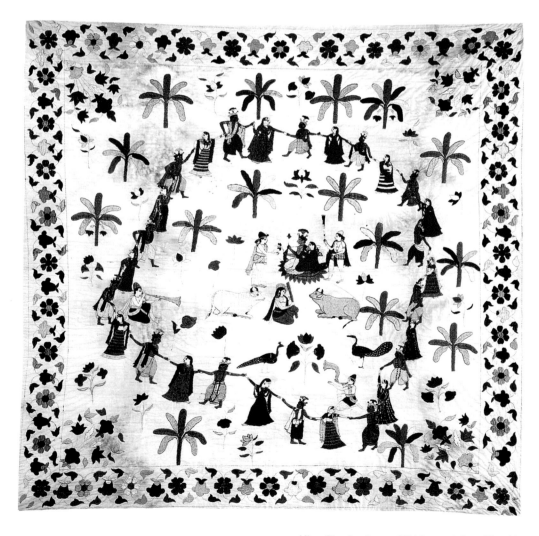

44b Circular dance of Krishna and the milkmaids

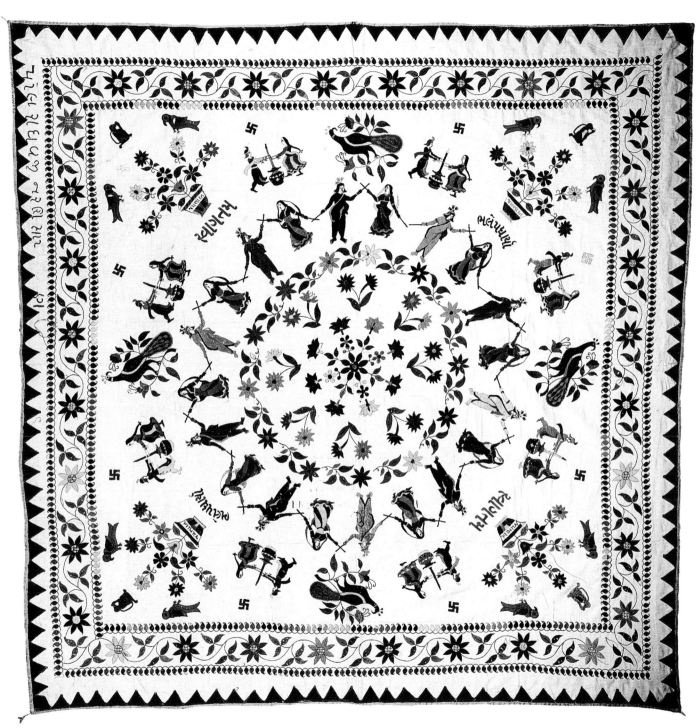

44d Circular dance of Krishna and the milkmaids

MUSIC AND DANCE FOR ALL OCCASIONS

Jim Masselos

Music and dance pervade everyday life in India as much as they pervade its religious experience. They are integral to daily activities and perform a variety of roles and functions, whose end is not the interpretation or expression of religious experience but the celebration of the present moment, the marking of everyday events, the life of the now.

Music and dance underscore occasions of all kinds. The first set of images in this section illustrates the place of music in life-cycle moments. Here the predominant note is celebration: music and dance express jubilation. The intense joy of Emperor Akbar when his wife finally gives birth to a male heir is reflected in the exultation of the dancers [144]. Another depiction of the same event [145], commissioned by Prince Salim after he had become Emperor Jahangir, retains the keynote of music and dance but imbues the scene with a far more stately and regal character.

There is an equally euphoric celebratory mood at the time of marriage as illustrated in the second part of this section. Dancers and musicians entertain Akbar's imperial court during the festivities around the marriage of an important noble [147]. In a later 'company period' painting of the groom's procession to his bride [148], women dance in front of the groom, and musicians head the procession through the streets, asserting its presence aurally. Quieter in its resonance is the embroidered *rumal* from Chamba where the bride, Rukmini, is accompanied by women musicians as she moves to the place of the marriage ceremonial, the ritual fire, while her groom Krishna has his own regal and masculine accompaniment of *shehnai*, drums and trumpets [149]. Finally, the marriage depictions culminate in the entry of the bride into her husband's paternal home, where a tambura player and singers underscore the significance of the occasion [150].

While music and dance express the idea of celebration in such rites of passage situations, they may also be used as demonstrations of power and to demarcate power. When Akbar returns from visiting the shrine of a sufi saint, he is welcomed into Delhi by a *naubat* ensemble [151]. Again, when nobles proceed in procession through the royal courtyard of Emperor Shah Jahan, they proceed to the accompaniment of very large imperial *naubat*, underscoring the wealth and power of the Emperor [152]. Smaller *naubat* ensembles are also present in depictions from the great Hindu epics and establish a similar point about power [153, 157].

On other occasions it is the noise of the musical instrument that is important. In tiger hunts the noise of drumming frightens the tiger [155]; itinerant acrobats use the roll of drums to heighten the tension of their derring-do [154]; and drummers add to the sound and fury of battle [156].

The final part of this section comprises images of festivals. The sound of drums again adds to the tumult, but here with a joyous, not a deadly, intent, in the public celebrations of

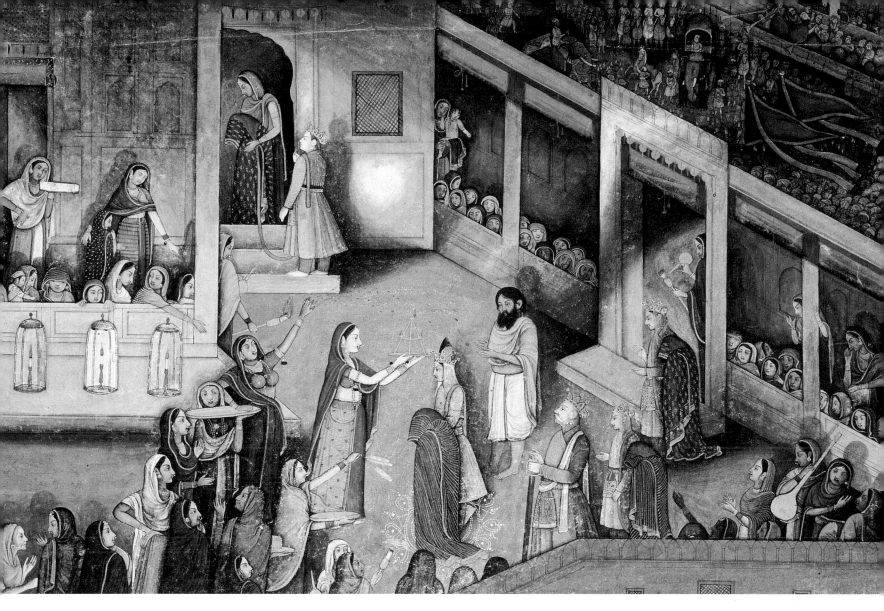

150 **Receiving the bride and groom**

Holi [158, 160, 159]. In festivals such as Holi or Diwali, music and dance were not an integral part of the religous ritual. The role of music was to enhance the mood of the occasion whether it was to express wild joy or celebration, or to underscore the epiphany of a lyrical or sensuous moment. The final paintings in this section establish a contrast in moods. On the one hand are the lyrical moments of the night-long vigil of Diwali celebrations and the more boisterous entertainment that took place during the night [161]. On the other hand are the feasting and dancing of the Santals [163].

 In the paintings in this section, music and dance are placed within depictions of a variety of different events and are part of the illustration of the event and of the verisimilitude of its representation. But the presence of music and dance goes beyond the merely literal depiction; music and dance add an element of ambiguity and suggest associated notions of sound and movement outside the frame of two-dimensional depiction. They provide a visual metaphor for another set of sensations beyond the visual: that of sound and movement. Even when the viewer does not specifically know what the sounds were or how the movements were structured, their depiction in the paintings introduces an allusion to non-visual sensations and reinforces in various ways the connotations evoked by the sensations aroused by other senses.

BIRTH AND CIRCUMCISION

144 **Akbar hears news of the birth of Prince Salim**
From an *Akbarnama* manuscript; attributed to Kesu Das (Kesu Kalan or 'Kesu the elder') for outline and Chitra for colouring.
North India, Imperial Mughal; c1590; 37.8 x 24.1
Victoria and Albert Museum, London

For many years the Mughal emperor, Akbar had been unable to father a male child; when his wife finally became pregnant he sent her to the care of a sufi saint, Sheikh Salim Chishti, in Sikri, a little village outside Agra. There in 1569 she gave birth to Salim, so named after the saint. Later, Akbar chose to honour the place and build Fatehpur Sikri, his grand new city there. The narrative of the painting is the delivery of the news of the birth of a son to Emperor Akbar by Shaikh Ibrahim Chishti, the son of the saint, probably the bearded elderly man on the left bowing to an attentive Akbar. Standing on the steps of the royal dais is in all likelihood Chand, the court astrologer (Sen, 1984, 133).

The emotion of the painting is conveyed by the dancing and music that is being performed in the space below the Emperor, counterpointing the narrative. A particularly excited man does a sword dance while the energetic movement of the two women dancing is intensified by the line of their dress, a high chaghtai hat and flowing gown associated with the Mongol clan, the Jaghatai, from which Babur's mother (Akbar's great-grandmother) was descended (Leach,1986, 69). A multitude of musicians accompany the dancers. At the bottom a woman clangs cymbals together while her partner beats a drum enthusiastically. Near them are the appurtenances of a *naubat* – a *shehnai* (*surna*) player and two drummers, and a group of women musicians (a flute player and two tambourine players).

The painting is one of a series recording the history of the reign of Akbar. The text was written by Akbar's official historian and personal friend, Abu'l Fazl, and an illustrated version was commissioned by, and finally presented to, Akbar in 1590 (Losty, 1982, 81-2). It has recently been argued that the paintings were completed for an earlier manuscript around 1586-1587 and then re-used to illustrate Abu'l Fazl's text (Seyller cited in Pal, 1993, 205). In any case, the version of the *Akbarnama* has long since been broken up but 116 of its surviving pages are now in the Victoria and Albert Museum.

Akbar's seminal role in developing and changing the nature of Indian painting included the building up of an atelier of artists. He also recognised and acknowledged individual artists whose names were often recorded on or around their paintings. Kesu Das, the creator of this illustration, was described by Abu'l Fazl as being the fifth best artist in the imperial atelier (Okada, 1992, 95-101).

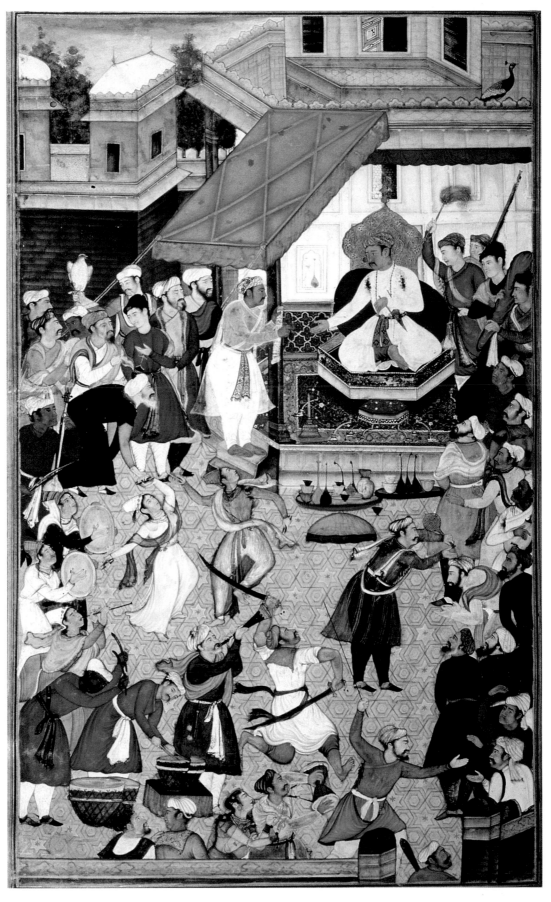

144 **Akbar hears news of the birth of Prince Salim**

145 **Birth of Jahangir**

From a *Jahangirnama* manuscript, ascribed to Bishan Das

North India, Imperial Mughal; c1610-1615; 26.4 x 16.4

Museum of Fine Arts, Boston; Francis Bartlett Donation of 1912 and Picture Fund

This stately version of the birth of Prince Salim provides one of the most detailed insights given by Mughal painting into the life of the *zenana*, the women's quarters of the palace. Music again underscores the celebration of the birth and comes from two women, a drummer beating a *dhola* and a singer who is clapping time to the music. All attention though is directed to the pavilion where the empress, Maryam-uz-Zamani, reclines beside a magnificent jewel encrusted crib, looking at her child cradled by a servant. His importance is indicated by an aureole. The Queen's darker complexion suggests a different origin from the others: she was a Rajput and the daughter of Bharmal, the Hindu Maharaja of Amber (Jaipur). Seated beside her on a throne is an imposing woman, probably Hamida Banu Begam, the mother of Akbar and grandmother of the newly born prince (Beach, 1978, 63). Auspicious neem leaves are strung across the doorway of the curtained entrance to the women's quarters, while outside it men sit, casting horoscopes for the new baby.

The *Jahangirnama* was written personally by the Emperor more as a set of memoirs and of his interests rather than as a detailed record of the great events of his reign (Beach, 1978, 61). The painting is not about the birth of Prince Salim but the birth of Emperor Jahangir ('World Seizer'), the regnal title by which Salim chose to be known. It has a staid and ceremonial presence, recording an important rather than an especially joyous event; the point of view is hence different from the treatment presented in the version commissioned by Akbar. It is a painting that is suffused with warmth and even intimacy just as its palette is rich and radiant. It represents to a high degree the particular talents of observation of the artist, Bishandas, and of his ability to record detail. Jahangir described Bishandas in his memoirs as being 'unequalled in his age for taking likenesses' and sent him to Iran in 1613 with an ambassadorial delegation to draw the likenesses of the Shah of Iran and his court (Welch, 1978, 70). On his return Jahangir gave him an elephant as a reward for his achievement. (Okada, 1992, 156-157).

146 **Celebrations at the circumcision ceremony for Akbar's sons**

attributed to Dharm Das

North India, Imperial Mughal; c1605; 34.7 x 22.5 with borders

The Cleveland Museum of Art; Andrew R. and Martha Holden Jennings Fund

The painting records the celebrations over the circumcision of Akbar's three sons, Salim and his two younger brothers, which took place in October 1573. The emperor sits on his throne looking towards the women's quarters where, in a twin painting to the one on

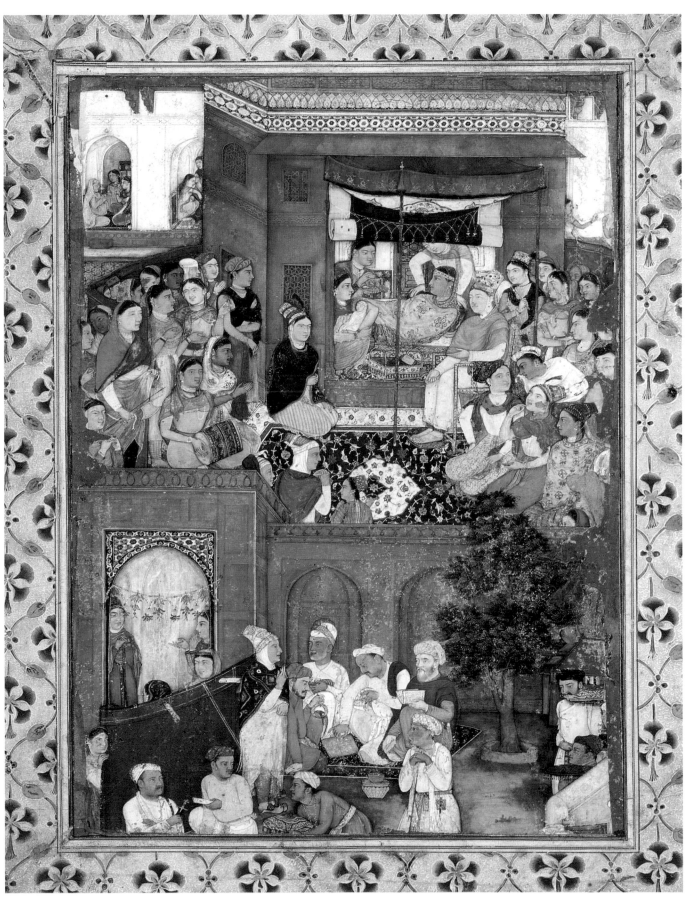

145 Birth of Jahangir

display, the three children are being cared for by the women of the court. Below Akbar, two women dressed in high *chaghtai* hats and flowing gowns dance to music provided by a woman beating a tambourine and another whose upraised hands indicate she is singing. On the left are the court's *naubat* musicians, two beating kettle drums vigorously, another playing a long gold trumpet and the last blowing a long black instrument, presumably a *shehnai*. At the bottom of the painting alms are being distributed to the poor on the occasion of the ceremony.

Although this painting bears some overall compositional resemblance to the painting of Akbar's celebration of Salim's birth [144], the painting comes from a later *Akbarnama* series commissioned by Akbar towards the end of his life around 1602 or perhaps, as is now argued, earlier from around 1597 (Beach, 1992, 64). Its execution may well have continued into the first few years of Jahangir's reign.

Marriage celebrations

147 **Celebrations at a royal wedding** *(see page 189)*

From an *Akbarnama* manuscript, attributed to Lal for composition and to Banwali for colouring
North India, Imperial Mughal; 1590; 38 x 24.5
Victoria and Albert Museum, London

Another example from the first imperial version of the *Akbarnama*, the scene is of musicians and dancers performing in Akbar's court. They are providing the entertainment for the marriage of Baqi Muhammed Khan, the elder son of Mahem Anaga who acted as Akbar's foster mother while he was growing up.

Entertaining the monarch and his court are two different kinds of music. On the right is a full scale *naubat* ensemble consisting of three different-sized kettle drums (*naqqara*), a large and magnificent convoluted trumpet, two other trumpets (*surna*), a *shehnai* player and a cymbal player. Contrasting with the male *naubat* musicians are the women musicians in front of them; with the dancers they form a unit of their own. Two tambourines, a pair of cymbals, and a *dhola* (drum) accompany the two dancers, one of whom holds a pair of rattles (*janjira*) to maintain the beat. The woman with the cymbals also seems to be singing in accompaniment.

148 **Marriage procession**

Madras, Company school; c1820; 25 x 50
Portvale Collection

The most public moment in an Indian wedding is when the groom proceeds in a grand procession (the *barat*) through the streets to take his wife in a marriage ceremony. By custom he always rides a white horse, richly caparisoned, and he himself is equally lavishly dressed and garlanded with flowers some of which hang in strings over his face. For this

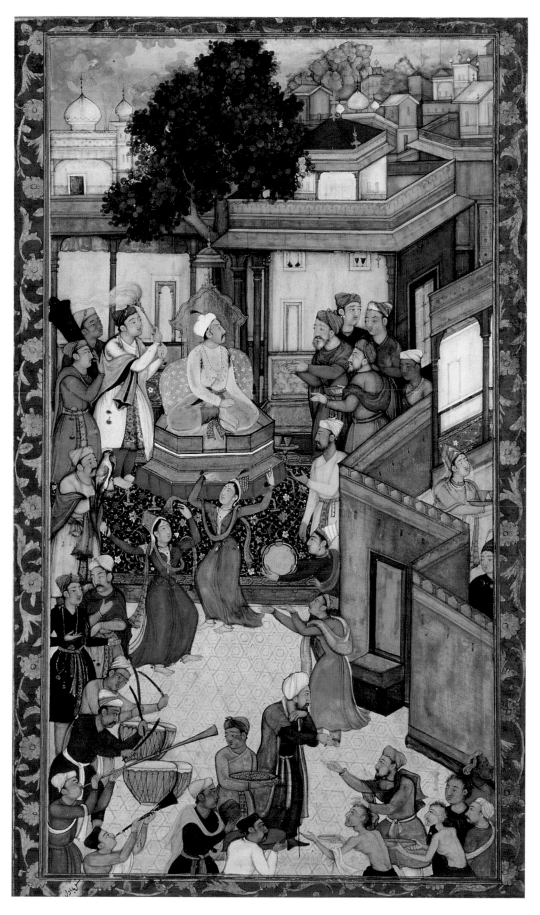

146 Celebrations at the circumcision ceremony for Akbar's sons

moment he has by right other accoutrements of power and nobility such as a ceremonial umbrella held over his head and an ornamental fly-whisk beside him. The richness of the occasion is heightened here by portable decorations and its importance is emphasised by fireworks of all kinds, crackers as well as sky-rockets and roman candles which light up the cobalt night sky. The moving space of the procession is defined by the bearers on either side with their flaming tapers; inside are the groom's relatives and friends. As the procession proceeds, women from his family circle dance in front of him to music coming from musicians around them in the crush of people. Forming a prowlike phalanx at the head of the procession are more musicians: the sound of their music establishes the procession aurally in the streetscape and their appearance, large curved trumpets and double-headed and kettle drums assert its presence visually.

The painting is one of a series of dispersed watercolours illustrating festivals and rituals in South India painted by an Indian artist for a European patron in the early nineteenth century. The artist has been influenced by European watercolour techniques as well as by a use of light and shadow but the painting as a whole retains the detailed and carefully considered parameters of traditional Indian painting.

149 **Coverlet (rumal) with marriage scene**
Himachal Pradesh, Chamba; c1880
cotton embroidered with silk; 68 x 124
Victoria and Albert Museum, London

Music accompanies Rukmini as she moves at the head of a procession of women from a temple to the wedding pavilion (*mandapa*) where she is to be married to Krishna. The music comes from a line of women below her, from a woman beating a double-headed drum, another playing a tambura while a third is perhaps playing a *sarangi*. Krishna, depicted seated and in profile above the pavilion, has his own ensemble of male musicians, an ensemble much like the Mughal *naubat*, with its kettle drums, *shehnai* and trumpets, though the trumpets are regional variants. Music hence underscores the moments before the marriage while the kind of music demarcates gender space.

Such embroidered *rumal* (literally 'handkerchief') from Chamba, once a small Hindu kingdom but now part of Himachal Pradesh, were worked by women of the royal family or the nobility. It has been suggested the outlines were drawn by the male artists who painted miniatures and murals for the courts of the region (Guy and Swallow, 1990, 147), yet the kind of detail contained in this and other such *rumal* reflects sensitivity to a woman's perceptual universe of the time and place. Above Rukmini are a range of pots and cooking utensils, a bed and a seat, a lampstand and other wedding gifts. Immediately in front of her is a square in which burns the sacrificial fire around which she will be married. Beyond are the great gods

148 Marriage procession

149 Coverlet (rumal) with marriage scene

who have come to earth to bless the occasion: Brahma, with his vehicle the goose below him; then Vishnu and his vehicle, Garuda; then Shiva and his vehicle, Nandi, the bull. Ganesh appears above the pavilion which is covered with parrots and surmounted with a pot and then a *chhatra* (umbrella). The central axis of the pavilion provides a symbolic link with the earth axis and a notion of fertility; while parrots have associations with tenderness and love. The small diagonal wall at the bottom of the *rumal* indicates that the marriage is taking place within a walled compound. The palette is delicate and the embroidering of blocks of colour by use of single silk threads mimic the flat block colouring of painted miniatures. (For comparisons see Bhattacharya, 1968, 60-63 and Irwin and Hall, 1973, 148-161)

150 **Receiving the bride and groom** *(see page 235)*
 Himachal Pradesh, Guler; c1780; 23.2 x 33.3
 Paul F. Walter Collection, New York

The final stage of a wedding occurs when the bride enters her new home, that of her husband's family where the couple will live as one unit in a joint household of many couples and family members. Here the couple have just entered through the doorway; they have also proceeded into the interior courtyard to a spot decorated with a *rangoli* pattern on the floor. There the senior woman of the house, probably the groom's mother, welcomes them ritually by performing *arati*, by waving a lighted flame in front of them. The bride stands beside her husband, head bowed modestly, and is entirely covered by an orange wedding shawl as she has been since she entered the building. Finally, shawl held in hand, she stands at the doorway of the couple's room, her husband looking towards her. They are still linked by the thread that bound them together during the marriage ceremony as a symbol of their unity in this and future lives. The painting thus combines consecutive moments in time into a single image which unites the scatter of situations into one totality.

The detailing of the image is striking. Since the lighting in the courtyard comes from large candles in glass stands and from the *arati* flame, dramatic shadows are created, an unusual element for Indian miniature painting and suggestive of European influence.

The presentation of music in the scene is subtle. In a corner a group of women provide a musical backdrop with one woman playing a tambura and others singing. But other musical undertones inhabit the space. Above the framing diagonal gallery on the right is a large mural of an impressive royal procession and in the diagonal above it is an imperial *naubat*, with full ensemble of drums, trumpets, *shehnai* and cymbals. The association underscores the importance of the main subject of the painting and of the family which is its focus.

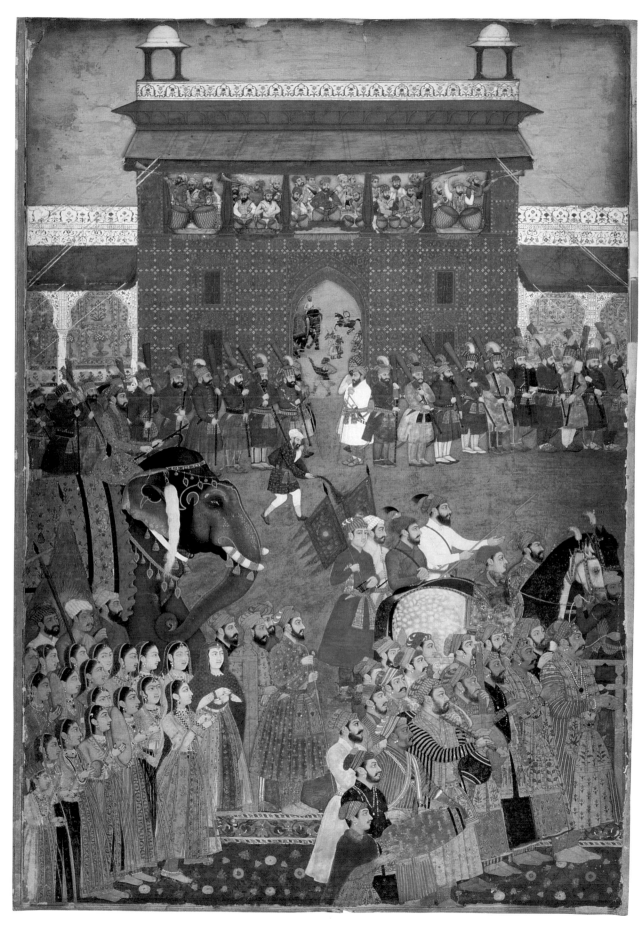

152 Procession scene

IMPERIAL MUGHAL PROCESSIONS

151 **An attempt to assassinate Akbar in the bazaars of Delhi**

From an *Akbarnama* manuscript; composition by Jagan, painting by Bhawani the
elder and faces by Madhu

North India, Imperial Mughal; 1590-1595; 38 x 25.4

Victoria and Albert Museum, London

Two events converge as Emperor Akbar returns from a visit to the shrine of the sufi
saint Shaikh Nizamuddin Auliya (in what is now a suburb of New Delhi). Akbar's procession
arrives at the crossways in Delhi where a reception is ready to honour him. Above the
gateway *naubat* musicians perform for him: there are three drummers on kettle drums (*naqqara*),
players of straight and curved trumpets and a cymbal player. Another kind of reception also
awaits Akbar: that from an assassin who shoots at him with an arrow as he passes by. The
arrow hit Akbar's shoulder but he was not seriously hurt. The would-be assassin was
immediately executed (Sen, 1984, 81-83).

The painting has the hallmarks characteristic of the early imperial *Akbarnama* series,
the skilful use of diagonals to isolate and make Akbar central in the composition, the same
skilled use of colour and the same verve in execution of the drawing.

152 **Procession scene**

From a *Padshahnama* manuscript

North India, Imperial Mughal; mid-17th century; 28.9 x 19.7

The Art Institute of Chicago; Kate S. Buckingham Endowment Fund

The clearest representation of an imperial musical ensemble appears in this painting
of courtiers and their womenfolk walking in procession to the royal court. Above them is the
naubat ensemble on top of the gateway in a room of their own, the *naubatkhana* or 'naubat
house'. The twenty-three musicians are seated symmetrically to balance the sound. In alcoves
at either end are two large kettle drums, one pair of cymbals and a trumpet. In the next pair of
inner alcoves are two pairs of kettle drums, cymbals, a straight trumpet and a *shehnai*. In the
middle alcove is the leader of the group on a dais with larger kettle drums, and around him on
each side are two pairs of kettle drums, two *shehnai* and two cymbal players.

This is an important picture as it depicts courtly music at its grandest. The *naubat* is
far larger in size than any featured in *Akbarnama* renditions of Akbar's court of a half century
earlier, and of course equal in size and pretension to the procession itself. Represented are the
majestic aspirations and imperial style of the grand Mughal, Emperor Shah Jahan, and the
subject matter is in keeping with the nature of the official account of his reign, the
Padshahnama or *Shah Jahannama*, which focuses on his military achievements and his

151 An attempt to assassinate Akbar in the bazaars of Delhi

impressive court durbar (audiences). The stately treatment of the procession, the massing of people into distinctive blocks and the lack of individual characterisation are in marked contrast to *Akbarnama* treatments and reinforce a notion of a distanced imperial grandeur (Pal, 1989, 23, 28, 93, 244 and Beach, 1978, 84).

SPORTS AND PASTIMES

153 **Bhima preparing for wrestling**
A scene from the *Mahabharata*
Himachal Pradesh, Bilaspur; 1700; 22.5 x 28.7
Private collection

Illustrating a scene from the great epic, the *Mahabharata*, the painting shows Bhima, the strong muscular warrior hero, in the middle of a wrestling match. The contest is heightened by music from a kettle drummer and a *shehnai* player, representing together a watered down version of the imperial Mughal *naubat* ensembles. The low vantage point selected by the artist establishes the wrestling field as almost a flat backdrop and directs attention to the wrestlers. On either side of them supporters hold flasks to quench their thirst. At the top of the painting the match is being observed by two sets of nobles seated on platforms – possibly representing the different sides of the battling wrestlers below them. Bhima was one of the five Pandava brothers who eventually went to battle against their cousins, the one hundred brothers, the Kauravas, in order to obtain their birthright, the rule of the kingdom.

154 Itinerant acrobats

154 **Itinerant acrobats**
Maharashtra (or Karnataka), Company school; c1800; 22.5 x 18.1
Art Gallery of New South Wales, Sydney; gift of George Sandwith, 1957

The acrobats are typical of those numerous sets of depictions of castes and occupations so much favoured by European patrons of Indian painters in the early nineteenth century. In this striking image all attention is focused on the woman balancing on top of the pole. Below her, providing a drum roll to intensify the drama of the act is a drummer playing a double-headed drum thats v-shaped lacing is clearly visible. Both women wear the long saris typical of the Maharashtran region of western India; the saris are long enough for women to be able to wind them between their legs, so achieving a pantaloon effect. The style enables the ease of moment necessary in acrobatic routines as illustrated here but also allowed Maratha women to ride astride on horses and fight in various military campaigns in the eighteenth century.

248

153 **Bhima preparing for wrestling**

155 **Tiger hunt**

155 **Tiger hunt**
Rajasthan, Kota; 1825; 36.5 x 56.5
Private collection

This large scene of the ruler of Kota hunting tiger represents the nineteenth-century culmination of hunting subject matter which had begun in Kota from around the 1740s, itself an extension of treatments dating back a century earlier (Beach, 1992, 178 and Archer, 1959. 47-58). By the nineteenth century, the main elements had become established: a usually nimbate monarch was shown shooting from his hide at a lion or tiger in the royal hunting grounds which, given the attention devoted to the detail of the landscape, virtually became the main subject matter of the painting. The Kota hunting scenes were often located in the royal preserve of Kaithun in the jungle south of the city near the ridge separating the state from Malwa (Desai, 1985, 60). And a magnificent subject matter it was with its picturesque backdrop of craggy hills and a foreground of numerous kinds of trees and plants. The ostensible purpose as intended by the ruler as patron of the painters was of course to have a proper record of his successes at the annual hunt.

What is of interest in this painting in terms of the exhibition is not so much in the hunter or the hunted, nor the locale in which their drama was played out, but the presence of music in the situation. Part of the procedure of the hunt involved beaters moving through the forest driving the animals to where the ruler could shoot at them. Among the beaters were drummers, shown on the right of the painting, one beating a kettle drum and another a shallow kettle drum of the kind used in processions. In this situation music was not intended to charm or to celebrate but to evoke fear in the animals and drive them towards the monarch.

BATTLE

156 **War elephants collide in battle**
From an *Akbarnama* manuscript
North India, Imperial Mughal, c1590; 37.8 x 25.2
Victoria and Albert Museum, London

The two drummers on the camels at the top of the painting demonstrate the place of drum beat in military battle. Below and the main subject of the painting is an incident in a battle when Emperor Akbar in full battle array with his prized war elephants put down the rebellion of Ali Quli Khan and Bahadur Khan. In the affray an arrow hit the horse of Bahadur Khan, both fell to the ground and Bahadur Khan was captured. Above him in a marvellously convoluted depiction of charging elephants is Akbar's war elephant Citranand. He was mast (on heat) and chased another of the royal elephants, Gaj Bhanwar, whose driver drove him into the rebel lines. Citranand followed and was confronted by the rebel elephant, Udiya,

156 War elephants collide in battle

whereupon Citranand turned to meet him in battle and was victorious. It is this tangle of bodies and the victorious imperial elephant that is here recorded.

The painting has all the characteristic verve, colour and boldness of other paintings from the first imperial *Akbarnama*. It is one of the few paintings in the series which does not have a specific inscription as to the artist (Sen, 1984, 113, 162) although its design has recently been attributed to Kesu Kalan and colouring to Chatar Muni, with special touches by Kesu Kalan (Welch, 1985, 151).

157 **Rama and his troops on the seashore**
Folio from a *Ramayana* manuscript
Himachal Pradesh, Kangra; c1810; 33.7 x 46.7
Paul F. Walter Collection, New York

This folio illustrates an incident from the *Ramayana*, the great epic account of Rama and the abduction of his wife, Sita, by the titan, Ravana, the ruler of Lanka. Rama and his brother, Lakshmana, have pursued Ravana down to the southern-most tip of India and are seated beside the sea looking across at Lanka where Ravana's castle is just visible. Rama is trying to work out a strategy to rescue Sita; he sits in discussion with the monkey general, Sugriva, the white monkey beside Rama, and Hanuman or Maruti, the brown monkey. Their army stretches to the left out of frame. Above them, as was the case with the armies of Mughal and princely India, the artist has depicted a *naubat* ensemble with the usual instruments, drums, trumpets and ensembles. The sea which separates Rama from Sita is handled with confident bravura by the anonymous Kangra artist who has chosen to populate it with an appropriately strange bestiary. In a touch of reverse irony the sea creatures are shown as being as curious about the strange monkey army as at least one of the monkeys is about them.

FESTIVALS

158 **Prince celebrating Holi** *(see page 195)*
North India, Imperial Mughal; c1750; 18 x 13
Victoria and Albert Museum, London

In this gentle and lyrical late Mughal painting a Muslim prince plays Holi with the women of his court. An attendant squirts water from a syringe and another pours water from a flask over the amorous lovers. Circling them are women musicians: at the top a woman beats a *daph* (a large frame drum), another, below her, plays a Mughal *rabab* and another a double-headed barrel-shaped drum. On the other side is another drummer and a woman playing a *bin*. Just as the palette is delicate and subtle in its colouring so too is the mood of the painting, suffused with a clear, if understated, eroticism.

157 Rama and his troops on the seashore

160 Maharana Ram Singh II playing Holi

A spring festival with many aspects and forms of celebration, Holi is one of the most important of Hindu festivals. Among a variety of other playful practices people throw coloured powder and water over each other, and sing and dance – sometimes with great abandon. It is also a festival associated with lovers and was so represented in a genre of miniature paintings of Krishna playing Holi with milkmaids [see 42]. It was not uncommon for Muslim rulers and certainly more common for their nobles to join in Holi festivities while their artists by the eighteenth century had incorporated it within their subject matter (for another Hyderabad example, see Sharma, 1978, fig 12). The mood inherent in the image of lovers playing Holi after all had a match in the romantic tenor of the Muslim lyric poetry of the day.

159 **Maharaja Amar Singh playing Holi with his chiefs**
 Rajasthan, Udaipur; 1708-1710; 47 x 40.5
 National Gallery of Victoria, Melbourne; Felton Bequest, 1980

The Holi festival was a kaleidoscopic and immensely varied social occasion, full of wild fun and emotional highs whatever its embedded meanings. The activity of covering people with red powder or dousing them with coloured water produced tumultuous enjoyment in situations where everybody was as much victim as perpetrator. This was also a time when the lowly might play a game of role reversal and mimic their superiors without fear of reprisal. The festival, in addition, had religious significance, which varied from region to region but often centred around the burning of an effigy of the demoness, Holika. In Rajasthan with its numerous princely kingdoms the festival also had major political connotations.

So it is here in a stately painting of Maharana Amar Singh II, the ruler of Udaipur, celebrating the eighth and last day (*phag*) of Holi with his close male relatives and other nobles. They are seated as in a formal audience (durbar), the Maharana aureoled, in the middle of the magnificent geometrically laid out Sabrat Vilas garden. The nobles (*sardar*) are throwing coloured powder at each other from mounds in the centre of the audience space. On the outside fringes, in between the trees, three musicians provide background music to the proceedings. There is no sense of wild revelry to this occasion nor wild throwing of powder. On the contrary the courtiers are re-affirming their adherence to the political order and the power of the Maharana in a situation rendered intimate and personal by the artist's handling of the scene. The nobles are contained within the space of the garden whose formalism is modified by its own vegetation, the trees and plants in it. Note the subtle variations in the use of red – from the intensity of the central mounds of powder through to the colour of the flowers which themselves form a square containing and echoing the shape of the audience terrace. While the primacy of the ruler is being reasserted, a further message conveyed is the unity between nobles and ruler as the one ruling elite.

159 Maharaja Amar Singh playing Holi with his chiefs

An inscription on the back of the painting identifies the courtiers by name but in addition, and most unusually, names the musicians. They are 'musicians Kanaji playing rabav [banjo-like instrument], Hasa playing chaga [tambourine], Mithya (?) playing dholak [drum]' (Desai, 1985, 66 and see also Topsfield, 1980, 62).

(see page 253)

160 **Maharana Ram Singh II playing Holi**

by Kishan Das

Rajasthan, Kota; 1844; 48.7 x 64

National Gallery of Victoria, Melbourne; Felton Bequest, 1980

The Holi tumult was much wilder when the ruler and his nobles went out in procession through the streets. Here the Maharao of Kota is, naturally given the order of things, seated on the largest elephant and naturally he also has the biggest and most powerful means of imposing on his subjects streams of coloured water. His delivery system is not a pot of water nor a syringe but the hose of the city's state-of-the-art fire engine whose water pressure is maintained by four servants working the pump below him. His aim is directed at the women on the first floor balconies of the street's buildings. They retaliate with coloured powder. Below him the townspeople play Holi, some dancing to the beat from a frame drum. Standing out in the crowd are soldiers dressed in British military costume, more likely soldiers from the Maharao's own guard rather than, as has been suggested, soldiers from the British army. An inscription on the back of the painting identifies the occasion, the ruler and his elephant, Gomah Gaj, while on the painting itself the names of nobles are written in Devanagari script (Desai, 1985, 117-118 and Topsfield, 1980, 22 and 46).

Although the figures are somewhat stocky and represent a decline in drafting skills, the portrayal of the elephants and the overall composition apexing in the central figure of the Maharao is striking in its richness and complexity. This is a Holi in which the role of the ruler over his subjects is re-asserted and celebrated. As a whole the painting is as vital and full of life as is the festival it is portraying.

161 **Diwali celebrations at Kota**

Rajasthan, Udaipur; c1690; 48.5 x 43.4

National Gallery of Victoria, Melbourne; Felton Bequest, 1980

The simple titling in Devanagari script on the back of the painting as a 'Depiction of Festivities in Kota' belies the complexity of this large overview of the palace and its surrounds. It also belies the originality of its conception, which has no counterpart in earlier Mughal or Rajasthani painting, though such treatments became a genre in later painting from this region of Mewar. Different kinds of perspective and points of view are juxtaposed so as to contain within the one frame the multiple events that mark the celebration. The primacy of

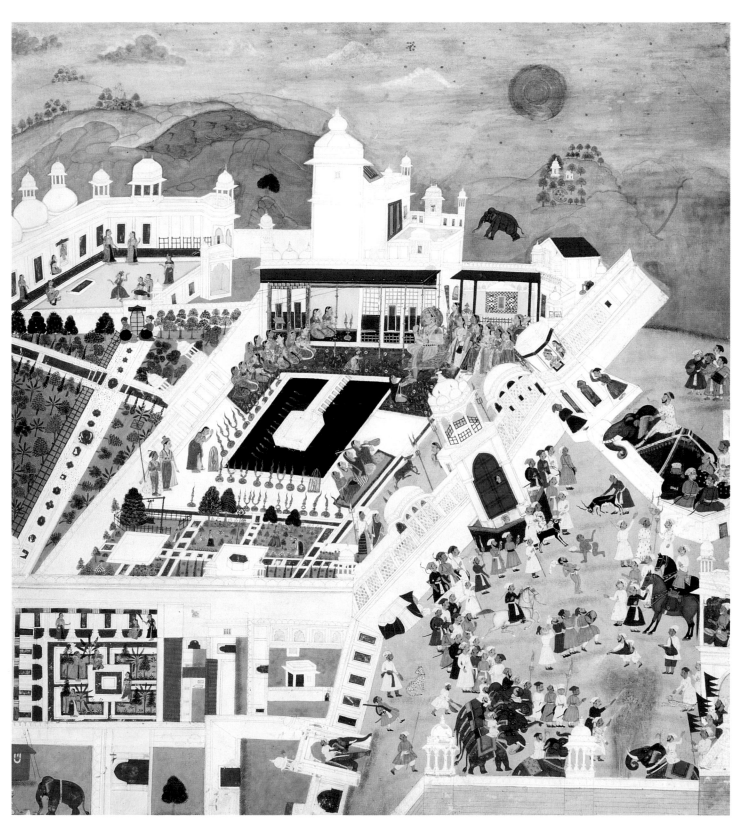

161 Diwali celebrations at Kota

the subject matter, the centrality of the ruler, is however never in doubt in this image, given the artist's clever positioning of strong diagonals – the palace walls – which frame the monarch. The occasion may be Divali, the festival of lights, an attribution which derives from the numerous lights and lamps within the palace and also explains the fireworks (Topsfield, 1980, 57). However the prominence of the full moon in a festival that is supposed to happen at the time of the new moon (of the Indian month of Kartika) suggests the likelihood of the depiction of 'a more generalized celebration' (Desai, 1985, 60).

Whichever, what is clear in this painting is the great importance attached to music and dance in the festivity. The nimbate ruler, possibly Ram Singh I, sits beside a formal pool in the *zenana mahal*, the palace of the queens, rewarding a dancer with a pearl necklace; she has been accompanied by a troupe of women musicians – tambura and *tala* players and a singer. In another women's courtyard in the upper left of the painting a dancer performs to the sound of a double-sided drum. In the courtyard on the right where the male courtiers are congregated the entertainment is more varied. A fight between two ibex is about to start, a wrestling match is in progress, a cheetah is making its entry on a lead, and a line of men dance to a drummer at their head while water carriers dampen the dust around them. The interior space is encircled by palace elephants and courtiers on horses. At the extreme right from their space above the entry gateway, accompanying music to all these activities is provided by a *naubat* ensemble of drummers and perhaps singers. Outside the palace, beyond the elephant peering over the palace wall, in the top right is another group of musicians playing a double-headed drum and cymbals.

162 Maharana Jagat Singh attending the Rasalila

by Jai Ram

Rajasthan, Udaipur; 1736; 59.8 x 44.8

National Gallery of Victoria, Melbourne; Felton Bequest, 1980

Although a small group of musicians (a *tala* and a *rabab* player and a drummer), are playing outside the palace walls, the main interest in this painting is in what is happening in the courtyard. The Maharana, appropriately aureoled, attended by his son, brother and nephew, observes a woman dancer performing *arati* in front of a line of other dancers. This is a customary invocation before beginning a performance. A dancer, already dressed as Krishna in the form of Sri Nathji, in the furthermost alcove, is being worshipped by a group of women. Beside him is a canopy with a depiction of clouds and the God Indra. Other props for the performance lie behind the lines of women: there are two kinds of drums and a small model of Mt Goverdhan with a shrine on top of it which Krishna will presumably lift during the performance. Such performances of stories about Krishna were common in the courts of Rajasthan and are depicted in a series of similarly composed paintings. The lines of dancers shown here will subsequently form a circle around Krishna in imitation of the Rasalila when he danced with the gopis (Topsfield, 1980, 94 and Desai, 1985, 69).

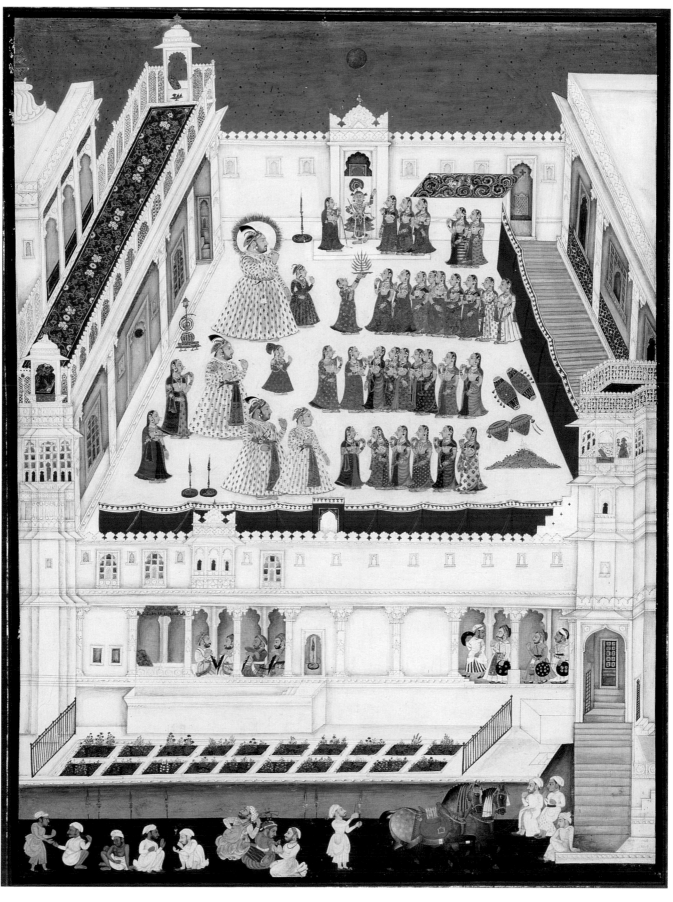

259

162 Maharana Jagat Singh attending the Rasalila

163 **Santals feasting and dancing**

North India, Santal tribe; c1850; painted scrolls; 464.8 x 30.5

Chester and Davida Herwitz Collection, Massachusetts

The Santals are a large tribe living in the Santal Pargana region of Bihar adjoining West Bengal and have their own life style, religion and language. Vertical scrolls much like the one on display here were created by a number of families of artists (*jadupatua*) living in the Santal Parganas for the entertainment of the Santals. The practice of the *jadupatua* was to move around the area from one village to another entertaining audiences with stories from various scrolls. Themselves Hindus, the artists varied their stories and scrolls according to their clientele, Hindu, Muslim or tribal. As for the Santals they regarded the painters as magic – or magician – painters (the literal meaning of the term *jadupatua*) and the scrolls created for their entertainment came to reflect their attitudes and to contain the important stories around which the identity of the tribe was constructed. Reproduced were images based around creation myths, the life after death, Santal festivals and dancing, personifications of Santal clans, and the adventures of Krishna (Archer, 1977, 15-26). The style of the scrolls varied from artist to artist but being rapidly painted they had vigour and vitality – and a richness derived from the tribal culture for which they were created. The scroll on display is a fine example of the genre, presenting scenes from the daily life of Santals and the dancing at their festivals.

164 **Harvest festival**

Bangladesh, Khulna; early 20th century;

embroidered cotton *kantha*; 18.4 x 59.7

Philadelphia Museum of Art; Stella Kramrisch Collection

Kantha represent the ultimate in recycling old materials. They were created out of threadbare saris and dhotis by Bengali village women in the nineteenth and early twentieth centuries with the most inspired coming from Kayastha women in what was 'then East Bengal and is now Bangladesh. Using the simplest of stitches women bound together old bits of cloth with thread obtained from unpicking parts of worn out saris; the result was the creation of original images of great vibrancy' (Kramrisch, 1968, 66-69 and Irwin and Hall, 1973, 171-180).

The image of women and men performing what is probably a harvest dance is amongst the finest of such *kantha*. A central lotus medallion separates the men from the women, around them are auspicious whirls (symbolic representations of the sun), birds, a tree of life and decorative motifs. The artist has not used flat blocks of colour in the embroidery but has created a stippled effect by juxtaposing small blocks of colour. Similarly, she has varied the closeness of the stitching in order to achieve an effect of modelling and volume in the figures. The sum effect is both of boldness and subtlety.

163 Santals feasting and dancing

detail

164 Harvest festival

MUSIC AND DANCE AS ENTERTAINMENT

Jackie Menzies

This section draws together a diverse group of images depicting the use of music for entertainment, usually within a palace, sometimes even within the women's quarters (*zenana*). The ability to play music was long considered a necessary accomplishment to aristocratic men and women. Texts like the *Kama Sutra* (Aphorisms of love) of Vatsyayana include in their lists of the necessary arts for a cultured person dancing, singing, and playing a musical instrument, while other texts often mention music halls in aristocratic homes, individual groups of musical and performing artists, royal musical preferences, and the use of music in the daily routine. Members of royalty were patrons, scholars and even creators of music, and this section focuses on their enjoyment of music as entertainment.

165 Court scene

165 Court scene

from a *Shahnama*

North India; 15th century, 38.1 x 25.4

Asian Art Museum of San Francisco; Avery Brundage Collection

Purchased through the City Art Trust Fund, the Asian Art Museum Acquisitions Fund, and a gift of Stuart Harvey and the Levi Strauss Foundation

Islamic rule in Northern India began with the conquests of Mohammad Ghori of Ghazni (Afghanistan) who died in 1206. In the centuries until the establishment of the Mughal dynasty in 1526, much of northern India was ruled by Muslim rulers known as sultans. It was in this Sultanate period that Delhi became the centre of authority with other prominent sultanates in Bengal, Malwa, Gujarat, and the Deccan.

The *Shahnama* (Book of kings) is the great epic of Persia written by Ferdousi around 980-1010 in which myth, legend and historical fact are woven together in poetic form. Sultans commissioned versions of it from itinerant Persian artists as well as local Indian painters trained in the Persian style. This folio, from an outstanding illustrated *Shahnama* manuscript that appeared in Europe only in 1987, is a rare and important 'bridge work' combining Persian text with illustrations by an Indian painter. The style, the colouring and the details, pronouncedly Indian, have parallels with the Western Indian Jain style [83-86], yet the style is something quite new. The obviously 'foreign' costumes and the three-quarter profiles of the faces with the pupils of the eyes placed in the corners, reveal a debt to Persian conventions, which the inventive artist has fused with Indian conventions (See Goswamy, 1988, for a discussion of this important find).

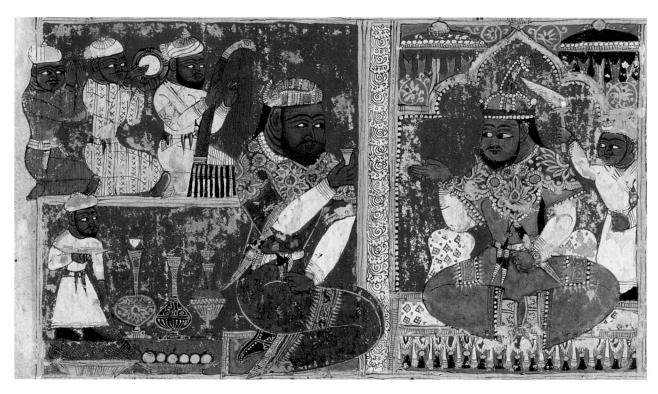

165 Court scene
detail

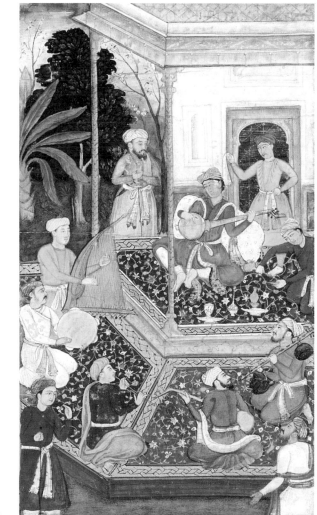

166 A musical party

This folio shows Rustam, the red-bearded national hero, conversing and drinking with the richly dressed king while three musicians entertain. Trays and vessels containing food and drink of various sorts underscore the significance of the occasion. The attentive drawing of the vertical harp and frame drum, as well as the foreground vessels and the elaborate clothing conveys a feeling of luxury and sophistication.

166 A musical party
North India, Sub-Imperial Mughal; c1600-1625; 14 x 7.7
Navin Kumar Gallery, New York

There were many painters outside the imperial atelier who catered to the taste of various princes and wealthy bourgeoisie by producing Mughal-style paintings which varied in quality from the excellent to hackwork. To distinguish such paintings from those of the imperial ateliers, the rather misleading term 'Sub-Imperial' is used. This painting, in style, composition and the attention to detailing individual features and costumes rivals many of its Imperial Mughal prototypes with the architecture, the sense of space and the focus on the prince on his raised platform all compling with Mughal devices. However the subject of a prince playing with his musicians, rather than passively listening, is rare. Similar Mughal paintings of a prince surrounded by a semi-circle of courtiers invariably include one, perhaps two, musicians as well as a poet and various advisers, but not often such a serious assembly of musicians. The scene is a valuable document of a Mughal musical party. A strong Central Asian influence is still discernible in the instruments being played. The prince plays a non-Indian type of four-stringed plucked lute as does one of the foreground musicians. Other instruments are the vertical harp, a frame drum, an end-blown flute and a *bin*. All instruments are being played, and the absorption of the musicians plus the rapt attention of the numerous attendants evoke the pleasure of an outdoor concert. The luxurious floral patterned carpets, the Chinese Ming dynasty blue and white porcelain, the very number of musicians and attendants confirm the cultured sophistication and wealth, even ostentation, of this unknown prince.

167 Grotesque dancers performing
North India, Sub-Imperial Mughal; c1680; 16 x 9
The Cleveland Museum of Art; Andrew R. and Martha Holden Jennings Fund

The unusual dance scene in this painting conveys a tension between its exotic practitioners and the codified milieu of the court. The three rustic dancers, wearing demonic masks, evoke more primitive responses than would normally be seen at court.

As Leach explains (1986, 111), 'The rows of bells worn by the man on the right are common ornaments of shamans officiating at village shrines, while the necklace is that of a Lingayat Shaivite. Like the bells, the animal bone held by the same dancer probably had a

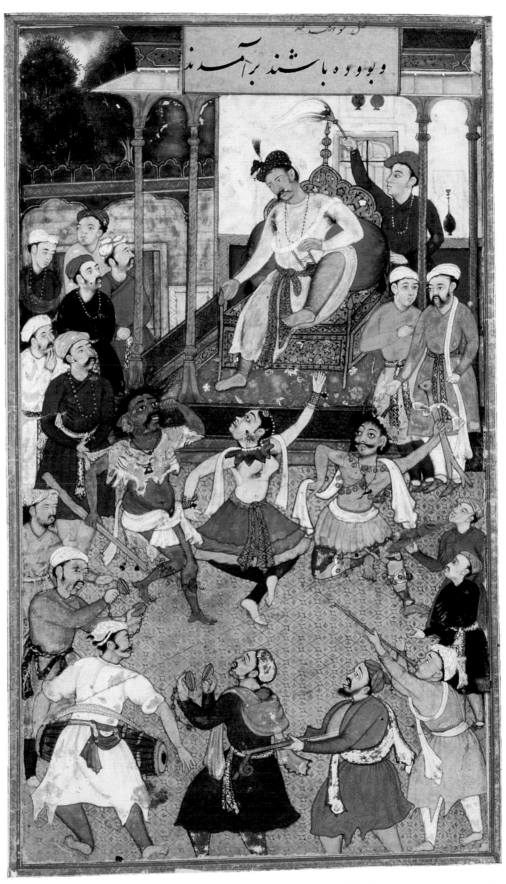

167 Grotesque dancers performing

shamanistic use.' (The Lingayat was a sect begun in Karnataka by Basava who preached against superstitous practices and caste distinctions. It became prominent in the twelfth century). She also concludes that the folio probably comes from an album of unusual fables done for an Akbari court noble.

168 Musician prince
Bilaspur; c1700; 22.8 x 16.5
Mr and Mrs John Gilmore Ford, Maryland

Bilaspur was a small but powerful state in the north-west of the Punjab. By the second half of the seventeenth century it had developed its own school of painting, characterised by this fine example. The musician prince is playing a *bin* while his companion on the left plays an early example of the sitar. The explosive colours, together with the use of malachite green to modify them, is distinctive to the Bilaspur palette which recalls that of the hill state of Basohli. Mughal influence is evident in the sensitivity to individual facial features, although the figure on the right has the novel Bilaspur detail of a long and wriggling side curl. The austerity of the composition with its minimal details, and large, static figures, is typical of Bilaspur painting.

169 A Sikh reception with musicians
Himachal Pradesh, Guler; c1815-1820; 22.5 x 31
Victoria and Albert Museum, London; gift of Colonel T.G. Gayer-Anderson, CMG, DSO, and his twin brother, Major R.G. Gayer-Anderson, Pasha

In the eighteenth century, as Mughal power weakened, the power of the Sikhs in the Punjab increased until Ranjit Singh (1780-1839) succeeded in unifying the Sikhs and annexing territory until he had built an empire. Subjugated kingdoms included Guler where Desa Singh Majithia was installed as Governor. Under his benign rule Guler artists began painting for the Sikhs and the central figure in this painting is considered by W. Archer (1966, 20) to be a possible portrait of him. This figure, seated within a courtyard on an elegantly fragile European chair, with a group of gentry, part Sikh, part Hindu, ranged about him, commands the homage one would expect someone of Desa Singh Majithia's status to receive. Moreover, the ebullient musicians, upper left, are escorting a party bearing a spinning wheel, stools and baskets – the conventional equipment for a bride. It is tempting to think this painting depicts Desa Singh Majithia's own wedding (ibid) which would make this painting a significant document as well as a beautiful Guler painting.

This painting carefully captures the profiles and individuality of the participants, notable warriors and leaders seated either side of the carpet, their position determined by their status. The seating arrangement at such formal functions was jealously noted as it

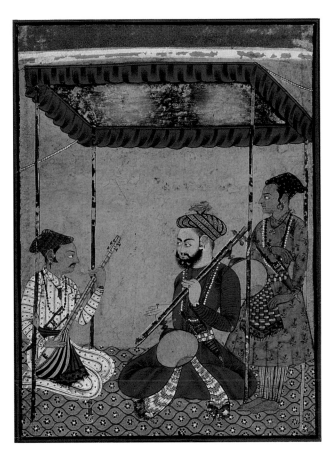

168 Musician prince

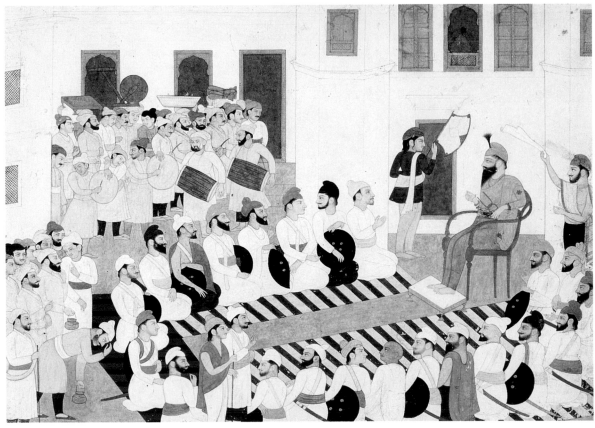

169 A Sikh reception with musicians

signalled the individual's current power and prestige. The massed expectation and the joyful gathering of musicians in the upper left is a foil to the formality of the official reception, emphasised by the characteristically Guler striped carpet.

170 Dancing in a palace
Uttar Pradesh, Mughal style at Oudh; 18th century; 40.6 x 29
The Art Institute of Chicago; Lucy Maud Buckingham Collection

This painting is a splendid example of the late eighteenth century genre of 'palace-scapes' which became popular in many of the princely states of India. Probably influenced stylistically by the *vue perspectifs* which were common in Europe around the same time, this painting illustrates a musical party for the ruler who is watching a dancer and her accompanying musicians, whose names appear in Urdu script beside them. The monarch sits central in his grand, geometrically laid out gardens, the pleasure of the moment reinforced by the fireworks being lit by servants. [JCM]

171 Raja Savant Singh with courtesan
Rajasthan, Kishangarh; 1760-1770; 35 x 46
Art Gallery of New South Wales, Sydney; purchased 1995

Kishangarh was a small state in central Rajasthan founded by Kishan Singh (1609-1615), a son of Raja Udai Singh of Jodhpur. The state developed under Rup Singh (1644-1658), a favourite of the Mughal Emperor Shah Jahan, and Kishangarh remained unusually dependent on the Mughal court and its culture. While there is little evidence of painting in the seventeenth century, in the eighteenth century Kishangarh produced perhaps the most important school of Rajasthani painting. By tradition the greatest patron of painting at Kishangarh was Raja Savant Singh (r1748-1764), an accomplished poet and religious devotee, as well as a friend of the Mughal emperor Muhammad Shah. His poems, written under the pseudonymn of Nagari Das, were intensely devotional verse in praise of Krishna and celebrating Krishna's love for Radha and their lives in a mythical Brindaban inspired by Kishangarh's beautiful scenery around Lake Gundaloo. In about 1740 he fell in love with a bewitching singer and poetess whose real name is unknown but who is known as Bani Thani. Their love became legendary, and inspired much of the evocative and romantic painting for which Kishangarh is justly famous.

While Savant Singh was a great inspiration to Kishangarh, it seems many of the large miniatures for which Kishangarh is most admired were painted in the reigns of succeeding rajas, since Savant himself spent so much of his time away from Kishangarh either dwelling in Brindaban with his beloved Bani Thani or going on pilgrimages (Binney and Archer, 1968, 37). It is generally accepted that larger paintings such as this one began to be

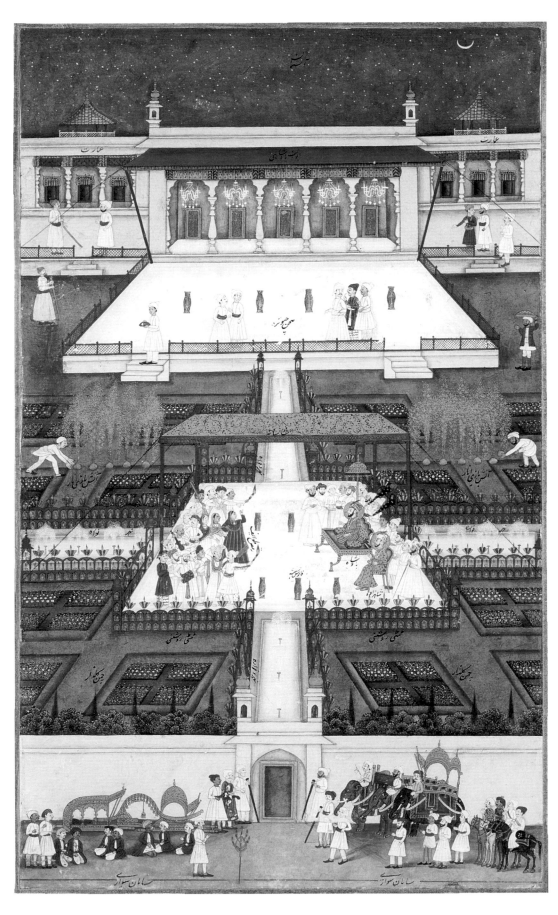

170 Dancing in a palace

produced during the reign of his son Sardar Singh (1756-1766). This painting conveys the luxury and elegance of the Kishangarh court while the setting of a musical performance on a marble terrace with a bevy of beautiful ladies recalls the popularity of such a subject with Muhammad Shah's court artists. In this painting a blue-skinned Krishna, wearing a gold turban, is seated under a canopy with his beloved Radha and a servant, surrounded by musicians, servants and court ladies. The absence of men would suggest this scene was taking place in the *zenana* (the few depicted would be eunuchs). In the balcony above the focus on Krishna is echoed in the central courtly couple, an earthly parallel to the divine couple below. The elongated figural style and distinguished faces with their sharp noses and chins, and long curving eyes and eyebrows, which are so distinctive to Kishangarh, are here fully evolved. The atmosphere of wealth, luxury and refinement to be seen in the best of Kishangarh painting is beautifully conveyed.

172 **Raja Mokham Singh watching a dance on a boat**
 Rajasthan, Kishangarh; c1820; 71.1 x 59.1
 Art of the Past Inc, New York

The unusual size of the painting distinguishes it immediately. It depicts Raja Mokham Singh enjoying a dance performance given by a young woman in blue, in a boat on Lake Gundaloo. His regal status is indicated by an aureole. Behind the main boat a smaller one carries the rest of the brightly dressed dancers, who would be called upon for other performances which took place throughout the night. The rest of the court can be seen lining the shore watching the spectacle on the lake. The perspective is skew but the beauty of the lake and the surrounding countryside is beautifully rendered. Such panoramic views of the lake and its palaces featured often in later Kishangarh paintings.

173 **Raja Bhup Singh of Guler and Queen watch monsoon clouds** (*see page 275*)
 Himachal Pradesh, Guler; late 18th century; 26.4 x 21
 Collection of Gursharan and Elvira Sidhu, California

The twelve months of the year, the *baramasa*, have provided a delightful theme for Hindu poets and painters [see 38]. The recurring theme of *baramasa* poems is that of 'love in union' (*samayoga*) and 'love in separation' (*viyoga*) against the backdrop of the six seasons (summer, rain, autumn, early winter, winter and spring). Bhadon, the month of rain that occurs in August/ September, is the time of lovers who revel in its cool breezes fragrant with the scent of jasmine and gardenias. Of all the seasons, none inspires more music than the monsoon, and paintings on the theme of love in union during the monsoon, against the backdrop of music, are numerous.

This painting of Raja Bhup Singh of Guler and his queen is similar to representations of Bhadon: rolling monsoon clouds, lightning and cranes flying in panic

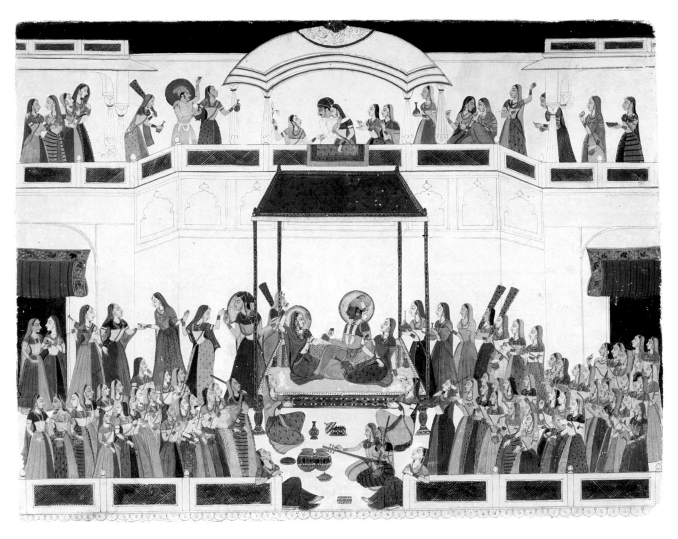

171 Raja Savant Singh with courtesan

271

172 Raja Mokham Singh watching a dance on a boat

emphasise the intensity of the storm which brings joy to poets and singers after the hot, dry summer months. The Raja and his Rani together watch the storm, sheltering in each other's embrace after being startled by the clap of thunder. The scene shows both the lush countryside and the open upper two stories of a marble Rajasthani palace, probably the *zenana*, with the lovers above and female musicians playing for them below. Outside, a peacock, symbol of the monsoons, stands on the wall, unsure where to shelter. What Keshavadasa (fl1580-1601), the court poet and author of the sixteenthcentury classic *Kavipriva* which contains the best-known of the *baramasa* poetry, wrote of Bhadon is quoted at left.

174 Dalliance at a Rajput court

Rajasthan, Bundi or Kota; 18th century; 22.8 x 17.8

Collection of Gursharan and Elvira Sidhu, California

The poet Keshavadasa whose verse was the source for many paintings on the *nayaka-nayika* (hero-heroine) theme, defined a *nayaka* or hero as a man who is young, expert in the art of love, emotional, proud, selfless, generous, handsome, rich and refined in taste and culture (Randhawa, 1962, 9). He identifies four types of heroine (*nayika*): *padmini* (lotus), *chitrini* (variegated), *sankhini* (conch-like) and *hastini* (elephant-like). In this painting, the lotus buds held by the two ladies, as well as their hesitancy towards the reclining prince allude to *padmini*. In the words of Randhawa (1962, 10): 'Padmini is a beautiful nayika, emitting the fragrance of a lotus from her body, modest, affectionate and generous, slim, free from anger, and with no great fondness for love-sports. Bashful, intelligent, cheerful, clean and soft-skinned, she loves clean and beautiful clothes. She has a golden complexion.' The idea of the shy heroine and the avid lover figures prominently in the classification of heroes and heroines.

The scene is redolent with the imagery of the senses and symbols of fecundity. Musicians play for the enjoyment of the prince; perfume and sweetmeat containers before him reinforce the courtly commitment to sensual fulfilment; and the abundance of carpets, cushions and brocade hangings signal luxury and comfort. Lush foliage, monkeys and a pond full of fish (as emphasised by the *gavial* or crocodile with one in his mouth), extend the imagery of plenty. The elaborate detail of the setting distinguishes many Bundi-Kota paintings and ensures viewing them is such a pleasurable experience.

The depiction of the god Surya, symbol of love, riding in his chariot across the midnight-blue sky, may mean the scene in fact depicts a prince waiting eagerly for his bride whose timidity and reassuring companions then make more sense. The painting is permeated with all the sense of anticipation and joy that is the outcome of 'love in union' (*samayoga*).

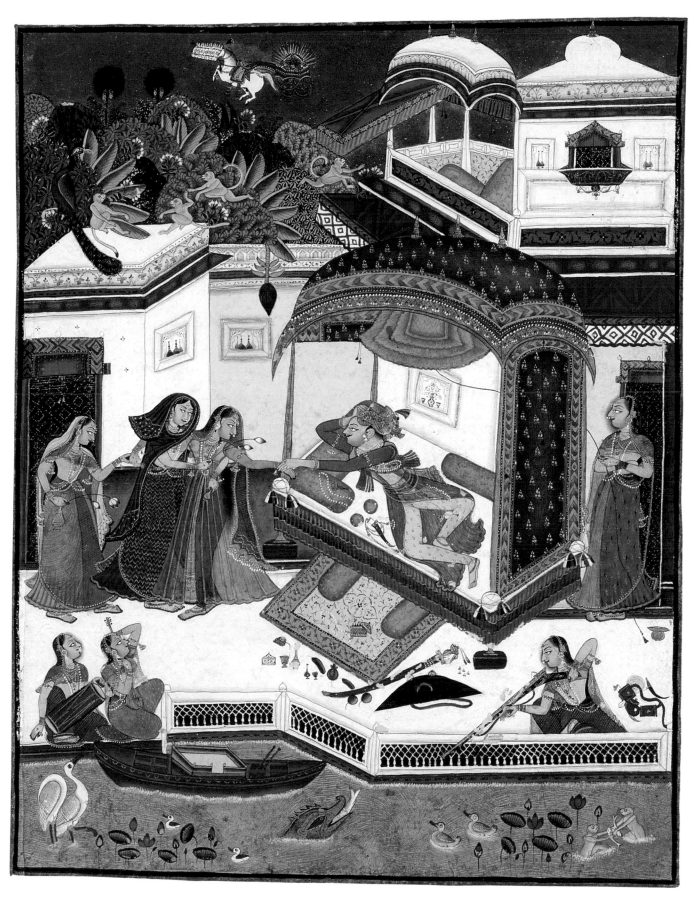

174 Dalliance at a Rajput court

175 **Ladies listening to a yogini**
Rajasthan, Bikaner; c1700; 24.5 x 17
Kapoor Galleries Inc, New York

Apart from female saints, the most famous of whom was Mirabai [99], who devoted themselves to singing, there were many other wandering female ascetics or yogini. It was customary for ladies of princely families to travel the countryside in the guise of a yogini: some did it as a path to spiritual enlightenment, some did it for distraction from the pain of lost love. Such women were outcasts, radically subverting the prescribed lives of most Indian women.

Ascetics used music and singing to transcend the mundane. In this painting the yogini appears in the lower left, playing on a terrace within a *zenana*. On an open terrace upper right, another yogini plays to two more women. The scene could comprise a sequential narrative ignoring conventions of time and space, or it could depict different events within the one palace.

The state of Bikaner was established in 1459, and it was an important and early presence at the Mughal court. Of the various Rajasthani courts, it was Bikaner whose paintings were stylistically closest to the Mughal style (It may have been the Mughal fascination with ascetics, religious teachers and mendicants that led the artist to this subject). It is generally held that by 1700 Bikaner artists were producing works as elegant and sophisticated as any Mughal paintings, evoking a fantasy world of pavilions, luxury and, in this case, the haunting notes of the yoginis' songs.

176 **Women surprised by the Emperor Muhammad Shah**
Delhi, Imperial Mughal; c1725; 26.8 x 39.8
National Gallery of Australia, Canberra

It was during the reign of Muhammad Shah that the death knell for the Mughal empire sounded with the sack of Delhi in 1739 by the Iranian Nadir Shah who returned to Persia with a huge booty, including Shah Jahan's fabled Peacock Throne. Yet the reign of Muhammad Shah (1719-1748) who was known as Rangila (the Pleasure Loving), was distinguished by its luxury, and his patronage of all the arts stimulated a renaissance referred to as the 'Muhammad Shah Revival'.

This painting is a poetic example of the vogue for lavish night scenes, depicting either a musical soiree on a terrace or a hunt in the forest, that became popular in his reign. Muhammad Shah, mounted on a symbolically blue horse, out hunting with his courtiers, has disturbed the musical idyll of a group of ladies, who have scattered behind some trees. An unseen moon bathes the lush scene with golden light, while in the far distance the imperial calvacade wending its way through the night-wrapped countryside is perhaps an allusion to the unrest that marked the Mughal decline from power.

173 Raja Bhup Singh of Guler and Queen watch monsoon clouds

175 Ladies listening to a yogini

177 **Court lady being entertained with music and fireworks**
Provincial Mughal; Lucknow, c1775; 26.8 x 17
Doris Wiener Gallery, New York

As imperial power disintegrated after Muhammad Shah's death, painters migrated from the court to the provincial Mughal areas, taking with them the popular Muhammad Shah painting genres of lavish night scenes and extended vistas. In the late eighteenth century Lucknow in Oudh assumed the role of chief imperial city, and became an urbane centre whose inhabitants devoted themselves to the enjoyment of dance, drama, poetry, music and gaming (Leach, 1986, 125). Painters refined the Muhammad Shah style for the nawabs and the bourgeoisie, to create seductively decorative scenes of luxurious pleasures.

Among the best Lucknow paintings are refined, extremely detailed night scenes such as this one, invariably depicting beautiful, langorous ladies at leisure. This scene could be a depiction of Diwali, the Hindu festival of lights held annually in October or November in honour of Lakshmi, the goddess of prosperity. Diwali is characterised by the placing of lights everywhere, and the enjoyment of fireworks. The numerous Mughal depictions of Diwali demonstrate the acceptance of the festival by Muslims and the eighteenth-century amalgamation of Hindu and Islamic beliefs within a secular, hedonistic framework (Leach, 1986, 139). The scene is suffused with golden light – from the moon, the sparklers held by two ladies, the soft flames of candles, and the luxuriant brocades and saris. The air of wealth and pleasure, the slender, short figures, the dark background that highlights the bright colours of the ladies' diaphanous robes, and the marble balustrade that frames the vista, are typical features of Lucknow painting.

178 **Madhavanala faints before Kamakandala**
a) Rajasthan, Bikaner; 1675-1700; 32.4 x 28.5.
Paul F. Walter Collection, New York

b) attributed to Chokha (fl. c1800)
Rajasthan, Devgarh; late 18th century; 18.7 x 11.4
Collection of Gursharan and Elvira Sidhu, California

These two paintings depict a much-illustrated scene from a romance that was written in 1583 by Jodh, a court poet of Akbar, but later became a popular subject in Rajasthani painting (Randhawa and Galbraith, 1969, 84). The tale concerns the tragic love of Madhava, a young brahmin, for Kamakandala, a beautiful courtesan. Madhava, whose playing on the vina so erotically excited all women they found him irresistible, was exiled from his country by the king who was jealous of the youth's success with women. One charming version of how he met Kamakandala goes as follows (Randhawa and Galbraith, 1969, 86):

176 Women surprised by the Emperor Muhammad Shah

177 Court lady being entertained with music and fireworks

'Mandhava arrived at Kamavati on a day when Kamakandala, a favourite of the King, was performing a dance at the palace of Kamsen, the King. The gatekeeper did not allow him to enter. So he waited outside and detected a flaw in the time rhythm of the accompanying music. He told the gatekeeper to inform the King that a particular tambourine player had an artificial thumb. Kamsen, finding this to be correct, honoured Madhava by inviting him inside. He offered him his own seat and gave him costly gifts. Kamakandala, the dancer, naturally desired to show her best to such a connoisseur of music. So she smeared sandal paste on her breasts. A bee, attracted by the fragrance alighted thereon, and stung her on the nipple. Without disturbing her rhythmic dance, she drove away the bee by forcing her breath through her breasts. This extraordinary feat of yogic breath control proficiency was discerned only by Madhava'.

Eventually Madhava and Kamakandala fell in love, and according to this version of the tale lived happily ever after. However, another version states that due to a misunderstanding, Kamakandala, unfortunately believing Mandhava had died, killed herself. When he learned of this, he followed suit (Welch, 1973, 51). This is the tragic misunderstanding depicted in these two paintings.

The earlier painting was done at the Rajput centre of Bikaner to which Mughal-trained artists migrated in the second half of the seventeenth century. An inscription on the back describes the artist simply as *patshah ustad*, meaning 'the imperial master', which can only mean that the artist was once associated with the imperial atelier, whence he came into the service of the Bikaner court (Pal, 1978, 92). As Pal says (ibid): 'the hand of a Mughal master has clearly left its imprint in the handling of space, the subtle variations of colour, particularly in the gloriously colourful sky, and the generous use of gold'. Devgarh, where the second painting was done, was a lesser court in Mewar which supported a vigorous school of painting in the late eighteenth-early nineteenth century. Chokha was an artist active at the turn of the century who was admired for his passionate subjects and rich use of colours (Welch, 1973, 52).

178b Madhavanala faints before Kamakandala

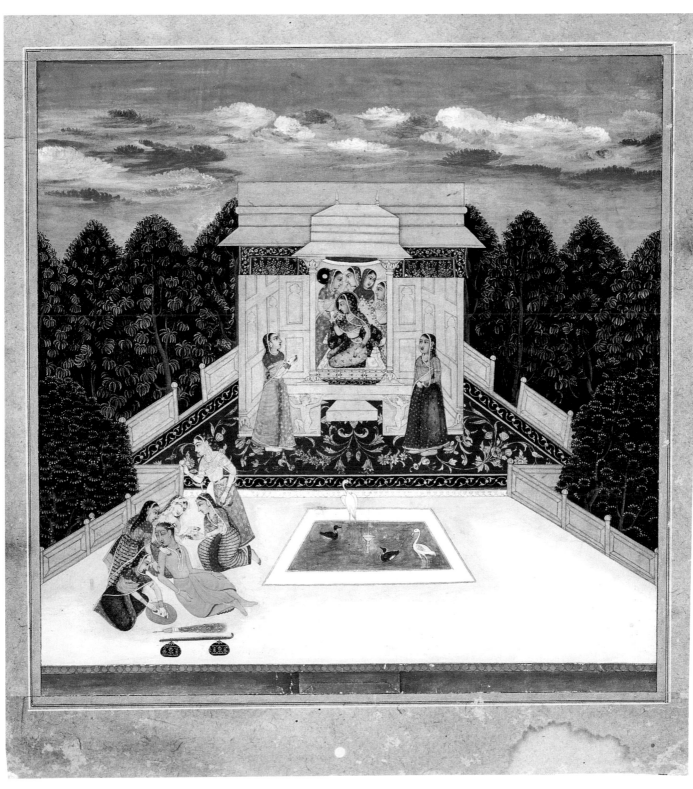

178a Madhavanala faints before Kamakandala

RAGAMALA: A GARLAND OF MUSICAL MODES

Jackie Menzies

So intrinsic is music to the Indian imagination, that there are paintings matched to specific melodies (raga). Though Indian music can be divided into two main traditions – the Northern Hindustani and the South Indian Karnatic systems – there is only one music in India: the music of the raga. The basis of the raga is a *svara*, best translated as a sound note, although it is the sound of a human utterance, the word having its roots in Sanskrit in which *sva* stands for 'self' and *ra* for 'shining forth'. Thus it is a sound in which the self must shine forth (Menon, 1995).

A raga is a progression of five, six, or seven *svara*; each of the six main ragas has subordinate ragas or consorts, referred to as ragini, as well as other offshoots regarded as sons or ragaputra. A collection of ragas is known as a ragamala – literally a garland of ragas. Each raga, ragini and ragaputra varies technically, spiritually, and emotionally, with each expressing a particular mood, for example devotion, loneliness, tranquillity, eroticism or heroism, and is linked to a specific hour of the day or night as well as to one of the six seasons of the Indian sub-continent. The origins of the raga are various: regional folk songs, the songs of wandering ascetics or the creations of great musicians. Ultimately their origin can be traced to Bharata's *Natyasastra*, dated variously between the second century BCE and the second century CE, the oldest document on the theory of Indian music and dance.

The essential feature of a raga is its power to evoke a certain state of being in the listener. Each playing is a unique performance since the musician improvises within the carefully prescribed progressions of the raga involved (Pal, 1967, 7). The possible number of ragas is very large, but the majority of classification systems recognise a basic thirty-six: six ragas, each with five raginis.

In ragamala paintings the image is linked, through iconography, poetry, text or mood, with a specific musical raga. The paintings deal mainly with the Hindustani tradition of ragamalas, and follow the sequence enunciated by various musical authorities. The most common system of thirty-six ragas is called the Painter's System, but other ones are the Hanuman and Mesakarna systems. Regardless of the classification, it is for their evocation of mood and emotion, their pictorial interpretation of the inexpressible as articulated through music, song and poetry that ragamala paintings are so universally significant.

This section comprises a selection of ragamala organised according to subject matter in the sequence of gods, ascetics, and lovers whether together, temporarily apart, or suffering the despair of being abandoned.

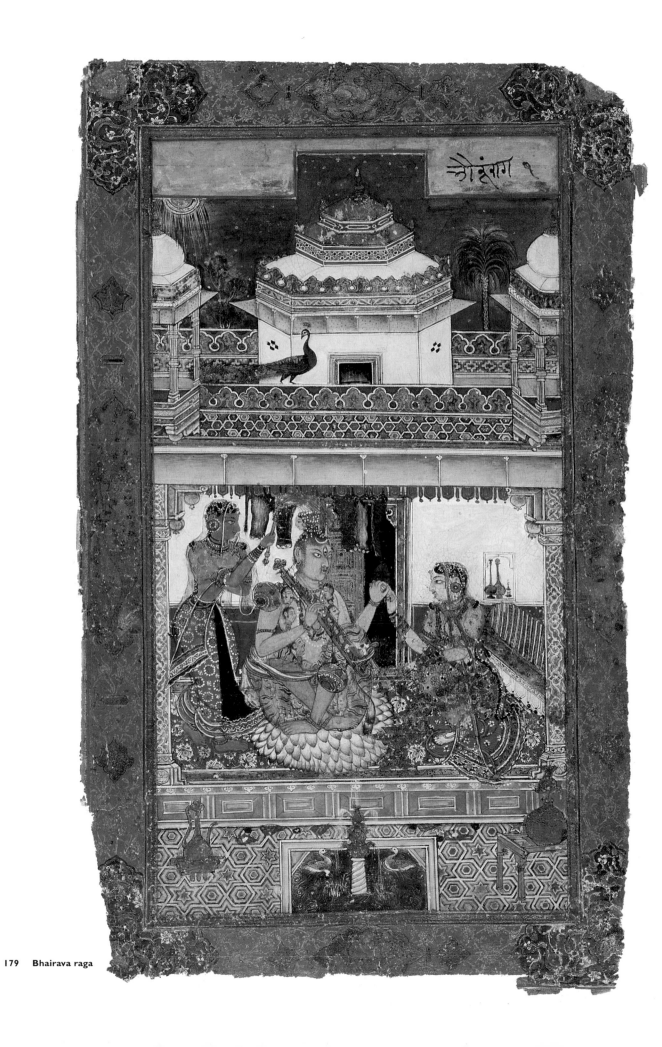

179 **Bhairava raga**

179 **Bhairava Raga**

Rajasthan, Bundi; dated 1591; 26.3 x 16.3

Victoria and Albert Museum, London

In virtually all known ragamala albums, raga Bhairava is the first. The raga is a morning one, to be sung at dawn in autumn, and is spiritual and devotional in its tone. Bhairava is an alternate name for Shiva in his terrifying aspect and in this benign representation he still bears many of the traditional attributes of Bhairava: the third eye on his forehead, the necklace of skulls, the lotus seat and the elephant-hide canopy. He wears the ascetic's garb of a tiger skin and the tall, distinctive ascetic *jata* (chignon) containing an image of the goddess Ganga in reference to the myth of Ganga descending from the heavens only after Shiva agreed to catch her in his matted hair to break her fall. Accompanied by his consort Parvati, Bhairava is depicted holding a vina rather than his more common attribute the *damaru* hand-drum, and is seated in ornate palatial surroundings at odds with the asceticism of his dress.

This painting is an extremely early and important one, dated to 1591, and hence serving to document the inception of the Bundi style of painting in Rajasthan. Bundi was founded in the mid thirteenth century by the Hara clan of the Rajputs. This painting, done at Chunar, Benares, by three Mughal-trained artists, belongs to a ragamala set that came into the possession of one of the rulers of Bundi when they were governors of Chunar (Guy and Swallow, 1990, 131). The set became the model for subsequent ragamala paintings in Bundi through a two-hundred-year tradition of iconographies and compositions, transmitted through a tracing method employing *charba*, drawings whose lines are perforated by sharp pins.

180 **A devotee performing puja: Bhairavi Ragini** (see page 147)

Rajasthan, Mewar; c1520-1540; 21.2 x 16.5

Victoria and Albert Museum, London; purchased with the assistance of the National Art Collections Fund from the executors of J.C. French.

The woman devotee beats cymbals (*tala*) and sings as she performs *puja* (worship) at a shrine of God Shiva. He is represented by a lingam garlanded with stylised flowers, both in bud and fully opened, forming an aureole around the image, a halo signifying its central sanctity. The shrine echoes the architectural style of the Sultanate period of architecture with its domed roof pavilion, its elegant brackets, and the finial in the form of a mythical animal-head (*makara*), its curled trunk grasping aloft a pointed religious banner. Although its place of origin is uncertain the painting may have originated from the Delhi-Agra neighbourhood but more likely its origin was in Rajasthan in the Mewar region around present day Udaipur, one of the Rajasthani Hindu kingdoms which was at the time holding out against Muslim domination (Guy, 1990, 34-35). The painting is an important example of pre-Mughal painting of a group in

181 Sri raga

183 Sarang ragini

the Chaurapanchasika style, itself a development from preceding Jain and Hindu traditions. Its use of bold contrasting fields is characteristic as is the painter's treatment of the devotee in the rounded form of her kneeling body and the check patterning of her skirt. The intensity and perhaps even the joy in her worship is conveyed by the elegant 'fish-shaped' drawing of her eye.

What equally distinguishes the devotee at her worship is that the painting represents the oldest known example of the ragamala tradition as it developed in Rajasthan. The couplet inscribed at the top of the painting (see left) summarises its mood and was to be repeated on miniatures created according to the Painters System of classifying ragamalas for the next three-hundred years or so.

The number two on the right-hand side of the painting suggests it was placed after a Bhairava raga painting, its rightful place as the 'wife of Bhairava' (ie Bhairavi ragini). Other ragas and raginis would have followed but none have survived from this set (Ebeling, 1973, 34-5). [JCM]

Out in the lake, in a shrine of crystal,
she worships Siva with songs punctuated
by the beat, the fair one, the bright one,
that is Narada-Bhairavi.
(cited in Ebeling, 1973, 120)

284

Splendidly enthroned, of peerless beauty
and lovely as the autumn moon,
he sits hearing stories from Narada
and Tumbara.
(cited in Ebeling, 1973, 124)

181 Sri raga
North India; Popular Mughal; c1625; 21.9 x 18.4
Los Angeles County Museum of Art; gift of John Ford

Sri means lord, and the iconography for the Sri raga is easily recognisable: a lord listening to music. The raga is one to be played in the second half of the afternoon, a spiritual tune of tenderness and melancholy. The Sanskrit couplet (missing in part on this painting) along the top of the image is a standard text for this raga. (See translation in part, left.)

Although the author of this text and the other couplets in this ragamala set is unknown, the texts, with their evocative descriptions of time, place and mood, are considered the literary basis of the iconographic tradition of Rajasthani ragamala.

Within an open-sided pavilion, the lord sits with his legs drawn up and tied by a narrow cloth of a type often used in meditation, partaking of something from a shallow dish in his left hand, and concentrating on the music. The music is being played by two famous figures: Narada, the great musician priest to the gods, and his favourite companion, the horse-headed Tumbara. So skilful with the vina is sage Narada, who has absorbed the teachings of the gods and mastered the transcendental potential of music, his notes strike to the depths of the soul, sparking our elemental intuition of the universe. While Narada is a celestial musician, his companion Tumbara, here playing cymbals, is a semi-divine being, a *gandharva*.

182 Malava ragaputra of Sri raga
Northern Deccan, c1675; 33.3 x 24.5
Asian Art Museum of San Francisco; Avery Brundage Collection; gift of Mr and Mrs George Hopper Fitch

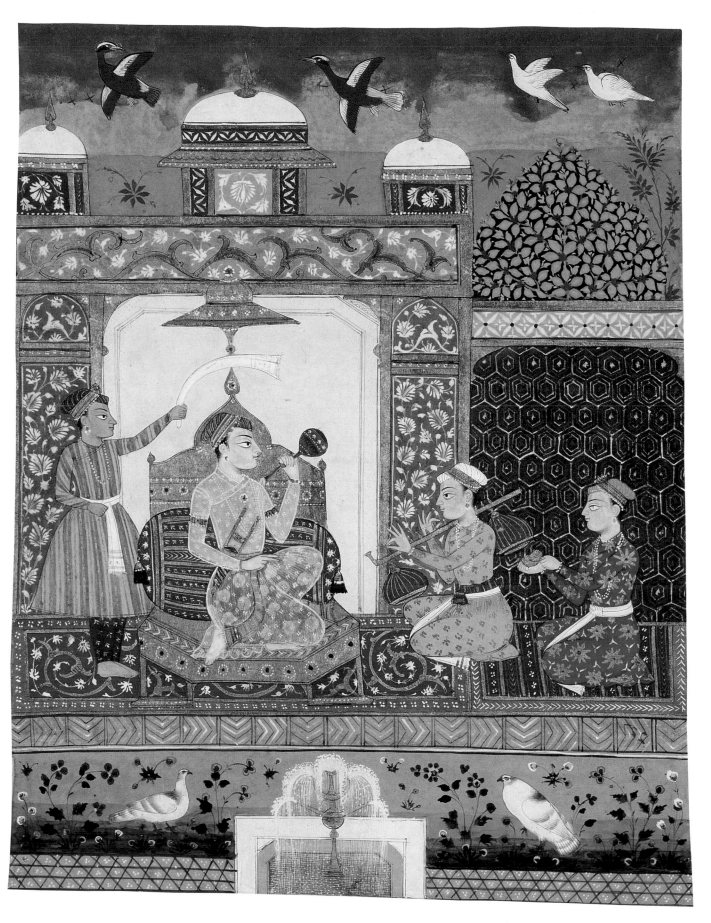

182 Malava ragaputra of Sri raga

Islamic rule prevailed in the Deccan, the plateau region of southern India, from its subjugation by Muslim rulers in the early fourteenth century until 1950 when the last *nizam* of Hyderabad relinquished power (Zebrowski, 1983, 9). A distinct Islamic culture evolved from the fusion of Turkish, Persian, Arab and Indian Muslim and Hindu elements, with paintings distinguished by extravagant colours and patterns, including a distinctive Deccani palette of blue, pink and mauve.

Much of the northern Deccan fell into Mughal hands in 1600 with the capital of Mughal Deccan being Aurangabad (Zebrowski, 1983, 48). Rajput noblemen were based in the northern Deccan, and influences there from Rajasthan and Malwa were strong. This painting of a lord listening to music depicts Malava ragaputra, the son of Sri raga. The painting can be considered an example of the importation into the northern Deccan of Rajasthani ragamala images. Stylistically it reflects the rigidity of pose and meticulous technique to be found in much late Mughal portraiture, while the colourful patterning reflecting the idiosyncratic Deccani heritage, make this a sensually beautiful image.

183 **Sarang ragini** (see page 283)

Maharashtra, Aurangabad; 18th century; 36.8 x 20

Collection of Gursharan and Elvira Sidhu, California

Dark skinned, with four arms,
like Vishnu, riding on Garuda,
his left side in the form of his wife,
in his hands bow and arrow, conch,
disc and mace.
(cited in Ebeling, 1973, 78)

The only ragamala system with which the iconography of this beguiling and unusual painting would seem to comply is that written by Mesakarna, a court priest from Rewa, whose text 'Ragamala', dated to 1570, and still extant, describes six raga, 31 ragini, and 49 putra in two series of evocative verses. His verse for the Saranga putra, at left, describes exactly the image before us.

Outside the Mesakarna system, which was popular throughout the seventeenth and eighteenth centuries with a small number of painters and patrons, particularly in the Pahari schools, the title Saranga appears on various images of differing iconography. The music itself was a raga to be performed at noon or in the early afternoon.

184 **Vasant ragini** (see page 181 & cover)

Rajasthan, Kota; c1770; 18.5 x 12.5

Art Gallery of New South Wales, Sydney; purchased 1997

Of the six Indian seasons — summer, monsoon, autumn, winter, cool season, spring — it is spring when music, dance and love predominate. The raga most closely associated with spring is that of Vasant and, since the major spring festival Holi, 'the festival of colours', is a predominantly Vaishnava festival, the raga is also dedicated to the Vaishnava god, Krishna, whose love adventures are detailed in the *Gitagovinda* [41].

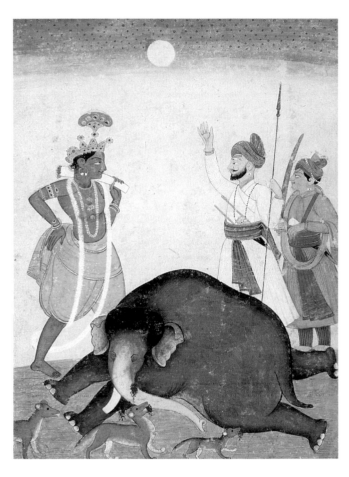

185 Kanhra ragini

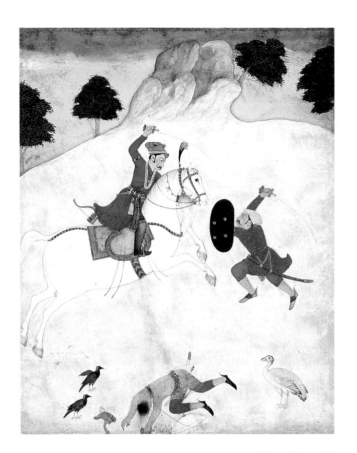

190 Nata ragini

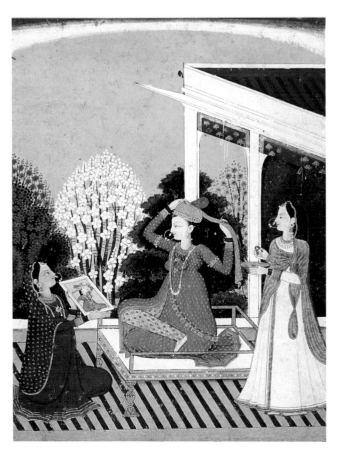

197 Vilavali ragini

In this vibrantly coloured image, rendered with a gem-cutter's precision, Krishna dances to the music of three young women, by a lotus-filled lake in a glade whose luxuriant foliage symbolises the creativity and fecundity of spring. In one hand he exultantly holds high a vase full of blossoms, while his other hand grasps a stylised vina of one gourd. Krishna wears a distinctive layered dancing skirt, each layer a different colour, tasselled shoes, a jewelled crown, and a long garland of white blossoms, while the body is covered in pearls and jewels. He is the focus of attention for the three ladies: one with an end-blown flute, another beating the classical two-faced drum (mridangam), while the lady opposite them marks time with *tala*.

This exquisite painting is a folio from a very large set of ragamala pictures that includes representations not only of the six raga and their ragini, but also of numerous sons (ragaputra) and daughters (ragaputri). The series is known as the 'Boston' series since the Museum of Fine Arts in Boston owns some thirteen paintings from the series. The series now is generally credited to Kota, a small Rajput kingdom in southeastern Rajasthan which became a separate kingdom in 1625 when the Mughal emperor Jahangir divided the kingdom of Bundi in half, each half being ruled by related branches of the Hara clan.

288

185 Kanhra ragini
Himachal Pradesh, Guler; c1775; 29.2 x 21.6
Art of the Past Inc, New York

The Kanhra ragini is one with an easily identifiable imagery: a noble, often represented as an incarnation of the god Krishna, being congratulated by his courtiers on a successful elephant hunt. The lord invariably holds the tusk of the slain elephant in one hand as a token of his victory. The image recalls an incident from the life of Krishna in which he, accompanied by his brother Balarama, slays the elephant Kuvalayapida which is guarding the evil king Kamsa whom they subsequently kill with the elephant's two tusks. This image typifies eighteenth-century representations of the subject where the scene is the actual place of the slaying, with the carcass of the slain elephant in the foreground.

The name of the ragini implies it came from the Karnataka region in the south of India, a melody to be sung in praise of a successful hunter of elephants – which abound in Karnataka. In musical terms, the ragini is a sonorous and sombre one to be sung in the summer in the first watch of the night. This painting was done in the north of India, in Guler, one of the thirty-four states of the Punjab Hills.

186 Kedara ragini
Central India, Malwa; c1650; 18.7 x 14.8 painting only, 20.8 x 16.4 with border
The Cleveland Museum of Art; purchase from the J.H. Wade Fund
Ex collection: Maharaja of Datia, Heeramaneck

186 Kedara ragini

Despair and loneliness overflow this starkly minimal depiction of a female ascetic singing the praises of her absent lover, wasting away through her distraction and obsession. Seated on an antelope skin on which ascetics habitually meditated, her intense introspection and solitude are echoed in the austere composition. As Leach (1986, 214) so potently explains, every unnecessary line has been eliminated to convey her desolation, and the two peacocks stretching their necks toward the sky mirror the yearning of Kedara.

The female ascetic theme was common in medieval literature and painting, but there are few so potent and emotive depictions of love's despair. A seven-line inscription on the reverse reads: 'The heroine Kedara, longing for her lover, has assumed the character of a yogi and waits intently for his return. She has smeared ash all over her body, which is reduced to a skeleton. Absorbed in love, she sings her lord's praise. In this yogic garb, her body is terrifying and looks like a male body. She sees that night seems to be prolonged and anticipates dawn eagerly. Lovesickness is killing Kedara.' (Leach, 1986, 213, paraphrasing V. Dwivedi)

187 Kedara raga (see page 37)

Himachal Pradesh, Arki (Baghal state); c1700; 21 x 18.5

Howard Hodgkin Collection, London

In the traditional Indian understanding of the course of an individual's life, there are four stages or *ashrama*: that of student (when one is under the spiritual guidance of a guru), that of a householder, that of a man retiring to the forest (*vanaprastha*), and finally that of a man renouncing everything (*sannyasin*). Since renunciation and retreat from worldly life constitute the last two stages of life, it is to be expected that asceticism, glorified as the path to spiritual salvation, is a common subject of raga and ragamala painting. Renunciation in addition could be an alternative path for an individual whereby he shortcut the householder stage and devoted himself to the search for salvation.

Mendicant ascetic Hindu holy men (sadhu), distinguished by their ash-covered, emaciated bodies, unkempt hair and beards, are often depicted playing music. Here one sadhu, seated in the half-lotus position on a leopard skin, plays the vina with rapt concentration, while his companion beats a rhythm with *tala*.

188 Vangala ragini

Rajasthan, Bundi; c1775; 19.4 x 12

Asian Art Museum of San Francisco; Avery Brundage Collection; gift of Mr and Mrs George Hopper Fitch

In this Vangala ragini, a female ascetic is seated on a tiger skin, on the small terrace

facing page
188 Vangala ragini of a pavilion beside a lotus pond teaming with aquatic fowl. The arching horizon is broken by

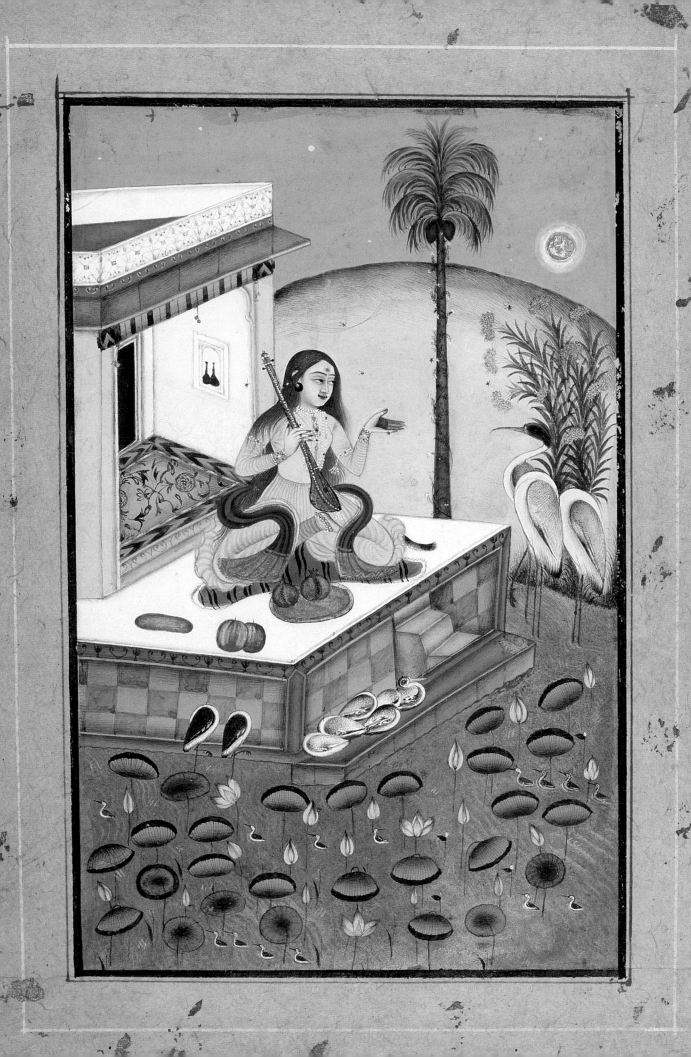

a coconut palm and blooming oleanders, motionless in the pre-dawn moonlight. This ragini, a melody originally from Bengal (Vangala) to be recited around sunrise, concerns the pain of separation from a lover: the loss of love that drives a woman to smear her body with ash and put a yellow *tilaka* (auspicious mark) on her forehead, and become an ascetic. Frequently she is accompanied by a tiger, leopard or cheetah, and sometimes she also holds Shiva's attributes, such as the trident. However in this poetically poignant depiction she is on her own, playing music and perhaps singing, hoping that music and the solitude of nature will bring relief.

189 Setamallar ragini
Rajasthan, Jaipur, late 18th-early 19th century; 30.5 x 22.6
The Art Institute of Chicago; restricted gift of Russell Tyson

Setamallar is an ascetic ragini, music of the rainy season. The imagery and composition of this painting, namely an emaciated female ascetic listening to musicians, while in the lower register disciples welcome a fat pilgrim in a patchwork quilt, is unique to ragamala albums produced in Jaipur in the eighteenth century when it was one of the few centres with any semblance of continuity and stability in the turbulence that accompanied the breakdown of the Mughal empire (Ebeling, 1973, 96). The emergence of the style of the paintings of these albums, of which an exceptionally large number of complete ones are still in existence, is credited by Ebeling to the patronage of Sawai Jai Singh II, Maharaja of Amber/Jaipur (1699-1743).

The same text is inscribed on all ragamala of the Jaipur eighteenth century style, although we know neither the origin, the poet nor the patron of this text. The Hindi verse on Setamallar Ragini is cited at left.

190 Nata ragini *(see page 287)*
Rajasthan, Bikaner; c1680; 15.1 x 11.9
Los Angeles County Museum of Art; Nasli and Alice Heeramaneck Collection, Museum Associates purchase

While most ragamala paintings are conceived in a devotional or erotic mood, Nata visualises music of a heroic mood. The iconography is standard: a warrior on horseback doing battle with foot soldiers, one of whom has been slain. The literary basis of this ragini is a text credited to the poet Kasyapa, of whom nothing is known and is quoted at left.

Bikaner was a desert state in northern Rajasthan which submitted early to the Mughals, with an incursion of Mughal trained artists in the second half of the seventeenth century. The Mughal influence is to be seen in the spongy treatment of the rocks, while the bare hillock with its sparse trees is indicative of Bikaner's desert scenery.

By reason of separation (from her beloved)
Malara is in a mood of renunciation,
she has become an ascetic
by adopting the dress of a male,
her body besmeared with ashes,
she wears round her loin a deer-skin,
immersed in (the sorrow of) separation,
her hair is dishevelled, her yoga trances
have given her matted locks,
and she sits in the mystic posture of a yogi,
she is counting on the day
on which her lover is due to return,
she has renounced all
the enjoyments of this world:
The black clouds have cast their shadows
on all quarters, my beloved who is
a generous lover has forgotten me.
(cited in Ebeling 1973, 144-5)

The neck of his steed is red, his body
daubed with blood shines with the
glow of gold; gripping his sword he
moves about the field of battle,
this one is called Nata.
(cited in Ebeling, 1973, 120)

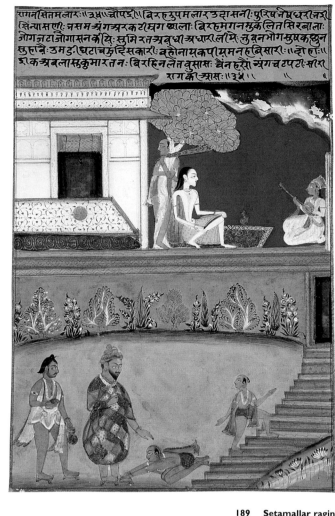

189 Setamallar ragini

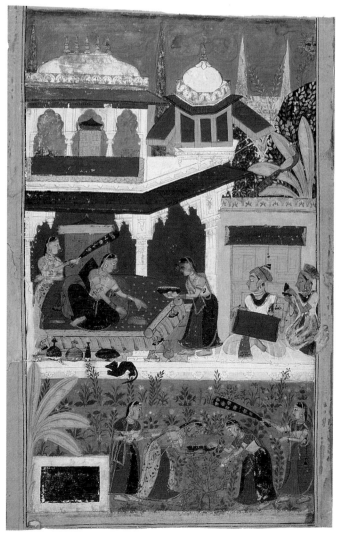

195 Gauri ragini

191 **Khokhara ragaputra** *(see page 187)*

Himachal Pradesh, Kangra; 1825; 25 x 30

Mr and Mrs John Gilmore Ford, Maryland

The iconography of this painting complies with that of the less common Mesakarna system of ragamala classification [see also 183]. Mesakarna's system, used by Pahari painters of centres such as Kulu, Basohli, Bilaspur and Kangra, compares the music of each mode to that of a sound in nature or in the household. The sound associated with this ragaputra is that of a parrot, and Mesakarna's verse describes the visual iconography as a man dancing happily, in loose-fitting garments, to the music of the clouds and the beat of drums (Ebeling, 1975, 64). The raga of which this putra is the 'son' is that of Megha (Cloud) which depicts the setting in of the rainy season to the accompaniment of rain, clouds and even thunder.

This painting is a masterly composition: the formality of the architecture, terrace and balustrade at odds with the asymmetrical composition and the abandon of the prince. The strong diagonal of the blue canopy together with the striped carpet (a Guler convention rarely used so effectively), emphasises the figure and instruments. Scattered over the carpet are two types of cymbals (*tala*), a lute, a drum, a large green tambura, another large stringed instrument (perhaps a sitar), a pair of kettledrums with their sticks, and one unidentified instrument. The seemingly inexplicably hurried departure of the musicians introduces an enigmatic note to the composition.

192 **Ragaputra Velavala of Bhairava**

Pahari, Basholi; c1710; 19.3 x 18.8

Art Gallery of New South Wales, Sydney; purchased with funds provided by the Margaret Olley Art Trust, 1992

Within a flaming orange and smouldering yellow frame, two lovers totally concentrate on each other, the intensity of their absorption hypnotic. The young hero (*nayaka*), seated cross-legged on the *chowkis* platform, is dressed in a long, pleated white *jama* with a broad side sash, a turban adorned with feathers and pearl strings, and anointed with aromatic paste, various pendants and jewellery. The heroine (*nayika*) wears a diaphanous, full-length muslin outer garment known as *peshwaj*, colourfully striped brocade trousers, and a finely woven *odhni* dropping naturally from her head. Her palms and fingers are dyed red in henna and she is lavishly bejewelled. The jewellery of both lovers is copiously studded with glowing iridescent fragments of beetle wing which enhances the luxurious aura of the scene. He plays the *rabab* with a plectrum while she offers him some *paan*, the popular refreshment of a betel leaf wrapped around a mix of lime, spices, crushed areca nut and condiments. The painting is an icon to the joys of love (*sringara*), a dominant theme of ragas, and an outstanding example of the Basohli style of painting.

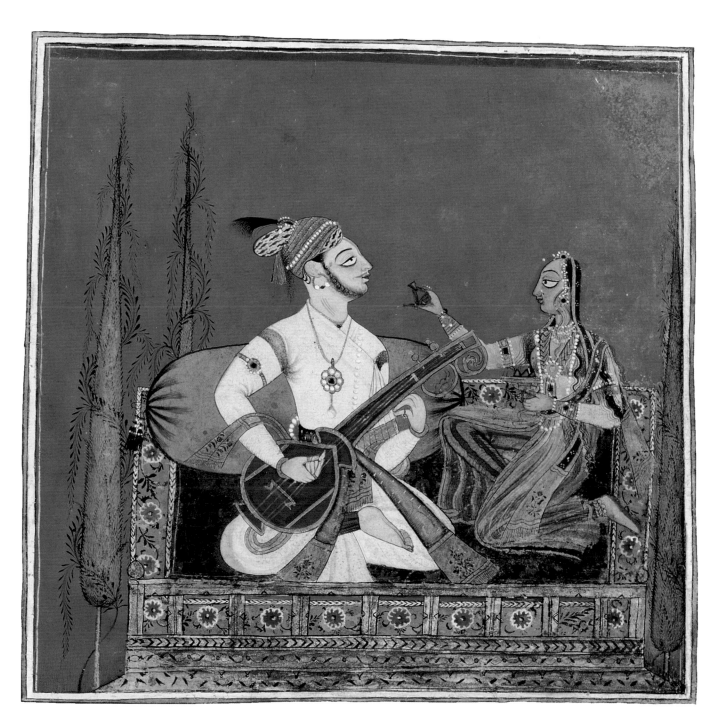

192 **Ragaputra Velavala of Bhairava**

Basohli was a small fortress town in the Punjab hills in northern India. The various hill states were ruled by Rajput princes belonging to the aristocratic *kshatriya* caste. The painting of this region, produced in the court ateliers of the various hill states, is referred to as Punjab Hills, or Pahari, painting. The beginnings of Pahari painting can be traced to the state of Basohli during the reign of Raja Kirpal Pal (1678-1695). This strikingly beautiful painting, from a recently discovered ragamala series, can be dated to between 1707 and 1715, on the basis of costume details, thus placing its production in the court atelier of Kirpal Pal's equally cultivated and admired son, Dhiraj Pal (1695-1725) (Tandan, 1983), and making it a significant document in our growing understanding of early Pahari painting.

193 **Varari ragini**

Northern Deccan; c1650-1700; 24.2 x 17.3

Victoria and Albert Museum, London

That most beautiful one, wearing fine armlets and, on her ear, a sprig from the heavenly (wishing) tree, and holding off her beloved with her fly-whisk – this excellent woman is called Vairari.

This text, whose roots in Rajasthani literature are much older than painted versions of this particular ragini, belongs to a ragamala set which was the basis for several early schools of painting in Rajasthan, Malwa and even the Deccan (Ebeling, 1975, 155). The image, a rare and beautiful early Deccani example, is a literal depiction of the text, visualising a passionate woman expectantly approaching her lover, keen to dally with him.

The folio is one of seven surviving from a complete set that copied, sometime during the second half of the seventeenth century, the splendid late sixteenth-century ragamala set from the Northern Deccan whose surviving folios are a benchmark for early Deccani painting as well as of an unexplained stylistic uniqueness. It is thought that the patron of the early set was probably one of the semi-independent Hindu rajas who lived in the northern Deccan, feudatories of the Muslim sultanate of Ahmadnagar (Zebrowski, 1985, 46). This painting evokes the lyricism, palette and striking sense of pattern of its sixteenth-century prototype, and is a special and poetic creation.

194 **Lalit ragini**

Deccan, Hyderabad; c1780; 23.6 x 16.9

Portvale Collection

In music Lalit is an early morning raga; in painting it is the man's leaving the sleeping ragini at daybreak after a passionate night. Enjoyment of love (*sringara*) is much celebrated by Indian poets and musicians. The dual aims of sensual pleasure and the renunciation of all worldly desires, so much the leitmotif of ragamala, are seen in verses such as the one by the lyric poet Bharthrihari (570?-651?) quoted on the left of page 298.

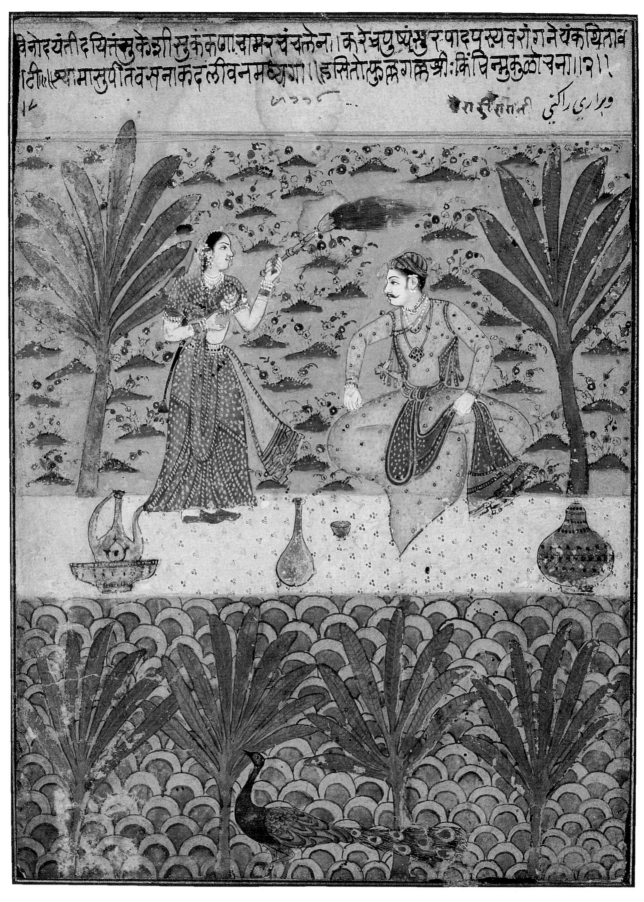

विनोदयंति दयितं सुकेश्री सुकंकणाताम्र चंचलेन । करेण एषु पंसु र पादपुस्यवरांगनेयंकयिताव
टीस्या मासुपीतवसनाकद लीवन मध्यगा । हसितोल्लुक गक्री: किंचिन्तुकुलोचना ॥ १२ ॥

In Lalit ragini the lover, perhaps called away by official obligations, usually holds one or two garlands of flowers, symbols of amorous joy. In this painting the intimate bonding the two lovers have enjoyed is reiterated by the pairs of cypress trees, silent sentinels under the balmy, starry sky. Pairs of cypress trees are a popular motif in Persian poetry, an unsurprising connection in consideration of the strong Islamic heritage of the Deccani courts. However the detailed rendering of architectural details reveals a strong Mughal influence. The painting was most likely done in Hyderabad which had witnessed the emergence of an independent kingdom in 1724 when the Mughal viceroy, Nizam al Mulk, had seized power in the Deccan and established the Asafiya dynasty. The Nizam's court at Hyderabad provided a wealthy and cultured centre of artistic patronage (Zebrowski, 1983, 244). This painting is a particularly graceful and lyrical representation of the best of later Deccani painting.

195 **Gauri ragini** *(see page 293)*

Rajasthan, Sirohi or Mewar; c1680; 38.1 x 26

The Art Institute of Chicago; Everett and Ann McNear Collection

Gauri ragini was originally a melody from East Bengal, a song concerning a lady longing for her lover, whiling away the time collecting blossoms. Although the iconography differs slightly for different images entitled Gauri, the underlying theme of love pining is the same. Different texts too agree on the beauty of Gauri ragini, her sweet and delicate voice, and her confusion and loneliness from which she tries to distract herself by picking flowers and sometimes stringing them onto flower sticks.

This beautiful image, in which we see the heroine sequentially picking flowers and being entertained by musicians in her pavilion, captures the idyllic yet limited world of women in the *zenana*. The painting is from Mewar or Sirohi, Rajasthani kingdoms which resisted Mughal influence and whose paintings have a vibrant colouring and effusive honesty lacking in Mughal influenced styles.

196 **Asavari ragini**

by Nisaruddin (fl. c1605)

Rajasthan, Mewar; 1605; 20.2 x 19

Victoria and Albert Museum, London

The fresh immediacy and animation of this colourful painting, its bold, frank colours, and subject of a female snake charmer, distinguish it as a Rajasthani painting free of the Mughal influences to be seen in other Rajput painting styles. The reason for this is its early date in terms of Rajasthani painting: it is from a series that contains the earliest known examples of the Mewar school, and that demonstrates stylistic links with the earlier important and distinctly Hindu style seen in [180]. The important series to which this painting belongs

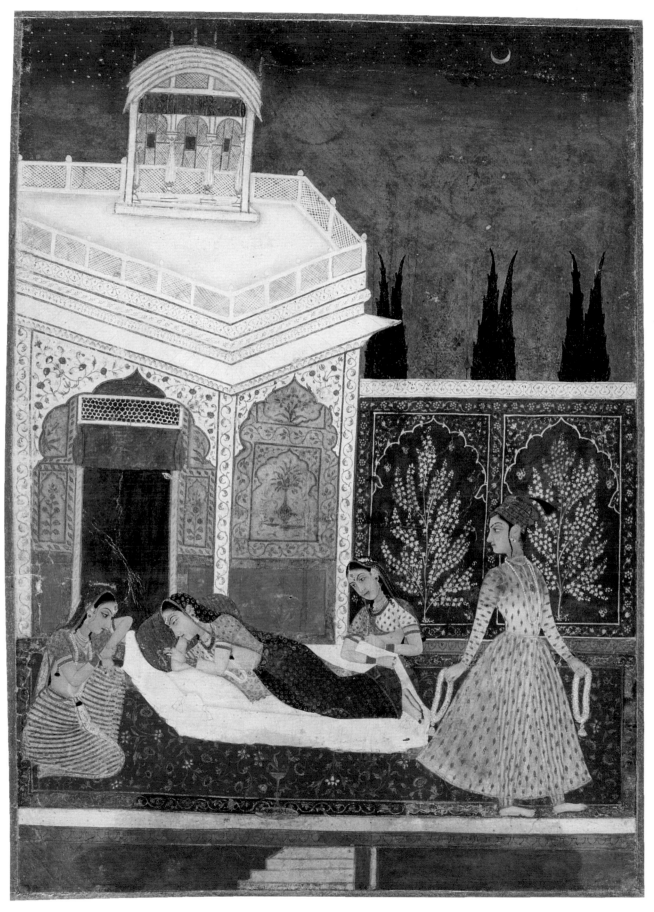

194 Lalit ragini

On the summit of the sandal-wood mount,
robed in the peacock's plumes,
with a splendid necklace
strung with pearls and ivory,
the variegated one draws to herself from
the sandal-wood tree the serpent
— the proud one wears it as a bracelet,
(her body) ablaze with dark splendour.
(cited in Ebeling, 1973, 126)

A face that rivals the moon,
eyes able to ridicule the pond-born lotuses,
a complexion eclipsing the (lustre of) gold,
a thick plait of hair more dark than the
black bee, breasts like the swelling temples
of an elephant, heavy buttocks, and an
enchanting softness of speech.
(cited in Waldschmidt, II, 1975,138)

Bathing, putting on clean and beautiful clothes,
applying mahavar (red lac dye) to the cheek,
dressing hair, using five angaragas
(vermilion on the parting of the hair,
painting sandal-paste mark on the forehead,
a mole on the cheek, saffron on the body,
and henna on the palms),
wearing ornaments and flowers,
cleaning teeth and chewing betel and cardamon,
rubbing missi (a fragrant paste) on the teeth,
reddening the lips,
and painting eye-lashes with collyrium,
are the sixteen adornments for a woman.
(cited in Waldschmidt, II, 1975,138)

300

is known as the Chawand ragamala, and is inscribed on one leaf with the date equivalent to the year 1605, and naming the artist as the Muslim painter Nisaradi (Nasir-ud-din), the place of execution as the village of Chand (Chawand), which was the temporary capital of the kingdom of Mewar after the major city of Chitor was destroyed by the troops of the Mughal Emperor, Akbar (Binney and Archer, 1968, 18).

The cult of snake worship is ingrained in India: snake charmers are still to be seen, and people still make offerings of milk, rice powder and tumeric powder to propitiate the snake god. The name of this raga, Asavari, is derived from the ancient tribe of the Savaras, jungle dwellers renowned for their skill at snake charming. The woman in this image, with her dark skin, peacock feather skirt, and her obvious ability to lure and tame the snakes, symbolises a long Indian veneration for the power of snakes. The blueness of her skin is like Krishna's and may suggest she has smeared her body with ashes, or perhaps indicate that she is of tribal origin.

The painting is iconographically easily recognisable. The text is from a ragamala set whose origin is unknown, but which represents the earliest complete text for ragas and raginis of the Painters system of classification. The Sanskrit couplet is cited at top left.

197 Vilavali ragini

(see page 287)

Himachal Pradesh, Guler; c1775; 29.2 x 21.6
Art of the Past Inc, New York

Bhartrihari, the lyric poet, enumerates seven qualities which form the natural adornment of a woman which are quoted at left. However beautiful a woman might be naturally, she will still seek to improve her looks with adornments. Ragini Vilavali is represented as a handsome woman who, in anticipation of meeting her lover, whether it is to be home or at a trysting place, is engaged in her toilet. She has nearly completed her preparations, a servant holding up a mirror. Her preparations recall the sixteen types of adornment set down by poet Keshavadasa (fl. 1580-1601), quoted bottom left.

The Vilavali name is derived from the Valava tribe of South India, and the ragini is one to be played in the second quarter of the day. This painting, typical of the style of Guler, is from the same set as the Kanhra raga [186].

198 Todi ragini

North India, Late Mughal; late 18th century; 19.0 x 14.2
Art Gallery of New South Wales, Sydney; bequest of Mr J. Kitto, 1986

The lone lady, symbolic of love in separation or loss, is a leitmotif of ragamala paintings. Whether gathering flowers, wandering through the forest, or ruefully strumming a musical instrument, the lady yearns for her absent lover. One of the most easily recognisable

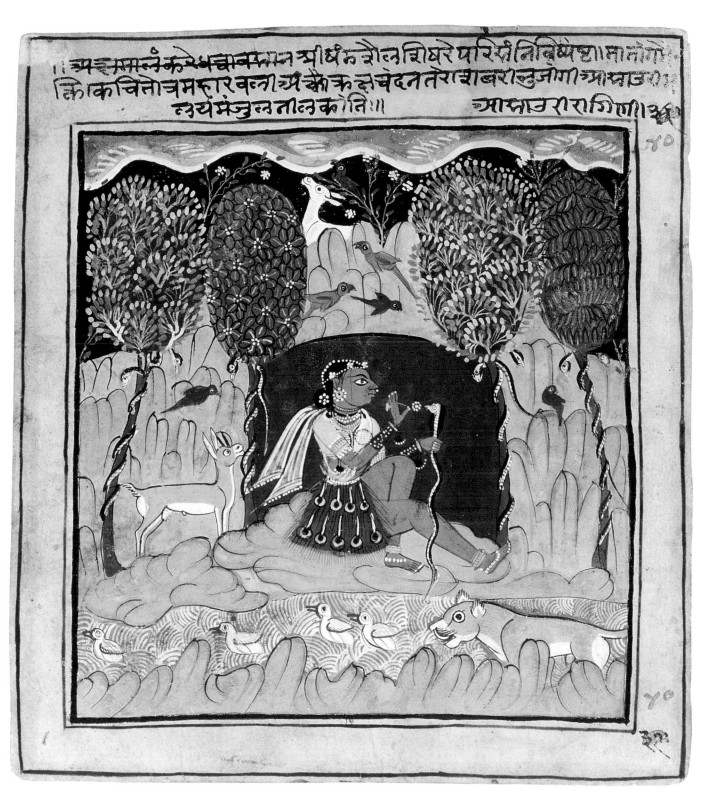

196 **Asavari ragini**

and common images is that of the Todi ragini, where the lady holds a *rudra vina* (*bin*), and is surrounded by deer. The physical attraction of bucks for human females has been used as a recurring sexual metaphor in Sanskrit poetry from antiquity (Pal, 1978, 128) and significantly, in this image as most other Todi ragini, the lady faces the buck rather than the fawn. The musical raga is to be played in the first quarter of the day from sunrise; its expression tender and loving. It is believed that originally Todi was a song of village girls guarding the ripening fields against the deer who became so absorbed in listening, they would stop feeding (Ebeling, 1973, 60).

The delicate drawing of this image, the fineness of detail focussed on the central figure, and the minimal background, is typical of late Mughal styles. Different texts on Todi ragini allude to the lady's limbs being tinged and perfumed with saffron and camphor. A typical verse which describes Todi ragini is cited at top left.

Divided from her darling,
most unhappy in love,
like a nun renouncing the world,
this Todi abides in the grove and
charms the hearts of the deers.
(Pal, 1978, 128, quoting Coomaraswamy)

199 Kakubha ragini
Deccan; 18th century; 23.3 x 14.6
Kapoor Galleries Inc, New York

Hindi verses found on several miniatures of this subject capture its leitmotif of love tormented by separation, as exemplified in the verse at left.

In Indian art, the peacock resonates with associations: it is the vehicle of Sarasvati, Goddess of Music; in Indian poetry it is a metaphor for courtship; and its feathers were a popular choice of Krishna for his headdress. They are a popular motif in ragamala painting, though not so often seen dancing as in this image. The instrument she holds is unusual: a two-stringed version of the *bin* with the melody string nearer the instrument, and the other string the drone string. The musical raga is to be sung late in the morning, towards midday.

Kakubha, a heroine (of love)
is upset by the pangs of separation,
Leaving her mansion
she has come to the woodlands
Where all varieties of flowers and trees
are spread about,
And she has made a wonderful garland.
...And the repeated voice of the peacocks diverts her,
And in the depths of her thoughts for her lover
she forgets herself,
The tide of love submerged her body
And made her thirst for union with her lover.
Contemplating on a sweet union,
her eyes are thirsting anxiously to see her lover.
Thus agitated Kakubha
is burning in the flames of separation.
(cited in Waldschmidt, II, 1975, 276)

200 The attractions of music (see page 175)
Central India; c1680; 21.6 x 16
The Cleveland Museum of Art; Andrew R. and Martha Holden Jennings Fund

This painting is unusual both iconographically and stylistically. The painting is reminiscent of Asavari ragini when the lady charms snakes, and Todi ragini where she lures the deer. Yet there is no precedent for a woman to be surrounded by as many animals as here, with birds, monkeys, foxes, cheetahs, tigers and even a dog suckling her puppies. The soft pink, blue and gray colouring is outside the ordinary range of Rajasthani or Central Indian painting, and the painting may even come from an as yet undocumented school (Leach, 1986, 122). This sensitive painting is an invocation of that sense of well-being and tranquillity which music provokes.

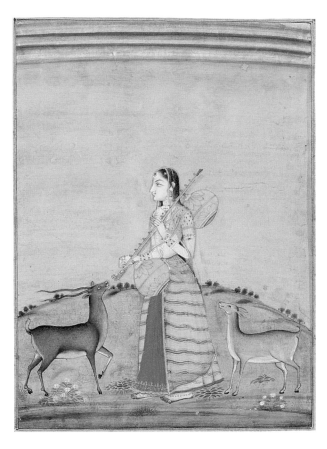

198 Todi ragini

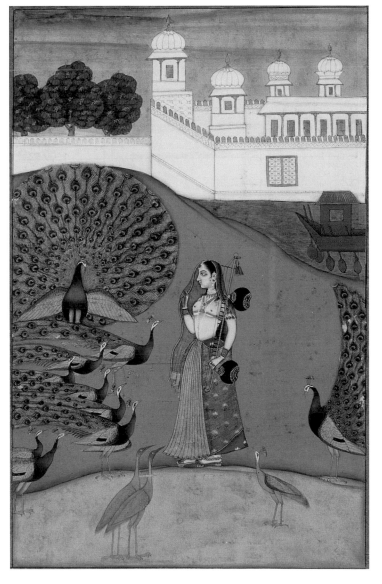

199 Kakubha ragini

Afterword

Jim Masselos

It may seem quixotic for us to have designed an exhibition of Indian art around a theme of performance – of music and dance. And especially so when the intention is not to provide mere illustration of music and dance but to celebrate the extraordinary achievements of Indian creativity. Object and performance exist in different kinds of spaces and are created differently. Dance and music progress through time and in time. They are linear, moving from one moment to another and are evanescent: once they have happened they are not repeatable and each performance is always different. This is in direct contrast with the created object, such as a painting or sculpture, which as an object in itself is constant and does not change during the time of its viewing, though it is of course perceived variously according to viewer and the circumstances of viewing. All of this makes an obvious point, the mediums are different and they do different things and try for different effects. A painting does not convey musical sounds nor does it reproduce the sequences of dance, only a representation of the merest part of a series of movements. One medium, obviously, cannot reproduce what is achieved in another medium.

Yet, as will be immediately clear from this exhibition, the theme of music and dance has been an underlying and consistent theme in the subject matter of Indian art in the art of the created object. Over the two thousand years represented the theme occurs and recurs in all sorts of forms and fashions. Jain and Buddhist monks dance; the gods have their musical instruments and themselves dance as do their devotees; monarchs have ensembles of instruments to mark their daily progress; festivals have their music as do tribal groups; there are women musicians and dancers who perform for audiences of women alone as well as for men and so on. The range and variety of the ways in which music and dance feature in these depictions is vast and covers the gamut of almost all forms of daily human activity, to say nothing of the gods, the lives they led and their cosmic activities.

The sheer variety may seem overwhelming and for good reason, for what appears in the exhibition is a summary of a great civilisation. Music and dance pervade and intersect Indian life and provide a site, a field on which an array of agendas are played out. And it is those intersections which appear captured in material form here. The objects summarise and represent all those cross-currents of Indian life and philosophy, but even more significantly, they are an integral part of them. When Shiva dances his cosmic dance of creation as Shiva Nataraja the image is not merely an illustration of philosophical notions of creation myths: it is part of the process of the formulation of the idea itself, even if the making of the great Chola bronzes of Nataraja also had a great deal to do with signalling the imperial style of the dynasty.

59 **A celestial flautist**

What will be apparent in the first section of the exhibition, the divine realm, is the way in which music and dance were keys to religious experience and expression. The gods expressed themselves through music, not as entertainment or celebration merely – though music did entertain them – but as part of their divine power. Sarasvati's vina is an obvious example but so too is a dancing Ganesh or Chamunda. And Krishna's flute was to sound through the centuries aurally but also visually and intellectually, providing a symbol, the sound of the divine, for the attraction of the divine.

When artists depicted the Gods in the shape of icons, they were creating God in material form. At the same time they were also establishing as concretely the sound of their music and the form of that dance. The image was reinforced by the context of music and dance; and in its turn the image added to the context. The created object and the performance thus co-existed rather than being separated and distinct. They conjoined in a statement about metaphysical profundities. All were, in an ultimate sense, mental constructs contained within the mind – and understood as such.

If the trajectory of the first part of the exhibition is that of the divine, the second part swings down to the world of the mortals. Almost everybody in India dances and sings at some time or other, – in festivals and at celebrations of all kinds. And that is what they do too in this section where music and dance are seen in a secular context that is celebratory, joyous and entertaining. Other readings of the joyous implicate images in contexts of power and space. Celebrations and music in public space differ from those in the private spaces of the dwelling or the palace. There are characteristic forms for celebrations by the powerful and other expressions for those who are not. And there is gendered space where women have their own music apart from when they perform for the men.

More intense is a further dimension, the emotional, the sensuous and the erotic. Here, depictions of music and dance recognise the sensuality of human beings and intensify the longing of love. Sometimes the imagery is religious, deriving from the *bhakti* desire for unity with Krishna but that is often by-passed for a romantic vocabulary of pining and desire as expressed through images of maidens with their tamburas craving an absent lover or the alternate male image of a man being entertained by a dancer. Sometimes man and woman are together listening to music, an expression of their union. The emotion and sexuality inherent in music and dance which in the divine realm images had been sublimated into religious experience is here freed of constraint and emerges freely in images of the greatest sensitivity. Love and music conjoin in images which contain both.

Love and religious transcendence, both incorporating ideas of union, are amongst the most strongly represented of the themes which emerge through the exhibition. Both are mediated through the presentation of sound and movement and draw as memory and metaphor upon remembered experience. The two blend.

GLOSSARY

Compiled by Haema Sivanesan. Musical references compiled by Reis Flora [RF]

ārati (aarti): a ritual of worship involving the waving of flame in a circular motion before the image of a deity

Āgama: traditional religious teaching contained in non-Vedic texts.

Ālvar: a group of Tamil Vaishnava 'saints' who sang ecstatic songs and hymns in worship of Krishna or other incarnations of Vishnu.

angarāga: the five 'colours' or 'tinges' that are applied to a woman's body as part of the rituals of adornment.

apsara: celestial nymphs who dance for the gods.

āśrama: denotes the four stages into which the life of the individual Hindu is divided; also the popular term for the hermitage of a holy man.

asura: anti-gods or titans.

avatar (avatara): an incarnation or 'appearance' of a god, who may assume innumerable forms.

bāul: an itinerant village musician.

bhakta: a devotee.

bhakti: worship of a personal god that is given through intense adoration or loving devotion.

Bhairava: the terrible or frightful form of Shiva.

bhāva: feelings or emotions.

bīn (been): though this term denotes two markedly distinct types of instruments – one of them being the snake charmer's reedpipe – it generally refers to the North Indian or Hindustani seven-stringed tube zither. This instrument is made of two large spherical gourds attached to a long hollow wooden tube which is capped at both ends with brass tubing. The bin is played kneeling or seated with the instrument held diagonally across the body, from upper left to lower right. The strings are played with downward strokes. The bin is also known as the rudra vina, the vina of the great ascetic god Shiva, a patron of the arts. See vina. [RF]

Brahman: God; the Absolute.

brahmin (also brahman, brāhmaṇa): the priestly class of Hindu society, or people descended from this caste who may be engaged in non-priestly occupations.

chatura: a dance pose or mode having one leg bent with raised heel.

chhatra: a tall umbrella used to shelter the image of a deity when carried in processional rituals; a parasol.

chitra: a picture or painting.

choli: a short, tight blouse worn by Indian women under the sari or with the half-sari.

chordophone: any musical instrument with strings.

ḍākinī: a quasi-divine being of Buddhist tantric mythology; also an attendant of the Hindu goddess Kali.

damaru: a small hourglass-shaped drum associated in iconography with Shiva. It symbolises the rhythms of the universe under Shiva's control. The damaru is played by grasping the drum at its centre and rapidly turning the instrument to and fro, clockwise and counter clockwise. This motion causes two pellets at the end of two opposing cords, which are attached to the centre of the drum, to alternatively strike one end and then the other. The rate at which the drum is turned back and forth controls the rate at which the pellets strike the heads, and thus the rhythmic sound of the drum. By increasing and decreasing the pressure on the lacing of the drum at the centre, the pitch and tone quality of the drum may be varied somewhat. Due to the difficulties of reproducing this important sound-producing detail iconographically – two sticks, each with a pellet, striking the two heads alternately – especially in sculpture, when a damaru is depicted the two cords, each with a pellet, generally are not represented. [RF]

daph (daff): a medium- to large-sized shallow frame drum which may be found with or without 'jingles' (metal rings attached or discs set into the frame) and with skin pasted or tacked to the frame, or sometimes laced to an anterior metal ring. It may be played with the hand or with a stick. In Mughal minature court scenes the daph is usually played by women. It is also played by Hindu mendicants and used in the playing of folk music, especially in North India and Pakistan. It also recurs in other regions of India. See khanjari. [RF]

darśana (darshan): Literally 'sight' or 'viewing', referring to the auspicious viewing of a sacred image for the purpose of taking into oneself the power of the deity.

devadāsī: a class of women dedicated to the service of the temple, particularly in Shaiva temples.

Devī: goddess.

dhol: a large double-headed drum usually made of wood with skins attached to wooden hoops and laced by cords or ropes in a V-shape, which may be shortened to a Y-shape for tuning. The treble head is struck by the left hand, sometimes using a light stick. The bass head is struck with the right hand using a heavier, usually curved stick. [RF]

dhoti: a length of unstitched cloth wrapped around the waist, worn by men.

Diwali (Dīpāvalī): literally 'a row of lamps'; a festival held on the day of the new moon in late October-early November to celebrate the 'triumph of light over dark, good over evil'. It is also a festival in honour of Lakshmi, the goddess of abundance and wealth. Festivities include the lighting of lamps and fireworks.

dvārapāla: the door guardian of a Hindu temple.

gana: the demi-gods who are the attendants of Shiva.

gandharva: a celestial or heavenly being often depicted as a flying musician.

garbhagrha: the 'womb chamber' or sanctum of the Hindu temple.

ghanti: hand bell.

gopī: (gopa – masculine) a milkmaid, or herdswoman (cow herd).

gopuram: the towered gateway of South Indian temple architecture.

gosāin: one who teaches the path of devotion to Vishnu or one of his incarnations; a sect leader.

hamsa: goose; the vehicle of Brahma the creator, and associated with the goddess Sarasvati. In Hinduism the hamsa characterises beauty, purity, discipline and grace and signifies the life-force or consciousness.

Holi: spring festival dedicated to the Lord Krishna and the gopis. Festivities include singing and dancing, and the throwing of coloured water and coloured powders.

jāmā: a close fitting coat with a full skirt and waist sash generally worn by noblemen.

jaṭā: the high matted or dreadlocked hair typical of a Shaivite ascetic.

Jina: literally 'conqueror' or 'liberator', denoting, in the Jain tradition, one who has conquered or freed himself from all worldly attachments.

karna: a long straight metal trumpet of conical bore originally from Persia, possibly dating from the Sassanid era (224 – 651CE). Fashioned sometimes in the shape of an 'S', it may reach up to two metres. The karna is an important instrument of the naubat, and may be seen in many miniature paintings depicting this ensemble. See nafir and naubat. [RF]

khañjarī (khañjani, kanjira): a small indigenous style of circular frame drum, with a heavy and deep rim, which may slightly taper or flare. The head is glued on or nailed, and is played by hand. This type may also have small metal disc jingles set into the frame. The kanjira of South India is used in classical Karnatic Music. See daph. [RF]

kinnara: half-human, half-horse mythical beings.

kīrtīmukha: a demonic mask placed above the doorway of temples or on the aureole of sacred images to drive away the impious; literally 'the face of glory'.

kshatriya: the ruling or warrior class of Hindu society.

linga (also lingam): literally 'sign'; the phallic symbol of Shiva.

makara: a mythical aquatic animal similar to a crocodile.

maṇḍapa: a temple hall.

mandala: a circular diagram of complex design which supports the power or energy of the deity.

Mohurrum: the first month of the Muslim year; also a commemorative festival.

moksa (moksha): the Hindu concept of final liberation, release or reintegration with God.

mridangam: an old revered name for the drum in India, currently associated with the double-headed drum played in South Indian or Karnatic music. The drum is played with the fingers. Masters of the mridangam delight in performing rhythmic patterns of great complexity and subtlety with astonishing skill. Composite heads on each end, and the addition of tuning paste on the heads, produces a rich, majestic sound. [RF]

mudrā: gesture or sign, particularly of the hands, fingers and arms.

nafir: The Arabic and Persian term for the long straight trumpet known as the karna in India. It is found extensively in the Islamic world as a member of the naubat ensemble. See karna and naubat. [RF]

nāga: a protective snake or serpent said to guard the wealth of the earth. Nagas are often depicted half-snake, half-human and are worshipped in many parts of India.

nāṭya: mime; dramatic expression in dance.

naubat (nahabat): an outdoor ceremonial band used during the Mughal era for accompanying troops into battle, and for various court functions and festivals. It comprises an ensemble of drums, mainly kettledrums, and long trumpets, reedpipes, and large cymbals. 'Naubat' refers to the 'stages of the day', marked by performances of the band. The naubat welcomed important guests. Today remnants of this ensemble may be found at certain religious shrines, and at the former courts of Jaipur and Jodhpur in Rajasthan. [RF]

nawab: provincial governor or vice-regent.

nāyaka: (nāyika – feminine) a hero.

Nayanmar: the sixty-three 'saints' or worshippers of Shiva revered for their total devotion to the Lord.

nirvāna: Literally 'extinction', used in a metaphorical sense to denote the extinction of all worldly desires; liberation, and the attainment of pure knowledge.

nizam: originally a Mughal viceroy; the independant ruler of Hyderabad.

nritya (nrtya): pure dance as movement.

odhnī: a light shawl or scarf worn over the head or as a veil as part of a woman's dress.

paan (pān): a variety of condiments, areca nut and spices wrapped into a betel leaf and chewed as a digestif and mild stimulant.

306

Pahari: term referring to painting of the Punjab Hills, 17th-19th century

pata: cloth.

pichhavai: a large background cloth used behind a shrine or altar, usually of Sri Nathji.

prāṇa: breath; the life force or vital energy.

pūjā: worship of a deity characterised by invocation, address and homage, given through simple offerings designed to express gratitude to the deity.

purdah: a system of seclusion whereby women were hidden from the sight of men or strangers.

Puruṣa: the Cosmic Man or the primordial masculine principle.

rabab: a term for various chordophones, particularly lutes. In Mughal times the rabab was one of the two main instruments of raga music in the court, along with the bin. The rabab was also played, however, by Brahmin religious song leaders, and by low-caste entertainers. In Mughal paintings two varieties of rabab are seen: one rounded with a skin covered shell and a straight, 'sawn-off' peg-box; the other with a much more ovoid shell, a thick bridge characteristic of India, and a semi-circular peg-box. [RF]

rāga: (masculine) one of the six chief musical modes or sounds.

rāgamālā: a garland of ragas or musical modes.

rāgapūtra: (ragaputri: feminine) a variation or offshoot of a raga, literally a son (or daughter) of a raga

rāginī: the feminine counterpart or consort of a raga; when united with the raga a further musical mode results.

rasa: literally sap or juice, essence; mood. Indian aesthetics identifies nine rasas (eg. sringara)

Rāsalīlā: the circular dance of Krishna and the gopis during which Krishna multiplied himself so that each gopi thought that she alone danced with him.

rudrākṣa: berries from the Elaeocarpus ganitrus shrub or tree used to make the Shaiva rosary

rumāl: literally a handkerchief; used to describe embroidered cloths from Chamba.

sādhu: a wandering ascetic, holy man or mendicant.

śalabhañjikā: a woman and tree motif which symbolises fertility and abundance.

samā: a sufi devotional ritual of dancing and chanting the name of God.

samvat: the Hindu system of classifying time. (1 CE = samvat 58)

śaṅkha (sankh): conch shell.

sannyāsin: an ascetic, or one who has relinquished all worldly attachments and values for a life of religious contemplation.

sastric: pertaining to the Śāstra which are authoritative 'manuals' or 'rule books' on various subjects and aspects of life for the Hindu.

Shaiva (also Shaivite): to the worship of Shiva.

shehnai (sahnai): an oboe of North India, of conical bore, about 50cm long, with a double reed of cane. Instruments of this type were part of the naubat ensemble. In addition to its use in certain folk traditions today, it is also a main instrument in an ensemble of reedpipes in the performance of classical North Indian or Hindustani music. [RF]

Śrī: an honorific prefix.

sitar: the most well known stringed instrument of modern North Indian or Hindustani art music. Though originally reaching India from West or Central Asia as a plucked instrument of three strings, the instrument has been dramatically modified and developed in India. It has four playing strings, three additional strings to reinforce the drone pitch of Indian music, and add to rhymic intensity in certain sections of a performance as well, and numerous sympathetic strings. The latter have been added only relatively recently. One feature that clearly marks the Indianisation of the instrument is the use of the gourd for the

lower main resonator, and for the complimentary resonator attached at the upper end. Another marked Indian feature is the wide slightly arched bridge that gives a distinctive sound to the plucked string. Previous versions of the sitar may be seen in miniature paintings of North India. [RF]

sringara (śṛṅgāra): the erotic sentiment or rasa.

stūpa: a hemispheric mound containing Buddhist relics and symbolic of Buddhist teachings.

sufi: a mystical and devotional Muslim sect; a member of this sect.

Swami (Svāmī): a Hindu religious teacher and holy man.

svara: a sound note with its basis in the sound of the human voice.

svastika: an auspicious mark or emblem symbolising good fortune and well-being; in dance, a posture with legs crossed one in front of the other.

tāla (tāl, tālam): a general term for cymbals. The word derives from Sanskrit 'tala' meaning 'palm of the hand', 'clap', 'metre'. There are two principal types of tala: cup cymbals, generally small and without a rim – their tone is bright and shimmering; and rim cymbals, usually larger with a central depression. Tala are made of thick bell metal and are used in devotional music, dance and dramatic performances. [RF]

tamburā (tamboura, tanburi, tampuri, tanpura.): a bowl-shaped lute of four or five strings with a long neck and the distinctive Indian thick bridge of ivory or bone, which is slightly curved in cross-section. This bridge gives rise to the rich, vibrant tone quality associated with many stringed instruments in India. The bowl is often of gourd but also of wood. The tambura which occurs in various sizes, is used for providing the all important drone pitch in Indian music. [RF]

tasha (taśa): a small kettle drum of pre-Islamic India, but especially widespread in the North. A goat skin is stretched by criss-cross

lacing over a clay or metal bowl. The instrument is suspended on a strap around the neck, in front of the body and the skin is struck with two thin bamboo sticks. The tasha is used notably during ritual cermonies in the month of Mohurrum and to lead marriage processions.[RF]

Tīrthaṅkara: forder; the twenty-four Jain teachers.

trivikrama: 'the three great strides'; in the Puranic myths, the god Vishnu is said to have delineated the universe – earth, sky and heavens – in three great strides.

venu: flute.

Venugopāla: the cowherder (Krishna) with the flute.

vīṇā (veena): The principal indigenous term for chordophones in India, which includes the musical bow, harps, short lutes, zithers. Nowadays the term usually refers to the long-necked plucked lute of South India, called the Sarasvati vina. This vina is played seated cross-legged with the fingers of the left hand on the frets to play the melody, while the fingers of the right hand pluck the melody strings in a downward direction. The name of the vina refers to the goddess of learning and music, the guardian of the supreme understanding of the nature of life. As the vina is associated with the quest for esoteric knowledge, this implies that the study and mastering of music allows one to acquire supreme bliss. The practice and performance of music thus may be considered as a type of yoga. See bin. [RF]

yakṣī (yakshi): a female celestial associated with nature and fertility.

yantra: a mystical diagram used as a tool for meditation or worship.

yoga: both a school of philosophy and a system of psycho-physical discipline used to achieve perfect unity of mind and body.

yogī: (yoginī: feminine) practioner of yoga.

zamindar: a landowner or land lord.

zenana: women's quarters in a palace where the only males allowed were eunuchs and the Master of the Household.

LIST OF TERMS WITH DIACRITICAL MARKS

ānanda	Gaṇeśa	lalitāsana	Paśupati	Somāskanda
Anantaśāyī	Gaṅgā	līlākamala	pradakṣiṇa	Svetāśvaratara Upaniṣad
Ardhanārīśvara	Garuḍa	Liṅgāyat	Premsāgar	Uttaradhyāyanasūtra
Ardhāṅginī	Gītagovinda	Mādhava	Rādhā	Umā
Āṣāḍhā	Hoyśala	Mahābhārata	Rāmāyaṇa	vāhana
Bālagopālastūti	Kālī	Mahāvidyā	Raṅganātha	Vāstuśāstra
Bāramāsā	Kalpasūtra	Narasimha	Rgveda	Vidyādevi
Bhagavadgītā	Kāṭhi	Naṭarāja	sandhyā tāṇḍava	Viṇādhara
Bhāgavatapurāṇa	Kāmakaṇḍalā	Naṭeśa	Sangīta Sāramṛta	Viṣṇu
Chāmuṇḍā	Kathāsaritasāgara	Naṭeśvara	saptarṣi	Viṣṇudharmottarapurāṇa
Devī	Kṛṣṇa	Nāṭyaśāstra	Sarasvatī	yajña
Durgā	Laghu Saṃgrāhaṇīsūtra	Padmanābha	Seṣaśāyī	Yamunā
ektārā	lakṣaṇa	pañchamuṇḍa	Śilpaśāstra	Yaśodā
Gajāntaka	Lakṣmī	Pārvatī	Śiva	

BIBLIOGRAPHY

Alamkara: 5000 years of Indian Art. 1994. Singapore: National Heritage Board in association with India: Mapin Publishing Pvt. Ltd.

Algeranoff, H. 1957. *My Years with Pavlova.* London: Heinemann.

Alphonso-Karkala, John B. (ed.) 1971. *An Anthology of Indian Literature.* Harmondsworth: Penguin.

Ambalal, Amit. 1987. *Krishna as Shrinathji. Rajasthani Paintings from Nathdvara.* Ahmedabad: Mapin.

Archer, Mildred. 1972. *Company Drawings in the Indian Office Library.* London: Her Majesty's Stationery Office.

Archer, Mildred. 1977. *Indian Popular Painting in the India Office Library.* London: Her Majesty's Stationery Office.

Archer, Mildred and Falk, Toby. 1989. *India Revealed. The Art and Adventures of James and William Fraser 1801-35.* London: Cassell.

Archer, W.G. 1959. *Indian Painting in Bundi and Kotah.* London: Her Majesty's Stationery Office.

Archer, W.G. 1966. *Paintings of the Sikhs.* London: Her Majesty's Stationery Office.

Archer, W.G. 1973. *Indian Paintings from the Punjab Hills: A Survey and History of Pahari Miniature Painting.* Sotheby Parke Bernet in association with Delhi: Oxford University Press.

Archer, W.G. and M. 1955. *Indian Painting for the British 1770-1880.* London: Oxford University Press.

Asia Society. 1981. *Handbook of the Mr and Mrs John D. Rockefeller 3rd Collection.* New York: Asia Society.

Ayar, P.V.J. 1920. *Southern Indian Shrines.* Madras: no listed publisher.

Banerji, P. 1942. *Dance of India.* Allahabad: Kitabistan.

Bayly, C.A. (ed.) 1990. *The Raj. India and the British 1600-1947.* London: National Portrait Gallery.

Beach, Milo Cleveland. 1978. *The Grand Mogul. Imperial Painting in India 1600-1660.* Williamstown: Sterling and Francine Clark Art Institute.

Beach, Milo Cleveland. 1992. *Mughal and Rajput Painting.* Cambridge: Cambridge University Press.

Bhattacharya, A.K. 1968. *Chamba Rumal.* Calcutta: Indian Museum.

Binney, E. and Archer, W.G. 1968. *Rajput Miniatures from the collection of Edwin Binney, 3rd.* Oregon: Portland Art Museum.

Binney, Edwin. 1973. *Indian Miniature Paintings form the Collection of Edwin Binney, 3rd. The Mughal and Deccani Schools.* Oregon: Portland Art Museum.

Bor, Joep. 1986/87. 'The Voice of the Sarangi: an Illustrated History of Bowing in India'. *A combined issue of the Quarterly Journal of the National Centre for the Performing Arts.* Bombay: 15(3-4) and 16(1).

Bowie, Theodore in collaboration with Davidson, L.J. 1966. *East West in Art Patterns of Culture and Aesthetic Relationships.* Bloomington: Indiana University Press.

Brand, Michael 1995. *Vision of Kings.* Canberra: National Gallery of Australia.

Brand, Michael (ed.) 1995. *Traditions of Asian Art: Traced through the Collection of the National Gallery of Australia.* Canberra: National Gallery of Australia.

Brockington, J.L. 1992. *The Sacred Thread. A Short History of Hinduism.* Delhi: Oxford University Press.

Bryant, Kenneth, E. 1978. *Poems to the Child God.* Berkeley: University of California Press.

Chandra, Pramod. 1985. *The Sculpture of India 3000 BC - 1300 AD.* Washington: National Gallery of Art.

Coomaraswamy, Ananda K. 1924. *The Dance of Shiva, Essays on Indian Art and Culture.* New York: Dover reprint, 1985.

Coomaraswamy, A. and Duggirala, G.K. 1917. (reprint 1970). *The Mirror of Gesture.* New Delhi: Munshiram Manoharlal.

Czuma, Stanislaw. 1975. *Indian Art from the George P. Bickford Collection.* The Cleveland Museum of Art.

Czuma, J Stanislaw with assistance of Morris, Rekha. 1985. *Kushan Sculpture: Images from Early India.* The Cleveland Museum of Art in association with Indiana University Press.

de Bary, W.T. et al. (eds) 1958. *Sources of Indian Tradition.* New York: Columbia University Press.

Danielou, A. (trans.) 1965. *Shilappadikaram (The Ankle Bracelet) by Prince Ilango Adigal.* New York: New Directions Publications Corp.

d'Argence, Rene-Yvon and Tse, Terese. 1969. *Indian and South- East Asian Stone Sculpture from the Avery Brundage Collection.* The Pasadena Art Museum in association with The San Francisco Centre of Asian Art and Culture.

Dehejia, V. 1988. *Slaves to the Lord. The Path of the Tamil Saints.* New Delhi: Munshiram Manoharlal.

Desai, V. 1985. *Life at Court: Art for India's Rulers, 16th-19th Centuries.* Boston: Museum of Fine Arts.

Desai, V and Mason D. 1993. *Gods, Guardians, and Lovers: Temple Sculptures from North India A.D. 700-1200.* The Asia Society Galleries, New York in association with Mapin Publishing Pty. Ltd, Ahmedabad.

Deva, B. Chaitanya. 1952. 'The Emergence of the Drone in Indian Music' in *Journal of the Music Academy.* Madras: 23.

Deva B. Chaitanya. 1956. 'Tonal Structure of Tambura' in *Journal of the Music Academy.* Vol. 27. Madras.

Deva B. Chaitanya. 1966. 'The Conch as a Musical Instrument' in *Bhavan's Journal.* Vol. 13(8).

Deva B. Chaitanya. 1977. (reprinted 1979 and 1985) *Musical Instruments.* New Delhi: National Book Trust.

Deva B. Chaitanya. 1977. 'The Santals and their Musical Instruments.' in *Jahrbuch fur musikalische Volks- und Volkerkunde.* Vol. 8. Cologne: Musikverlage Hans Gerig.

Deva B. Chaitanya. 1981. *The Music of India: a scientific study.* New Delhi: Munshiram Manoharlal.

Deva B. Chaitanya. 1987. (second revised edition) *Musical Instruments of India: their History and Development.* New Delhi: Munshiram Manoharlal.

Dimock, E.C. 1966. *The Place of the Hidden Moon.* Chicago: University of Chicago Press.

Doshi, Saryu (ed.) 1992. *Tribal India, Ancestors, Gods and Spirits.* Bombay: Marg Publications.

Dubois, Abbe J.A., Beauchamp, H.K. (trans.) 1906. (reprinted New Delhi, 1983) *Hindu Manners, Customs and Ceremonies.* Oxford: Clarendon Press.

Ebeling, Klaus. 1973. *Ragamala Paintings.* Basel: Ravi Kumar.

Edwardes, S.M. 1912. *By-Ways of Bombay.* Bombay: D.B. Taraporevala and Sons.

Embree, Ainslie T. (ed.) 1972. *The Hindu Tradition.* New York: Vintage Books, Random House.

Embree, Ainslie T. (ed.) 1988. (second edition) *Sources of Indian Traditions.* Vol. 1. Columbia University Press.

Falk, T. and Archer, M. 1981. *Indian Miniatures in the India Office Library.* London: Her Majesty's Stationery Office.

Findly, Ellison. 1981. *From the Courts of India: Indian Miniatures in the Collection of the Worcester Art Museum.* Worcester Art Museum.

Flora, Reis. 1983. 'Miniature Paintings: Important Sources for Music History' in *Asian Music.* Vol. XVIII - 2. Ed. Bonnie C, Wade. Berkeley: University of California.

Flora, Reis. 1988. 'Music Archeological Data from the Indus Valley Civilisation ca.2400-1700 BC' in *The Archeology of Early Music Cultures: Third International Meeting of the ICTM Study Group on Music Archeology.* Eds. Hickman, Ellen and Hughes, David W. Bonn: Verlag fur Systematische Musikwissenschaft.

Flora, Reis. 1995. 'Styles of the Sahnai in Recent Decades: from Naubat to Gayaki Ang' in *Yearbook for Traditional Music.* New York: International Council for Traditional Music.

Fuller, C.J. 1984. *Servants of the Goddess. The Priests of a South Indian Temple.* Cambridge: Cambridge University Press.

Gadon, Elinor W. 1986. 'Dara Shikuh's Mystical Vision of Hindu-Muslim Synthesis' in *Facets of Indian Art. A symposium held at the Victoria and Albert Museum on 26, 27 April and 1 May 1982.* Eds Robert Skelton, Andrew Topsfield, Susan Strong and Rosemary Crill. London: Victoria and Albert Museum.

Gaston, Anne-Marie. 1992. *Siva in Dance, Myth and Iconography.* Delhi: Oxford University Press.

Ghosh, A. (ed.) 1957. *Adhinayadarpana by Nandikesvara.* Calcutta: K.L. Mukhopadhyay.

Ghosh, M. (trans. and ed.) 1967. *The Natyasastra (A Treatise on Ancient Indian Dramaturgy and Histronics) ascribed to Bharata Muni.* Vol. I. Calcutta: Manisha Granthalaya.

Gittinger, Mattiebelle 1982. *Master Dyers to the World.* Washington: Textile Museum, 1982.

Gopal, R. 1957. *Rhythm in the Heavens.* London: Secker and Warburg.

Goswamy, B.N. and Dahmen-Dallapiccola A.L. (trans.). 1976. *An Early Document of Indian Art. The Chitralakshana of Nagnajit.* New Delhi: Manohar.

Goswamy, B.N. 1986. *The Essence of Indian Art.* Asian Art Museum of San Francisco.

Goswamy, B.N. 1988. *A Jainesque Sultanate Shahnama.* Zurich: Museum Reitberg.

Goswamy, B.N. and Eberhard Fischer (eds.) 1992. *Pahari Masters. Court Painters of Northern India.* Zurich: Artibus Asiae and Museum Rietberg.

Goswamy, Roshmi. 1995. *Meaning in Music.* Shimla: Indian Institute of Advanced Study.

Granoff, Phyllis. 1995. 'Jain Pilgrimage: in memory and celebration of the Jinas' in *The Peaceful Liberators. Jain Art from India.* Ed. Pratapaditya Pal. Los Angeles: Los Angeles County Museum.

Gray, Basil, (ed.) 1981. *The Arts of India.* Oxford: Phaidon.

Grey, E, (ed.) Havers, G. (trans.) 1892. (reprinted New Delhi, 1991.) *The Travels of Pietro della Valle in India.* 2 vols. London: printed for the Hakluyt Society.

Griffith, R.T.H. 1963. *The Hymns of the Rgveda.* 2 vols. Varanasi: Chowkhamba.

Guy, John 1989. 'Sarasa and Patola: Indian Textiles in Indonesia.' in *Orientations.* Vol. 20(1).

Guy, John and Swallow, Deborah, (eds) 1990. *Arts of India: 1550-1900*. London: Victoria and Albert Museum in association with Mapin Publishing.

Emanul Haque, 1992, *Bengal Sculptures: Hindu Iconography upto c1250*. Dhaka: Bangladesh National Museum.

Hawley, John Stratton. 1984. *Sur Das. Poet, Singer, Saint*. Seattle and London: University of Washington Press.

Heeramaneck, Alice N. 1979. *Masterpieces of Indian Sculpture from the former Collections of Nasli M Heeramaneck*. New York: Privately printed.

Highwater, Jamake. 1992. *Dance Rituals and Experience*. London: Oxford University Press.

Hultzsch, E. 1895. *South Indian Inscriptions*. Vol. 2, part III. Madras: ASI.

In the Face of Change: Traditional Crafts in Modern India. 1985. Sydney: The Crafts Council of Australia

Ingalls, Daniel H. H. 1965. *An Anthology of Sanskrit Court Poetry*. Cambridge, Massachusetts: Harvard University Press.

Irwin, John and Margaret Hall. 1973. *Indian Embroideries*. Ahmedabad: Calico Museum of Textiles.

Jackson, William, J. 1992. *Tyagararaja Life and Lyrics*. Oxford: Oxford University Press.

Jain, Jyotindra and Aggarwala, Aarti. 1989. *National Handicrafts and Handlooms Museum, New Delhi*. Ahmedabad: Mapin Publishing Pvt Ltd.

Jenkins, Jean and Olsen, Paul R. 1976. *Music and Musical Instruments in the World of Islam*. London: World of Islam Publishing Company.

Jones, J.J. 1976. *The Mahavastu*. 3 volumes. London: The Pali Text Society.

Jones, Betty True 1987. 'Kathakali Dance Drama' in *Asian Music*. Vol. XVIII-2. Ed. Bonnie C. Wade Berkeley: University of California

Kaufmann, Walter 1961. 'The Musical Instruments of the Hill Maria, Jhoria and Bastar Muria Gond Tribes' in *Ethnomusicology* 5(1).

Knizkova, H. 1992. 'India' in *The World of Masks*. Ed. Erich Herold. London: Hamlyn.

Kothari, K.S. 1968. *Indian Folk Musical Instruments*. New Delhi: Sangeet Natak Akademi.

Kothari, S. (ed.) 1979. 'Natya' in *Bharata Natyam. Indian Classical Dance Art*. Bombay: Marg Publications.

Kramrisch, Stella 1928. *Vishnudharmottara (Part III): A Treatise on Indian Painting and Image Making*. Calcutta: University of Calcutta.

Kramrisch, Stella 1968. *Unknown India: Ritual Art in Tribe and Village*. Philadelphia Museum of Art.

Kramrisch, Stella 1981. *Manifestations of Shiva*. Philadelphia Museum of Art.

Kramrisch, Stella 1986. *Painted Delight: Indian Paintings from Philadelphia Collections*. Philadelphia Museum of Art.

Krishnaswamy, S. 1965. *Musical Instruments*. New Delhi: Government of India, Ministry of Information and Broadcasting Publications Division.

Lalit Kala. Nos. 1-2, April 1955 and March 1956. *Editorial notes A Contemporary Portrait of Tansen*. New Delhi: Lalit Kala Akademi.

Lambert, C., Michell, G. and Holland, T. (eds.) 1982. *In the Image of Man*. Arts Council of Great Britan with Weidenfeld and Nicolson.

Lawler, Lillian B. 1964. *The Dance in Ancient Greece*. Middletown: Weslyan University Press.

Leach, Linda 1986. *Indian Miniature Paintings and Drawings: The Cleveland Museum of Art Catalogue of Oriental Art*. The Cleveland Museum of Art in association with Indiana University Press.

Lee, Sherman E. 1970. *Asian Art from the Collection of Mr and Mrs J.D. Rockefeller 3rd, Part II*. Asia Society Inc. Asia House Gallery Publications.

Leidy, Denise Patry 1994. *Treasures of Asian Art. The Asia Society's Mr and Mrs John D. Rockefeller 3rd Collection*. New York: The Asia Society Galleries.

Lerner, Martin and Kossak, Steven 1991. *The Lotus Transcendant. Indian and Southeast Asian Art from the Samuel Eilenberg Collection*. New York: The Metropolitan Museum of Art.

Lynn, V. 1993. *India Songs, Multiple Streams in Contemporary Indian Art*. Sydney: Art Gallery of New South Wales.

Mahapatra, Sitakant 1991. *The Endless Weave. Tribal Songs and Tales of Orissa*. Calcutta: Sahitya Akademi.

Mallebrein, Cornelia 1993. *Die Anderen Gotter. Volks – und Stammesbronzen aus Indien*. Koln: Rautenstrauch-Joest-Museum.

Marcel-Dubois, Claudie 1941. *Les Instruments de Musique de l'Inde Ancienne*. Paris: Presses Universitaires de France.

Masselos, J. 1982. 'Change and Custom in the Format of the Bombay Mohurrum during the 19th and 20th centuries.' in *South Asia*, NS. Vol. 2: 47-67.

Masselos, J. 1991. *Divine and Courtly Life in Indian Painting*. Sydney: Art Gallery of New South Wales.

Massey, Reginald and Jamila 1989. *The Dances of India*. London: Tricolour Books.

Masson, J.L. and Pathwardhan, M.V. 1969. *Santarasa and Adhinavagupta's Philosophy of Aesthetics*. Poona: Bhandarkar Oriental Research Institute.

Maxwell, Robyn 1995. 'Heirloom Textile (ma'a)' in *Traditions of Asian Art*. Michael Brand et al. Canberra: National Gallery of Australia.

Menon, Raghava R. 1995. *The Penguin*

Dictionary of Indian Classical Music. New Delhi: Penguin.

Mevissen, Gerd J.R. 1996. 'Chidambaram – Nrttasabha. Architektur, Ikonographie und Symbolik.' in *Berliner Indologische Studien. Band 9/10*: 345-420.

Michell, George (ed.) 1992. *Living Wood: Sculptural Traditions of Southern India*. Bombay: Marg Publications.

Miller, Barbara S. 1977. *Love Song of the Dark Lord*. New York: Columbia University Press.

Misra, Susheela 1991. *Musical Heritage of Lucknow*. New Delhi: Harman.

Mitter, Partha 1994. *Art and Nationalism in Colonial India 1850-1922*. Occidental Orientations. Cambridge: Cambridge University Press.

Mode, Heinz and Chandra, Subodh 1985. *Indian Folk Art*. New York: Alpine Fine Arts Collection, Ltd.

Murphy, Veronica and Crill, Rosemary 1991. *Tie-dyed Textiles of India. Tradition and Trade*. London: Victoria and Albert; Ahmedabad: Mapin.

Nabholz-Kartaschoff, Marie-Louise 1986. *Golden Sprays and Scarlet Flowers: Traditional Indian Textiles*. Kyoto: Shikosha.

Nagaswamy, R. 1983. *Masterpieces of Early South Indian Bronzes*. New Delhi: Nationla Museum.

Naidu, B.V.N., Naidu, P.S. and Pantulu, O.V.R (eds) 1936. (reprinted New Delhi, 1971.) *Tandava Lakshanam or the Fundamentals of Ancient Hindu Dancing*. Madras: G.S. Press.

Narayana, Vasudha 1987. *The Way and the Goal*. Washington D.C.: Institute for Vaishnava Studies.

'The Nartaki in Indian Dance.' 1990. in *Sangeet Natak*. No.97. July-September.

Nevile, Pran 1996. *Nautch Girls of India*. Paris: Ravi Kumar.

Newman, Richard 1984. *The Stone Sculpture of India: A Study of the Materials used by Indian Sculptors from c.2nd century B.C. to the 16th century*. Cambridge Massachusetts, Centre for Conservation and Technical Studies; Harvard University Art Museum.

Oddie, Geoffrey A. 1995. *Popular Religion, Elites and Reform: Hook-Swinging and its Prohibition in Colonial India, 1800-1894*. Delhi: Manohar.

O' Ferrall, M., Tandan, R. and Natesan, K. 1984. *Spirit of India: A Survey of Indian Art*. Perth: Art Gallery of Western Australia.

Okada, Amina and Dusinberre, Deke (trans.) 1992. *Indian Miniatures of the Mughal Court*. New York: Harry N. Abrams.

Oldenburg, Veena Talur. 1991. 'Lifestyle as Resistance: The Case of the Courtesans of Lucknow' in *Contesting Power. Resistance and Everyday Social Relations in South Asia*. Eds Haynes, Douglas and Prakash, Gyan. New Delhi: Oxford University Press.

Pal, Pratapaditya 1967. *Ragamala Paintings in the Museum of Fine Arts, Boston*. Boston: Museum of Fine Arts.

Pal, Pratapaditya 1977. *The Sensuous Immortals: A Selection from the Pan-Asian Collection*. Los Angeles: Los Angeles County Museum of Art.

Pal, Pratapaditya 1978. *The Classical Tradition in Rajput Painting from the Paul F. Walter Collection*. New York: The Pierpont Morgan Library and the Gallery Association of New York State.

Pal, Pratapaditya 1983. *Court Paintings of India: 16th-19th Centuries*. New York: Navin Kumar.

Pal, Pratapaditya 1986. *Indian Sculpture, Volume 1 (circa 500B.C-A.D 700)*. Los Angeles: Los Angeles County Museum of Art in association with University of California Press.

Pal, Pratapaditya 1988. *Indian Sculpture, Volume 2 (700-1800): A Catalogue of the Los Angeles County Museum of Art Collection*. Los Angeles: Los Angeles County Museum of Art in association with University of California Press.

Pal, Pratapaditya 1993. *Indian Painting, Volume 1 (1000-1700)*. Los Angeles: Los Angeles County Museum of Art in association with Mapin Publishing, Ahmedabad.

Pal, Pratapaditya, Leoshko, J. and Markel, S. 1993. *Pleasure Gardens of the Mind*. Los Angeles County Museum of Art.

Pal, Pratapaditya 1994. *The Peaceful Liberators: Jain Art from India*. Los Angeles: Los Angeles County Museum of Art in association with Thames and Hudson.

Pal, Pratapaditya (ed.) 1986. *American Collectors of Asian Art*. Bombay: Marg Publications.

Pal, Pratapaditya (ed.) 1991. *Master Artists of the Imperial Mughal Court*. Bombay: Marg Publications.

Pal, Pratapaditya (ed.) 1995. *Ganesh the Benevolent*. Bombay: Marg Publications.

Pal, P, Leoshko, J, Dye, J. and Markel, S. 1989. *Romance of the Taj Mahal*. Los Angeles: Los Angeles County Museum of Art in association with Thames and Hudson.

Pandey, S. M. and Norman Zide. 1966. 'Surdas and his Krishna-bhakti' in *Krishna: myths, rites and attitudes*. Ed. Milton Singer. Honolulu: East-West Center Press.

Panikkar, R. 1994. (third edition) *The Vedic Experience*. Delhi: Motilal Banarsidass.

Penzer, N.M. (ed.) Tawney, C.H. (trans.) 1922. *The Ocean of Story. Somadeva's Katha Sarit Sagara*. Vol.I London: C.S. Sawyer. (private press for subscribers only).

Peterson, I.V. 1989. (reprinted Delhi, 1991.) *Poems to Shiva. The Hymns of the Tamil Saints*. New Jersey: Princeton University Press.

Poster, Amy G. 1986. *From Indian Earth: 4000 Years of Terracotta Art*. New York: The Brooklyn Museum.

Prasad, Onkar 1985. *Santal Music: a Study in Pattern and Process of Cultural Persistence.* New Delhi: Inter-India Publications.

Ramachandran, N. 1969. 'Classical Dance of the Ancient Tamils.' in *Proceedings of the First International Conference Seminar of Tamil Studies, Kuala Lumpur, 1966.* Vol. 2. Kuala Lumpur: International Association of Tamil Research.

Ramanujan, A.K., Rao, Velcheru Narayana and Shulman, David 1995. *When God is a Customer, Telugu Courtesan Songs by Ksetrayya and others.* New Delhi: Oxford University Presss.

Randhawa, M.S. 1962. (reprint 1994). *Kangra Paintings on Love.* New Delhi: Publications Division, Ministry of Information and Broadcasting, Government of India.

Randhawa, M.S. 1963. *Kangra Paintings of the Gita Govinda.* New Delhi: National Museum.

Randhawa, M.S. and Galbraith, J.K. 1969. *Indian Painting, The Scene, Themes and Legends.* London: Hamish Hamilton.

Rao, S.R. and Sastry, B.V.K. 1980. *Traditional Paintings of Karnataka.* Bangalore: Karnataka Chitrakala Parishath.

Rao, U.S. Krishna and Devi, U.K. Chandrabhaga. 1993. *A Panorama of Indian Dances.* Delhi: Sri Satgura Publications.

'Recent Acquisitions' 1984. *The Victoria and Albert Album 3.* London: Victoria and Albert Museum.

Rizvi, S.A.A. 1978. *A History of Sufism in India.* Vol.I. New Delhi: Munshiram Manoharlal.

Rodin: Sculpture and Drawings. 1982. New Delhi: National Gallery of Modern Art.

Sadasivan, K. 1993. *Devadasi System in Medieval Tamil Nadu.* Trivandrum: C.B.H. Publications.

Sadie, Stanley (ed.) 1984. *The New Grove Dictionary of Musical Instruments.* 3 vols. London: Macmillan Press.

Sagar, Vinay, Lath Mukund and Singh, Chandramani 1977. *Kalpasutra.* Jaipur: Prakrit Bharati.

Sambamoorthy, P. 1967. (third edition) *The Flute.* Madras: The Indian Music Publishing House.

Sastri, Vasudeva K. 1957. *Bharatarnava of Nandikeswara.* Tanjore: Saraswati Mahal Library.

Sen, Geeti 1984. *Paintings from the Akbar Nama. A Visual Chronicle of Mughal India.* Calcutta: Lustre Press and Rupa and Co.

Shah, U.P. 1978. *Treasures from the Jain Bhandars.* Ahmedabad: L.D. Institute of Indology.

Sharma, Brijendra Nath 1978. *Festivals of India.* New Delhi: Abhinav Publications.

Shirali, Vishnudass 1977. *Sargam: an Introduction to Indian Music.* New Delhi Abhinav/Marg Publications.

Singer, M (ed.) 1966. *Krishna: Myths, Rites and Attitudes.* Honolulu: East-West Centre.

Sivaramamurti, C. 1974. *Nataraja in Art, Thought and Literature.* New Delhi: National Museum.

Skelton, R. 1973. *Rajasthani Temple Hangings of the Krishna Cult.* New York: The American Federation of Arts.

Smith, D. 1989. 'Chidambaram' in *Temple Towns of Tamil Nadu.* Ed. George Michell. Bombay: Marg.

Snellgrove, D.L. 1959. *The Hevajra Tantra.* London: Oxford University Press.

Spink, Walter M. 1971. *Krishnamandala.* Ann Arbor: University of Michigan.

Tagore, Rabindranath 1945. *Gitabitan.* Calcutta: Vishva Bharati Granthalaya.

Talwar, Kay and Kalyan, Krishna 1979. *Indian Pigment Paintings on Cloth.* Ahmedabad: Calico Museum.

Tandan, R.K. 1983. *Pahari Ragamalas.* Bangalore: Natesan Publishers.

Tarlekar, G.H. and N. 1972. *Musical Instruments in Indian Sculpture.* Pune: Pune Vidyarthi Griha Prakashan.

Thurston, Edgar 1909. *Castes and Tribes of Southern India.* Madras: Government Press.

Topsfield, Andrew 1980. *Paintings from Rajasthan in the National Gallery of Victoria, A Collection acquired through the Felton Bequest's Committee.* Melbourne: National Gallery of Victoria.

Topsfield, Andrew and Beach, Milo C. 1991. *Indian Paintings and Drawings from the Collection of Howard Hodgkin.* Thames and Hudson.

Varadarajan, Lotika et al. 1979. *Homage to Kalamkari.* Bombay: Marg Publications.

Vatsyayan, Kapila 1976. (Second revised and enlarged edition, 1987) *Traditions of Indian Folk Dance.* New Delhi: Clarion Books.

Vatsyayan, Kapila 1977. *Classical Indian Dance in Literature and the Arts.* New Delhi: Sangeet Natak Akademi.

Vatsyayan, Kapila 1982. *Dance in Indian Painting.* New Delhi: Abhinav Publications.

Vatsyayan, Kapila 1983. *The Square and the Circle of the Indian Arts.* New Delhi: Rolli Books International.

Vatsyayan, Kapila (ed.) 1988. "Vishnu Upanisad, II" in *Kalatattvakosa.* New Delhi: Indira Gandhi National Centre for the Arts.

Wade, Bonnie C. 1996. 'Performing the Drone in Hindustani Classical Music: What Mughal Paintings Show us to Hear' in *The World of Music.* 38(2)

Wade, Bonnie C. 1997. *Imaging Sound: An Ethnomusicological Study of Music, Art and Culture in Mughal India.* Chicago: University of Chicago Press.

Waldschmidt, Ernst and Rose Leonore 1975.

Minatures of Musical Inspiration Part II. Berlin: Museum fur Indische Kunst.

Walker, Benjamin 1968. *The Hindu World: an Encyclopedic Survey of Hinduism.* 2 vols. New York and Washington: Frederick A. Praeger, Inc., Publishers.

Welch, Stuart Carey 1965. *Gods, Thrones and Peacocks.* New York: Asia House Gallery.

Welch, Stuart Carey 1973. *A Flower from Every Meadow.* New York: Asia House Gallery.

Welch, Stuart Carey 1978. *Imperial Mughal Painting.* London: Chatto and Windus.

Welch, Stuart Carey 1978. (2) *Room for Wonder: Indian Paintings during the British Period 1760-1880.* New York: The American Federation of Arts.

Welch, Stuart Carey 1985. *India: Art and Culture 1300–1900.* New York: Metropolitan Museum of Art.

Welch, Stuart Carey 1985 (2). *A Second Paradise. Indian Courtly Life 1590-1947.* London: Sidgwick & Jackson Ltd.

Widdess, Richard 1996. *The Ragas of Early Indian Music.* London: Oxford University Press.

Yocum, Glenn E. 1982. *Hymns to the Dancing Siva.* Columbia, Michigan: South Asia Books.

Younger, Paul 1995. *The Home of Dancing Sivan.* Oxford: Oxford University Press.

Zebrowski, Mark 1983. *Deccani Painting.* London: Sotheby Publications and USA: University of California Press.

310

LIST OF ACCESSION NUMBERS

PHOTO CREDITS

Unless otherwise noted, all photographs are courtesy of the lender.

Art Gallery of New South Wales
25, 28, 29, 35, 40, 44(d), 47, 52, 86, 87, 93, 98, 116(c), 119, 132, 135, 139, 148, 194

Australian Museum 114 (a) (b)

Richard Bell 4, 42(a)

John Briggs 163

Cleveland Museum of Art 80

Robert and Aida Mates 6, 9, 14, 19, 20, 23(a), 36(d), 41(b), 42(b), 44(b), 45, 56, 60, 61(b), 67, 69, 72, 75, 81, 90(c), 105, 109(b), 117, 131, 143(b), 150, 157, 166, 172, 175, 178(a), 185, 197, 199

Owen Murphy 116(b)

Steve Oliver 15, 16, 36(c), 43, 91, 92, 99(a) (b), 109, 127, 138

Kaz Tsuruta 31, 85, 173, 174, 178(b), 183

Graydon Wood 58, 79

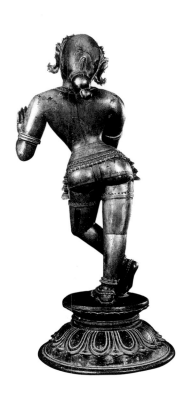